Black Threads

Black Threads

An African American Quilting Sourcebook

by KYRA E. HICKS

with a foreword by
CUESTA R. BENBERRY

McFarland & Company, Inc., Publishers
Jefferson, North Carolina, and London

SPACE JAM, characters, names and all related
indicia are trademarks and © of Warner Bros.

Library of Congress Cataloguing-in-Publication Data

Hicks, Kyra E., 1965–
Black threads : An African American quilting sourcebook /
by Kyra E. Hicks; foreword by Cuesta R. Benberry.
p. cm.
Includes bibliographical references and index.

ISBN 0-7864-1374-3 (illustrated case binding : 50# and 70# alkaline papers)

1. African American quilts. 2. African American quilts—
Bibliography. 3. African American quilts—History—Sources.
4. Quilting—United States—History—Sources. I. Title.
NK9112 .H53 2003 746.46'089'96073—dc21 2002011892

British Library cataloguing data are available

On the cover: Prodigy African Core Progressive Quilt Top, 1994.

Manufactured in the United States of America

*McFarland & Company, Inc., Publishers
Box 611, Jefferson, North Carolina 28640
www.mcfarlandpub.com*

To my parents,
Richard Wayne and Elizabeth Ann Crockett Hicks

and

In memory of
Granny, Kathaleen Richardson Millben (1893–1997)
and Roland Charles, photographer (1938–2000)

Contents

Acknowledgments

The journey to complete this book was accomplished with the daily encouragement of three women. First, I am especially grateful to Cuesta Benberry, who unselfishly shared countless quilt history insights and artifacts with me. Next, Gwendolyn Magee, whose infectious joy in uncovering new avenues of the African American quilt story has made research *fun!* Third, I am indebted to my sister, Iyisa K. Hicks, for her unending research and typing assistance.

Literally hundreds of people have contributed materials for this book. I am particularly thankful to Joanna Banks, NedRa Bonds, Claire Carter, Hazel Carter, Sarah Dangelas, Bill Gaskins, Jean Gianfagna, Gina Paige Gobourne, Deborah Grayson, Alston Green, Joyce Gross, Monica Dee Guillory, Kevin Hinton, Gail Johnson, Carolyn Mazloomi, Marlene O'Bryant-Seabrook, Tim Ruder, David Smalls, Andrew Stasik, Sherry Whetstone-McCall and Ron Wiley for their distinctive contributions.

My sincere gratitude goes to the staffs at the American Folk Art Museum Library, the Moorland-Spingarn Research Center at Howard University, and the National Quilting Association library. I would also like to thank Elizabeth Stapleton-Roach at the John F. Kennedy Library, volunteer Carol Tyler at the New England Quilt Museum in Lowell, MA, Mike Jolly at the Tuskegee Institute National Historic Site, and Director Martha Mayo at the University of Massachusetts Lowell Center for Lowell History.

This research was partially funded by a grant from the National Quilting Association, for which I am most appreciative.

Finally, I am indebted to my mother, Elizabeth Hicks, for her manuscript suggestions and prayers. Only one's mother would read one's book completely, four times.

I have diligently attempted to ensure the accuracy of each listing, and I accept responsibility for any mistakes. Working on *Black Threads* has been a pleasure. I look forward to hearing about other African American quilters and quilting events, past and present, not recorded here.

Kyra E. Hicks
Arlington, Virginia
www.Black-Threads.com

To everything there is a season,
A time for every purpose under heaven...
A time to tear,
And a time to sew...

—Ecclesiastes 3:1,7
Holy Bible,
New King James Version

Foreword

This book by Kyra Hicks is an amazing compendium of historical data concerning African American quiltmakers and their quilts. When one considers that serious, scholarly investigations of African American quilt history date only from the mid- to late 1970s, the enormous scope of *Black Threads'* citations becomes even more remarkable. Undergirded by the extensive and detailed research conducted, this document explores the diverse contributions of African American quilts from the early 1800s to the present time, nearly two centuries later.

By demonstrating how pervasive within the African American quilt community the quilting tradition has become and all of its resulting auxiliary outcomes, Kyra Hicks' sourcebook can best be described as comprehensive. For interwoven with her text are examples of the quilting tradition's influence on African American fine and folk artists, the Black literati, political and religious figures. By including documented evidence of quilting from the African continent, the cultural ties of the descendants of the African diaspora are re-established with their motherland. There clearly exists a connection between the bibliographic entries on patchwork and quiltmaking efforts in West Africa and South Africa and those of African Americans in the United States, in Canada, in the Caribbean areas and in Surinam and Brazil, South America.

As African Americans have always been a distinct minority group in American society, they have been affected in numerous ways by the mainstream's popular perceptions of them. Thus there was another aspect of the role of quilts in Black people's lives that needed to be placed on the historical record. How were African Americans portrayed on pictorial quilts made by white Americans? Were the images of African Americans on white-made quilts negative ones, such as comic-derogatory caricatures or stereotypical portraitures, or were they positive realistic or humanistic depictions? *Black Threads* supplies ample and incontrovertible visual evidence to answer each of those questions.

Kyra Hicks has expanded and modernized her bibliography to include a broad

1

range of new topics characteristic of millennium age thinking. She conducted Internet-based surveys and from the considerable responses received, she was able to compose statistically reliable documents that gave brand-new information about contemporary African American quilters. Her forays into the subject of textiles used by African American quilters, whether the special commemorative printed fabrics showing Black heroes, institutions, and religious symbols, or the imported woven West African textiles, are documented in this bibliographic sourcebook.

In addition to being a most exhaustive reference of African American quilts and quilters, this book serves another equally valuable function. It is a book of empowerment for African American quilters and for scholars who are dedicated to researching African American quilt history. For here is the fullest record yet conceived that verifies and substantiates the long and continuing contributions of Black American quilters. For the general public *Black Threads* is a book of enlightenment. And for Kyra Hicks, the book represents an impressive master work of a distinguished scholar.

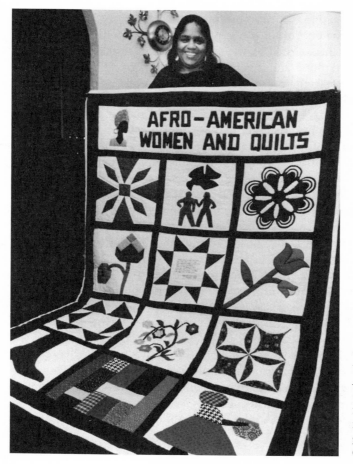

Cuesta R. Benberry
St. Louis, Missouri

Cuesta Ray Benberry with her sampler *Afro-American Women and Quilts* (1980). Reprint from *Quilters' Journal*, no. 23, 1983. (Photograph courtesy Joyce Gross.)

Introduction

In 1991, a friend took me to the Taft Museum (Cincinnati, OH) to see the *Stitching Memories: African American Story Quilts* exhibit. No one in my family quilted. I had taken only a seventh grade sewing class. But I remember *knowing* when I walked into the exhibit hall and saw quilts by Faith Ringgold, Clementine Hunter, Winnie McQueen, and others that I wanted to quilt, too. I found my voice that day and made my first quilt soon after. Over the years, various mentors such as Cuesta Benberry and Carolyn Mazloomi have encouraged me to make artistic as well as scholarly contributions to American quilting. This book marks my first scholarly effort.

My primary goal in compiling this book is to document the range of ways African American quiltmaking has been interpreted: in cloth, in art and in written and spoken words. The book includes references to famous Black quilters as well as casual quilters in towns across America. *Black Threads* also seeks to quantify the African American quilting experience in general and on the Internet.

The book consists of seven chapters:

1. ***African American Quilting Industry Overview.*** According to *Quilting in America 2000*, an industry study, close to twenty million American adults quilt. From my research, I estimate there are one million African American adult quilters. This chapter quantifies the African American quilting population and industry value for 1997 and 2000. U.S. Census data is used to help estimate the Black quilting population by state.

2. ***Bibliography and Resources.*** This section catalogs over 1,700 books, magazine and newspaper articles, dissertations, musical works, films, plays, artworks, quilting patterns and ephemeral materials dealing with African American quilting. References, many annotated, span more than two hundred years.

3

The bibliography is organized in categories such as books primarily devoted to black quilting; exhibit catalogs; quilt and other African American needlework patterns; articles on quilters; films; artwork; grant opportunities and other subjects. Selected references to cloth doll, crochet, and other needlework patterns are included as a convenience for quilters. Most quilters participate in multiple needlecrafts and sometimes incorporate these crafts in their quilting.

Teachers will find this section useful for its extensive guides to children's literature, videos, and lesson plans related to African American quilting.

There is also a state-by-state guide to African American quilting guilds. The oldest ongoing African American quilting group identified here is the Jolly Sixteen Art Club in Kansas City, which has been meeting since 1926. Where possible, each group is identified with a contact name and address. Even defunct groups are included to assist future researchers in this area.

Lastly, there is a guide to online African American quilting. One can locate popular Web sites, online discussion groups, and resources for quilting ecommerce.

3. *Museums and Galleries with African American Quilts.* Included is a listing of about 100 American museums (and one in England) which together hold more than 500 African American quilts in their permanent collections. Museums and libraries with oral histories and ephemeral materials related to African American quilting are also included. The listing is a result of a survey sent to over 400 museums nationally—including fine art and folk art museums, historically Black college museums, presidential libraries and selected corporate art collections.

Interestingly, more than 60 percent of African American–made quilts in museums are housed at just seven institutions: The International Quilt Study Center at the University of Nebraska, the American Folk Art Museum (NYC), Michigan State University Museum (East Lansing, MI), the Old State House Museum (Little Rock, AR), the Smith Robertson Museum (Jackson, MS), the Old Capital Museum of Mississippi (Jackson, MS), and the Kansas African American Museum (Wichita, KS).

This section also includes a list of approximately thirty galleries that specialize in African American quilts. These gallery owners frequently promote quilting and actively seek other quilters to represent.

4. *African American Quilters and Internet Usage Overview.* The Internet exploded as a popular medium in 1994 and has had a profound effect on our daily lives—including the lives of quilters. This section shows the results from the first major online survey of quilters. During the summer of 2000, nine hundred and seventy (970) quilters responded to a 20-question online survey about how the Internet has affected their quilting. Almost one in ten respondents was an African American woman. We learn how many years she has quilted, how she defines her skill level, what style quilt she prefers making, and what aspects of her Internet experiences are most important to her quilting.

5. *African American Fabric Purchasing and Theme Fabrics.* This section will be of interest to quilt appraisers, fabric store owners, and textile manufacturers. In January and February 2001, some 1,400 quilters responded to an online survey of their fabric purchasing habits. Six percent of the respondents were African American quilters. Major similarities and differences between African American quilters on the Internet and other quilters are outlined.

African American quilters purchase an estimated $40–$45 million in fabrics per year. This section also includes photographs of past African American theme fabrics from the 1980s to 2000.

6. *African American Quilting History Timeline.* Significant events from 1800 to 2000 related to African American quilting are listed in this timeline. The timeline includes a range of events—completion of important historical quilts, sewing inventions, publications related to American quilting, awards to Black quilters, important museum exhibits, and newsworthy popular culture, fine arts, and needlework events that may have influenced African American quilters.

7. *Future Developments in African American Quilting.* This final section outlines my wishes for future exploration in African American quilting.

It is my hope that this book will provide a foundation for the next two hundred years of African American quilting documentation.

CHAPTER 1

One Million
African American Quilters—
Industry Overview

If you are a quilter, then you probably have a fabric stash, a pile of colorful cottons for future quilting projects. You most likely know where each fabric store within a 25-mile radius is located. And, chances are, you own a shelf full of quilting "how-to" books and magazines. You are not alone in your quilting passion!

U. S. Quilting Industry Households (HH) 1994–2000

	Quilters as % of U.S. HH	Number of Quilting HH*	Quilters per HH	Number of U.S. Quilters	Avg. Dollars Spent per HH	Total Dollars Spent Annually
2000	15.1%	15,560,550	1.27	19,761,899	$118.02	$1,836,456,111
1997	12.2%	12,032,000	1.15	13,826,800	$100.64	$1,210,900,480
1994	14.7%	14,091,000	1.10	15,500,100	$110.29	$1,554,096,390

SOURCE: *Quilting in America*—2000, 1997, 1994 surveys. Contact Tina Battock (Primedia 303-273-1321) or Nancy O'Bryant (Quilts, Inc. 713-781-6264) for further information. Nineteen ninety-four was the first year the survey was conducted. It is unclear from the published survey data why 1997 expenditures and number of quilters declined.

The number of quilting households increased, in part, because the number of U.S. households increased 4.2 percent from 1997 to 2000.

INDUSTRY OVERVIEW

U.S. quilters spent $1.8 billion on quilting related expenditures in 2000, according to *Quilting in America*, an on-going industry study jointly funded by *Quilter's*

Newsletter Magazine and the International Quilt Market and Festival. Moreover, total quilting expenditures increased an astonishing 51.5 percent since 1997.

Fifteen percent of all U.S. households participate in quilting. The average quilting household now includes 1.27 quilters. As a result, there are approximately 19.7 million American quilters.

DEDICATED QUILTERS

A passionate group of quilters, only 6 percent, account for a disproportionate 94 percent of all quilting expenditures, according to *Quilting in America 2000*. The survey identifies this core group as "dedicated quilters."

The average "dedicated quilter" is a woman 55 years of age. She is likely to be college educated with a household income of $74,806. She has an average of 11.2 years quilting experience and generally describes her skill level as intermediate or advanced. Forty-six percent of dedicated quilters define themselves as "traditional" style quilters. Forty-nine percent, though, enjoy making both contemporary and traditional style quilts. Far outpacing the average U.S. quilter, the dedicated quilter spent $1,556 a year on quilting expenditures. She spent 43 percent of her quilting dollars or $667 on fabrics alone. She spent an average of $624 on "big ticket" items such as sewing machines, quilting frames, and cutting tables. Her annual expenditure for quilting books averaged $105. She subscribed to an average of 3.7 quilting magazines.

U.S. Dedicated Quilters (DQ) 1994–2000

	DQ as % of All U.S. Quilters	*Avg. Dollars Spent per DQ*	*DQ as % of Total Industry Expenditures*	*DQ Avg. Age*	*DQ Years Quilting*
2000	6.0%	$1,556	94%	55	11.2
1997	4.9%	$1,430	77%	54	10.7
1994	5.4%	$1,203	50%	52	10.5

SOURCE: *Quilting in America—2000, 1997, 1994 surveys.*

Note: In 1997, the number and total quilting expenditures declined. It is interesting to note, though, "dedicated quilters" continued to spend more dollars on this passion each year.

QUILTING INDUSTRY FOCUS
BEYOND DEDICATED QUILTERS

At first glance, it appears the U.S. quilting industry is centered on satisfying and expanding the "dedicated quilter" market segment. This highly concentrated consumer is increasingly older. She presumably has more time and discretionary income to devote to quilting, a craft she has nurtured for at least a decade.

What are U.S. quilting fabric manufacturers, sewing machine makers, quilting magazines, and retail stores doing to expand the quilt market or uncover unmet quilter needs beyond the "dedicated quilter"?

One avenue is to examine the race of U.S. quilters. The assumption is that African American, Hispanic, and Asian quilters may have unmet quilting needs based on culture or language. In a simple example, there may be unmet fabric needs based on culture. Sixty-seven percent of dedicated quilters purchased holiday prints in the last 13 months, according to *Quilting in America 2000.* Are fabric manufacturers and quilt stores consistently offering relevant holiday prints such as Black Santa or Feliz Navidad cotton prints?

There is no widely published statistical data on African American quilters. The Hobby Industry Association (HIA) has surveyed consumer attitudes and behaviors biennially since 1988. HIA provides a profile of thirty-three different activities in four major areas (Needlecrafts, Painting and Finishing, Floral Crafts, and General Crafts) relative to household participation, demographics, and buying behaviors. Quilting is one of the needlecraft activities surveyed. Sadly, the HIA 1998 Nationwide Craft/Hobby Consumer Study did not include race as a demographic variable. The *Quilting in America* surveys also have not specifically examined quilter race or ethnicity to determine how cultural variables may affect quilting expenditures. Given the increasing diversity in America, this should be an option for the next industry surveys.

WHY MEASURING IS IMPORTANT

There are a few reasons why it is important to understand African American quilting industry and population figures. First, measuring race as a demographic variable will demonstrate that the quilt industry values the cultural heritage of its consumer base. This market research may uncover unmet cultural quilting needs and potentially expand total industry expenditures.

Second, institutions and organizations that preserve quilt history need a context for collecting *all* American quilt stories. State quilt documentation coordinators can use ethnicity data to help guide efforts to appropriately include African American quilters in these historically important efforts. Community and state museums can use the ethnicity figures to ensure their textile collections reflect African American creative efforts.

Finally, individual Black quilters can use industry and population figures in applying for grants and other financial endeavors where industry figures are critical.

ONE MILLION AFRICAN AMERICAN QUILTERS

Tina Battock, *Quilter's Newsletter Magazine* publisher and primary contact for the *Quilting in America* surveys, shared in a January 2001 email that 5.1 percent

of quilting households are African American in 2000, up from 3.6 percent of quilting households in 1997. With these essential data points, it is possible, for the first time, to estimate several points concerning the African American quilting population:

• There were 1,007,587 African American quilters in 2000.

• The African American quilting population grew 102 percent vs. 43 percent for the total U.S. quilter population since 1997.

• African American quilters spent $118,947,262 in 2000, up 137 percent since 1997.

• 60,471 dedicated African American quilters spent $94,092,876 on quilting expenditures in 2000. This assumes that 6 percent of Black quilters are "dedicated quilters."

• Dedicated Black quilters spent $40.3 million on fabric in 2000.

• One in twenty U.S. quilters is African American.

African American Quilting Industry Households (HH) 1997–2000

	% of Quilting HH which are Black*	Number of Black Quilting HH	Quilters Per HH†	Number of Black Quilters	Avg. Dollars Spent per HH†	Total Dollars Spent by Black Quilters
2000	5.1%	793,588	1.27	1,007,857	$118.02	$118,947,262
1997	3.6%	433,152	1.15	498,125	$100.64	$ 50,131,280

SOURCE: *Tina Battock, Primedia, January 26, 2001, email to author. African American quilting household figures not available for 1994.

†Assumes number of quilters per household and average dollars spent per household are same for Black quilters as for all quilters. More research is needed to determine if this assumption is verifiable.

WHAT IS FUELING THE GROWTH IN BLACK QUILTERS?

Certainly, research needs to be conducted to determine the underlying factors fueling the growth in both African American quilting expenditure and population. During the four years between 1997 and 2000, three major national events promoting African American quilting may have motivated potential crafters to start stitching quilts.

First, two major traveling museum exhibits, with accompanying publications, focused exclusively on Black quilters. At each museum venue, community outreach programs increased awareness for the quilting craft and local quilters. Local news media covered both exhibits extensively. The first exhibit was Roland Freeman's landmark *A Communion of the Spirits: African American Quilters, Preservers, and Their Stories*. For more than twenty years, Freeman traveled to thirty-eight U.S. states and Washington, DC, photographing hundreds of Black quilters and collecting their stories. This exhibit opened January 1997 at the Mississippi

Museum of Art in Jackson, MS, and toured nine other museums through 2000. *Communion of the Spirits* demonstrated more clearly then ever that Black quilters were prevalent across America. The *Detroit News* estimated an average of 10,000 visitors a month saw *Communion of the Spirits* in the first four months it was at the Museum of African American History in Detroit, Michigan.

The second exhibit was Carolyn Mazloomi's unprecedented *Spirits of the Cloth: Contemporary African American Quilts* (1998), which opened at the American Craft Museums in New York and continued to travel throughout 2001. The exhibit showcased fifty contemporary quilts with themes as diverse as home, sacred spaces to praise and abstract designs. Mazloomi's book *Spirit of the Cloth* was awarded the 1999 Black Caucus of the American Library Association Literary award for non-fiction.

Finally, *Hidden in Plain View: A Secret Story of Quilts and the Underground Railroad* (1999) co-written by Raymond Dobard and Jacqueline Tobin, introduced Charleston, NC, resident Ozella McDaniel Williams's oral history of the role quilting played on the Underground Railroad. This book received extensive media coverage. Co-author and quilter Raymond Dobard even appeared on a segment of the number one rated *Oprah* daytime program.

In 2000, I conducted an online survey targeting quilters. The goal of the survey was to understand how Internet usage affected quilting activities. Nine hundred and seventy quilters responded to the survey. Nine percent of the respondents checked African American as their ethnicity. The survey results showed that Black quilters on the Internet entered quiltmaking at a higher percentage than total respondents; 21.6 percent of African American quilters on the Internet started quilting between 1998 and 2000 vs. 13 percent for all respondents. This result seems to mirror the growth in new Black quilters seen in the overall quilting industry.

WHERE ARE ONE MILLION AFRICAN AMERICAN QUILTERS?

To help understand how one million African American quilters are dispersed in America, U.S. Census data has been used. The Black quilter population is assumed to be proportional to African American population figures by state. A proportional distribution is assumed in the absence of quilt industry data.

Table A lists the Black quilting population by state and the estimated number of Black quilters by state. We find, then, that 80 percent of Black quilters reside in sixteen American states in rank order: New York, California, Texas, Florida, Georgia, Illinois, North Carolina, Maryland, Michigan, Louisiana, Virginia, Ohio, New Jersey, Pennsylvania, South Carolina, and Alabama.

These sixteen states have produced a number of noted quilting groups. For example, groups such as the Quilters of Color Network of New York, Inc., the Ebony Quilters of New Jersey, the San Diego People of Color Quilt Guild, and the 54-50 African American Quilting Guild of Virginia have an active schedule of community quilt exhibits. The famed Freedom Quilting Bee, which held a record

in 1969 for sewing the world's largest quilt, hailed from Alabama. Historian Marsha L. MacDowell has edited a book documenting the traditions of Black quilters in Michigan.

Certainly more research is needed to verify these by state estimates. In addition, more research is needed to understand how geography has affected, if at all, the level of quiltmaking participation.

FUTURE AFRICAN AMERICAN QUILTING EXPENDITURES AND POPULATION

One million African American quilters spent $118 million on quilt-related expenditures in 2000. Previously no one has celebrated or examined the economic value that Black quilters bring to this passionate industry. A total of $118 million represents many thousands of yards of fabric and spools of threads, shelves of quilting "how-to" books and magazines, pallets of sewing machines, and multiple quilting classes.

The quilting industry should begin to delve deeper into and beyond the homogeneous dedicated quilter segment to understand how culture may be affecting the quilting market. African American quilters are entering the craft at more than twice the rate of the total U.S. quilting population. Does the quilt industry have the necessary data to address needs that may be unique to Black quilters?

It is hoped the next *Quilting in America* national survey will consider reviewing the role ethnicity may play in our industry. This basic demographic is key to help examine not only the African American quilting market, but also the Hispanic, Native American, and Asian quilting segments. Understanding the role culture plays in quilting may uncover unmet quilter needs and expand future industry expenditures and population.

Table A. Estimating the Number of African American Quilters by State

		Total Population, 7/1/99*	Est. Black Population, 7/1/99*	State as % of Total Black Population	Est. Black Quilters by State†	Est. Black Dedicated Quilters†
1	New York	18,196,601	3,222,461	9.2%	93,161	5,590
2	California	33,145,121	2,487,006	7.1%	71,899	4,314
3	Texas	20,044,141	2,470,194	7.1%	71,413	4,285
4	Florida	15,111,244	2,333,424	6.7%	67,459	4,047
5	Georgia	7,788,240	2,235,897	6.4%	64,639	3,878
6	Illinois	12,128,370	1,854,173	5.3%	53,604	3,216
7	North Carolina	7,650,789	1,686,143	4.8%	48,746	2,925
8	Maryland	5,171,634	1,454,381	4.2%	42,046	2,523

Table A *(cont.)*		Total Population, 7/1/99*	Est. Black Population, 7/1/99*	State as % of Total Black Population	Est. Black Quilters by State†	Est. Black Dedicated Quilters†
9	Michigan	9,863,775	1,415,201	4.1%	40,913	2,455
10	Louisiana	4,372,035	1,415,195	4.1%	40,913	2,455
11	Virginia	6,872,912	1,384,651	4.0%	40,030	2,402
12	Ohio	11,256,654	1,304,126	3.7%	37,702	2,262
13	New Jersey	8,143,412	1,197,430	3.4%	34,617	2,077
14	Pennsylvania	11,994,016	1,170,095	3.4%	33,827	2,030
15	South Carolina	3,885,736	1,156,946	3.3%	33,447	2,007
16	Alabama	4,369,862	1,138,726	3.3%	32,920	1,975
17	Mississippi	2,768,619	1,010,216	2.9%	29,205	1,752
18	Tennessee	5,483,535	912,577	2.6%	26,382	1,583
19	Missouri	5,468,338	617,148	1.8%	17,842	1,070
20	Indiana	5,942,901	497,976	1.4%	14,396	864
21	Arkansas	2,551,373	410,821	1.2%	11,877	713
22	Massachusetts	6,175,169	405,159	1.2%	11,713	703
23	District of Columbia	519,000	318,657	0.9%	9,212	553
24	Connecticut	3,282,031	308,772	0.9%	8,927	536
25	Wisconsin	5,250,446	293,367	0.8%	8,481	509
26	Kentucky	3,960,825	288,336	0.8%	8,336	500
27	Oklahoma	3,358,044	262,136	0.8%	7,578	455
28	Washington	5,756,361	203,853	0.6%	5,893	354
29	Colorado	4,056,133	176,277	0.5%	5,096	306
30	Arizona	4,778,332	175,506	0.5%	5,074	304
31	Kansas	2,654,052	157,176	0.5%	4,544	273
32	Delaware	753,538	149,290	0.4%	4,316	259
33	Minnesota	4,775,508	148,596	0.4%	4,296	258
34	Nevada	1,809,253	140,031	0.4%	4,048	243
35	Nebraska	1,666,028	68,067	0.2%	1,968	118
36	Oregon	3,316,154	62,012	0.2%	1,793	108
37	Iowa	2,869,413	58,013	0.2%	1,677	101
38	West Virginia	1,806,928	56,108	0.2%	1,622	97
39	Rhode Island	990,819	50,292	0.1%	1,454	87
40	New Mexico	1,739,844	45,792	0.1%	1,324	79
41	Hawaii	1,185,497	33,752	0.1%	976	59
42	Alaska	619,500	24,067	0.1%	696	42
43	Utah	2,129,836	19,481	0.1%	563	34
44	New Hampshire	1,201,134	9,044	0.03%	261	16
45	Idaho	1,251,700	7,561	0.02%	219	13
46	Maine	1,253,040	6,258	0.02%	181	11
47	South Dakota	733,133	5,099	0.01%	147	9
48	Wyoming	479,602	4,210	0.01%	122	7

Table A *(cont.)*		Total Population, 7/1/99*	Est. Black Population, 7/1/99*	State as % of Total Black Population	Est. Black Quilters by State†	Est. Black Dedicated Quilters†
49	North Dakota	633,666	4,118	0.01%	119	7
50	Vermont	593,740	3,184	0.01%	92	6
51	Montana	882,779	3,168	0.01%	92	5
Totals		272,690,813	34,862,169	100.00%	1,007,857	60,471

SOURCE: *Population Estimates Program, Population Division, U.S. Census Bureau, Washington, DC (ST-99-45) States Ranked by Black Population, July 1, 1999.

†*Author estimates assume the number of quilters is proportional to the total population by state.*

CHAPTER 2

Bibliography and Resources

AFRICAN AMERICAN QUILTING BOOKS

The following non-fiction books are exclusively devoted to African American quiltmaking or quilters.

Benberry, Cuesta. *Always There: The African-American Presence in American Quilts*. Forewords by Jonathan Holstein and Shelly Zegart. Louisville, KY: The Kentucky Quilt Project, Inc., 1992. 132 p. Cuesta Benberry is one of America's leading quilt historians. Subjects covered in this book include slave-made quilts in ante-bellum America, African American quilting beyond the US borders, a profile of Elizabeth Keckley, Bible quilts, quilts from the late nineteenth and twentieth centuries, and discussion of how Black artists have incorporated quilts and quiltmaking into literature and art.

_____. *A Piece of My Soul: Quilts by Black Arkansans*. Introduction by Raymond G. Dobard. Fayetteville, AK: University of Arkansas Press, 2000. 158 p. This book introduces readers to the extensive collection of seventy-five African American quilts in the Old State House Museum in Little Rock. The quilts date from the 1890s to the 1990s. There are color photographs of each quilt. The book provides insights into the importance of quilting to Black Arkansans, quilt uses and patterns, and the quilters themselves. No other American state has preserved such an extensive collection of quilts by its African American citizens.

Callahan, Nancy. *The Freedom Quilting Bee*. Tuscaloosa, AL: University of Alabama Press, 1987. 256 p. History of the rural quilting cooperative from 1966 through the mid-1980s. Follows the group's development and commercial efforts to obtain a Sears contract and, later, to make the "Largest Quilt in the World" for Du Pont. Callahan also provides insights into *Vogue* editor-in-chief Diana Vreeland and New York interior designer Sister Parish of Parish-Hadley efforts to promote patchwork fashions using Freedom Quilting Bee quilts. Book includes fascinating profiles of original members such as Minder Pettway Coleman and Estelle Abrams Witherspoon.

Cameron, Dan. *Dancing at the Louvre: Faith Ringgold's French Collection and Other Story*

Quilts. University of California Press, 1998. 168 p. This book includes essays by Ann Gibson, Thalia Gouma-Peterson, Patrick Hill, Richard J. Powell, Moira Roth, and Ringgold's daughter, Michele Wallace. Text from selected French Collection quilts are also included.

Crosby, David. *Quilts and Quilting in Claiborne County: Tradition and Change in a Rural Southern County.* Port Gibson, MS: Mississippi Cultural Crossroads, 1999. 32 p. This fascinating booklet, which has color photos on nearly every page, covers local history, pattern piecing, string quilts, and story quilts by residents. Available for $8 from the Mississippi Cultural Crossroads, 507 Market Street, Port Gibson, MS 39150.

Ezell, Nora McKeon. *My Quilts and Me: The Diary of an American Quilter.* Introduction by Gail Trechsel. Preface by Hank Willett. Montgomery, AL: Black Belt Press 1999. 192 p. Nora Ezell is a 1992 Fellow in the National Endowment for the Arts program. She also received the Alabama Folk Heritage Award in 1990. One of the unique aspects of this book is reading how Ezell sets a fair price for her prized pictorial quilts. The diary details the amount of time and materials used for each story quilt. Fascinating insights into one artist's creative process.

Freeman, Roland. *A Communion of the Spirits: African American Quilters, Preservers, and Their Stories.* Foreword by Cuesta Benberry. Preface by David B. Levine. Nashville, TN: Rutledge Hill Press, 1997. 396 p. Over twenty years of on-going documentation focuses on Black men and women quilters. This book is the first national survey of its kind covering thirty-eight states and Washington, DC. Freeman opens the book with his childhood memories of quilts. He shares stories of early photodocumentation in the mid-1970s while director of the Mississippi Folklife Project. Most of the book focuses on the quilters Freeman met from 1992 to 1996. The book blends narrative with touching photos of quilters and quilts. The book also uncovers African American quilt groups in seventeen states.

_____. *Something to Keep You Warm: The Roland Freeman Collection of Black American Quilts from the Mississippi Heartland.* Jackson, MS: Mississippi State Historical Museum, 1981. This out-of-print booklet is a sought-after collectible. It's one of the first books solely devoted to documenting African American quilters.

Fry, Gladys-Marie. *Stitched from the Soul: Slave Quilts from the Ante-Bellum South.* Foreword by Dr. Robert Bishop. New York: Dutton Studio Books, 1990. 102 p. Subjects covered in this book include the slave seamstress, quilting in the slave quarters, differences in types of quilting parties, and profile of Harriet Powers. Interesting discussion about impromptu quilting parties compared to elaborately planned Christmastime quilting parties.

Galvin, Sean. *What's This Got to Do with Quilting?: Nine Stories of Southern Women Quilters Living in New York City.* Albany, NY: Lane Press, 1995. 24 p. The Elder Craftsmen Textile Project 1989–1994. Includes story about the Southern African-American Quilters, a sewing group which met in Brooklyn. Artists who participated include Fannie Roberts Chaney, Georgia Clark, Trannie Mae Cooper, Vivian Evans, Virginia Hall, Eunice Morgan, Mollie Rieves, Mary Ruffin and Marian Webber. Extensive photos of quilters and quilts.

Grudin, Eva Ungar. *Stitching Memories: African-American Story Quilts.* Williamstown, MA: Williams College Museum of Art, 1990. 95 p. Groundbreaking exhibit catalog featuring thirty quilts in six story categories: home, Bible, family, history, fictional, and feminist. This book was one of the first to present a broad range of African American quilting styles. It did not focus solely on improvisational style quilts. Included are quilts by Lillian Beattie, Clementine Hunter, Wini McQueen, Aminah Robinson, Marie Wilson and others.

Leon, Eli. *Who'd A Thought It: Improvisation in African-American Quiltmaking.* Preface by Robert Ferris Thompson. San Francisco: San Francisco Craft and Folk Art Museum, 1987. 88 p. Examples of improvisational quilts by several artists including Sherry Byrd, Charles Carter, Willia Ette Graham, Angelia Tobias, Rosie Lee Tompkins and others.

Lyons, Mary E. *Stitching Stars: The Story Quilts of Harriet Powers.* New York: Charles Scribner's Sons, 1993. 42 p. This story for young readers tells about the life of quilter Harriet Powers, a mother of eleven children. She is also the spiritual mother of African American quilters. Two of Powers' Bible quilts are in the permanent collections of the Smithsonian Institution and the Museum of Fine Arts, Boston.

MacDowell, Marsha. *African American Quiltmaking in Michigan.* East Lansing: Michigan State University Press, 1997. 162 p. More than 140 photographs of quilts, quiltmakers, and quiltmaking activities. Essays cover the history and meaning of quilting in Michigan quilters's life, community, and family. Cuesta Benberry provides a brief history of African American quilting. Darlene Clark Hine provides a context for examining quilting as part of Black women's cultural history. Included are interviews with quilters Deonna Green, Carole Harris, Rosa Parks and Ione Todd. Also includes story of Michigan connection to *The Couples Quilt.* Extensive bibliography related to Black quilters in Michigan.

Marsh, Carole. *Let's Quilt Our African-American Heritage and Stuff It Topographically.* Decatur, GA: Gallopade, 1989. 36 p. Also available on computer disc. This softcover book, which can be used to teach children about quilts and quiltmaking, focuses on quilting during slave times. No other era of African American quilting is discussed.

_____. *Let's Quilt Our Black Heritage.* Decatur, GA: Gallopade, 1991.

Mazloomi, Carolyn. *Spirit of the Cloth: Contemporary African American Quilts.* Preface by Faith Ringgold. Foreword by Cuesta Benberry. New York: Clarkson N. Potter, Inc., 1998. 192 p. Showcases 150 contemporary quilts by sixty-three nationally known artists. Stunning full-color photographs and insightful text. The quilts are divided into eight categories: visions of Africa, home, healing, sacred space, social and political protest, praise, Black women-focused, and design.

Museum of Fine Arts, Boston. *A Pattern Book, Based on Appliqué Quilts by Mrs. Harriet Powers, American, 19th Century.* Boston: Museum of Fine Arts, 1973. [32] p. Fifteen block patterns from Powers' quilt.

Perry, Regenia A. *Harriet Powers's Bible Quilts.* New York: Rizzoli International Publications, Inc. Large-format. 1994. [24] p. Overview of Harriet Powers's life. Detailed photos and descriptions are presented for both of Power's Bible Quilts. These quilts are presently in the permanent collections of the Smithsonian Institution and the Museum of Fine Arts, Boston.

Ringgold, Faith. *The French Collection: Part 1.* New York: Being My Own Woman Press, 1992. 40 p. Includes essays by Michele Wallace and Moira Roth. This softcover book includes photos and text for the series of eight quilts in the French Collection: Part 1. In addition, a photo and the text for *Change 3: Faith Ringgold's Over 100 Pounds Weight Loss Performance Story Quilt* is included.

_____. *Seven Passages to a Flight.* San Diego, CA: Brighton Press, 1995. 42 p. Nine handpainted and hand stenciled etchings with autobiographical text printed on linen. The book is housed in a clamshell box covered with handpainted linen and fabric inlays. Signed by Faith Ringgold. Edition size: 30. Available for $4,800. A deluxe edition includes a hand stenciled and hand sewn quilt for $15,000. Edition size: 10.

_____. *We Flew Over the Bridge: The Memoirs of Faith Ringgold.* New York: Bulfinch Press,

1995. 288 p. This remarkable autobiography in divided into three sections: Harlem Born and Bred; Men, Marriage, and Motherhood; and Making Art, Making Waves, and Making Money.

Tobin, Jacqueline L., and Raymond G. Dobard. *Hidden in Plain View: A Secret Story of Quilts and the Underground Railroad.* Forewords by Cuesta Benberry, Floyd Coleman, and Maude Southwell Wahlman. New York: Doubleday, 1999. 208 p. Introduces readers to an Underground Railroad oral history by Charleston, NC resident Ozella McDaniel Williams.

Turner, Robyn Montana. *Faith Ringgold.* New York: Little, Brown & Company, 1993. 32 p. This book is part of the *Portraits of Women Artists for Children* series.

Wahlman, Maude Southwell. *Signs and Symbols: African Images in African-American Quilts.* New York: Studio Books, 1993. Wahlman's main thesis is that "most African-American quiltmaking derives its aesthetic from various African traditions, both technological and ideological." Subjects covered in this book include defining selected aesthetic traditions, reviewing appliqué traditions, tracing religious symbols, use of protective charms in African American art and quilts. Twenty-two quilters are profiled including Mozell Benson, Nora Ezell, Pearlie Posey, Joyce and Elizabeth Scott, Sarah Mary Taylor, Pecolia Warner, and Yvonne Wells.

Watts, Katherine, and Elizabeth Walker. *Anna Williams: Her Quilts and Their Influences.* Paducah, KY: American Quilter's Society, 1995. 40 p. Out-of-print book filled with full-color photos of twenty-four dazzling quilts by Williams. Four quilters comment on Williams' influence on their own work. The book does not appear to include comments by other African American quilters on how Williams' quilts have affected their work.

Wilson, Sule Greg. *African American Quilting: The Warmth of Tradition.* New York: Rosen Publishing Group, 1999. 64 p. This book, for grades 4–7, explains the art and craft of African American quilting and describes its roots in African textiles and traditions. Whole cloth, piecing, and appliqué quilts are illustrated.

BOOKS—MORE REFERENCES TO AFRICAN AMERICAN QUILTING, NEEDLEARTS & TEXTILES

Algotsson, Sharne, and Denys Davis. *The Spirit of African Design.* New York: Clarkson Potter Publishers, 1996. Quilts as home décor reviewed.

Allen, Gloria Seaman, and Nancy Gibson Tuckhorn. *A Maryland Album.* Nashville, TN: Rutledge Hill Press, 1995. Book based on the Maryland Association for Family and Community Education quilt documentation project. Reference to African American quilts purchased at estate sales on p. 26; Harriet Tubman quilting on p. 32; slave-made quilts on pp. 32–33; slave-made quilts of the Edelen Family on pp. 64–65; use of tree leaves for quilt patterns by Black quilters on p. 178; profile and photo of Maryland quilter Ruby Purnell on pp. 211–213.

Always Remember: A Section of Panels Created by and for International Fashion Designers. New York: Simon & Schuster Edition, 1996. Includes quilts made in memory of Scott Barrie, David Clay, Angelo Donghia and Willi Smith.

American's Best Quilts: Created by the Country's Best Quilters. New York: Publications International, Ltd., 1990. Includes Michael Cummings, *Haitian Boat People I, Haitian Boat People II,* and *African Jazz* quilts on pp. 46–47.

Arnett, Paul, and Maude Southwell Wahlman, eds. *Souls Grown Deep: African-American*

Vernacular Art of the South, Vol. 1: The Tree Gave the Dove a Leaf. Atlanta, GA: Tinwood Books, 2000.

Art of Survival: Fabric Images of Women's Daily Lives. Nurnberg, Tara Publishing, 1995. Centre for International and Intercultural Research on Women's Daily Lives. Chapter by Omope Carter Daboiku (pp. 97–101) features the Women of Color Quilter's Network.

Atkins, Jacqueline Marx. *Shared Threads: Quilting Together Past and Present.* New York: Viking Studio Books in association with Museum of American Folk Art, 1994. Includes mention of the Freedom Quilting Bee group and photo of *The Rosa Parks Quilt* by the Boise Peace Quilt Project in 1992.

Austin, Mary Leman, ed. *The Twentieth Century's Best American Quilts.* Golden, Co: Primedia Special Interest Publications, 1999. Among the 100 quilts featured are the *Bible Scenes Quilt* (1900) by Georgia quilter and *The Men: Mask Face Quilt #2 (1986)* by Faith Ringgold.

Bacon, Lenice Ingram. *American Patchwork Quilt.* New York: William Morrow, 1973. See pp. 95–96 for Harriet Powers quilt in Museum of Fine Arts, Boston.

Bailey, Pearl. *Talking to Myself.* New York: Harcourt Brace Jovanovich, Inc., 1971. Bailey writes on p. 37 that she "learned needlepoint during the lonely times."

Baker, Houston Jr., and Charlotte Pierce-Baker. "Patches: Quilts and Community in Alice Walker's 'Everyday Use.'" In *Afro-American Writing Today: An Anniversary Issue of the Southern Review.* James Olney, ed., Baton Rouge: Louisiana State University Press. Also in *Southern Review* no. 21, 1985, pp. 706–720.

Bank, Mirra. *Anonymous Was a Woman.* New York: St. Martin's Press, 1979. See pp. 118–119 for mention of Harriet Powers.

Barney, Deborah Smith. "An Interview with Rosa Parks, the Quilter." In *African American Quiltmaking in Michigan*, ed. Marsha MacDowell, pp. 132–138. East Lansing: Michigan State University, 1997.

Bassett, Lynne, and Jack Larkin. *Northern Comfort: New England Early Quilts 1780–1850.* Nashville, TN: Rutledge Hill Press, 1998. Includes small mention of anti-slave movement quilts.

Batchelder, Ann, and Nancy Orban, eds. *Fiberarts Design Book Five.* Asheville, NC: Lark Books, 1995. This 240-page book showcases the best of contemporary tapestries, quilted work, wearables, basketry, needlework, sculpture and more. Includes works by quilters Jim Smoote (Chicago) and Michael Cummings (New York).

Bell-Scott, Patricia, ed. *Flat-Footed Truths: Telling Black Women's Lives.* Owl Books, 1999. Includes art by Wini Akissi McQueen.

Bell-Scott, Patricia, et al. *Double Stitch: Black Women Write About Mothers and Daughters.* Boston: Beacon Press, 1991. Collection of short stories, poems, narratives, and essays. Book cover features *Memories of Childhood Quilt* 1983 by Senior Neighbors of Chattanooga, TN.

Benberry, Cuesta. "Afro-American Women and Quilts: An Introductory Essay." In *Uncoverings 1980*, ed. Sally Garoutte, pp. 64–67. San Francisco: American Quilt Study Group, 1981. Benberry distinguishes her research as a quilt historian from academic researchers (ethnologists, anthropologists, folklorists, and art historians) studying African American quilts and quilters. She encourages researchers to take a broad look at all aspects and styles of African American quilting, not narrowly focus on a single aspect.

_____. "Quilt Cottage Industries: A Chronicle." In *Quiltmaking in America: Beyond the Myths*, ed. Laurel Horton, pp. 142–155. Nashville, TN: Rutledge Hill Press, 1994. Includes references to various African American quilting collectives like the Freedom Quilting Bee of Alabama, the Arkansas Country Quilts group, a Mississippi Delta

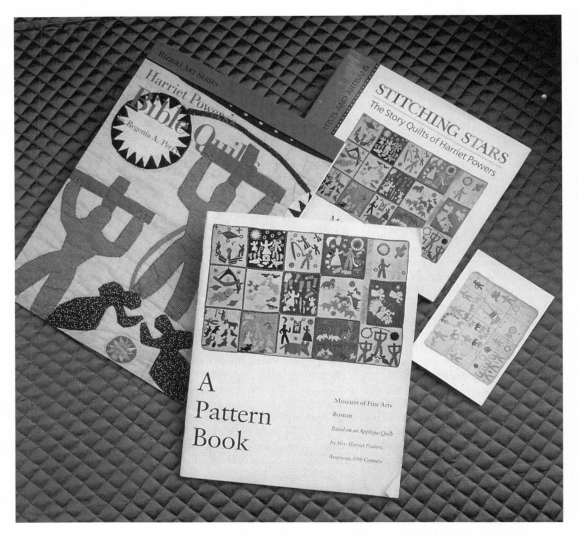

Harriet Powers' *Bible Quilts* have been documented through books, patterns, and post-cards.

project in Tutwiler, and one sponsored by the Mississippi Cultural Crossroads organization.

_____. "White Perceptions of Blacks in Quilts and Related Media." In *Uncoverings 1983*, ed. Sally Garoutte, pp. 59–74. San Francisco: American Quilt Study Group, 1984. This paper chronologically traces the "historical attitudinal changes of white Americans towards African-Americans, as revealed in quilts and related media." Benberry covers pre- and post-Civil War periods as well as early, middle, and late 20th century quilts and needle work forms, crafts, paintings, and other popular culture items. Detailed examination of anti-slavery quilts and "mammy" related textiles and quilt patterns. Extensive reference notes.

Benberry, Cuesta, and Carol Pinney Crabb. *A Patchwork of Pieces: An Anthology of Early Quilt Stories 1845–1940*. Paducah, KY: American Quilter's Society, 1993. Includes fictional stories involving quilts, quiltmaking. Extensive time line from 1844–1945 covering American history and quilt literature. See pages 15–17 for a brief discussion on the portrayal of African Americans and the "mammy" figure in nineteenth century quilt fiction. Short stories reprinted in this book with African American characters include *Patch-Work Quilt (1846); Mammy Hester's Quilt (1889)*.

Bilk, Jen, ed. *Women of Taste: A Collaboration Celebrating Quilt Artists and Chefs*. Concord, CA: C & T Publishing, 1999. Includes quilts by Sherry Whetstone-McCall and Carolyn Mazloomi.

Binford, Virgie. "Quilting Time." In *Honey, Hush! An Anthology of African American Women's Humor*, ed. Daryl Cumber Dance, pp.157–158. Story of a young girl who is the "needle-threader" at her grandmother's quilting bees.

Birch, Eva Lennox. *Black American Women's Writing: A Quilt of Many Colours*. Harvester Wheatsheaf (UK), 1994.

Bishop, Robert, and Jacqueline M. Atkins. *Folk Art in American Life*. New York: Viking Studio Books, 1995. Photos of *String Quilt (1920–1930), Hens Quilt* by Pearly Posey, and *Log Cabin Pictorial Quilt (1870)* are included on pp. 128, 134-135, 137. Interesting *Civil War "Reconciliation" Quilt (1867)* including blocks with black human figures on p. 142.

Bishop, Robert, and Patricia Coblentz. *New Discoveries in American Quilts*. New York: E.P. Dutton, 1975. Pieced quilt from Michigan, c. 1900, with stylized primitive black figures that may be of Afro-American origin, pp. 54–55; photo of Black women in Urban Quilt Workshop, p.89.

The Black Family Dinner Quilt Cookbook. The National Council of Negro Women, Inc. Memphis, TN: Wimmer Companies, 1993. Includes recipes featuring both traditional and contemporary African American cuisine. Illustrated with quilts throughout the cookbook.

Bowman, Doris M. *The Smithsonian Treasury American Quilts—National Museum of American History*. Washington, DC: Smithsonian Institution Press, 1991. African American quilts in the Smithsonian's collection show are: *Frances Jolly's Quilt* top, p. 31; *Ann's Quilt*, a slave-made quilt, p. 36; *Betty West's Quilt*, p. 76; *Harriet Powers' Bible Quilt*, p. 81.

Brackman, Barbara. *Civil War Women: Their Quilts, Their Roles, Activities for Re-Enactors*. Concord, CA: C & T Publishing, 2000. Includes chapter on freed slave and quilter Susie Taylor King as well as references to other Black women quilters.

_____. *Quilts from the Civil War: Nine Projects, Historic Notes, Diary Entries*. Lafayette, CA: C&T Publishing, 1997. Includes photos of two different Black families posing in front of quilts on p.112. No references to quilts by African Americans during this time.

Bresenhan, Karoline, and Nancy Puentes. *Lone Stars: A Legacy of Texas Quilts, 1836–1936*. Austin, TX: University of Texas Press, 1986. State quilt project. *String Scrap Quilt* by Gazzie Hill in 1925 on pages 138–139.

Britton, Crystal A. *African American Art: The Long Struggle*. New York: Todtri Production Ltd., 1996. Includes quilts by Amalia Amaki and Harriet Powers.

Brown, Hallie Q. *Homespun Heroines and Other Women of Distinction*. Xenia, OH: Aldine Publishing Co., 1926. Biographies of sixty Black women. See page 30 for Dinah Cox (1804–1909) known for her knitting and quilting. See pages 46–49 for Mrs. Jane Roberts (1809—?), the wife of the first African president of Liberia. Mrs. Roberts accompanied Martha Ann Ricks to visit Queen Victoria. Ricks presented the queen with a handmade silk quilt. Another quilter mentioned was Grandmother Gross (1817—?), known for her hand-sewn silk quilts.

Browne, Martha Griffin. *Autobiography of a Female Slave.* New York: Redfield, 1857. This book includes several references to sewing activities and "fancy-sewing."

Bullard, Lucy Folmar. "Late 19th Century Quilts." *Quilts: From Colonial to Contemporary.* Lincolnwood, IL: Publications International, Inc., 1992. Includes *Princess Feather Quilt* by Mahulda Mize, a slave; *Bible Scenes Quilt* from Georgia, pp. 50–51.

Butler, Broadus. *Craftsmanship: A Tradition in Black America.* New York: RCA, 1976.

Callahan, Nancy. "Helping the Peoples to Help Themselves." In *The Quilt Digest.* Michael Kile, ed. San Francisco: The Quilt Digest Press, 1986, pp. 20–29. Story of the Freedom Quilting Bee.

Cavallo, Adolph S. *Needlework.* The Smithsonian Illustrated Library of Antiques, 1979. Includes chapter on the needlework of indigenous African people.

Chase, Judith Wragg. *Afro-American Art and Craft.* New York: Van Nostrand Reinhold Company, 1971. According to Wahlman, Chase was one of the first to write extensively on African American quilt designs. See pp. 85–89 for quilt section.

Chinn, Jennie. "African American Quiltmaking Traditions: Some Assumptions Reviewed." In *Kansas Quilts & Quilters.* Lawrence, Kansas: University Press of Kansas 1993, pp. 156–175. Includes profiles of Kansas City quilters Georgia Patton, her daughter NedRa Bonds, and quilters from the historically Black town of Nicodemus, Kansas.

Christian, Barbara T., ed. *Alice Walker: "Everyday Use."* New Brunswick, NJ: Rutgers University Press, 1994. This book includes a reprint of "Everyday Use" short story and essays by Houston Baker, Jr., Thadious Davis, Margot Anne Kelley, Charlotte Pierce-Baker and Mary Helen Washington.

Christopherson, Katy. *The Political and Campaign Quilt.* Frankfort: The Kentucky Heritage Quilt Society, 1984. Includes *Afro-American Bicentennial Quilt* coordinated by Mrs. J. M. Gates of Portland, OR.

Clark, Mary Clare. *Story Quilts & How to Make Them.* New York: Sterling Publishing Co., 1995. See "The Album Quilt" chapter pp. 82–87 for quilt by Sarah Ann Wilson dated August 1854. See also pp. 92–99 for the *Phebe Cook Quilt,* which has black human figures.

Clark, Ricky. "Ruth Finley and the Colonial Revival Era." In *Uncoverings 1995,* ed. Virginia Gunn, pp. 33–65. San Francisco: American Quilt Study Group, 1995. Finley was the author of the classic book *Old Patchwork Quilts and the Women Who Made Them,* first published in 1929. The paper examines the influences Finley's early life in Ohio's Western Reserve had on her later life, writing, and the Colonial Revival. The *Lincoln Quilt* by Elizabeth Keckley (circa. 1860–1880) was once in the Finley personal collection. The paper provides a brief background on the quilt, which is now in the Kent State University Museum.

Clark, Ricky, George Knepper, and Ellice Ronsheim. *Quilts in Community: Ohio's Traditions.* Nashville, TN: Rutledge Hill Press, 1991. Profile of Mary Bell Johnson with her *Pine Burr* quilt on p. 19. Segment on Phebe Cooper Cook (1804–1891) and her appliquéd story quilt that included both black and white human figures on pp. 124–126. Photo of *Underground Railroad Quilt* by the Oberlin Senior Citizens in 1982 on pp. 159–160.

Clarke, Duncan. *Art of African Textiles.* San Diego, CA: Thunder Bay Press, 1997. An overview of handweaving in African with detailed photographs of kuba, raffia, kente, and mud cloths.

Cochran, Rita, et al. "The African American Presence." *New Jersey Quilts, 1777 to 1950: Contributions to an American Tradition.* Paducah, KY: The American Quilter's Society, 1992. See pp. 146–149.

Collins, Willie. "Use What You Got: A Profile of Arbie Williams, Quilter." In *African-*

American Traditional Arts and Folklife in Oakland and the East Bay: A Collection of Essays. Oakland: City of Oakland, 1992, pp. 13–16.

Cooley, Rossa B. *Homes of the Freed*. New York: New Republic Inc., 1926. An important work about Black women in the South from perspective of Rossa Cooley, the longtime headmistress of Penn School of St. Helena Island. The school was founded during the Civil War. Discusses quiltmaking at Penn School on pp. 87–88, 181.

Country Quilts. Alexandria, VA: Time Life Books, 1989. See pages 36–37 for tied quilts by African American quilters.

Dash, Julie. *Daughters of the Dust: The Making of an African American Woman's Film*. New York: The New Press, 1992. Dash describes a scene cut from the final movie of Nana Peazant's mother cutting a piece of her (mother's) hair and placing it inside a baby quilt that will go with her child that is about to be sold. See pp. 33–34.

Davis, Elizabeth Lindsay. *Lifting as They Climb*. Washington, DC: National Association of Colored Women, 1933. Reprint, New York: G. K. Hall, 1996. The National Association of Colored Women (NACW) was founded in 1896. This federation of Black womens' clubs included several actively engaged in needlework. For instance, Mrs. Anna Lewis, representing the Willing Workers of Detroit, presented the NACW with a silk quilt to be sold for fundraising in 1912. The Willing Workers were founded in 1887. Mrs. Delia Barrier served as Club President for at least forty years. The fifty-member club, known for making and selling quilts, belonged to the Needle Work Guild of America (pp. 54–55, 320-321). In 1914, Mrs. M. C. B. Mason presented the NACW with a silk quilt also for revenue generation (p. 56). The Phillis Wheatley Woman's Club of Chicago, organized in 1896, operated a sewing school for five years and served 90 to 100 children (p. 138). The Ne Plus Ultra Art Club of Topeka, KS, founded in 1898, to increase the beauty of home life through embroidery, crocheting, tatting, painting, and decorating, received state recognition for its artwork (p. 160). Two members of the Montana Club received blue ribbons at state fairs for their oil painting and needlework (p. 352). The Monday Evening Charity Sewing Club of Texas sold handsewn and embroidered items for its treasury (p. 398). Other clubs included the Sallie Stewart Needle Craft Club of Kansas City, KS (p. 159); the Dorcas Club of Muskogee, OK (p. 201); the Ladies Sewing Circle of Kentucky (p. 299); the Wednesday Afternoon Sewing Club of St. Louis, MO (p. 345); and the Pleasant Company Needle Craft Club of Wisconsin (p. 405).

Davis, Lenwood. *Black Artists in the United States: An Annotated Bibliography of Books, Articles, and Dissertations on Black Artists 1779–1979*. Westport, CT: Greenwood Publishing, 1980.

Delaney, Lucy. *From the Darkness Cometh the Light or Struggles for Freedom*. St. Louis, MO: Publishing House of J.T. Smith, 189?. Delaney, an expert seamstress, felt the "art of fine sewing was lost when sewing machines were invented." See pp. 54–55.

Dewhurst, C. Kurt, et. al. *Artists in Aprons: Folk Art by American Women*. New York: E.P. Dutton, Inc. in association with the Museum of American Folk Art, 1979. Includes references to Clementine Hunter, Harriet Powers and other Black women folk artists on pp. 49, 54–55, 82, 94, and 169.

Dimmick, Robb. *A Selected List of Catalogues to Exhibitions of Art by African-Americans*. Providence, RI: Cornerstone Books, 1989. Bibliography booklet. Includes selected quilt exhibitions.

Dimond, E. Grey, and Herman Hattaway, eds. *Letters from Forest Place: A Plantation Family's Correspondence 1846–1881*. Jackson: University Press of Mississippi, 1993. See pp. 197–198 for the letter slave Martha Watkins dictated. Watkins describes a quilting party.

Diuguid, Norah M., ed. *History of the Helping Hand Club of the Nineteenth Street Baptist Church*. Washington, DC: Associated Publishers, Inc., 1948. Mary Emma Cabaniss, founder. History of an African American women's service club. The preface reveals that Dr. Carter G. Woodson read the manuscript and assisted with the 86-page book's publication. See pp. 51–53 "Completing a Quilt" about the group's sewing efforts.

Dobard, Raymond G. "A Covenant in Cloth: The Visible and the Tangible in African American Quilts." In *Connecting Stitches: Quilts in Illinois Life, Symposium Papers*, ed. Jan Wass. Springfield: IL: Illinois State Museum, 1995.

Doering, Henry, ed. *Book of Buffs, Masters, Mavens and Uncommon Experts*. Englewood Cliffs, NJ: World Almanac Publications, Prentice-Hall, Inc., 1980. Profile of quilt historian Cuesta Benberry on pp. 192–194.

Eanes, Ellen Fickling, and Ruth Haislip Robinson, et al. *North Carolina Quilts*. Chapel Hill: The University of North Carolina Press, 1988. Story and photo of slave, Kadella's chintz appliqué quilt *Floral Wreath Medallion* quilt (1820–1840) on pp. 59, 61. Jennie Neville's *Cotton Boll Quilt (1864)*, which has been passed down three generations, is profiled on pp. 110–111. Profile of Pauline Williams' *Log Cabin (1970s)* quilt on pp. 132–134.

Easter, Opal. *Nannie Helen Burroughs*. New York: Garland Publishing, Inc., 1995. Burroughs opens the National Training School for Women and Girls in Washington, DC, in 1909. The school philosophy centers on the three Bs—The Holy Bible (clean living), the Bathtub (clean bodies), and the Broom (clean homes). The curriculum includes mission work, academics, sewing and music. Needlework remained an important part of the curriculum as late as 1958 when plain sewing, dressmaking, and tailoring classes were offered.

Elbert, E. Duane, and Rachel Kamm Elbert. *History from the Heart: Quilt Paths Across Illinois*. Nashville, TN: Rutledge Hill Press, 1993. Photo of African American Hattie O. Holliday Hall's 1928 *Crazy Quilt* on pp. 140–141; profile and photo of ninety-four year old Anna Roberts Borders and her *Cake Stand* quilt on pp. 203–204.

Elsley, Judy. "The Smithsonian Quilt Controversy: Cultural Dislocation." In *Uncoverings 1993*, ed. Laurel Horton, pp. 119–136. San Francisco: American Quilt Study Group, 1994. The Smithsonian Quilt controversy refers to when the Smithsonian Institution first arranged to have selected quilts in its collection reproduced overseas. This angered many American quilters. Elsley's paper seeks to explain the debate and its cultural and ideological significance. One argument is that the reproductions remove the quilt from the context of the quilter. Harriet Power's *Bible Quilt* was one selected for reproduction. Elsey briefly outlines the importance of Power's quilt to Black quilting history.

England, Kaye. *Voices of the Past: A History of Women's Lives in Patchwork*. Santa Monica, CA: ME Publications, 1994. Profile of Harriet Tubman, Underground Railroad Conductor, and mentions her patchwork quilt, on pp. 32–33. Includes pattern to make a 12" *Harriet Tubman* quilt block designed by Kaye England.

Farrington, Lisa, and Faith Ringgold. *Art on Fire: The Politics of Race and Sex in the Paintings of Faith Ringgold*. Millennium Fine Arts Publishing, Inc., 1998.

Farris, Phoebe, ed. *Women Artists of Color: A Bio-Critical Sourcebook to 20th Century Artists in the Americas*. Westport, CN: Greenwood Press, 1999. See pp. 231–371 for chapter on African American artists, including Faith Ringgold.

Fax, Elton C. *Seventeen Black Artists*. New York: Dodd, Mead & Co, 1971. Includes chapter on Faith Ringgold in her pre-quilting days.

Ferris, William, ed. *Afro-American Folk Arts and Crafts*. Boston: G.K. Hall, 1983. Includes essay "Aesthetic Principles in Afro American Quilts" by Maude Wahlman and John Scully. Includes article by William Ferris "Pecolia Warner Quilt Maker" on pp. 99–108.

Ferris, William. *Local Color: A Sense of Place in Folk Art.* New York: McGraw-Hill, 1982. An examination of the work of nine Mississippi traditional artists including blues musician and sculptor James "Son Ford" Thomas, quilter Pecolia Warner, and needle-worker Ethel Wright Mohamed. Basket maker Leon "Peck" Clark, who also crocheted, is shown with two of his needlework pieces.

Fine, Elsa Honig. *The Afro-American Artist.* New York: Holt, Rinehart and Winson, Inc., 1973.

Forrest, John. *Lord, I'm Coming Home: Everyday Aesthetics in Tidewater North Carolina.* Ithaca: Cornell University Press, 1988. Includes section on quilts and quiltmaking.

Fox, Sandi. *For Purpose and Pleasure: Quilting Together in the Nineteenth-Century America.* Nashville, TN: Rutledge Hill Press, 1995. Includes reprint of a April 21, 1883 Harper's Weekly illustration of a black quilting party, *"Brothers" Assisted in the Quilting*, on p. 9.

_____. *Wrapped in Glory: Figurative Quilts and Bedcovers 1700–1900.* New York: Thames and Hudson, 1990. See pp. 119–121 for *The Couples Quilt*.

Fox-Genovese, Elizabeth. *Within the Plantation Household: Black and White Women of the Old South.* Chapel Hill: University of North Carolina Press, 1988.

Franger, Gaby. *The Art of Survival: Fabric Images of Women's Daily Lives.* Nuremberg, Germany: Tara Pub. Frauen in der Einen Welt, 1995/1996. Discusses quilting by Wyrelene Mays, Carolyn Mazloomi, Barbara Payne and Angela Washington.

Freeman, Roland. *Margaret Walker's "For My People."* Jackson: University Press of Mississippi, 1992. This photo essay book celebrates the fiftieth anniversary of *For My People*. Includes photo of Anner Brinner, a 100-year old quilter.

Friedland, Shirley, and Leslie Pina. *African Prints: A Design Book.* Schiffer Publishing, Ltd., 1999.

Frost, Helen Young, and Pam Knight Stevenson. *Grand Endeavors: Vintage Arizona Quilts and Their Makers.* Flagstaff, AZ: Northland Publishing Company, 1992. See p. 55 for a 1935 "mammy" quilt and p. 189 for a *Cake Walk* quilt.

Frye, Daniel. *African American Visual Artists: An Annotated Bibliography of Educational Resource Materials.* Scarecrow Press, 2000.

Gabbin, Joanne. "Romare Bearden: *Patchwork Quilt.*" In *Worlds of Art*, pp. 450– 451. Mountain View, CA: Mayfield Publishing Company, 1991. Review of collage.

Gebel, Carol Williams. "Quilts in the Final Rite of Passage: A Multicultural Study." In *Uncoverings 1995*, ed. Virginia Gunn, pp. 199–227. San Francisco: American Quilt Study Group, 1995. Includes mention of African American funeral wreath ribbon quilts on pp. 218–219.

Genovese, Eugene D. *Roll, Jordan, Roll: The World Slaves Made.* New York: Pantheon Books, 1974. Quiltmaking discussed on pp. 395–396, 499.

George, Phyllis. *Living with Quilts: Fifty Great American Quilts.* New York: GT Publishing, 1998. See pp. 196–199 for photos for a 1940s appliquéd *World Geography Quilt* by Virginian sisters Bertha Lomax Froe and Dorothy Lomax.

German, Sandra K. "Surfacing: The Inevitable Rise of the Women of Color Quilters' Network." In *Uncoverings 1993*, ed. Laurel Horton, pp. 137–168. San Francisco: American Quilt Study Group, 1994. This essay "identifies the attitudes and perceptions of some American quiltmakers who feel that barriers exist between themselves and the mainstream." It also recounts the evolution of the Women of Color Quilters' Network, a national organization dedicated to preserving African American quiltmaking. German reviews preliminary results of a 1992-1993 survey in which Black quilters indicated they had low expectations for fairness, acceptance, and success from traditional or mainstream quilting ventures (e.g., quilt guilds, magazines, contests). The Women of Color Quilters' Network was formed as a result of an ad Carolyn Mazloomi placed in

a popular quilting magazine. WCQN founding members, Claire E. Carter, aRma Carter, Cuesta Benberry, Melodye Boyd, Michael Cummings, Peggie Hartwell, and Marie Wilson, each responded to Mazloomi's small ad requesting correspondence with other Black quilters. While the group formed in 1986, its first newsletter was published in 1987. When German wrote this article, WCQN membership was more then 450 worldwide.

Gibbs, C. R. *Black Inventors from Africa to America: Two Million Years of Invention and Innovation*. Silver Spring, MD: Three Dimensional Publishing, 2000. Includes a chapter devoted to Black women inventors such as Sarah Boone of New Haven, CT (ironing board), Julia Hammonds of Lebanon, IL (apparatus for yarn skeins), and Washington, DC residents Beatrice L. Cowans with Virginia E. Hall (embroidered fruit bowl wall hanging and kit). The book also mentions that in 1901Garret A. Morgan, the inventor of an automatic traffic signal, sold his first invention, a belt-fastener for sewing machines. In 1870, Thomas Elkins received a patent for an improved dining, ironing table, and quilting frame.

Gilbert, Anne. *Collecting Quilts*. Brooklyn, New York: Alliance Publishers, Inc., 1996. Includes section on African American quilts.

Gilfoy, Peggy Stolz. *Patterns of Life: West African Strip Weaving Traditions*. Washington, DC: National Museum of African Art, Smithsonian Institution Press, 1988.

Gilley, Shelby. *Painting by Heart: The Life and Art of Clementine Hunter, Louisiana Folk Artist*. Baton Rouge, LA: St. Emma Press, 2000. See pp. 72–75 for chapter discussing quilts by Clementine Hunter.

Goldson, Elizabeth, ed. *Seeing Jazz: Artists and Writers on Jazz*. Chronicle Books with the Smithsonian Institution, 1997. Includes *African Jazz Quilts #1, #4, #11, and #12* by Michael Cummings.

Gordon, Beverly. *Domestic American Textiles: A Bibliographic Sourcebook*. Ambridge, PA: Center for the History of American Needlework, 1979.

Gordon, Maggi McCormick. *The Quilting Sourcebook: Over 200 Easy-to-Follow Patchwork and Quilting Patterns*. North Pomfret, VT: Trafalgar Square Publishing, 1997. Photo of an African American-made string pieced quilt (c. 1935) on p. 32.

Great American Quilts 1990. Oxmoor House. Features quilts and photos of Michaeline Reed of Pittsburgh, PA.

Greenbacker, Liz,and Kathleen Barach. *Quilts: The First and Only Guide to Affordable 19th and 20th Century Quilts*. New York: Avon Books, 1992. Chapter 15–African American Quilts (pp. 285–288). Photo of a "mammy" quilt from 1950 on p. 250. In 1992, the authors predicted that African American quilts would be among "the new quilt-collecting item(s)."

Grier, Rosey. *Needlepoint for Men*. New York: Walker & Co., 1973. Football hero shares his "feminine side" with this introduction to needlepoint techniques and patterns. Includes photos of projects completed by Grier and other men and boys.

Harlan, Louis, ed. *The Booker T. Washington Papers 1895–1898 Volume 4*. Champaign, IL: University of Illinois Press, 1975. This book provides insights into the story of Martha Ann Ricks, a Liberian quilter who presented Queen Victoria with a quilt representative of the "African coffee tree in bloom." The account on page 40 states that Ricks made two quilts of the same design. One quilt was presented to the queen. The other silk quilt was given to AME Bishop Henry McNeal Turner. This book can be accessed online at http://www.historycooperative.org/btw. Cuesta Benberry published an article about this quilt in a 1987 issue of *Quilter's Newsletter Magazine*.

Harris, Middleton. *The Black Book*. New York: Random House, 1974. See pp. 101 and 104 for slave-made quilts.

Rosey Grier provides insights into why he needlepoints. This is one of only two books focusing exclusively on Black men and needlearts. In 1998, Dr. Gladys-Marie Fry wrote the exhibit catalog *Man Made: African American Men and Quilting Traditions.*

Hassan, Salah M., ed. *Gendered Visions: The Art of Contemporary Africana Women Artists.* Trenton, NJ: African World Press, Inc., 1997.

Hausman, Gerald, and Kelvin Rodriques. *African-American Alphabet: A Celebration of African-American and West Indian Culture, Custom, Myth, and Symbol.* New York: St. Martin's Press, 1996. See *Q–Quilt* on pp. 141–144. Includes poem by Terri Lynne Singleton "We Call Your Name, Harriet Powers."

Hechtlinger, Adelaide. *American Quilts, Quilting, and Patchwork.* Harrisburg, PA: Stack-

Thomas Elkins of Albany, New York
Improved Dining and Ironing-Table and Quilting-Frame
U.S. Patent February 22, 1870 Patent No. 100,020

Thomas Elkins wrote the following in his patent application. "The nature of my invention consists of a table furnished with detachable pieces, three or more in number, to form the top, which pieces or leaves when placed in position constitute a dining-table, but when the outer pieces or leaves are removed, and the central piece is permitted to remain, an ironing-table is formed, and when all the pieces comprising the top are removed, and rollers provided, inserted in their places, the article becomes a quilting-frame." More research is needed to determine if this invention was ever sold to housekeepers of the nineteenth century.

pole Books, 1974. See pp. 223–224, 229 for text and photos of the Freedom Quilting Bee.

Hedges, Elaine, and Ingrid Wendt, eds. *In Her Own Image: Women Working in the Arts.* New York: The Feminist Press, 1980. Includes feature about Harriet Powers.

Hedges, Elaine, Pat Ferrero and Julie Silber. *Hearts and Hands: The Influence of Women*

and Quilts on American Society. San Francisco: Quilt Digest Press, 1981. Includes an insightful chapter on *The Plantation Mistress and the Female Slave*. Describes advertisements for "sewing slaves" and the needlework activities of various anti-slavery societies.

Henkes, Robert. *The Art of Black American Women: Works of Twenty-Four Artists of the Twentieth Century*. Jefferson, NC: McFarland, 1993. Critical analysis of various artists, including Faith Ringgold.

Herr, Patricia. *Quilting Traditions: Pieces from the Past*. Atglen, PA: Schiffer Publishing, 2000. Discussion of the Quilter-dominated Anti-Slavery Society of Penna on p. 45.

Hine, Darlene Clark, and Kathleen Thompson. *A Shining Thread of Hope: The History of Black Women in America*. New York: Broadway Books, 1998. See pp. 186–188 for Harriett Powers references.

Hindman, Jane E. "Quilt Talk: Verbal Performance Among a Group of African-American Quilters." In *Uncoverings 1992*, ed. Laurel Horton, pp. 85–108. San Francisco: American Quilt Study Group, 1993. This paper "explores the social and oral context within which African-American women teach and perform quilting." Hindman participated in a predominately Black quilting group in Tucson, Arizona, over a four-month period.

hooks, bell. "Aesthetic Inheritances: History Worked by Hand." In *Yearnings: Race, Gender and Cultural Politics*. Cambridge, MA: South End Press, 1990. Essay about the role of quiltmaking in Black women's lives. Hooks relates story of her own grandmother, Sarah Hooks Oldham, who was a quilter.

_____. *Art of My Mind: Visual Politics*. New York: The New Press, 1995.

Horwitz, Elinor Lander. *Contemporary American Folk Artists*. New York: J. B. Lippincott Company, 1975. Book discusses the lives and works of twenty-two American folk artists, including Clementine Hunter on pp. 43–48. Reference to her quilting on p. 44.

Howorth, Lisa. *The South: A Treasury of Art and Literature*. South Port, CT: Hugh Lauter Levin Assoc., Inc., 1993. Includes *Yesterday: Civil Rights in the South* quilt by Yvonne Wells.

Hufford, Mary, Marjorie Hunt, and Steven Zeitlin. *The Grand Generation: Memory, Mastery, Legacy*. Washington, DC: Smithsonian Institution Traveling Exhibition Service, 1987.

Igoe, Lynn. *250 Years of Afro-American Art: An Annotated Bibliography*. New York: Bowker, 1981.

Jackson-Coppin, Fanny. *Reminiscences of School Life and Hints on Teaching*. Philadelphia, PA: A.M.E. Book Concern, 1913. Jackson-Coppin, a former slave, became principal of the Institute for Colored Youth in Philadelphia in 1869. She devoted 37 years to the Institute. The curriculum of the school included tailoring, dressmaking, and millinery among other subjects. Book includes photos of the sewing and dressmaking classes.

Jenkins, Susan, and Linda Seward. *The American Quilt Story: The How-To and Heritage of a Craft Tradition*. Emmaus, PA: Rodale Press, 1991. Segment on Afro-American quilts on pp. 50–51 includes photo of *The Album Quilt* (circa 1860–70) by Mary E. Rutland. Brief mention of black women quilting during the Civil War for both the Union and Confederacy on pp. 59, 80–81. Segment on "mammy" quilts on pp. 100–101.

Johnson, Dinah, and Myles C. Pinkney (ill.). *Sitting Pretty: A Celebration of Black Dolls*. New York: Henry Holt and Company, 2000. This 45-page book includes photographs and poems about Black dolls—many are cloth dolls.

Johnson, Venice. *Voices of the Dream: African-American Women Speak*. San Francisco: Chronicle Books, 1995. Includes images of several Faith Ringgold quilts.

Jones, Bessie, and Bess Lomax Hawes. *Step It Down: Games, Plays, Songs and Stories from*

the Afro-American Heritage. New York: Harper and Row, 1972. Quilting discussed on pp. 149–150.

Jones, Cleve, and Jeff Dawson. *Stitching a Revolution: The Making of an Activist.* New York: Harper Collins, 2000. Inspiration story about a quilt that changed America. See pp. 193–196 for Jones' meeting with Rosa Parks. Photo of Mrs. Parks working on an AIDS quilt panel included.

Jones, Suzi, ed. *Webfoots and Bunchgrassers: Folk Art of the Oregon Country.* Oregon Arts Commission, 1980. Photo of Evelyn Nelson of Portland with her *Tulip* quilt on page 116.

Kardon, Janet, ed. *Revivals! Diverse Traditions: The History of 20th Century American Crafts 1920–1645.* New York: Harry N. Abrams, Inc., 1994. Includes photos of three photos of 1934 Tennessee Valley Authority quilts by Ruth Clement Bond, a *Spider Legs Variation Quilt* by Alabama quilter Peaches, and a 1940s *Strip Quilt* by Susan Pless as well as quilts by other Black quilters.

Keckley, Elizabeth. *Behind the Scenes: Thirty Years a Slave and Four Years in the White House.* New York: G.W. Carleton, 1868. See pp. 36–37. Mrs. Keckley purchased her and her son's freedom and moved to Washington, DC. She became seamstress and friend to Mary Todd Lincoln. Mrs. Keckley made a silk quilt from scraps of Mrs. Lincoln's gowns and embroidered the word "Liberty" in its center.

Kelley, Margot Anne. "Sisters' Choice: Quilting Aesthetics in Contemporary African-American Women's Fiction." In *Everyday Use: Alice Walker,* ed. Barbara T. Christian, pp. 167–194. New Brunswick: Rutgers University Press, 1994. This essay examines quilting in Alice Walker's *The Color Purple,* Gloria Naylor's *Mama Day,* and Toni Morrison's *Beloved.*

Kemp, Kathy, and Keith Boyer. *Revelations: Alabama's Visionary Folk Artists.* Birmingham, AL: Crane Hill Publishing Co., 1994. Includes works by quilters Chris Clark on pp. 24–27, Nora Ezell on pp. 48–53, and Yvonne Wells on pp. 208–211.

Kiracofe, Roderick, and Mary Elizabeth Johnson. *The American Quilt: A History of Cloth and Comfort 1750–1950.* New York: Clarkson Potter/Publishers, 1993. See pp. 200–203 for "Quilts Made By African American Women."

Kroese, Dr. W. T. *The Origin of the Wax Block Prints on the Coast of West Africa.* Hengelo, Netherlands: NV Uitgeverij Smit, 1975. Kroese served as the authorized biographer of the Vlisco textile factory in Helmond, Holland. This factory produced wax prints.

Lasansky, Jeannette, ed. *On the Cutting Edge: Textile Collectors, Collections, and Traditions.* University of Pennsylvania Press, 1994.

Lavitt, Wendy. *Animals in American Folk Art.* New York: Knopf, 1990. Includes *Noah's Ark* quilt by Yvonne Wells.

_____. *Contemporary Pictorial Quilts.* Layton, UT: Gibbs Smith, Publisher, 1993. See pp. 71–80. Includes quilts by Michael Cummings, Francelise Dawkins, Carolyn Mazloomi, Marlene O'Bryant-Seabrook, Barbara Pietila and Yvonne Wells.

Laury, Jean Ray. *Ho for California! Pioneer Women and Their Quilts.* California Heritage Quilt Project, 1990. Includes story and quilts by Lorilla Gregg, a former slave (p. 109), and Dorinda Green Mansfield (pp. 112–113).

Lewis, Samella. *African-American Art and Artists.* Berkeley: University of California Press, 1978, 1990. Includes profile on Faith Ringgold.

Lyons, Mary E. *Talking with Tebe: Clementine Hunter, Memory Artist.* Boston: Houghton Mifflin Co., 1998.

MacDowell, Marsha, and C. Kurt Dewhurst. *To Honor and Comfort: Native Quilting Traditions.* Museum of New Mexico Press and Michigan Statue University Museum, 1997. *American Eagle Star Quilt* by the Freedom Quilting Bee featured on pages 67, 70.

MacDowell, Marsha, and Ruth D. Fitzgerald. *Michigan Quilts: One Hundred and Fifty Years of a Textile Tradition.* East Lansing: Michigan State University, 1987.

Makowski, Colleen Lahan. *Quilting 1915–1983: An Annotated Bibliography.* Metuchen, NJ; Scarecrow Press, Inc., 1985.

Manuel, Earthlyn Marselean. *Black Angel Cards: A Soul Revival Guide for Black Women.* New York: Harper, 1999. Book and 36 tarot cards—including *The Quilt Maker* card.

Mattera, Joanne. *The Quiltmaker's Art: Contemporary Quilts and Their Makers.* Asheville, NC: Lark Communications, 1982. While no African American quilter was included as a profiled artist, the book is dedicated to Harriet Powers.

Mavor, Anne, and Christine Eagon. *Strong Hearts, Inspired Minds: 21 Artists Who Are Mothers Tell Their Stories.* Portland: Rowanberry Books, 1996. Addresses the socially imposed conflicts between creating art and parenthood. Includes profile on Adriene Cruz.

Mazloomi, Carolyn, and others. *Star Quilt.* Bangalore, India: Streelkha Publishing, 1995. Published in celebration of the Forth UN World Conference on Women in Beijing. Quilts and stories by women and cooperatives worldwide are highlighted. The Women of Color Quilters Network (WCQN) is profiled. Quilts by WCQN members include Hazel Blackman, Peggie Hartwell, Kyra Hicks, Ed Johnetta Miller, Marie Wilson, and others. Review of the book is included in *Cover Stories: Newsletter of the Canadian Quilt Study Group* vol. 7, no. 4, March 1996, p. 19.

McCormick, Patty. *Pieces of an American Quilt: Quilts, Patterns, Photos and Behind the Scenes Stories from the Movie.* Concord, CA: C&T Publishing, 1996. Story about the movie *How to Make an American Quilt.* Barbara Brown, of Maryland, designed *The Life Before* fifteen block quilt and Dora Simmons, of the Afro-American Quilters of Los Angeles, appliquéd blocks and completed the top used in the movie.

McDaniel, George W. *Hearth & Home: Preserving a People's Culture.* Philadelphia, PA: Temple University Press, 1982. See pp. 108–109 for descriptions of slave beds and bedcovers. See pp. 156–157 for description of Nora Cusic's family quilts made for utility.

McDonald, Mary Anne. "Symbols from Ribbons: Afro American Funeral Ribbon Quilts in Chatham County, North Carolina." In *Arts in Earnest: North Carolina Folklife,* ed. Daniel Patterson and Charles Zug, pp. 164–178. Durham, NC: Duke University Press, 1990.

McMorris, Penny. "Afro-American Quilts." *Quilting II.* Bowling Green: WBGU-TV, Bowling Green University Press, 1982. See pp. 53–57 for interviews with Cuesta Benberry, Gladys-Marie Fry, and Maude Whalman.

McMullan, Kate. *The Story of Harriet Tubman, Conductor on the Underground Railroad.* New York: Dell Books, 1991. Mentions quilt made by Harriet Tubman. See also Ann Petry's book, written forty years prior, on similar subject.

Mignon, Francois, and Clementine Hunter. *Melrose Plantation Cookbook.* Natchitoches, LA: Baker Printing, 1956. In addition to painting sewing and quilting, folk artist and quilter Clementine Hunter also cooked. Thirty-two page cookbook with photos of authors.

Mitchell, Felicia, ed. *Words and Quilts: A Selection of Quilt Poems.* Lincolnwood, IL: The Quilt Digest Press, 1996. Includes photos of *African-American Spider Quilt* by Ida Jacobs (p.27) and *The Crowded Cross* by Yvonne Wells (p.25).

Moore, Sylvia, ed. *Gumbo Ya-Ya: Anthology of Contemporary African-American Women Artists.* New York: Midmarch Arts Press, 1995.

Nadelstern, Paula, and LynNell Hancock. *Quilting Together: How to Organize, Design, and Make Group Quilts.* New York: Crown Publishers, Inc., 1988. Includes photo of *Weaver of Dreams,* a quilt designed by Marie Wilson to illustrate Martin Luther King's legacy. According to the Summer 1989 issue of the Women of Color Quilters Network news-

letter, the quilt hung in the Rosa Parks Room of the Martin Luther King, Jr. Center for Nonviolent Social Change, Atlanta, Georgia.

Nemy, Enid. *Judith Leiber: The Artful Handbag.* New York: Harry N. Abrams, Inc., 1995. Color photograph of "Minaudiere," a drop-in beaded chain purse inspired by the Faith Ringgold quilt *The Street,* is on page 55.

Neverdon-Morton, Cynthia. *Afro-American Women of the South and the Advancement of the Race, 1895–1925.* Knoxville, TN: University of Tennessee Press, 1989. Includes references to the Baltimore Oblate Sisters of Providence, a Catholic order which operated a school for Black girls. Sewing was one subject taught. References also to domestic arts as part of the curriculum of selected Black colleges: Spelman Seminary of Atlanta in 1881, basketry and handweaving of cloth at Hampton Institute in 1900, and "plain sewing," dressmaking, millinery, mattress making, and basketry at Tuskegee Institute in 1901.

Newbill, Carol Logan. *The Olympic Games Quilts: America's Welcome to the World.* Birmingham, AL: Oxmoor House, Inc., 1996. The segment "Simply... Congratulations" focuses on Huisha Kiongozi's quilt of the same name. Includes pattern for quilt. See pp. 32–35. Other African American quilts include *African Stars (p. 96) and African-American Kente Cloth Quilt* (p. 114).

O'Bryant-Seabrook, Marlene. "Symbiotic Stitches: The Quilts of Maggie McFarland Gillispie and John Gillispie Jr." In *Uncoverings 1995,* ed. Virginia Gunn, pp. 175–198. San Francisco: American Quilt Study Group, 1995. O'Bryant-Seabrook "reviews the literature on Southern African-American matrilineal quilters, discusses the existence of African males in the textile arts... and explains how European gender-role ideology has permeated the African-American male views of quilting and other needle arts." Photos of quilts by Maggie and John Gillispie, Jr. are shown.

Oliver, Celia Y. *Enduring Grace: Quilts from the Shelburne Museum Collection.* Concord, CA: C&T Publishing, 1997. See "Pieced Quilt: Figural Mosaic Pattern" on p. 72. There are two African American figures on this 1880–1920 quilt, which may indicate a Black artisan made the quilt.

Orlofsky, Patsy, and Myron Orlofsky. *Quilts in America.* New York: McGraw-Hill, 1974. Reprinted in 1992 by Abbeville Press, Inc. This quintessential guide includes 300 year history of quilt design, patterns, techniques and styles. See p. 283, fig. 246 for "Ellen Dicus, ex-slave, Greenfield, MO" in 1992 edition.

Oshins, Lisa Turner. *Quilt Collections: A Directory for the United States and Canada.* Washington, DC: Acropolis Books, 1987. This source also indicates if the museum has African American quilts in the collection.

Patton, Sharon F. *African-American Art.* Oxford University Press, 1998. Quilts from the 1800s are discussed on pp. 67–71. The influence of African American quilts on Romare Bearden is mentioned on p. 189.

Peck, Amelia. *American Quilts & Coverlets in The Metropolitan Museum of Art.* New York: Dutton Studio Books, 1990. Includes quilt by "Aunt Ellen" and "Aunt Margaret" slaves on the Marmaduke Beckwith Morton Family of Kentucky.

Peppers, Cathy. "Fabricating a Reading of Toni Morrison's *Beloved* as a Quilt of Memory & Identity." *Quilt Culture: Tracing the Pattern,* eds. by Cheryl Torsney, Judy Elsley, pp. 84–95. Columbia, MO: University of Missouri Press, 1994.

Perry, Regenia A. "Harriet Powers (1837–1910)." In *Selections of Nineteenth-Century Afro-American Art.* New York: Metropolitan Museum of Art, 1976.

Peto, Florence. *Historic Quilts.* New York: The American Historical Company, Inc., 1939. This collection of stories about various quilts included an account of Virginia slave quiltmaker, Sarah Harris, who was permitted to sign and date her quilt during the

time when it was illegal for slaves to be taught to read and write. The signed 1848 quilt *Rob Peter to Pay Paul* was featured on the book's dust jacket.

Pfeffer, Susanna. *Quilt Masterpieces.* New York: Hugh Lauter Levin Association, Inc., 1988. Sarah Ann Wilson's *Black Family Album* quilt (1854) is on the cover as well as on pp. 56–57. This thirty-panel appliquéd quilt includes figures in black cloth. It is unclear if Wilson was African American.

Picton, John, and Mack, John. *African Textiles: Looms, Weaving and Design.* London: British Museums Publications Ltd., 1979.

Powel, Richard J. *Black Art & Culture in the 20th Century.* New York: Thames and Hudson, Inc., 1997.

Price, Sally, and Richard Price. *Afro-American Arts of the Suriname Rain Forest.* Los Angeles: University of California Press, 1980.

Quarles, Benjamin. *Black Abolitionists.* New York: Oxford Univeristy Press, 1969. Includes references to Black women and young adults in the abolitionist movement who used sewing and needlework to help raise funds.

Ramsey, Bets. "The Land of Cotton: Quiltmaking by African-American Women in Three Southern States." In *Uncoverings 1988,* ed. Laurel Horton, pp. 9–28. San Francisco: American Quilt Study Group, 1989. The cover of the book features a 1981 quilted wall-hanging by Lillian Beattie. Ramsey interviewed thirty-five Black women, quilters from Alabama, Georgia, and Tennessee, who grew up primarily in rural settings and later moved to an urban setting. Ramsey's goal was to determine if there were any similarities or differences between the quilts made when in rural settings vs. city settings. She found the "most significant change" was around the quilters' purpose. In their youth, quiltmaking was out of necessity. In their later years, the quilters made quilts for pleasure.

_____. "Recollections of Childhood Recorded in Tennessee Quilt." In *Uncoverings 1983,* ed. Sally Garoutte, pp. 27–37. Mill Valley, CA: American Quilt Study Group, 1983. Essay describes the inspiration and process behind the creation of *The Childhood Memories* quilt by the Senior Neighbors of Chattanooga, Inc. This group was primarily composed of African American senior citizens. The quilt is featured on the cover of *Double Stitch: Black Women Write About Mothers and Daughters,* ed. Patricia Bell-Scott.

Ramsey, Bets, and Merikay Waldvogel. *The Quilts of Tennessee: Images of Domestic Life Prior to 1930.* Nashville, TN: Rutledge Hill Press, 1986. Three year survey of over 1,500 Tennessee quilts including *Winding Rose* quilt by slave Aunt Eliza "Liza" circa 1860s (p. 2–3), Sarah Moore's 1920s *School House* block quilt (pp. 65, 104), Estella Thompson Lillard's 1930s *Red and Green Star* block quilt (pp. 66–67), and Ozella Drummond Angel's 1925 *String Star Block* (pp. 77–78).

_____. *Southern Quilts: Surviving Relics of the Civil War.* Nashville, TN: Rutledge Hill Press, 1998. Includes segment on "Narcissa's Quilts," a slave and expert seamstress and a photo of one of her 1860s quilts (pp. 82–85).

Reno, Dawn. *The Encyclopedia of Black Collectibles: A Value and Identification Guide.* Radnor, PA: Wallace-Homestead, 1996. Pages 199–204 focus on quilts and sewing collectibles.

Richardson, Ben. *Great American Negroes.* New York: Thomas Y. Crowell Co., 1945. See pp. 154–155. Profile of George Washington Carver includes mention of his fine needlework, knitting and quilting. House visitors could not tell the difference between his expert stitches and those of his mistress, Mrs. Carver.

Riggs, Thomas, ed. *St. James Guide to Black Artists.* Detroit, MI: St. James Press, 1997. Bibliographical, career information, and brief critical essays on nearly four hundred

prominent Black artists. Fiber artists or quilters include Gloretta Baynes, Roland Freeman, Michael D. Harris, Clementine Hunter, Martha Jackson-Jarvis, Napoleon Jones-Henderson, Harriet Powers, Faith Ringgold, and Joyce Scott.

Robinson, Beverly J. *Aunt [ant] Phyllis*. Washington, DC: American Folklife Center, Library of Congress, 1982. A profile of a traditional medicine woman known for her stories, her healing powers, and her quilts.

Robinson, Charlotte. *The Artist and the Quilt*. New York: Alfred A. Knopf, 1983. The book pairs various artists and quilters together to make a collaborative quilt. References and photos of Faith Ringgold and Willi Posey (p. 103–105) and Betye Saar (p. 87–89).

Rountree Green, Danita. *Grandmother's Gift of Memories: An African-American Family Keepsake*. New York: Broadway Books, 1997. It's a fill-in-the-blank book to record personal history. Quilt motif and illustrations by James Ransom. One of the images seems to be influenced by Sarah Ann Wilson's 1854 *Black-Family Album* quilt.

Ruskin, Cindy. *The Quilt: Stories from the NAMES Project*. New York: Pocket Books, 1988. Book tells of the beginning of the AIDS quilt project. Nearly 2,000 three-by-six foot individual panels celebrating the life of someone who has died of the disease. The panel for African American fashion designer Willi Smith is shown on p. 100.

Rydell, Robert W. *All the World's a Fair*. Chicago: University of Chicago Press, 1984. At the Colored Department of the 1885 New Orleans World's Industrial and Cotton Exposition, Washington, DC schoolteacher Sarah H. Shimm exhibits a silk embroidery divan featuring the story of Toussaint L'Ouverture. She sewed the motto "The First of the Blacks" onto it (pp. 81–82). The Ohio Colored Exhibit included quilts (p. 82).

Safford, Carleton, and Robert Bishop. *America's Quilts and Coverlets*. New York: Dutton, 1972. A comprehensive guide with emphasis on patchwork and appliqué quilts. See p. 211 for Harriet Powers' quilt, p. 220 for slave-made quilts, and p. 306 for Martin Luther King Freedom Quilting Bee.

Salmon, Larry, Cartherine Kvaraceus, and Matthew X. Kiernan. *From Fiber to Fine Art: Handbook of the Department of Textiles*. Entry no. 29. Boston: Museum of Fine Arts, 1980. Includes mention of Harriet Powers' *Bible Quilt*.

Seiber, Roy. *African Textiles and Decorative Arts*. New York: Museum of Modern Art, 1973.

Sellen, Betty-Carol, and Cynthia Johanson. *Self Taught, Outsider, and Folk Art: A Guide to American Artists, Locations and Resources*. Jefferson, NC: McFarland, 2000. Outstanding guide to galleries, fairs, auctions, museums, organizations, exhibits and publications. Includes references to quilters Chris Clark, Yvonne Wells, Jacquelyn Hughes-Mooney, and Clementine Hunter.

_____. *Twentieth-Century American Folk, Self-Taught, and Outsider Art: A Guide*. New York: Neal-Schuman Publishers, Inc, 1993. Reference guide to arts institutions, organizations, educational opportunities, publications, and audio/visual materials about folk art.

Shaw, Robert. *America's Traditional Crafts*. New York: Hugh Lauter Levin Associates, Inc., 1993. Brief mention of African American quilting on p. 22. A stuffed *Turtle Quilt* by an unknown African American quilter is featured on p. 35. This quilt may be the same one auctioned at Sotheby's in July 1999 (sale #7253, lot #485). Other quilts are illustrated on pp. 37–38, including *Tied Scallop Pattern Quilt* (circa 1910).

_____. *Art Quilts*. New York: Hugh Lauter Levin Associates, Inc., 1997. Includes works by African American quilters, including Carole Y. Lyles.

_____. *Quilts: A Living Tradition*. New York: Hugh Lauter Levin Associates, Inc., 1995. African American quilts are featured on pp. 186–211.

Shigley, Sally Bishop. "Empathy, Energy, and Eating: Politics and Power in *The Black Family*

Dinner Quilt Cookbook" In *Recipes for Reading: Community Cookbooks, Stories, Histories*, ed. Anne L. Bower, pp. 118–131. Amherst, MA: University of Massachusetts Press, 1997.

Simpson, Grace. *Quilts Beautiful: Their Stories and How to Make Them.* Winston-Salem, NC: Hunter Pub. Co., 1981. Pattern and story for *I Have a Dream Quilt* and *Underground Railroad Quilt* on pp. 88–90.

Slabbert, Norma. *A Passion for Quiltmaking: Leading South African Quilters Show and Tell.* J.P. van der Walt and Son, P.O. Box 123, Pretoria, 0001, South Africa. Email: jpvdwalt@iafrica.com, $29.95. Published 1998, 112 pages.

Sotheby's Important Americana: Furniture and Folk Art catalog, New York, July 16 and 17, 1999—sale #7253, lot #485, p. 125. Auction featured rare stuffed, pieced cotton *Turtle Quilt*, attributed to an African American woman, dated late 19th or early 20th century. Quilt sold for $12,650.

Sotheby's Important Americana: Silver, Folk Art, and Furniture, New York, October 13, 2000 catalog. Sale 7521. Lot 51 featured "A rare and important pieced calico and cotton quilt top by the enslaved African, 'Yellow Bill.'" Circa 1852. Estimated $20,000–$40,000. Did not sell. Lot 52 featured "A fine and rare appliquéd and pieced, flannel and velvet African American Baltimore memorial quilt." Circa 1900–1910. This quilt has an appliquéd Black couple and was featured on *The Antiques Road Show* in August 1999. Estimated $12,000–$18,00. Quilt sold for $31,800.

Sterling, Dorothy. *We Are Your Sisters: Black Women in the Nineteenth Century.* New York: W. W. Norton & Company, 1984. See pp. 216–217, 508 for examples of Black women advertising their sewing and quilting skills in black magazines and newspapers in the 1860s.

Stewart, Charlyne Jaffe. *Animals to Applique.* New York : Sterling Publishing Company, Inc., 1989. Includes work by Michael Cummings.

Suggs, Eliza. *Shadow and Sunshine.* Omaha, NE: no publisher listed, 1906. Suggs was a devoted Christian and woman of physical small size, probably a midget. In her autobiography, she shares that her father, a former slave, purchased for her mother a "remarkable" chariot-wheel pattern quilt, which was "truly a masterpiece of skill." At one point, her mother pleaded successfully with Union soldiers not to confiscate the quilt.

Taulbert, Clifton. *The Last Train North.* Tulsa, OK: Council Oak Books, 1992. This autobiographical work includes the chapter "Quilts: Kiver for My Children."

Taylor, Susie King. *Reminiscences of My Life in Camp with the 33d United States Colored Troops Late 1st S.C. Volunteers.* Boston: published by author, 1902. Taylor was a quilter. In 1898, Taylor made a large red, white, and blue ribbon quilt that "made quite a sensation" and was awarded to the Women's Relief Corps president, Mrs. E.L. Waterman, of Boston. Reprinted as *Reminiscences of My Life: A Black Woman's Civil War Memoirs.* Patricia W. Romero and Willie Lee Rose, eds. New York: Markus Wiener, 1988.

Texas Heritage Quilt Society. *Texas Quilts: Texas Treasures.* Paducah, KY: American Quilter's Society, 1986. State search project. Black quilter identified. There is also a photo of a 1919 *Aunt Jemima Quilt* by Eva Amanda Brown Morgan. The 70" × 85" quilt features thirty-six cut outs of an Aunt Jemima image from corn meal sacks.

Thompson, Robert Farris. *Flash of the Spirit: African and Afro-American Art and Philosophy.* New York: Vintage Books/Random House, 1984.

Thurman, Sue Bailey, ed. *The National Council of Negro Women Presents The Historical Cookbook of the American Negro.* Washington, DC: The Corporate Press, 1958. Includes photos of the *Harriet Tubman* and *Fredrick Douglass* quilts created by the Negro History Club of Marion City, CA.

Tournier, Nan. "Sea Island Black Quilters." In *Social Fabric: South Carolina's Traditional Quilts*, ed. Laurel Horton and Lynn Robertson Myers, pp. 41–46. Columbus, SC: McKissick Museum, The University of South Carolina, 1985.

Trowell, Margaret. *African Design*. London: Faber and Faber Ltd., 1960.

Twining, Mary A. "Baskets and Quilts: Women in Sea Island Arts and Crafts." In *Sea Island Roots: African Presence in the Carolinas and Georgia*, ed. Mary A. Twining and Keith E. Baird, pp. 129–140. Trenton, NJ: Africa World Press, Inc., 1991.

Valentine, Fawn, with the West Virginia Heritage Quilt Search, Inc. *West Virginia Quilts and Quiltmakers: Echoes from the Hills*. Athens: Ohio University Press, 2000. Photo of Jane and Henry Jones, the first Black citizens to own property in a certain area of WV. A quilt by Jane Jones from about 1930 was photographed for the state project. The quilt was later destroyed by fire. Photo of quilter Mariah Dunlap and one of her quilts from 1875 included. Dunlap's granddaughter, Claire E. Dunlap Carter, was a founding member of the Women of Color Quilters' Network.

Vlach, John Michael. *The Afro-American Tradition in Decorative Arts*. Cleveland, OH: Cleveland Museum of Art, 1978. *Quilting* chapter on pp. 44–75 includes several photos of appliquéd and strip quilts.

_____. *By the Work of Their Hands: Studies in Afro-American Folklife*. Charlottesville: University Press of Virginia, 1991.

Von Gwinner, Schnuppe. *The History of the Patchwork Quilt: Origins, Traditions and Symbols of a Textile Art*. West Chester, PA: Schiffer Publishing, Ltd., 1988. Includes sections on "Symbolic West African Appliques" and "Afro-American Quilts."

Waldvogel, Merikay. *Soft Covers for Hard Times: Quiltmaking & the Great Depression*. Nashville, TN: Rutledge Hill Press, 1990. See pp. 78–82 on Tennessee Valley Authority Quilts and Black quilter Ruth Clement Bond.

Walker, Alice. "In Search of Our Mothers' Gardens." In *In Search of Our Mothers' Gardens*. New York: Harcourt, Brace, Jovanovich, 1983. Essay on Black women's creativity. See p. 239 for reference to a Smithsonian Institution Crucifixion quilt by "an anonymous Black woman in Alabama."

Walker, Marilyn I. *Ontario's Heritage Quilts*. Erin, Ontario: Boston Mills Press Book, 1992. See page 108 for photography and brief overview of an A.M.E. *Conference Quilt* made by members of the local Missionary Mite Societies in the Canadian Annual Conference.

Warren, Elizabeth V., and Sharron L. Eisenstat. *Glorious American Quilts: The Quilt Collection of the Museum of American Folk Art*. New York: Penguin Studio, 1996. See Chapter 10, pp. 132–139 for African American Quilts.

Welters, Linda, and Margaret T. Ordonez, ed. *Down by the Old Mill Stream: Quilts in Rhode Island*. Kent, OH: The Kent State University Press, 2000. A brief report on slaves in Rhode Island on pages 9–11. Reference to a black quilter is on pages 42–44.

Wentwork, Joan. *Quilts*. New York: Crown Publishers, 1989. *Mammy Patchwork* and *Lola, 1902* featured quilts.

Where Love Resides: Reflections on Love and Life. Bothell, WA: That Patchwork Place, Inc., 1996. Inspirational book based on the movie *How to Make an American Quilt*. African American-inspired quilt, *The Life Before* is featured on pp. 44–45.

White, Deborah Gray. *Ar'n't I a Woman?: Female Slaves in the Plantation South*. W. W. Norton & Company, 1999. Mentions quilting among slaves.

Wilens, Patricia, ed. *Better Homes and Gardens America's Heritage Quilts*. Des Moines, IA: Meredith Corporation, 1991. Includes photo of an *Underground Railroad* quilt as well as pattern to make quilt on pp. 83, 100–101.

Williams, Fannie Barrier. "The Club Movement Among Colored Women of America." In

A New Negro for a New Century, ed. J. E. MacBready, pp. 379–405, 414–428. Chicago: American Publishing House, 1900. Outlines the activities of the Woman's League of Washington, DC, which was organized in 1892. One of its standing committees included the "Committee on Mending and Sewing." The club organized sewing schools. The Harper Woman's Club of Jefferson City, MO, founded in 1890, established a training school for sewing instruction.

Williams, Thelma. *Our Family Table: Recipes & Food Memories from African-American Life Models.* Memphis, TN: The Wimmer Companies (1-800-727-1034), 1993. Introduction by Dr. Camille O. Cosby. Cover of 96-page book features block quilt created by Oakland, CA quilter Willia Ette Graham, who was taught to quilt by her great-grandmother, who was a slave.

Willis, Deborah. *Imagining Families: Images and Voices.* Washington, DC: National African American Museum, Smithsonian Institution, 1994. Includes section on Fay Fairbrother's *The Shroud Series, Quilt Shroud I through IV* on pp. 8–9, 28–29.

Willow, Ann Soltow. *Quilting the World Over.* Radnor, PA: Chilton Books Co., 1991. See chapter 11 "African Appliqué" on pp. 122–132.

Wilson, Charles Reagan, and William Ferris, eds. *Encyclopedia of Southern Culture.* Chapel Hill: University of North Carolina Press, 1989. References to African American quilts on pages 157, 457–458, and 460–461.

Wilson, James L. *Clementine Hunter: American Folk Artist.* Gretna, LA: Pelican Publishing, 1988. Mentions Hunter's making "of quilts of brilliant colors and complex patterns" on p. 24.

Witzling, Mara R., ed. *Voicing Our Visions: Writings by Women Artists.* Women's Press, Limited, 1999. Includes profile of twenty important 19th and 20th century artists, including Faith Ringgold. See pp. 351, 353-355. Book cover features quilt by Ringgold.

Woodard, Thomas, and Blanche Greenstein. *Classic American Quilts.* New York: E.P. Dutton, 1984. Full-page color photo of 1870 silk pictorial quilt featuring a Black community. Quilt composed of 277 blocks of three types: pictorial log cabin homes, people, and log cabin pattern blocks. Quilter unknown. See pp. 44–45.

_____. *Crib Quilts and Other Small Wonders.* New York: E.P. Dutton, 1982. Photo 136 features an appliqué rug with the inscription *We's Free* above a little Black girl figure.

_____. *Twentieth Century Quilts: 1900–1950.* New York: E.P. Dutton, 1988. Foreword by Cuesta Benberry.

Woods, Marianne. *Stitches in Time: A Legacy of Ozark Quilts.* Rogers, AR: Rogers Historical Museum, 1986. See pp. 35–36 for mention of *The Modern Priscillas,* a Fayetteville, Arkansas, Black women's club (named for an early needlework magazine) in the 1920s-30s.

Wooster, Ann-Sargent. *Quiltmaking: The Modern Approach to a Traditional Craft.* New York: Drake Publishers, 1972. Also published by Galahad Books. References to Harriet Powers on pp. 93–95.

Yabsley, Suzanne. *Texas Quilts, Texas Women.* College Station: Texas A & M University Press, 1984. Black quilters are included on pp. 56, 58–61, 86. The Tarrant County Black Historical Society of Fort Worth is said to have a "small collection of quilts made by black quilters."

Zalkin, Estelle. *Zalkin's Handbook of Thimbles and Sewing Implements.* Radnor, PA: Warman Publishing Co., Inc., 1988. See chapter 26 entitled "Black Memorabilia in the Sewing Basket." Photos of two Singer Sewing Machine Trade Cards illustrating Black women sewing in Rhodesia and Zululand (circa 1892). The cards appear to be the same designs as those distributed at the 1893 Chicago's World Fair.

EXHIBITION CATALOGUES

African-American Art in Atlanta: Public and Corporate Collections. Atlanta, GA: High
 Museum, 1984. Includes work by Michael Cummings.
Africobra: Universal Aesthetics. Washington, DC: Howard University Gallery of Art and
 Blackburn Center Gallery, November 6–December 17, 1989. Quilts by Michael D. Har-
 ris included.
Amish Quilts and African American Quilts: Classics from Two Traditions. Intercourse, PA:
 People's Place Quilt Museum, April 1, 2000–October 31, 2000. Phyllis Pellman Good,
 curator. Exhibit brochure.
Andrews, Gail, and Janet Strain McDonald. *Black Belt to Hill Country: Alabama Quilts from
 the Robert and Helen Cargo Collection.* December 13, 1981–January 24, 1982. Birming-
 ham, AL: Birmingham Museum of Art, 1981.
Art in Embassies. Collection at the residence of the U.S. Ambassador to the UN in Geneva,
 1999. Includes profile by Chicago quilter Jim Smoote.
Beck, Tom, and Cynthia Wayne. *Visual Griots: Works by Four African-American Photogra-
 phers.* Baltimore: University of Maryland, Albin O. Kuhn Library & Gallery, 1996.
 Includes profile on Deborah Willis and her photo quilts on pp. 22–25. Exhibit check-
 list as well.
Bell, Michael Edward, and Carole O. Bell. *Quilting: Folk Traditions of the Rhode Island Afro-
 American Community.* Rhode Island Black Heritage Society, 1981. This endearing eight-
 page booklet features quilts from the St. Martin DePorres Quilting Club of Providence.
 Interesting essay on group quilting dynamics. Precious photograph of a circle formed
 by all the quilters' hands.
Benjamin, Tritobia Hayes, and Alvia J. Wardlaw, co-curators. *Black Women Artists in the
 Academy.* Washington, DC: Howard University Gallery of Art, June 24–July 23, 1999.
 This exhibit was one component of a Black Women in the Academy II conference held
 in Washington, DC (the first conference was in 1994). The exhibit featured thirty-one
 artists who also work within academia as faculty or administrators. Quilters and fab-
 ric artists represented include Nichole Gray, Viola Burley Leak, and Deborah Willis.
Benson, Jane, and Nancy Olsen. *The Power of Cloth: Political Quilts, 1845–1986.* Cupertino,
 CA: Euphrat Gallery, 1987. Includes Cuesta Benberry's *Afro-American Women and
 Quilts,* work by Faith Ringgold and Jean Ray Laury's *Sojourner Truth* quilt. Exhibit
 March 3 to April 19, 1987.
Bickford, Kathleen. *Everyday Patterns: Factory-Printed Cloth of Africa.* Craig Allen Subler,
 curator. Kansas City, MO: University of Missouri, Kansas City. 1997. 34 p. Each page
 is filled with color photos of wax, fancy, and commemorative prints. The names of
 various fabric designs are explained.
Black Creativity: Juried Art Exhibition. Chicago, IL: Museum of Science and Industry, Feb-
 ruary 1–March 9, 1997. Tenth annual art competition exhibition checklist. All art
 forms. Exhibit included quilt by Kyra Hicks.
Black Creativity: Juried Art Exhibition. Chicago, IL: Museum of Science and Industry, Feb-
 ruary 1–29, 1996. Ninth annual art competition exhibition checklist. All art forms.
 Exhibit included quilt and textile works by Kyra Hicks, Jill N. Parker-Trotter and Jim
 Smoote, who won an Honorable Mention.
Black on Black: The Works of Black Artists from Chicago Black Collectors. University of Illi-
 nois at Chicago, 1983. Includes work by Michael Cummings.
Block Party: The Art of Quilting by Quilters of the Round Table. Philadelphia, PA: The Free
 Public Library of Philadelphia, 1996.
Bold Improvisation: A Focus on African-American Quilts from the Collection of Scott Heffley.

St. Joseph, MO: Albrecht-Kemper Museum of Art, 1999. [4] p. Includes essay by Dr. Maude Wahlman "Secret African Signs Encoded in African-American Quilts."

Bontemps, Arna Alexander, ed. *Choosing: An Exhibit of Changing Perspectives in Modern Art and Art Criticism by Black Americans, 1925–1985.* Catalog sponsored by Philip Morris Companies, Inc., 1986. Exhibit includes quilts by Michael D. Harris.

Bontemps, Arna Alexander, ed. *Forever Free: Art by African-American Women 1862–1980.* Alexandria, VA: Stephenson, 1980. See pp. 88–89 for references to quilter and folk artist Clementine Hunter.

Brackman, Barbara. *Patterns of Progress: Quilts in the Machine Age.* Los Angeles: Autry Museum of Western Heritage, 1997. Includes Jacquelyn Hughes Mooney's quilts *Fly Away* and *Jane* on pp. 92–95 and Carolyn Mazloomi's quilt *Nate Love, African American Cowboy* on pp. 122–123.

Brooks, Marylin. *The World of Quilts at Meadow Brook Hall: A Celebration of Matilda Dodge Wilson's 100th Birthday Anniversary.* Rochester, MI: Oakland University, 1983. September 8–25, 1983. See p. 35 for Elizabeth Keckley's quilt for Mrs. Mary Lincoln, wife of President Abraham Lincoln.

Burning Issues: Contemporary African-American Art. Museum of Art, Fort Lauderdale, FL, 1996–1997. Included works by Michael Cummings.

"A Celebration of Culture." *National Black Arts Festival National Juried Exhibition Catalog— 1996.* Atlanta, GA. Includes *Outside the Lines Quilt* by Carole Harris, p.20; *Tutu Egun* textile by Adriene Cruz, p.13.

Christopherson, Katy. *The Political and Campaign Quilt.* Frankfort, KY: The Kentucky Heritage Quilt Society & The Kentucky Historical Society, October 1, 1984–November 11, 1984. Includes the *Afro-American Bicentennial Quilt* made by J.M. Gates and the Afro-American Heritage Bicentennial Commemorative Quilt Committee of Portland, Oregon, pp. 60–61.

Clark, Ricky. *Quilts and Carousels: Folk Art in the Firelands.* Oberlin, OH: Firelands Association for the Visual Arts, 1983. Includes *Underground Railroad* quilt on pp. 24–25; *Shooting Star* quilt on pp. 34–35.

Collins, Willie. "Use What You Got: A Profile of Arbie Williams, Quilter." In *African-American Traditional Arts and Folklife in Oakland.* City of Oakland, CA: Cultural Arts Division, 1992, pp. 13–16.

Community Fabric: African American Quilts and Folk Art. Philadelphia Museum of Art, 1994. [12] p. Exhibit brochure and exhibit were organized in collaboration with Dr. Maude Southwell Wahlman.

Dawson, C. Daniel. *Family Medicine: The Art of Elizabeth Talford Scott.* Willis-Kennedy, Deborah, curator. Washington, DC: Anacostia Museum, 1997. 20 p.

"Deborah Willis: African American Extended Family." University of Arizona. Center for Creative Photography, 1994. Exhibit brochure.

A Different Image: African American Art in Louisianan Collections. Louisiana Arts and Science Center. No date.

Dorsey, Frances. *For John Cox' Daughter: African-American Quilts from the Southeastern United States.* Ann Arbor, MI: The Jean Paul Slusser Gallery, University of Michigan School of Art, 1991.

Eight + One From Atlanta. Tangeman Gallery, University of Cincinnati. January 4–February 12, 1993. Included mixed-media quilts by Michael D. Harris.

Eyewinkers, Tumbleturds and Candlebugs: The Art of Elizabeth Talford Scott. George Ciscle, curator. Maryland Institute College of Art. 1998. 52 p.

Fact, Fallacy and Illusion: Historical African-American Imagery. Chicago, IL: Satori Fine Art Gallery, February 9–March 10, 1996. Solo quilt exhibition featuring noted fiber artist

Venus Blue. Exhibit postcard. Postcard front featured a detail of a mixed media quilt entitled *Gettysburg*.

Faith Ringgold: Change: Painted Story Quilts. New York: Bernice Steinbaum Gallery, 1987.

Farr, Francine. *Flying Colors: Military Flags of Africa and African America.* Boston: The Museum of Afro-American History: The African Meeting House, 1991. 14 p. Includes pieces from Dahomey (Benin), Ghana, Ethiopia, the Caribbean—Haiti, Dominican Republic, and the USA. Includes Faith Ringgold's *Flag Story Quilt*.

Ferris, Alison. *Memorable Histories and Historic Memories.* Brunswick, ME: Bowdoin College Museum of Art, 1998. Photographer and quilter Deborah Willis is one of eight featured artists. Her *Enslaved (1995)* photo-tie quilt is featured on the exhibit catalog cover. See pp. 28–31.

Flomenhaft, Eleanor, curator. *Faith Ringgold: A 25 Year Survey.* Hempstead, NY: Fine Arts Museum of Long Island, 1990.

Freeman, Roland. *Common Threads: The Buffalo-Ontario-Caribbean Connection.* Washington, DC: The Group for Cultural Documentation, Inc., 2000. 16 p. Symposium program. Exhibit at the Buffalo (NY) Museum of Science June 24–September 23, 2000. Includes essays about quilts at the Buxton, Ontario Canada settlement, the use of patchwork by the Maroons in Suriname, quilts from the St. Joseph's Convent School in Trinidad, Gwendolyn Magee's *Lift Every Voice and Sing* quilt series, and works by Washington, DC artist Julee Dickerson-Thompson.

_____. *Common Threads: Creating a Cloth of Empowerment: The Role of Textile Collectives in Women's Empowerment and Recent Research on African-American Quilters.* Washington, DC: The Group for Cultural Documentation, Inc., 1999. [8] p. Symposium program. This international symposium took place at the S. Dillon Ripley International Center of the Smithsonian Institution, March 19–20, 1999.

_____. "Quilt Close-up: Five Southern Views." In *Quilts from the Mississippi Heartland*, pp. 35–42. Asheville, NC: The Hunter Museum of Art and Folk Art Center of the Southern Highland Handicraft Guild, 1983.

_____. *Quincentenary: More Than Just Something to Keep You Warm: Tradition and Change in African American Quilting.* Philadelphia, PA: Springside School, 1992.

_____. *Something to Keep You Warm.* Jackson, MS: Mississippi State Historical Museum, 1981.

From the African Loom to the American Quilt: An Exhibit of African-American Quilts from the 1920s to the 1990s. Four-page exhibit checklist. Research Triangle, NC: National Humanities Center, February 1–March 15, 1998. Gladys-Marie Fry, curator.

Fry, Gladys-Marie. *Broken Star: Post Civil War Quilts Made by Black Woman.* Dallas, TX: Museum of African-American Life and Culture, 1986.

_____. "Harriet Powers: Portrait of a Black Quilter." In *Missing Pieces: Georgia Folk Art 1770–1976*, ed. Anna Wadsworth, pp. 16–23. Atlanta, GA: Georgia Council for the Arts and Humanities, 1976.

_____. "Made By Hand." In *Mississippi Folk Arts.* Jackson, MS: Mississippi State Historical Museum, 1980.

_____. *Man Made: African American Men and Quilting Traditions.* Washington, DC: Anacostia Museum and Center for African American History and Culture, 1998. 34 p.

_____. *Militant Needles: An Exhibit of Slave Made Quilts.* Columbus, OH: National Afro-American Museum Project, 1984.

_____. "Not by Rules, But by the Heart: The Quilts of Clementine Hunter." In *Clementine Hunter, an American Folk Artist.* Dallas, TX: Museum of African-American Life and Culture, 1993.

_____. *Quilts and Quiltmaking in Black America.* Nashville, TN: Fisk University, n.d.

Gates, J.M. *Afro-American Heritage Quilt and Historical Exhibit: The Afro-American Bicentennial Quilt.* Portland, OR: Oregon Historical Society, 1976.

Gateway to the World: Art & Architecture of Concourse E. Hartsfield Atlanta International Airport, 1995. Brochure of artwork includes Michael D. Harris' *Silence/Prayer*, mixed-media quilt.

Glass, Barbara, ed. *Uncommon Beauty in Common Objects: The Legacy of African American Craft Art.* Willis "Bing" Davis, curator. Wilberforce, OH: National Afro-American Museum and Cultural Center, 1993. Includes quilted pieces by Tina Williams Brewer, Viola Canady, Michael Cummings, Raymond Dobard, Sandra Gould Ford, Sandra German, Shirley Grear, Carole Harris, Peggie Hartwell, Anita Knox, Ed Johnetta Miller, Carolyn Mazloomi, Marlene O'Bryant-Seabrook, Elizabeth Scott, and Jim Smoote.

Goldson, Elizabeth, ed. *Seeing Jazz: Artists and Writers on Jazz.* Washington, DC: Chronicle Books in association with the Smithsonian Traveling Exhibition Service, 1997. Includes Michael Cummings *Jazz Series* quilts #1, #4, #11, #12.

Griffin, James S. *Geometry in Motion: Afro-American Quiltmakers.* Eugene, OR: Visual Arts Resources of the University of Oregon Museum of Art, n.d. The director of the Southwest Folklore Center, University of Arizona provides a brief description of black quilters from Pima County, Arizona.

Gross, Joyce, and Cuesta Benberry. *20th Century Quilts, 1900–1970: Women Make Their Mark.* Paducah, KY: Museum of the American Quilter's Society, 1997. See p. 29 for *Star of Bethlehem Quilt* by Freedom Quilting Bee, Gees Bend, AL.

Hall, Robert. *Gathered Visions: Selected Works by African American Women Artists.* Washington, DC: Anacostia Museum, 1992.

Hammett, Lisa Reynolds. *Patterns: A Celebration of Georgia's Quilting Traditions.* Madison, GA: Madison-Morgan Cultural Center, 1990. Includes African American quilters from select counties in Georgia.

Hand Me Downs: Innovations Within a Tradition. Michael Godfrey, curator. Charlotte, NC: Afro-American Cultural Center, January 6–March 26, 1995. This fifteen-page catalog includes an introductory essay by Michael D. Harris which explores African consciousness in African American art. Artwork included quilts, dolls, and fiber sculptures. Quilters included Amalia K. Amaki, K. Joy Ballard-Peters, Stephanie Ballentine, Michael Cummings, Francelise Dawkins, Virginia R. Harris, Peggie Hartwell, Kyra Hicks, Dorothy Holden, Carolyn Mazloomi, Elizabeth Scott, Joyce Scott, Yvonne Wells, and Deborah Willis.

Holstein, Jonathan. *Abstract Designs in American Quilts: A Biography of an Exhibition.* Louisville, KY: The Kentucky Quilt Project, 1991. Foreword by Shelly Zegart. First edition limited to 1,000 copies. Includes mentions of African American quilting.

_____. *The Pieced Quilt: An American Design Tradition.* Boston: New York Graphics Society, 1973. The end papers feature a Harriet Powers quilt.

Horton, Laurel, and Lynn Robertson Myers. *Social Fabric: South Carolina's Traditional Quilts.* Columbus, SC: McKissick Museum, The University of South Carolina, 1985.

Imami-Paydar, Niloo. *Stitch by Stitch: A Quilt Potpourri.* Indianapolis: Indianapolis Museum of Art. February 10–August 4, 1996. Includes Carolyn Mazloomi's quilt *I've Got an Ace Up My Sleeve* on back cover.

In the Spirit of the Cloth. Columbus, OH: Columbus Museum of Art, 1995. Carolyn Mazloomi, curator. Exhibition checklist.

Jasper, Pat. *Quilts of Color: Three Generations of Quilters in an Afro-Texan Family.* Austin, TX: Texas Folklife Resources Gallery, August 12, 1999–November 13, 1999. Artists included Sherry Byrd, Laverne Brackens, Gladys Henry, and Katie Mae Tatum.

Jolly, Marva Lee Pitchford. *Issues of Identity: A Sapphire & Crystals Exhibition of Art by 20*

African American Women Artists. Chicago, IL. No date is listed, but most likely 1995. Twenty page booklet profiling each member of this cooperative. Quilter Venus Blue included.

Joyful Improvisation: The Quilts of Anna Williams. Brochure. Baton Rouge, LA: Louisiana State University Textile and Costume Gallery, October 4–December 18, 1998.

Kentucky Quilt Project. *Kentucky Quilts 1800–1900.* New York: Pantheon Books, 1982. Essays by Jonathan Holstein and John Finley. See pp. 25–26 for photo of the 1860 *Princess Feather with Oak Leaves* quilt by slave Mahulda Mize.

Kirkham, Pat, ed. *Women Designers in the USA, 1900–2000 Diversity and Difference.* New Haven: Yale Univeristy Press, 2000. Chapters include "Three Strikes Against Me: African American Women Designers" and "Tradition and Transformation: Women Quilt Designers." African American quilters mentioned include Ruth Clement Bond, Carolyn Mazloomi, Harriet Powers, Faith Ringgold, Anna Williams, and Lucile Young.

Lankford, Susan Roach. *Patchwork Quilts: Deep South Traditions.* Alexandria, LA: Alexandria Museum, 1980.

LeFalle-Collins, Lizetta. *Emerging Artists: Figurative Abstraction.* Second Biennial Exhibition. Los Angeles: California Afro-American Museum, 1988. Includes profile of Michael Cummings, his artist statement, and two quilts: *Grandma's Porch* and *Haitian Boat People.*

Leon, Eli. "African Transformations in Afro-American Whole Quilt Patterns." *Traditions in Cloth: Afro-American Quilts/West African Textiles.* Los Angeles: California Afro-American Museum. 1986.

_____. *Arbie Williams Transforms the Britches Quilt.* The Regents of the University of California, 1993. [16] p.

_____. *Model in the Mind: African Prototypes in American Patchwork Quilts.* Diggs Gallery. Winston-Salem, NC: Winston-Salem State University, January 1992.

_____. *No Two Alike: African-American Improvisations on a Traditional Patchwork Pattern.* Columbia, SC: South Carolina State Museum, 1998. 27 p.

_____. *Showing Up: Maximum-Contrast African-American Quilts.* Richmond (CA) Art Center, January 10–March 23, 1996. [4] p.

_____. *Something Else to See: Improvisational Borders on African-American Quilts.* Amherst: University of Massachusetts, 1997. 44 p.

_____. "Wrapping Home Around Me: How the Patchwork Quilt Became a Medium for the Expression of African Values." In *Rambling on My Mind: Black Fold Art of the Southwest,* pp. 18–33. Dallas: Museum of African-American Life and Culture, 1987.

Lewis, Samella, curator. *Jazz…A Montage of a Dream.* Kansas City, MO: Kansas City Jazz Museum, January 22–April 23, 1999. The museum's inaugural art exhibit included works by fourteen artists, including quilts by Michael Cummings and tapestry by Napoleon Jones-Henderson. Catalog cover of Cumming's *African Jazz #5* quilt.

Lindsey, Jack. *Community Fabric: African American Quilts and Folk Art,* Philadelphia: Philadelphia Museum of Art, February 13–April 10, 1994. Exhibition checklist. Maude Wahlman collaborated with the museum in organizing the exhibit. Activities includes lectures by Maude Wahlman and Cuesta Benberry.

Livingston, Jane, and John Beardsley. *Black Folk Art in America 1930–1980.* Washington, DC: Corcoran Gallery of Art, 1982.

Lohrenz, Mary Edna, and Anita Miller Stamper. *Mississippi Homespun: Nineteenth-Century Textiles and the Women Who Made Them.* Mississippi State Historical Museum, 1989.

Louisville Celebrates the American Quilt: A Guide to the Exhibitions. Kentucky Quilt Project, Inc., November 22, 1991–May 3, 1992. A catalog and checklist of seven exhibi-

tions held at the same time include Cuesta Benberry's *Always There: The African American Presence in American Quilts,* pp. 10–11; and *Narrations: The Quilts of Yvonne Wells and Carolyn Mazloomi,* pp. 34–35.

MacDowell, Marsha. *African American Quiltmaking Traditions in Michigan.* East Lansing, MI: Michigan State University Museum, February 2, 1991–September 29, 1991. [8] p. Exhibit traveled throughout state of Michigan. See reference to book with same title.

MacDowell, Marsha, and Ruth Fitzgerald, ed. *Michigan Quilts: 150 Years of a Textile Tradition.* East Lansing, MI: Michigan State University Museum, 1987. Black quilters are included in this state search.

Maryland Quilts of the Month: Where, Where, Oh Where Can They Be. Maryland Commission on Afro-American History and Culture and the Banneker-Douglass Museum, Annapolis, MD, 1989. Five African American quilts from Maryland featured during the exhibit of *More Than Just Something to Keep You Warm.* Reprinted in Women of Color Quilters' Network Newsletter, issue #5, Fall 1990.

Mason, Rhonda. *Daughters of Harriet Powers: Tribute to an American Quilt Maker.* Tampa, FL: Museum of African American Art, February 7, 1997–March 22, 1997. This exhibit featured works by twenty-seven contemporary quilters from across the country. African American quilters featured included Ana Arzu, Alice M. Beasley, Kianga Hanif, Radiah Harper, Virginia R. Harris, Peggy Hartwell, Kyra Hicks, Ed Johnetta Miller, Sherry Whetstone-McCall, and Deborah Willis. Exhibition checklist booklet.

Mazloomi, Carolyn. *In the Spirit of the Cloth: Contemporary African American Quilts.* Atlanta, GA: Spelman College Museum of Fine Arts, February 22–July 19, 1998. Six-panel brochure. Essay and exhibit checklist.

Mazloomi, Carolyn, and David R. McFadden. *Spirits of the Cloth: Contemporary Quilts by African American Artists.* New York: American Craft Museum, 1999. Six-panel brochure and exhibition checklist.

McDonald, Mary Anne, "Jennie Burnett: Afro American Quilter." In *Five North Carolina Folk Artists,* ed. Charles G. Zug, III, pp. 27–39. The Ackland Art Museum and the University of North Carolina, Chapel Hill, February 1–March 23, 1986. Burnett, who was born November 22, 1892, is interviewed. Seven quilts included in exhibit. This interesting essay mistakenly claims there are certain characteristics that define a quilt by a Black American.

McKinney, Nancy, ed. *Traditions in Cloth: Afro-American Quilts/West African Textiles.* Los Angeles: California Afro-American Museum, 1986. 23 p. Essays by Maude Wahlman and Eli Leon; Introduction by Cuesta Benberry.

McMorris, Penny. *Contemporary Quilts from the James Collection.* Paducah, KY: American Quilter's Society, 1995. Includes two quilts by Faith Ringgold—*The Women Mask Face Quilt #1* on p. 32; *The Men: Mask Face Quilt, #2* on p. 33.

Miller, Ed Johnetta, and Margaret Penn. *African-American Master Quiltmakers.* Hartford, CT: CRT Department of Fine Arts, 1986.

One True Collective Face: African American Art. Atlanta, GA: Emory University, January–March 5, 1998. Exhibit of various art forms in the Hugh F. MacMillan Law Library. Quilters included Kyra Hicks and Edna J. Patterson-Petty. Six-page exhibit checklist.

The Peace Quilt Project. Durban, South Africa: Natal Quilters Guild Seasons National Quilt Festival, July 1996. The exhibit features almost 800 fabric "bricks" from 29 different countries which were used to build a wall of peace. Barbara Brown of Maryland made brick number 737. The catalog acknowledges that the initial inspiration from the project came in October 1993 when a group of South African quilters visiting the U.S. saw the *Freedom Quilt* featured in Cuesta Benberry's book *Always There.*

Perkins, Zoe Annis. *Textiles from the Collection—Textiles of the World: An Introduction to*

the Saint Louis Art Museum's Collection. St. Louis: St. Louis Art Museum, 1994. See pp. 58–59 for Faith Ringgold's commissioned quilt *Jo Baker's Birthday*—purchase 10.1994.

Perry, Regenia. "Quilt Making." *Black Folk Art in America, 1930–1980*. Washington, DC: Corcoran Gallery of Art, 1982.

Pickett, Thelma W. *Quilts—A Bit of Afro American History*. Oakland, CA: Ebony Museum of Art, 1984. Exhibit featuring more than 70 quilts at the Veterans Memorial Building. Eight page booklet.

Picton, John, ed. *The Art of African Textiles: Technology, Tradition and Lurex*. London: Barbican Art Gallery, Lund Humphries Publishers, 1995. Fascinating history of factory-printed textiles and wax prints. Includes several photos of individual prints with translations to explain the print's meaning. Exhibit September–December 1995.

Pierce, Sue, and Verna Suit. *Art Quilts: Playing with a Full Deck*. Pomegranate Artbooks, Inc., 1995. Includes *Nine of Spades* by Carolyn Mazloomi and *Five of Diamonds* by Dorothy Holden. Images from quilts in this exhibit were also featured on playing cards (*The Art Quilt: A Full Deck*, manufactured by Lark Books).

Porcella, Yvonne. *Comments on the American 20th Century*. Atlanta, GA: Connell Gallery, 1999. Features quilts by Carolyn Mazloomi and Wini Akissi McQueen.

Printed Quilts/Quilted Prints. New York: Pratt Graphics Center Gallery, 1976. Andrew Stasik, exhibit director. The exhibit catalog included postcards of selected quilts—including an untitled quilt (1975–1976) by Romare Bearden. The 94" × 76" screen-printed quilt was pieced by Olga Alexander and hand quilted by an Ohio Amish member. The quilt featured a stenciled image of a Black women framed by a tree on one side and plants on the other side.

Quilting Partners. Pub. Sao Paulo, Illinois Partners—Museu De Arte De Sao Paulo, Brazil, 1989. Includes works by Chicago quilter Jim Smoote.

Quilts Like My Mama Did. Columbia, SC: McKissick Museum, No date. Flyer. Quilts by women of the Pawleys Island, South Carolina.

The Quilts of Rosie Wilkins: Improvisational Quiltmaking in African-American Tradition. Lansing, MI: Michigan Women's Historical Center and Hall of Fame, August 1–September 24, 1989. Six-panel brochure. This eleven-quilt exhibit was co-curated by Marsha MacDowell and Jacquelyn Faulkner.

Quilts: The Permanent Collection—MAQS, Vol. II. Paducah, KY: American Quilter's Society, 1994. Quilts purchased or acquired during 1991–1994. Includes *Discovery* appliquéd "silkollage" by Francelise Dawkins (p. 25) and *Lilies of Autumn* by Juanita Gibson Yeager (p. 40).

Rambling on My Mind: Black Folk Art of the Southwest. Dallas, TX: Museum of African-American Life and Culture, 1987.

Ramsey, Bets. *Quilt Close-Up: Five Southern Views*. Chattanooga, TN: Hunter Museum of Art, 1983. Includes essay "Quilts from the Mississippi Heartland" by Roland Freeman, pp. 35–42.

Ramsey, Bets, and Gail Andrews Trechsel. *Southern Quilts: A New View*. McLean, VA: EPM Publications, 1991. Exhibit featuring 28 southern artists including Matilda Wood, Mattie Ross, and Lillian Beattie (pp. 28–30) and Dorothy Holden (pp. 73, 75).

Recovering History: The Tradition of African American Quilting. Milwaukee, WI: Milwaukee Art Museum, October 23–November 1, 1998. Brochure. Display of quilts made after 1950. Featured artists included Allie Crumble, Sharon Kerry-Harlan, Josephine Littleton, Lateefah Muhammad, Viola Nicholson, Emma Parker, Ivory Pitchford, Diane Pratt, Velma Seales, Blanche Shankle and Marilyn Young.

Reynolds, Elizabeth. *Southern Comfort: Quilts from the Atlanta Historical Society Collections*, 1978. Includes a slave quilt thought to be made between 1825 and 1850.

Robinson, Jontyle Theresa, curator. *Bearing Witness: Contemporary Works by African American Women Artists*. Spelman College and Rizzoli International Publications, Inc., 1996.

Ross, Doran H. *Fighting With Art: Appliquéd Flags of the Fante Asafo*. Los Angeles: UCLA Museum of Cultural History, 1979.

_____. *Wrapped in Pride: Ghanaian Kente and African American Identity*. Los Angeles: UCLA Fowler Museum of Cultural History, 1998. Includes quilts by Dorothy Taylor (p. 180–181) and Adriene Cruz (p. 179).

Roth, Moira. *Faith Ringgold: Change: Painted Story Quilts*. New York: Bernice Steinbaum Gallery, 1987.

Romare Bearden: 1970–1980. Mint Museum, Charlotte, North Carolina, 1981. Bearden celebrated quilting in two paintings—*Quilting Time* and *Patchwork Quilt*. The exhibit also included an untitled quilt designed by Bearden in 1976 (p. 120).

Sarah Mary Taylor…Yazoo Folk Artist Who Charms the Nation with Her Ideas and Skills. Yazoo City, MS: Yazoo County Convention & Visitors Bureau, 2000. Eight-panel brochure of Taylor's 2000 exhibit schedule.

"Sew On and Sew On" by The Quilters of The Round Table. Philadelphia, PA: The Afro-American Historical and Cultural Museum, 1995. 24 p. Catalog includes biographical sketch and photography of each quilter and her work. Exceptional documentation of local quilting group.

Siporin, Steve, ed. *CityFolk, the Portland Folklife Project*. Salem: Oregon Arts Commission, 1981. Includes profile of local African American quilter.

Smythe, Victor, ed. *Black New York Artists of the 20th Century: Selections from the Schomburg Center Collections*. New York: New York Public Library, 1998. Includes quilt by Michael Cummings.

The Society of Contemporary Crafts, Pittsburgh. *Stop Asking, We Exist: 25 African-American Craft Artists*. Joyce Scott, curator. 1999. 60 p. Includes profile and photographs of quilts by Amalia Amaki, Tina Williams Brewer, Raymond Dobard, Carolyn Mazloomi, and Elizabeth Scott.

South Carolina Arts Commission. *South Carolina Sea Island Quilt*. Pamphlet. No date. Color photo of quilt and quilters in the South Johns Island quilting cooperative. The *Charleston News and Courier* reported on this group in 1972.

Stachiw, Myron O. *Northern Industry and Southern Slavery*. Boston: Merrimack Valley Textile Museum, 1981. Exhibition catalog about the manufacture of "Negro cloth."

Steinbaum, Bernice. *The Definitive Contemporary American Quilt*. New York: Bernice Steinbaum Gallery Ltd., 1990. Includes quilts made by New Yorkers Michael Cummings, Faith Ringgold and Marie Wilson.

Stitch by Stitch: A Quilt Potpourri. Indianapolis Museum of Art, February 10–August 4, 1996. Includes *I've Got an Ace Up My Sleeve* quilt by Carolyn Mazloomi.

Stitched in Time—American Needlework Past and Present. New York: Hallmark Gallery, May 14–July 18, 1969. Five-page press release. Exhibit included over 500 items, including needlework by Pearl Bailey and a quilt by the Freedom Quilting Bee. Show also traveled to the Halls department store in Kansas City in 1970.

Stuempfle, Stephen, ed. *Florida Folklife: Traditional Arts in Contemporary Communities*. Historical Museum of Southern Florida (Miami), 1988. Profile and photos of quiltmaker Sally Jones on pp. 37, 45.

Sullivan, Kathlyn. *Gatherings: America's Quilt Heritage*. Paducah, KY: American Quilter's Society, 1995. Paul Pilgrim and Gerald Roy, curators. Includes *Slave Chain* quilt by Phoeba Johnson (1883–1983).

Swann, Mary. *Knot as They Seam: Puns and Permutations in the Fiber Arts.* Baltimore: Maryland Art Place, 1998. Includes a Michael Cummings Jazz Series quilt.

Taggard, Mindy Nancarrow. *Deborah Willis: Tied to Memory.* Kansas City, MO: Kemper Museum of Contemporary Art, May 5–July 16, 2000.

Tale of the Quilt: 150th Anniversary 1841–1991. Washington, DC: Fifteenth Street Presbyterian Church, 1992. Sixteen page brochure about the *Anniversary Quilt* made by church members. The quilt measures 100″ × 70″ and has 63 blocks. Brochure details meaning of each block, block sponsors, and those who participated in making.

Timby, Deborah Bird, ed. *Visions: The Art of the Quilt.* San Diego, CA: C and T Publishing, 1992. *Kitty and Fireflies in the Bush Quilt* by Michael Cummings on p. 38.

Tournier, Nan. "Sea Island Black Quilter." In *Social Fabric: South Carolina's Traditional Quilts*, pp. 41–46. Columbia, SC: McKissick Museum, The University of South Carolina.

Twining, Mary A. *Checkered Paths: A Continuing Tradition in European-American and African-American Quilts.* Buffalo, New York: Upton Hall Gallery, Buffalo State College, September 1986. [4] p.

Two Black Folk Artists: Clementine Hunter, Nellie Mae Rowe. Oxford, OH: Miami University Art Museum, January 10–March 15, 1987. 16 p.

Urquhart, Heather J. *Grand Slam: 20th Century Baseball Quilts.* Exhibit traveled September 1997–August 1998. Included *The Great American Pastime: Homage to Jackie Robinson, 1997* quilt by Yvonne Wells.

Wahlman, Maude. *Contemporary African Arts.* Chicago: Field Museum of Natural History, 1974. Chapters on pattern-dyed textiles and woven textiles.

Wahlman, Maude Southwell. "Africanisms in Afro-American Visionary Arts." In *Baking in the Sun: Visionary Images from the South*, pp. 28–43. Lafayette, LA: University Art Museum, University of Southwestern Louisiana, 1987.

_____. *Contemporary African Fabrics.* Chicago, IL: The Museum of Contemporary Art, 1975.

Wahlman, Maude Southwell, and Ellen King Torrey. *Ten Afro-American Quilters.* University, MS: The Center for the Study of Southern Culture, 1983. [32] p.

Wahlman, Maude Southwell, and John David Scully. *Black Quilters.* New Haven: Yale School of Art, 1979. Exhibition of quilts by Keisie Anderson, Lydia Anderson, Anna Campbell, Arester Earl, Amanda Gordon, Jimmie Lee Hill, Susie Ponds, Hetty Fountain Stulz, Pecolia Warner and Onie Williams. Art and Architecture Gallery January 15–February 2, 1979.

Wardlaw, Alvia J. *Patchwork Quilts and Shotguns.* Houston, TX: Transco Gallery, January 19–February 28, 1987.

Weisbach, Elise, and Barbara Krause. *Stitched, Layered, Pieced: Michigan Artists and the Quilt.* Ann Arbor: University of Michigan Museum of Art, 1995. Includes Carole Harris' quilt *Something Like a Jitterbug* as the cover design.

Woods, April. *Clementine Hunter: From the Schoephoerster Family Collection.* Greeley, CO: University of North Colorado, Mariani Gallery, February 16–March 13, 1998. Essay by Michael Coronel about African American quilt making.

Zegart, Shelly. *Kentucky Quilts: Roots & Wings.* Morehead, KY: Kentucky Folk Art Center, 1998. Cites Kentucky African American quilters, including Gwendolyn Kelly, Ophelia Searcy and Juanita Yeager.

MAGAZINE, JOURNAL AND NEWSLETTER ARTICLES

Abbott, Shirley. "Celebrating the Great American Quilt." *McCall's*, April 1991, pp. 61–66. Includes photo of Johnetta Cole, president of Spelman College, with quilt made by

Mable Benning and her daughter, Shilla Benning, for Nelson Mandela. The quilt included blocks representing thirty-eight historically Black colleges and universities.

Adams, Marie Jeanne. "The Harriet Powers Pictorial Quilts." *Black Art* vol. 3, no. 4, 1979, pp. 12–28.

Adams, Dr. Monni. "Harriet Powers' Bible Quilts." *The Clarion*, Museum of American Folk Art, New York, Spring 1982, p. 43.

Adams, Monni. "Kuba Embroidered Cloth." *African Arts* vol. 12, no. 1, November 1978, pp. 24–39.

"African American Quilters Organize Retreat." *Quilter's Newsletter Magazine* vol. 287, November 1996, p. 12.

"African-American Quilts and Photographs." *Studio Art Quilt Associates Newsletter* vol. 10, no. 2, Spring 2000, p. 4.

"African Fabric Art." *Black Collegian* vol. 11, August/September 1980, pp. 189–190.

"Afro-American Quilts." *Quilt World Omnibook*, Fall 1988, pp. 47–48. Preview of quilts for "Country to City" exhibit at American Museum of Quilts and Textiles in San Jose, CA. Bets Ramsey, curator.

Ahart, Larry. "The Soul of Black Quilts." *Quilting Today* no. 35, April 1993, pp.34–35.

"Alabama Quilts Add New Facet to University Collection." *Quilter's Newsletter Magazine*, September 2000, p. 8. African American quilts from the Dr. and Mrs. Robert Cargo Collection are donated to the International Quilt Study Center.

Alexander, Adele Logan. "White House Confidante of Mrs. Lincoln." *American Visions*, February/March 1995, pp. 18–19. Profile of Elizabeth Keckley.

Alexander, Karen. "Common Threads: Creating a Cloth for Empowerment—An International Symposium: The Role of Textile Collectives in Women's Empowerment and Recent Research on African-American Quilters." *Blanket Statements (AQSG)*. Summer 1999, p.9. Review of March 19–20, 1999 symposium organized at the Smithsonian Institution by Roland Freeman.

_____. "Cuesta Benberry's Gift." *The Quilters Hall of Fame Newsletter* no. 12, Fall 1997, p.1. Benberry donates her collection of more than 800 documented cloth quilt books, five large photo scrapbooks, and seven quilts to the Quilters Hall of Fame (P.O. Box 681, Marion, IN 46952).

_____. "Evidences of Friendship: The Quilt Block Collection of Cuesta Benberry." *The Quilters Hall of Fame Newsletter*, Spring 1999, p. 3.

"Alpha Phi Alpha Fraternity Makes Anti-Apartheid Quilt." *Quilters Newsletter Magazine*, January/February 1994, p. 7. *Anti-Apartheid Quilt: Love For All Mankind*, was a project of the Pi Chi Chapter of the Alpha Phi Alpha fraternity of Eastern New Mexico University to commemorate Nelson Mandela's release from prison.

"Amateur Needlework Competition." *New York Amsterdam News*, September 18, 1973, p. B4.

American Anthropologist vol. 43, 1941, pp. 43–50. Article mentions Gullah quilting bees on pp. 45–46.

Amsden, Deirdre. "Quiltmaking Around the World: South Africa." *Quilters Newsletter Magazine*, September 1982, pp. 28, 38. Focuses on the quilt group within the Zamani Soweto Sisters Council, a self-help women's organization.

_____. "A Sisterhood of Quilting from Soweto." *Quilting U.S.A. Magazine* no. 4, 1988, pp. 30–33.

_____. "Zamani Soweto Sisters: A Patchwork of Our Lives." *Fiberarts Magazine*, March/April 1983, pp. 48–49.

Angelou, Maya. "Why Blacks Are Returning to Their Southern Roots." *Ebony Magazine*, April 1990. Photo in article shows author Maya Angelou standing in front of a $50,000

quilt gift from Oprah Winfrey, who commissioned Faith Ringgold to create the quilt.

"Anna Williams's Untitled Quilt." *Quilter's Newsletter Magazine* no. 266, October 1994, p. 82.

"Artist Faith Ringgold is entitled to trial in copyright infringement claim against HBO and Black Entertainment Television, for the use of a poster of her artwork as set decoration in an episode of sitcom 'Roc'; Court of Appeals rules that use of poster was not de minimis and may not have been a fair use." *Entertainment Law Reporter* vol. 20, no. 1, June 1998, Recent Cases.

"Artists Salute Dr. King's Vision." *American Visions*, February 1987, p. 42. Article features the *Weaver of Dreams* quilt coordinated by Marie Wilson of Brooklyn, New York.

Atkins, Leah Rawls. "Callahan, Freedom Quilting Bee." *Alabama Review* vol. XLII, no. 2, April 1989, p. 150.

"Aunt Jemima Quilt." *Texas Homes Magazine*, December 1980, p. 67. Features 1930s quilt owned by Jane Bobitt of Glendale, TX.

"Aunt Pattie Earthman." *Hearth and Home Magazine*, April 3, 1875, p. 236, article unsigned. Aunt Pattie Earthman is described as a "colored centenarian," born in 1773. She was a quiltmaker, and at age 103, could still sew without the use of eyeglasses.

Avery, Virginia. "The Pot of Stew at the End of the Rainbow." *American Quilter*, Spring 1989, pp. 43–45.

"BAQ Interviews Howard Smith." *Black Art, an International Quarterly* vol. 1, no. 2, Winter 1976, pp. 4–11. Textile artist spent 14 years living and producing art in Finland. Color photos of appliqued wall hangings.

Baraka Amiri. "Faith." *Black American Literature Forum*. Indiana: Indiana State University, Spring 1986.

Barrett, Carolann. "Quiltmaking: Telling the Truth of Women's Lives." *Sojourner: The Women's Forum*, July 1991, pp. 13–15.

Beauchamp, Larry. "Meet the Quilters: Eleanor Green from the Heart of Texas." *Quilt Magazine* vol. 20, no. 3, Fall 1998, pp. 40–41, 105.

Benberry, Cuesta. "The African-American Quilt: Its Social and Historical Context." *Essay*, 1989.

_____. "African-American Quilter's Forum." *American Quilter*, Fall 1993, pp. 76–77.

_____. "African American Quilts: Paradigms of Black Diversity." *International Review of African American Art* vol. 12, no. 3, 1995, pp. 30-37.

_____. "African Jazz: In Black and White." *American Quilter*, Winter 1991, pp. 6, 8. Heartwarming and personal article in which Mrs. Benberry describes the emotional impact in seeing Michael Cumming's *African Jazz Quilt #1*.

_____. "Afro-American Slave Quilts and the British Connection." *America in Britain* vol. XXV, no 2, 1987, pp. 16–20. See also vol. XXV, no. 3, 1987 pp.16–20 for conclusion of this two-part article.

_____. "Always There: The African-American Presence in American Quilts." *Quilter's Newsletter Magazine*, November 1991, pp. 42–45. Article summarizes African American quilt history. Includes review of a 1993 African-American Quilters' Forum—the first all-African American expert panel discussion held in a major museum setting. Participants included Emma Blane, Cuesta Benberry, Dr. Raymond Dobard, Roland Freeman, author Shirley Grear, Dr. Carolyn Mazloomi, and Pearl Smith.

_____. "Carole Harris: Played with Ideas on How to Use Her Art Before Deciding on Quilting." *American Quilter* vol. 4, no. 1, Spring 1988, p. 24.

_____. "Missouri—20th Century Quilt Pattern Supplier." *Patchwork Quilts*, May 1988, pp. 38–43, 57. Includes full-page photo of Benberry sitting at a table filled with quilt

pattern sheets. The *Afro-American Women and Quilts* piece hangs in the background.

_____. "A Quilt for Queen Victoria." *Quilter's Newsletter Magazine* no. 189, February 1987, pp. 24–25. Article about Americo-Liberian quilter Martha Ann Ricks who personally presented Queen Victoria with a "coffee tree" pattern quilt. Queen Victoria included the quilt with the British needlework exhibit at the 1893 Chicago World's Fair. See also Benberry's 1994 speech "Before *Always There*: Its Historical Underpinnings" for more details.

_____. "A Quilt Research Surprise." *Quilter's Newsletter Magazine*, July/August, 1981, pp. 34–35. The article describes Mrs. Benberry's document of an 1836 Anti-Slavery Society Ladies Fair baby quilt.

_____. "Quilting Bee." *Quilter's Newsletter Magazine*, September 1979, pp. 23–24.

_____. "Reflections on a Favorite Quilt: African Jazz in Black and White." *American Quilter Magazine* vol. 7, no. 4, Winter 1991, pp. 6–8.

_____. "The Storytellers: African-American Quilts Come to the Fore." *Quilter's Newsletter Magazine* no. 227, November 1990, pp. 46–47.

_____. "Style of Their Own—Two Black Quiltmakers." *American Quilter Magazine* vol. 4, no. 1, Spring 1988. Interviews with quilters Carole Harris from Detroit and Lillian Beattie of Chattanooga, TN.

_____. "The 20th Century's First Quilt Revival." *Quilter's Newsletter Magazine*. Three-part series. Part 1 examines quilts created between 1890 and the 1930s (July 1979). Part 2 examines quilts from the 1910s (September 1979). Part 3 reviews quilts and patterns from War World I era (October 1979).

_____. "Uncovering African American History—Including Quilts." *AQSG Blanket Statements*, Fall 1999, pp. 9–10.

_____. "Woven into History: Threads of African American Quilters." *American Visions*, October/November 1993, pp. 14–18.

Bickford, Kathleen E. "The A.B.C.'s of Cloth and Politics in Cote d'Ivoire." *African Today* vol. 41, no. 2, Second Quarter, 1994, pp. 5–25.

Bishop, Kathleen. "Quiltmaking in Liberia: Linked to American Tradition." *Quilter's Newsletter Magazine*, October 1995, pp. 32–33.

_____. "Quiltmakers of Liberia." *Topic—A Publication of the United States Information Agency, U.S. State Department* issue 181, Summer 1989, pp. 47–48.

"Black Collectors." *Ebony* vol. 50, no. 3, January 1995, p.52. This five page article highlights Roland Freeman's quilt collection.

"The Black Woman in Fashion Designing." *Black Woman's World*, October 1969. Profile of fashion designer and quilter Hazel H. Blackman. Article reprinted in the Fall 1990 Women of Color Quilters Network Newsletter.

Blair, Margot Carter. "An Interview with Cuesta Benberry." *The Flying Needle, National Standards Council of American Embroiderers*, February 1985, pp. 10–12.

Bonner, Marita. "Patch Quilt: A Story." *The Crisis*, March 1940, p. 71.

Boyle, Wickham. "Not Your Ordinary Quilting Bee." *CODE, the Style Magazine for Men of Color*, October 1999. Short article about Chicago quilter Jim Smoote and New York quilter Michael Cummings.

Brabec, Barbara. "The Contemporary Tapestries of Marie Wilson." *Creative Crafts* vol. 7, April 1981, p. 45.

Brackman, Barbara. "Michigan Patterns." *Quilter's Newsletter Magazine*, September 1987. Features quilt by Claire Carter.

_____. "Peerless Patchwork: Record Breaking Quilts." *Quilter's Newsletter Magazine*, October 1986, pp. 46–48. History of extraordinary quilts. The Freedom Quilting Bee set

the record for world's largest quilt from 1970 to 1982. The quilt was twenty feet by fourty-four feet.

_____. "The Strip Tradition in European-American Quilts." *The Clarion*, Fall 1989, pp. 44–51.

Braunstein, Jack. "Developing a Style All Her Own." *Quilting Today* vol. 12, Issue 70, 1999. About Hystercine Rankin of Mississippi; shows her receiving National Heritage Fellowship award from Hillary Rodham Clinton and Jane Alexander, head of National Endowment for the Arts.

_____. "Wearing Her Heart on Her Sleeve." *Quilting Today*. October 1994, pp. 29–31.

Bray, Rosemary, and Roland Freeman. "Quilts: More Than Something to Keep You Warm." *Essence*, November 1978, pp. 106–114. Photos by Roland Freeman.

Brecker, Elinor J. "Political Patchwork." *The Courier-Journal Magazine* (Louisville, KY), November 4, 1984, pp. 16–19. Features the *Afro-American History* quilt coordinated by Mrs. O.J. Gates, Portland, Oregon.

Brown, Barbara. "African-American Quilts: What They Are, What They Are Not." *Cover Stories: Newsletter of the Canadian Quilt Study Group* vol. 9, no. 4, April 1998, pp. 14–16. Also appeared in Summer 1998 issue of *Blanket Statement*, newsletter of the American Quilt Study Group.

_____. "Flooded with Quilts." *Blanket Statements — AQSG* vol. 60, Spring 2000. Daughters of Dorcas and Sons Guild of Washington, DC, organize donations of quilt blocks and make seventy quilts for families of the September 1999 hurricane in North Carolina.

Brown, Minnie Miller. "Black Women in American Agriculture." *Agricultural History* vol. 50, January 1976, pp. 202–212.

Brown, Miriam. "A Cargo of Quilts for Nebraska: With a Focus on African American Quilts." *Quilt Magazine*, Winter 2000, pp. 24, 104. Alabama quilt collector Robert Cargo donates 156 quilts to The International Quilt Study Center at the Univeristy of Nebraska–Lincoln.

Brown v McCormick, D. Md., No. L-96-3450, 3/7/00. United States District Court of the District of Maryland—Brown vs. McCormick. Quilter Barbara Brown brings suit against Patricia McCormick, technical consultant to the movie *How to Make an American Quilt*. Copy of the judgement is available from http://www.mdd.uscourts.gov. [Accessed September 9, 2001.]

Brown, Wendell. "Flights of Fancy and Journeys to Self." *International Review of African American Art* vol. 15, no. 2, 1998, pp. 60–61. Insights into Faith Ringgold's book *Dancing at the Louvre*.

_____. "Tracing the Stitches." *International Review of African American Art* vol. 15, no. 4, 1999, pp. 36–39. Explores the experience of Black men in fiber arts.

Bruce, John B. "A Palmetto Patch." *Living in South Carolina*, October 1998, pp. 10–13, 32. Includes profile of nine South Carolina quilters, including Dr. Marlene O'Bryant-Seabrook and Joann Thompson.

Burnham, Dorothy. "The Life of the Afro-American Woman in Slavery." *International Journal of Women's Studies*, July/August 1978, pp. 363–377.

Butler, Atiya. "Family Fabrics." *American Legacy: A Celebration of African American History and Culture* (magazine) vol. 2, no. 1, Spring 1996, pp. 45–49.

Callahan, Nancy. "Freedom Quilting Bee Puts Possum Bend on the Map." *Witness* no. 71, November 1988, pp. 12–14.

_____. "Hard Times for Freedom Quilters." *The Christian Century*, March 22–29, 1989, pp. 317–318. Details "present day" plight of this Black women's cooperative started in 1966.

_____. "'Helping the Peoples to Help Themselves'." *The Quilt Digest* vol. 4, 1986, pp. 20–29.

Cameron, Elizabeth, and Ann Svenson Perlman. "The Patterned Kuba Cloth of Zaire." *Piecework*, July/August 1997, pp. 29–33.

Campbell, Elsie. "African-American Quilts Beauty in Diversity." *Traditional Quiltworks* no. 69, pp. 42–43.

Carter, Claire. "Michigan's Water Wonderland Star (quilt)." *Quilter's Newsletter Magazine*, July 1973, p. 5.

Carter, Hazel. "Cuesta's Choice." *Quilters' Journal* no. 23. *Cuesta's Choice* is a block pattern Hazel Carter designed to commemorate Cuesta Benberry's induction into the Quilter's Hall of Fame in 1983. Two page block pattern and instructions.

_____. "Patricia Almy Randolph & Nimble Needle Treasures." *Quilters Hall of Fame Newsletter*, Spring 2000, pp. 3–4. Randolph founded the quarterly magazine *Nimble Needle Treasures*, which was published from September 1969 until 1975. Includes quotes by Randolph about Cuesta Benberry's invaluable historical articles for the magazine.

_____. "The Smithsonian Collection." *Quilter's Newsletter Magazine* vol. 92, June 1977, p. 12. Photos of African American Betty West and her 1879 quilt.

Cash, Floris Barnett. "Kinship and Quilting: An Examination of an African-American Tradition." *Journal of Negro History*, Winter 1995, p. 30. Quilting together forms a cross-generational link among working class Black and White women that enable them to talk while they work as well as "speak" within their communities as they sell quilts to raise money for civic projects.

Chaveas, Lucille. "Who'd A Thought It: Improvisations in African American Quiltmaking." *Journal of American Folklore* vol. 105, no. 418, Fall 1992, pp. 477–479. Critical review of book and exhibit of the same name.

Chenfeld, Mimi Brodsky. "Aminah Robinson." *The Clarion* vol. 14, no. 3, Summer 1989, pp. 54–60.

Child, Lydia Maria. "The Ladies Fair." *Liberator*, January 2, 1837, p. 3. Article on an antislavery fair held in 1837 Boston. The article contains a description of a baby quilt with a poignant inscription about slave mothers. The quilt is in the collection of the Society for the Preservation of New England Antiquities.

Clark, Ann. "The Golden Girls." *Quilt World*, April/May 1989. Heartwarming account of Ann Clark and other women who traveled to Browns Town, Jamaica to lead the Coo-Ya ("look here") Quilt Project endorsed by the United Methodist Church. The Coo-Ya Quilt Project taught about 30 Jamaican women to quilt so the women could earn money with this skill.

Clark, Rachel Kincy. "A Vest for Quilters." *Threads Magazine*, January 1992, pp. 64–67.

Clark, Ricky. "Making a Case for the Abolistionist Quilt." *Piecework*, July/August 1995, pp. 66–70.

Clarke, Averil. "African Textiles, Afro-American Quilts: The Evolution of a Tradition." *The Williams Journal of Afro-American Studies* (A Williams College Student Publication) vol. 1, no. 1, Spring 1988, pp. 1–11.

"Classified Ads." *Stitch 'N Sew Quilts* (magazine), July/August 1986, p. 63. Extensive listing for various "Black Mammy" patterns including Little Black Sambo quilt (12 different blocks) for $4.50; Uncle Mose (dressed in Sunday best) rag doll for $4.00; and 22" Honey Chile (fat baby with pigtails all over head) rag doll for $4.00 from a Canton, GA seller.

"Clementine Hunter: Plantation Artist." *Sepia* vol. 11, March 1962, pp. 52–53.

Coleman, Floyd. "Mediating the Natural: Craft Art and African American Cultural Expression." *International Review of African American Art* vol. 11, no. 2, 1994, pp. 24–27.

Contemporary Art/Southeast vol.1, January/February 1978, pp. 10–21. Discusses Afro-Carolinian traditions in quiltmaking, pp. 14–16; illus.

Cothern, Lynn. "Kickin' It with the Old Masters." *Fiberarts*, September/October 2000, pp. 40–44. Interview with Joyce Scott.

Courtney, Karen. "Ohio's Underground Railroad Quilt." *Quilt Ohio*, Winter 98–99, p. 15.

Cover, Ruth. "Ten Afro-American Quilters: An Exhibit." *The Flying Needle, National Standards Council of American Embroiderers*, February 1985, pp. 8–9. Review on Maude Wahlman's exhibit with the same name.

"Crazy for Quilts." *Life*, May 5, 1972. Article includes photo of Freedom Quilting Bee member Luella Pettway. Sales to the quilt cooperatives reached $29,000 in 1971.

Cruz, Adriene. "Technicolor Quilts." *Threads* vol. 56, December 1994/January 1995, p. 48.

"Cuesta Benberry Accepts Induction into Quilter's Hall of Fame." *Quilter's Newsletter Magazine*, issue 159, February 1984, p. 23. Reprint of Benberry's acceptance speech. She is the fourteenth inductee.

"Cuesta Benberry Donates Quilts, Research Papers to the Hall of Fame." *Quilter's Newsletter Magazine*, March 1998, pp. 9, 12. Illustrated with Carolyn Mazloomi's *Black Family Series Quilt.*

Dace, Rosalie. "Stars of Africa: Inter-Continental Quilts." *American Quilter*, Fall 1993, p. 58. Star blocks created and donated by many quilters around the world to help a South African guild raise funds for disadvantaged quilters.

Dailey, Cleo. "African-American Quilters Take the State." *Lady's Circle Patchwork Quilts* no. 102, October 1994, pp. 28–31. Article about Second Annual African-American Quilt Show and Conference held in Lancaster, PA.

Dalton, Karen. "The Past Is Prologue but Is Parody and Pastiche Progess?—A Conversation." *International Review of African American Art* vol. 14, no. 3, 1997, pp. 17–29. Illustrations to this transcript include Wendell Brown's *Chicken, Watermelon and Green Peas* quilt.

Daniel, Janice Barnes. "Function or Frill: The Quilt as Storyteller in Toni Morrison's *Beloved*." *The Midwest Quarterly* vol. 41, no. 3, Spring 2000, p. 321.

Davis, Joann Marie. "Jelly Jars, Quilts, Flour Sacks: Preserving Memorabilia from a Shiloh Farm." *About…Time*, February 28, 1997, p. 10.

Davis, Olga Idriss. "The Rhetoric of Quilts: Creating Identity in African-American Children's Literature." *African-American Review* vol. 32, no. 1, Spring 1998, pp. 67–76. Several black authors of children's literature, including Valeri Flournoy, Deborah Hopkinson, Patricia McKissack, Faith Ringgold, Bettye Stroud, and Courtni C. Wright, use the tradition of quilts in their stories to "read the world."

Day, Gregory. "Afro-Carolinian Art, Towards the History of a Southern Expressive Tradition." *Contemporary Art/Southeast* vol. 1, no. 5, 1978, pp. 10–21. Two quilts are included.

Dent, Lisa. "Artfully Documenting History." *Ms.* March/April 1995, p. 84. Profile on Deborah Willis. Includes photo of *T.E.: Tie Quilt.*

Dobard, Raymond. "A Covenant in Cloth: The Visible and the Tangible in African-American Quilts." *Connecting Stitches: Quilts in Illinois Life.* Symposium papers edited by Janice Tauer Wass. Springfield, IL: Illinois State Museum, 1995.

_____. "Quilts as Communal Emblems and Personal Icons." *International Review of African American Art*, vol. 11 no. 2, 1994, pp. 38–43.

Dobson, Jenni. "Flexing the Pattern: African-American Quilt-Making and Its Inspirational Potential." *Quilters' Review* no. 26, Winter 1998, p. 5.

Dodson, Angela. "Patches: Quilts as Black Literary Icons." *Black Issues Book Review* vol. 1, no. 3, May 1, 1999, p. 40.

_____. "Secrets of the Quilts." *Essence*, February 1999, pp. 146–148.

_____. "Stitches of History." *BET Weekend— Home & Family Issue*, April 1998, pp. 16–17, 26. Photo illustrations by Roland Freeman.

Domowitz, Susan. "Wearing Proverbs: Anye Names for Printed Factory Cloth." *African Arts* vol. 25, no. 3, 1992, pp. 82–87, 104. This article focuses on the Anyi people of eastern Cote d'Ivoire, who have assigned names to different patterns of factory cloths. Photos of various cloths, such as "Jealousy," "Condolences to My Husband's Mistress," and "You Go Out, I Go Out."

Dunn, Margaret M., and Ann R. Morris. "Narrative Quilts and Quilted Narratives: The Art of Faith Ringgold and Alice Walker." *Explorations in Ethnic Studies* vol. 15, no. 1, January 1992, pp. 227-232.

Edwards, Audrey. "A Strip of History." *Family Circle*, May 1979, p. 90. Photos by Roland Freeman.

Eitel, Jean. "Sewing Stitches from the Past." *Quilt Magazine*, Summer 1986, pp. 24–25.

Elsley, Judy. "*The Color Purple* and the Poetics of Fragmentation." In *Quilt Culture: Tracing the Pattern*, eds. Cheryl Torsney and Judy Elsley. Columbia, Missouri: University of Missouri Press, 1994, pp. 68–83.

_____. "'Nothing Can Be Sole or Whole That Has Not Been Rent': Fragmentation in the Quilt and *The Color Purple*." *Weber Studies: An Interdisciplinary Humanities Journal* vol. 9, Spring/Summer 1992, pp. 71–81.

Ertel, Grace. "Quilting a Heritage." *Essence*, November 1978, pp. 108, 111. Article about Louisiana quilter Alice Neal and making family/friendship quilts.

Ezell, Nora. "A Quilter's Diary: The Making of the Civil Rights Quilt." In *Tributaries: Journal of the Alabama Folklife Association*. Summer 1994, pp. 90–95.

"Fabric of our Heritage." *American Visions* vol. 15, no. 1, February/March 2000, pp. 16–21.

"Fabrics of Africa." *Topic— A Publication of the United States Information Agency, U.S. State Department* Issue 181, Summer 1989, pp. 17–19, unsigned. About African fabrics in the collection of the National Museum of African Art, Smithsonian Institution.

Falling-rain, Sunny. "A Literary Patchwork Crazy Quilt: Toni Morrison's *Beloved*." In *Uncovering 1994*, ed. Virginia Gunn, pp. 111–140. San Francisco: American Quilt Study Group, 1995. Falling-rain argues that Morrison wrote *Beloved* using the form and structure of the crazy quilt. The paper describes this process by providing an outline of the novel and then analyzing the novel in quilt terms: crazy quilt styling, foundation, center, color, images, embellishments, fabrics, and stitches.

"Family Album: Afro-American Quilts." *Quilt: Special 10th Anniversary Issue*, Spring 1989, p. 22–23. Photos of three quilts in the collection of Kay Doerner of Clarksville, OH.

Faubion, Trish. "To Tell a Story: Harriet Powers and the Religious—Narrative Traditions in African American Quilts." *Piecework*, May/June 1994, pp. 40–47. About African American religious-themed quilts including Harriet Powers, the *Bible Scenes* quilt and Philadelphian Lorraine Mahan's *The Lord's Prayer Quilt*.

"Featured Artist: Faith Ringgold." *Shooting Star Review* vol. 2, no. 2, Summer 1988, p. 18. Quilt-related short story follows.

Fedde, Gerry. "The Quilt Craft of Harriet Powers." *Ebony, Jr.* March 1984, p. 13.

Ferris, Allison. "Deborah Willis: Fabricated Histories." *Fiberarts* vol. 25, no. 5, March/April 1999, pp. 52–56. Article includes several color photos of Deborah's narrative photo quilts.

Finch, Lucine. "A Sermon in Patchwork." *Outlook*, a weekly journal of the Y.M.C.A. vol. 108. October 26, 1914. The illustrated quilt, though not identified by name, is the Harriet Powers' *Bible Quilt* that is presently in the Smithsonian Institution collection.

Fragd, Lulamae. "Quilting a Black Feminist Methodology." *Journal of Caribbean Studies* vol. 14, no. 3, Summer 2000, pp. 215–228.

Freeman, Roland. "African-American Quilters & Their Stories." *American Quilter* vol. VIII, no. 4, Winter 1992.

_____. "Afro-American Quilters from the Black Belt Region of Alabama: A Photo Essay." In *1986 Festival of American Folklife*, Thomas Vennum, Jr., ed. pp. 94–100.

_____. "Alice Walker: Quilting a Legacy." *The Crisis* vol. 106, no. 4, July/Aug 1999, pp. 70–72.

_____. "Artworks of Patchwork: The Roland Freeman Collection of Quilts Made by Black Women from the Mississippi Heartland." *Black Collegian*, v. 14, March/April 1984, pp. 58–59.

_____. "Folkroots: Images of Mississippi Black Folklife, 1974–1976." *Southern Exposure*, vol. 5, no. 2, 1977, pp. 29–36.

_____. "Mississippi Black Folklife." *Southern Exposure: Southern Black Utterances Today* (Institute for Southern Studies Chapel Hill, NC Journal) vol. 3, no. 1, Spring/Summer 1975, pp. 84–87.

_____. "More Than Something to Keep You Warm." *American Quilter* vol. 8, no. 4, Winter 1992, pp. 14–19.

_____. "Philadephia's African-Americans: A Celebration of Life." *National Georgrahic* vol. 178, no. 2, August 1990, pp. 56–91. Features photo of Mrs. Lorraine Mahan working on a 119th Psalm quilt with 176 panels, one for every verse.

_____. "Quilts from the Mississippi Heartland." *American Visions* vol. 1, no. 3, May-June 1986, pp. 28–32.

_____. *Quilts Japan Magazine.* See vol. 9, 1997, pp. 134–137 for article and photos on *Communion of the Spirits*; vol. 1, 1998, pp. 134–135 for article featuring Hystercine Rankin and the Mississippi Crossroads Quilters; see vol. 3, 1990 pp. 135–137 for additional photos from *Communion of the Spirits*.

_____. "Something to Keep You Warm." *Needle Arts*, Summer 1984, pp. 14–16.

_____. "Tradition and Change Among African-American Quilters." *Needle Arts*, May 1988, pp. 19–23.

Freeman, Roland, and Rosemary L. Bray. "Keepsakes." *Essence* magazine. November 1978, pp. 106–114.

Fry, Gladys-Marie. "From the African Loom to the American Quilt." *Ideas* vol. 5, no. 2, 1988.

_____. "Harriet Powers: Portrait of a Black Quilter." In *Missing Pieces: Georgia Folk Art, 1770–1776*, Atlanta: Georgia Council for the Arts and Humanities, 1976, pp. 16–23. Also found in *Sage: A Scholarly Journal on Black Women* vol. 4, no. 1, Spring 1987, pp. 11–16.

Galligan, Gregory. "The Quilts of Faith Ringgold." *Art Magazine* vol. 61, January 1987, pp. 62–63.

Galvin, Sean. "Southern Quilt Traditions in New York City." *Piecework*, July/August 1997, pp. 39–43. Profile of members of the Southern African-American Quilters group in Brooklyn, New York—including founder Virginia Hall.

Gibbs, Eleanor. "The Bible Quilt: Plantation Chronicles." *Atlantic Monthly*, July 1922, pp. 65–66.

Gibson, Janice Cole. "Carson House Quilts." *Quilt World*, May 1992.

Goldstein, Myran Chandler. "In Support of South Africa Quiltmaking." *Fiberarts* vol. 21, March/April 1995, p. 24. Marianne Hatton's quilt *My Country, Right or Wrong* is featured. The quilt was completed April 1994 during the historic elections and renamed *Nkosi Sikekel'l Afrika* (Lord Bless Africa).

Golphin, Vincent. "Beyond the Image: A Realistic Look at Aunt Jemima." *About...Time*,

July 31, 1995, p. 23. Interesting article about Anna Short Harrington, who played the Aunt Jemima character from 1935–1955. A family member recounts that Harrington was an award-winning seamstress and quilter who entered her quilts in the New York State Fair.

Gouma-Petterson, Thalia. "Faith Ringgold's Narrative Quilts." *Art Magazine* vol. 61, January 1987, pp. 64–69.

Grabiner, Dana M. "Slave Quilts: Threads of History." *Fiberarts* vol. 13, September/October 1986, p. 22.

Graulich, Melody, and Mara Witzling, "The Freedom to Say What She Pleases: A Conversation with Faith Ringgold." *NWSA Journal* vol. 6, no. 1, 1993.

Gross, Joyce. "Cuesta Ray Benberry." *Quilters' Journal* no. 23, pp. 1–4, 12–13, 16. In-depth interview covering childhood years to early interest in quilt history. (Seems to be a 1983 newsletter.)

Grudin, Eva. "The Exquisite Diversity of African-American Quilts." *Fiberarts*, November/December 1989, pp. 40–43.

"Handcrafts For Sale." *Quilt World*, January/February 1982, p. 69. Four classified listings for stereotyped needlework items: "Mammy Doll Toaster Cover—$2," "Little Black Sambo rag doll pattern—$1," "Black Mammy and Rastus potholder patterns—$2/set," and "Black Pickaninnies watermelon eaters potholder patterns—$2" from a Canton, GA seller.

"Handicraft." *Quilt World*, March/April 1984. Classified listing for "Very Old Black Mammy patterns," including a "mammy" face apron—$3 from a Canton, GA seller.

"Handicraft Ads." *Quilt World*, July/August 1984, p. 61. Listing for "Mammy Days of the Week" cross-stitch tea towels for $3 and for a 19th Century "mammy" doll pattern for $3 from a Canton, GA seller. The same seller also offered patterns for Shirley Temple, Mickey Mouse, and Heidi dolls for $3 each in a separate ad.

"Handicraft Ads." *Stitch 'N Sew Quilts*, May/June 1986, p. 62. Listing for various old patterns including Little Koko rag doll for $4; Topsy and Eva upside down rag doll for $2 from a Canton, GA seller.

"Handicrafts to Buy–Sell–Exchange." *Popular Needlework*, December 1976, p. 60. Magazine retail price was 60 cents. Listing for a "mammy" mixer cover pattern and clothes for $1.20 from a Kansas City, MO seller.

Hardin, James. "Plain and Fancy Quilters Display Their Talents at Spring Workshop." *Folklife Center News-Journal of American Folklife Center, The Library of Congress* vol. xi, no. 2, Spring 1989, pp. 7–9. Washington, DC based Daughters of Dorcas quilt group cited.

Harris, Joanne. "Portfolio." *American Vision* vol. 11, no. 4, August/September 1996, p. 23. Carolyn Mazloomi is one featured artist.

Harris, Juliette, ed. "Private Dancer, Private Dealer—Private Show!" *International Review of African American Art* vol. 16, no. 3, 1999, pp. 3–60. Includes quilts by Carolyn Mazloomi, Phyllis Stephens, and Sandra Smith.

"The Healing Quilt." *Health Quest: The Publication of Black Wellness* vol. 21, p.35. Roland Freeman featured.

"Hear My Quilt: 150 Years of African-American Quilts." *New Exhibitions—St. Louis Art Museum Magazine*, September/October 1992, p. 5.

Hearder, Valerie. "Spirit of Africa." *American Quilter* vol. XI, no. 1, Spring 1995. Valerie Hearder expresses the poetry of Africa in contemporary quilts.

Herskovits, Melville J., and Frances S. Herskovits. "The Art of Dahomey: Brass-Casting and Applique Cloths." *American Magazine of Art*, February 1934, pp. 67–76.

Hindman, Jane E. "'A Little Space, a Little Time, Some Way to Hold Off Eventfulness':

African American Quiltmaking as Metaphor in Toni Morrison's *Beloved.*" *Literature Interpretation Theory* vol. 6, 1995, pp. 101–120.

_____. "African-American Quiltmaking as Metaphor in Toni Morrison's *Song of Solomon*: Finding That Ineffable Quality That Is Curiously Black." *Western Ohio Journal* vol. 12, 1991, pp. 18-35.

"History Quilt Club Prepares Unique Display." *Negro History Bulletin* vol. 16, April 1953, pp. 150–151. Includes photo of quilt club at work on the Frederick Douglass quilt, shown in Cuesta Benberry's book *Always There.*

Hochstein, Rollie. "The Pride of Five Women." *Good Housekeeping*, June 1969. Mrs. Eugene Witherspoon, the manager of the Freedom Quilting Bee, is profiled.

Holden, Dorothy. "Starting Young." *Lady's Circle Patchwork Quilts*, Summer 1982. Holden shares how she has taught several different beginning quilt classes to children—with great success.

Hollander, Stacy C. "African American Quilts: Two Perspectives." *Folk Art* vol. 18, Spring 1993, pp. 44–51. Critique of Wahlman and Benberry's diverse perspectives of African American quilt aesthetic origins.

Horton, Laurel. "Afro-American Quilts: A Presentation to the Southern Quilt Symposium." *Essay*, March 22, 1988.

Horvitz, Deborah. "Nameless Ghosts: Possession and Dispossession in *Beloved.*" *Studies in American Fiction* vol. 17, no. 2, Autumn 1989, pp. 157–167.

Houck, Carter. "Body and Soul." *Lady's Circle Patchwork Quilts*, July 1993, pp. 24–27.

_____. "Cultural Crossroads." *Lady's Circle Patchwork Quilts*, July 1989. Quilts by Hystercine Rankin.

_____. "DC Quilters Are Diverse." *Lady's Circle Patchwork Quilts*, September/October 1991, p. 38–43. Include full-page color photo of the Daughters of Dorcas quilting group.

House & Garden magazine. The Freedom Quilting Bee is mentioned in selected 1968 and 1969 issues.

Hunt, P.K. "A Plantation Quilt from South Carolina: Analysis and Meaning." *ARS Textrina* vol. 28, 1997, pp. 123-136.

_____. "The Struggle to Achieve Individual Expression Through Clothing and Adornment: African American Women Under and After Slavery." In *Discovering the Women in Slavery: Emancipating Perspectives on the American Past*, ed. P. Morton, pp. 227-240. Athens, GA: The University of Georgia Press, 1996.

Hunt-Hurst, P. "Round Homespun Coat and Pantaloons of the Same: Slave Clothing as Reflected in Fugitive Slave Advertisements in Antebellum Georgia." *The Georgia Historical Quarterly* vol. 63, no. 4, 1999, pp. 727-740.

Hunter-Gadsden, Leslie. "Marketing the Motherland." *Black Enterprise*, December 1990, pp. 76–82. Notes increase usage of African prints and fabrics.

Impey, Sara. "Quilting for a Better Future." *The Quilter: The Quilters' Guild of the British Isles*, Winter 1999, pp. 34–36. Roland Freeman profiled.

"Improvisation in African American Quilt Making." *Quilt Craft*, August 1992, pp. 14–15.

Jackson, Phyllis J. "(In)Forming the Visual: (Re)Presenting Women of African Descent." *International Review of African American Art* vol. 14, no. 3, 1997, pp. 30–37. Includes photos of *Tribute to the Hottentot Venus* by Deborah Willis and a quilt by Faith Ringgold.

Jackson, Reginald. "The Art of Adriene Cruz: Quilter and Fabric Artist." *Abafazi: The Simmons College Journal of Women of African Descent* vol. 7.2, Spring/Summer 1997, pp. 56–57. Art layout. See also http://www.simmons.edu/abafazi/ to order issues online.

_____. "The Art of Deborah Willis." *Abafazi: The Simmons College Journal of Women of African Descent* vol. 6.2, Spring/Summer 1996, pp. 42–43. Photos of *Chicken Bone Beach, Daddy's Ties II* quilts included.

Janeiro, Jan. "African American Quilts Feature Flexible Patterning." *Fiberarts* vol. 15, no. 2, 1988, pp. 41–42. Review of Eli Leon's exhibition *Who'd A Thought It.*

Jeffries, Rosalind. "African Retentions in African American Quilts and Artifacts." *International Review of African American Art* vol. 11, no. 2, 1994, pp. 28–37.

Jeffries, Tamara. "Going Under: Artists on the Healing Power of Artmaking." *International Review of African American Art* vol. 16, no. 4, pp. 3–15. Includes profile and quilt by Carolyn Mazloomi.

Joiner, Dorothy. "Quilt Artists Review the 20th Century." *Fiberarts*, September/October 2000, p. 58. Features *Home, Too Alone* quilt by Wini McQueen.

Jones, Kellie. "In the Thick of It: David Hammons and Hair Culture in the 1970s." *Third Text* (UK) no. 44, Autumn 1998, pp. 17–24. Hammons used hair as material in his art, including his quilts.

Jones, Plummer F. "The Negro Exposition at Richmond." *American Review of Reviews* vol. 52, August 1915. Description of the Negro Historical and Industrial Exposition, held July 5–27, 1915, at the State Fair Grounds in Richmond, VA. Exhibits by the Hampton Normal and Industrial Institute (VA) and the public schools of Henrico County (VA) included displays of "all kinds of sewing."

Jones-Henderson, Napoleon. "Life and Art: An Artist's Viewpoint." *The Flying Needle*, August, 1994. First-person article by artist and quilter.

"Judgement Announced in Legal Battle Over Quilter's Copyright." *Quilter's Newsletter Magazine*, September 2000, pp. 8–9. Barbara Brown v. Patricia A. McCormick, et. al.

Kauffman, Kathy. "Providing Protection: Early African-American Quilts." *Fiberarts* vol. 18, November/December 1991, p. 7.

Keiter, Ellen. "A Stitch in Time." *Raw Vision*, Fall 2000, pp. 54–59. Profile of needlework artist Denise Allen.

Kelly, Patrice. "Captured in Cloth." *American Legacy*, Spring 2000, pp. 30–34. Review of *Spirit of the Cloth: Contemporary African American Quilts* traveling exhibition.

Kiewe, H. E. "Can Migration of Man Be Traced by African Textile Designs?" *West African Magazine*, June 25, 1955.

Kilson, Marion. "Harmony and Syncopation: African American Quilting Tradition." *Sextant: The Journal of Salem State College (MA)* vol. 6, no. 2, 1996.

Kitsen, Mary Louise. "Quilts in History—A Depression Story." *Quilt World*, August 1986, pp. 56, 59. Story of a domestic servant who sold quilted items in exchange for food and gifts for the household.

Kogan, Lee. "Marie Wilson 1923–1997." *Quilt Connection* (Museum of American Folk Art), Fall 1997, p. 3. Obituary.

Koplos, Janet. "Stitching Memories: African-American Story Quilts." *Crafts* (London) no. 103, March/April 1990, p. 49. Review of exhibit at Studio Museum in Harlem, New York.

_____. "Who'd A Thought It: Improvisation in African-American Quiltmaking." *Crafts* (London) no. 103, March/April 1990, p. 49. Review of exhibit at American Craft Museum, New York.

Kratovil, Debby. "Daughters of Dorcas." *Quilt Magazine*, Summer 1998, pp. 36–37, 71. Includes photo of quilts by this Washington, DC quilting group founded by Viola Canady. Pattern for *Sparkling Star* block also included.

_____. "Viola Canady and the Daughters of Dorcas." *Quilt Almanac*, 1998, pp. 28–29.

Kusserow, Karl. "Attributing an Anonymous Quilt to an African-American Maker." *Folk Art*, Spring 1994, p. 46–49.

"Kyra Hicks, MBA '91, Sews Stories into Her Quilts." *Dividend* (University of Michigan Business School alumni magazine), Fall 1993, pp. 13, 39. Highlights Hicks' first quilt

Sistahs @ Breakfast made to celebrate monthly breakfasts with three other Black MBA students Joy Calloway, Lisa Commons, and Monica Dee Guillory.

Kyser, Pat Flynn. "Pieces & Patches." *Quilt World*, March/April, 1979, pp. 4–7. Article about string quilts. Includes photo of Freddie Mae Woods of Hixson, TN and one of her utility quilts.

_____. "Pieces & Patches." *Quilt World*, July/August, 1985, pp. 46–49. Story about two 1880–81 autograph quilts by Sarah F. Gallop of Massachusetts. Mrs. Gallop wrote to various celebrities of the day to ask them to sign a piece of fabric for a veterans fundraising quilt. Eighty-eight people responded including two presidents and abolitionist Frederick Douglass. The article includes a photo of Douglass as well as the letter he wrote when sending back the signature cloth.

_____. "Pieces & Patches." *Quilt World*, September 1992, pp. 7–9, 30. Interesting article about modern quilt history that starts with the 1971 *Abstract Designs in American Quilts* exhibit at the Whitney Museum. Includes mention of *Always There* exhibit and the contributions of many quilt historians.

Lady's Circle Patchwork Quilts, May 1989, p. 4. Photo of *Black Doll* quilt 1920s–1930s, Texas. Quilt assembled by Kathleen McCrady, who found the blocks at a garage sale. The block pattern is similar to Betty Johnson's "mammy" quilt shown on page 16, *Quilt World*, February 1982 issue.

Landsmark, Theodore. "Comments on African American Contributions to American Material Life." *Winterthur Portfolio* vol. 33, no. 4, Winter 1998, pp. 261–282.

Lane, Jennifer. "The Quilt That Mrs. Keckley Made." *Ohio Antiques Review*, February 1981, p. 23.

LaReaux, Sherri. "The Family Album: Quilts by Black Brothers." *Quilt Magazine*, Fall 1999, pp. 14-15, 105.

"The Largest Quilt in the World." *DuPont Magazine* (Wilmington, DE), February 1970, pp. 11–12. Article and photo about Freedom Quilting Bee making "The Largest Quilt in the World" in 1969.

Lawler, Susan. "A Common Thread." *Quilting International*, September 1993, pp. 8–10. Review of *A Common Thread—Innovations and Improvisations in Contemporary Textiles* at the Bomani Gallery in San Francisco. Includes photo of Adriene Cruz with quilt. Others mentioned: Michael Cummings, Faith Ringgold, Deborah Willis.

Leder, Priscilla. "Alice Walker's American Quilt: *The Color Purple* and American Literary Tradition." *Journal of the American Studies Association of Texas* vol. 20, October 1989, pp. 79–93.

Ledes, Allison Eckardt. "Textiles Made by Southern Slaves." *The Magazine Antiques* vol. 136, August 1989, p. 222+. Review of *Stitched From the Soul* exhibit at the Eva and Morris Feld Gallery, Museum of American Folk Art, New York.

Leman, Bonnie. "What's New and News in Quilting" column. *Quilter's Newsletter Magazine*, May 1994, p.7. Color photo of *Nurse's Quilt*, circa 1879 by Betty West, a black housekeeper, is featured. The quilt is in the Smithsonian Institution collection.

_____. "African Influences on American Quilts." *Piecework*, July/August 1997, pp. 34–38. Adopted from previously published works. Fabulous strip and block quilt examples by Rosie Lee Tompkins.

_____. "Cut It Down the Middle and Send It to the Other Side." *Threads* no. 19, October/November 1988, pp. 70–75. Reprinted in Women of Color Quilt Network Newsletter, Summer 1989, pp. 50–55.

Linch, Lauri. "The New Image Quilters." *Quilter's Newsletter Magazine*, October 1984, pp. 28–29. Fifteen art quilters from Washington, DC exhibit together. African American quilter Dorothy Holden is a member.

Linden, Jean. "The Story Quilt." *Wilson Library Bulletin*, January 1975, p. 385.

Lohrenz, Mary. "Two Lives Intertwined on a Tennessee Plantation: Textile Production as Recorded in the Diary of Narcissa L. Erwin Black." *The Southern Quarterly: A Journal of the Arts in the South* (University of Southern Mississippi) vol. 27, no. 1, Fall 1988, Special Issue, pp. 72–93. Includes an account of the joint sewing activities of a slave and the slave's mistress.

Lyle, Carole Y. "Pentecostal Cross Quilts: A Journey of Faith." *American Quilter*, Winter 1996, pp. 32–33. Inspirational story and photos of Lyle's *Pentecostal Cross* series of religious quilts.

_____. "Redefining Cultural Roots: Diversity in African American Quilts." *Surface Design Journal* vol. 20, Spring 1996, pp. 13–14.

MacDowell, Marsha, and Lynne Swanson. "Michigan's African American Quilters." *Michigan History*, vol. 75, July–August 1991, pp. 20–23.

Mainardi, Patricia. "Quilts: The Great American Art." *Feminist Art Journal* vol. 2, Winter 1973. Mentions slave-made quilts on p.18; African influences on quilts on p. 19; references to quilts from Judith Chase and Faith Ringgold on p. 23.

"Man That Needle." *Life*, May 28, 1971, pp. 80–83. Features Rosey Grier's needlepoint.

"Marita Dingus: Francine Seders Gallery." *Sculpture* (Washington, DC) vol. 17, no. 10, December 1998, pp. 67–69. Review of *When Spirits Were Moved* installation piece which was inspired by the African American slave experience.

Martin, Charles. "What's New and News in Quilting—Women of Color Network Membership Approaches 1,000." *Quilter's Newsletter Magazine*, May 1996, p. 7.

Masciere, Christina. "Over the Rainbow: Jacquelyn Hughes Mooney Pieces It Together." *New Orleans Magazine* vol. 33, no. 1, October 1998, p. 32 (3).

Mason, Rhonda. "Daughters of Harriet Powers: A Tribute to an American Quiltmaker." *Patchwork Quilts Magazine*, October 1997, p. 15–20. Includes text and photos of quilts by Ana Aruz , Virginia Harris, Peggy Hartwell, and Kyra Hicks.

May-Machunda, Phyllis. "Family and Community Traditions: Afro-American Quilting from the Black Belt Region of Alabama." *Needle-Arts* vol. xviii, no. 4, November 1987.

Mayer, Barbara. "Celebrating Craft." *Art & Antiques* vol. 23, no. 2, February 2000, pp. 46–47. Review of *Spirits of the Cloth* exhibit at the Mint Museum.

McDaniel, M. Akua. "Black Women Making Quilts of Their Own." *Art Papers* vol. 2, September/October 1987, pp. 20–22.

_____. "Stitching Memories: African-American Story Quilts and Their Relationship to Oral Tradition." *Essay*, 1989.

McDaniel, Sharon A. "Museum Exhibits: Stitching Memories." *About...Time* vol. 19, no. 7, July 1991, pp. 24–26. Cover story—*Caldwell-Scott Quilt (1984)* by Joyce Scott is featured on magazine cover.

McDonald, Mary Anne. "Scenes from a Marriage: Working on the Tarboro African American Quilt Project." *North Carolina Folklore Journal* vol. 40, Summer/Fall 1993, pp. 70–75.

Mebane, Mary E. "Her Quilts Witness to Roxcine Brimmage's Gift." *Encore* vol. 6, May 23, 1977, p. 35.

"Meet the Quilters: The Quilted World of Rachel Clark." *Quilt*, Winter 1986, pp. 40–41. Profile of Rachel Clark, Watsonville, CA.

"The Meetin' Place: Carrie Jackson." *Quilter's Newsletter Magazine* vol. 64, February 1975, p. 10. This profile by Marion Whitley introduces readers to Mrs. Carrie Jackson, who made her first quilt in 1909 at the age of nine. Mrs. Jackson is photographed with three quilts.

"The Meetin' Place: Colette Wolff Introduces Us to Marie Wilson of Brooklyn, New York." *Quilter's Newsletter Magazine* no. 191, April 1987, pp. 42–43.

"The Meetin' Place: Janet Jo Smith Introduces Heather Williams of New Haven, CT." *Quilter's Newsletter Magazine* no. 312, May 1999, pp. 61–62.

"The Meetin' Place: Let Us Introduce Mary Bedford Brewer of Pinewood Springs, CO." *Quilter's Newsletter Magazine* no. 206, October 1988, pp. 28–29. In 1975, Brewer started teaching quiltmaking at the Simi Valley Adult School in California.

"The Meetin' Place: Let Us Introduce You to Cuesta Benberry of St. Louis, MO." *Quilter's Newsletter Magazine* no. 119, October 1980, p. 25.

"The Meetin' Place: Profile of Elaine Capobianco of Walpole, MA by Kay Jesse." *Quilter's Newsletter Magazine* June 1994, p. 29. Includes photo of an Underground Railroad quilt her students made.

Metcalf, Eugene W. "Black Art, Folk Art, and Social Control." *Winterthur Portfolio* vol. 18, no. 1, 1987, pp. 1–3.

Mikkelsen, Nina. "Insiders, Outsiders, and the Question of Authenticity: Who Shall Write for African American Children." *African American Review* vol. 32, no. 1, Sprint 1998, p. 33 (7 pages). Includes discussion of Faith Ringgold's *Tar Beach*.

Miller, Maureen E. "Storyteller: The Creative Process of Aminah Robinson." *Acclaim Magazine*, Fall 1988, pp. 28–34.

Mitchell, Alphonsus J. "A Rainbow Opening: The Development of Afro-American Studies." *Yale Alumni Magazine*, April 1980, pp. 24–27, 40. Includes photos of African American-made quilts.

M.O.F. (Mary O'Boyle Franko). "Cuesta Benberry: A Quilt Historian." *Topic—A Publication of the United States Information Agency, U.S. State Department* Issue 181, Summer 1989, p. 49.

Morris, Pat. "Questions & Answers" quilt column. *Quilt World Magazine*, February 1982, p. 16–17. Photo of a quilt block from Californian Betty Johnson who was asking readers to identify pattern for a Black woman figured design. Photo of block included.

Moton, Dorothy. "A Quilt of Many Colors Stitched by a Woman of Color." *Sampler Quilts* vol. 18, 2000, p. 22–23. Profile of Illnois quilter Dorothy Moton.

"Movie Studio, Quilter Found Liable for Copyright Infringement Over Quilt Pattern." *IP Law Weekly*, March 22, 2000. Resolution of dispute over two quilt props for the movie *How to Make an American Quilt*.

Mullen, Harryette. "African Signs and Spirit Writing." *Callaloo* vol. 19, no. 3, 1996, pp. 670–689. Includes discussion of Harriet Powers quilts

Mulligan, Kate. "Picking Up the Pieces: Quilting Thrives as the Most Adaptable of Crafts." *Modern Maturity* (an AARP magazine), April 1999, pp. 32–33. Includes mention of Faith Ringgold.

"Museum Quilt." *Quilter's Newsletter Magazine* Issue 70, August 1975, p. 14. Photo of Clara Rothmeier, Bourbon, Missouri and her *Baseball Quilt*. The quilt features appliquéd and embroidered portraits of leading baseball heroes prior to 1959. The quilt took ten years to complete. Players actually signed their own blocks. Jackie Robinson and Roy Campanella are included.

Nadelstern, Paula. "Citiquilts: A Show of Diversity." *Clarion* vol. 16, Spring 1991, pp. 55–59. Includes profile of Michael Cummings, whose work was included in *Citiquilts, the Great American Quilt Fest* in New York City.

"The Needle's Eye." *Quilter's Newsletter Magazine* vol. 199, February 1988, p. 4. Describes three African American quilt shows.

Newsweek vol. 79, January 10, 1972, p. 42. Discusses Martin Luther King Freedom Quilt-

ing Bee, Gees Bend, AL. Eight-five Black women making quilts with patterns handed down from slavery days.

"New/Works." *Art/Quilt Magazine* no. 7, p. 44. Features Dorothy Holden's *Mr. And Mrs. Afro P. Angel and Michael* quilt.

"No Guilt About the Quilt." *Journal of Blacks in Higher Education,* Winter 1997–1998, p. 80. Story of a Caucasian second grade teacher who assigns students to create pictures of Civil Rights people and events. The pictures are made into a quilt and later, a book cover. Black teachers angered over images.

Nzegwu, Nkiru. "Creating Memory: A Conversation with Carole Harris, A Detroit-Based Quilt Artist." *Ijele: Art eJournal of the African World* vol. 1, no. 1. (www.ijele.com)

_____. "Spiritualizing Craft: The African American Craft Art Legacy." *International Review of African American Art* vol. 11, no. 2, 1994, pp. 16–23. Work by quilter Carole Harris is included.

"Oberlin Spells Freedom." *Lady's Circle Patchwork Quilts,* March 1986, pp. 20–21, 67. Photo of *The Underground Railroad Quilt* and several of its original makers. The quilt was made by twenty-five seniors to commemorate the sesquicentennial of the Underground Railroad and Oberlin's (Ohio) role.

O'Bryant-Seabrook, Marlene. "*Hidden in Plain View: A Secret Story of Quilts and the Underground Railroad*" book review. *The Avery Review of African American History and Culture* (College of Charleston, SC), Spring 2000.

O'Donnell, Paul, and Seth Stevenson. "How Runaway Slaves Found the Path to Freedom." *Newsweek,* January 25, 1999, p. 6.

"Originality and Quilting: Two Case Studies." *Quilter's Gallery Magazine,* 1995 annual issue, p. 45. Features Virginia Harris.

"Out of Necessity: Harriet Powers Pieced Together Her African Continuity." *About...Time,* May 31, 1999, p. 40.

"Pandora's Box Contest." *Quilt World,* December/January 1992, pp. 22–23. Shirley Grear of Santa Rose, CA won the First Place prize of $1,000 for her *Bits and Pieces of America* quilt. Pandora's Box is a quilt template brand from Quick Strip.

Parker, Blanche Ransome. "African-American Pieced and Appliquéd Quilt." *Antiques* vol. 138, October 1990, p. 687.

Parker, Pat, and Jenny Williamson. "Images of Africa." *American Quilter,* Winter 2000, pp. 26–28. Includes photo of five colorful, pictorial quilts.

Parkhurst, Jessie. "The Role of the Black Mammy in the Plantation Household." *Journal of Negro History* vol. 23, July 1938, pp. 349–369.

Peacock, John. "When Folk Goes Pop: Consuming *The Color Purple.*" *Literature Film Quarterly* vol. 19, no. 3, July 1991, pp. 176–180. Discusses the omission of quilting from the movie.

"The People Behind the Quilt." *Lady's Circle Patchwork Quilts,* Fall 1984, pp. 30–31, 57. Includes photo of the James Island Senior Citizens Nutrition Program quilting bee with various completed quilts. Also includes butterfly appliquéd block by Ethel Turner.

Peoples, Betsy. "Threading Art and History." *Emerge,* July/August 1999, p. 14. Article on Jacqueline Hughes Mooney.

Picton, John. "Africa and African-American Quilts." *Quilters' Review* no. 26, Winter 1998, pp. 1–4.

Pines, Deborah. "No Remedy for Use of Quilt in TV Show." *New York Law Journal,* October 3, 1996, p.1. Decision in *Ringgold v. Black Entertainment Television Inc.,* 96 Civ. 0290.

"Political Fiber: A Portfolio." *Fiberarts* vol. 17, Summer 1990, pp. 43–50. Profile of Tina Brewer.

Preyer, Morris. "The Historian, the Slave, and the Ante-Bellum Textile Industry." *Journal of Negro History* vol. 44, no. 2, April 1961, pp. 68–82.

Price, Sally. "The Afro-American Tradition in Decorative Arts: Basketry, Musical Instruments, Wood Carvings, Quilting, Pottery, Boat Building, Blacksmithing, Architecture, Graveyard Decoration." *Ethnohistory* vol. 39, no. 2, Spring 1992, pp. 242–244.

Prochnow, Kathy. "Auction Blocks." *Traditional Quilter*, July 1999, pp. 48–49. Article about Jan 1999 Sotheby's auction featuring a rare stuffed, pieced cotton *Turtle Quilt*, attributed to an African American woman, dated late 19th or early 20th century. Included quilt photo and pullout pattern. See also *Sotheby's Important Americana: Furniture and Folk Art* catalog, New York, July 16 and 17, 1999—sale #7253, lot #485, p. 125. Quilt sold for $12,650.

"Profile of Michael A. Cummings." *Black Art, an International Quarterly* vol. 3, no. 1, 1978, pp. 26–27. Color photos of 1977 quilts *Flight of the Phoenix* and *The Magician*.

"Prose, Poetry and Songs Captured in Cloth." *Crafts Report* vol. 26, no. 286, February 2000, p. 10. A review of *Spirits of the Cloth: Contemporary African American Quilts* exhibit at the Mint Museum.

"QNM Readers' Quilt Show." *Quilter's Newsletter Magazine*, July/August 1985, p. 24. Photo of *Martin Luther King Quilt* designed in 1982 by Ed Larson and made by Judith Rasmussen.

Queenan, Linda. "Uncovering Roots: African Story Quilts." *Quilting International*, September 1992, pp. 44–45, 57. Interview with Carolyn Mazloomi.

"Quilt Art Gallery." *American Quilter*, Summer 1995, p. 38. Includes photo of Shirley K. Grear's *Ten African Maidens* quilt.

"Quilt designer established prima facie claim of copyright infringement against those involved in producing and merchandising movie *How to Make an American Quilt*, federal court rules." *Entertainment Law Reporter* vol. 20, no. 11, April 1999, Recent Cases.

"Quilter Leaves Her Mark of Tradition." *The Michigan Woman*. October/November 1985. Interview with Carole Harris.

"Quilter's Exchange—Needle and Pin Pals." *Quilter's Newsletter Magazine*, January 1986, p. 41. Beatrice Kornegay wishes to correspond with "Black women quilters in New York."

"Quilter's Exchange—Needle and Pin Pals." *Quilter's Newsletter Magazine*, February 1986, p. 35. Carolyn Mazloomi wishes to correspond with "Black quilters worldwide." This ad eventually led to the formation of the Women of Color Quilters Network.

"Quilt Shows: Alexandria (LA) Museum Exhibit." *Quilt World*, July/August 1980, p. 30. Announcement for July 1980 invitational quilt exhibit that featured 30 "Anglo Saxon and African"quilts.

"Quilts." *Surface Design Journal* vol. 20, Spring 1996, pp. 8–23. Special eight article issue on quilts. Includes sections on African American quilts and a summary of an informational survey of attitudes to quilts in U.S. museums.

"Quilts in Women's Lives." *Quilter's Newsletter Magazine* vol. 138, January 1982, pp. 32–33. Profile of Nora Lee Condra, who is featured in the film "Quilts in Women's Lives" by Pat Ferrero.

"Quilts, the American Craft." *Friends, the Journal of the National Association of Senior Friends*, July/August 1993, pp. 8–9, 19. Includes Fredericka Clark, a senior quilter and quiltmaking teacher from Chicago. Photograph of Clark is also on the cover. Article unsigned.

"Quilts Warm the World." *Quilter's Newsletter Magazine* vol. 146, October 1982, pp. 20–21. Color photo of *The Couples Quilt* as featured at the 1982 World's Fair in Knoxville.

Ramsey, Bets. "Country to City: Changing Styles in Afro-American Quilts." *Quilting Today*,

April/May 1989. Review of *Country to City: Changing Styles in Afro-American Quilts of the South* exhibit at the American Museum of Quilts and Textiles in San Jose, CA from October 4 to November 19, 1988.

_____. "The Search for Slave-Made Quilts." *Quilters' Journal* no. 23, p. 7. Profile of Cuesta Benberry and her research into slave-made quilts. (Seems to be a 1983 newsletter.)

Reale, Robin. "Uncommon Art: Lyles' Quilts Explore African, Religious Motifs." *Loyola College of Maryland Magazine*, Winter 1995, pp. 9–10. Profile of Carole Y. Lyles.

Reed, Robert. "Treasured Slave Quilts." *Antique Collecting Magazine*, May 1991.

Reid, S.A. "Crocheting a Future in Art—Former DOT Employee Bypasses Chickens, Cows for Portraiture." *Atlanta Journal/Atlanta Constitution*, January 9, 1997, p. JD2. Todd Paschall of southwest Atlanta crochets portraits of people. His work sells for $250 to $10,000.

Ringgold, Faith. "Being My Own Woman." *Women's Studies Quarterly*, Spring/Summer 1987, pp. 31–34.

_____. "Contemporary Quilts: The Bitter Nest." *Gallerie: Women Artists* Issue 9, 1990, pp. 6–8.

Ringgold, Faith, and Yi, Lisa. "My Best Friend." *Heresies: A Feminist Publication of Art and Politics* vol. 6, no. 4, issue 24, 1989.

Ringgold v. Black Entertainment Television Inc. and Home Box Office, Inc., United States Court of Appeals for the Second Circuit, No. 96-9329, Decided September 16, 1997.

Roach, Susan. "African American Quiltmakers in North Louisiana: A Photographic Essay." *Louisiana Folklife* vol. XVII, Special Issue: African American Folklore in Louisiana, December 1993.

Robinson, Joan Seeman. "Stories in Cloth." *American Craft* vol. 58, no. 2, April/May 1998, pp. 40–43, 74. Profiles Women of Color Quilters Network founder, Carolyn Mazloomi.

Ronsheim, Ellice, and Ricky Clark. "The 'Boys and Girls Quilt' of Phebe Cook." *Timeline, a publication of the Ohio Historical Society*, November/December 1999, pp. 19–21. Interesting history of this 1872 quilt, which includes figures of both Causasian and African American neighbors.

Roth, Edith Brill. "The Quilting Circle at P.S. 48." *American Education Magazine* (Washington, DC), July 1980, pp. 18–22. Quilting activities of Black school children in a New York public school.

Rovedo, Betty, and Jim Burchell. "Your Computer Quilting Neighborhood: Online Services and the Internet." *Quilters Newsletter Magazine* Issue 281, April 1996, p. 40–43. Includes description of online quilting activities from various internet service providers. Includes mention of African American online quilting activities on Prodigy.

Rubin, Cynthia Elyce. "Handmade Quilts by a Born Storyteller." *Fiberarts* vol. 27, no. 2, September/October 2000, p. 15. Profile of Yvonne Wells.

Ryan, Bob, and Yvonne Ryan. "Clementine Hunter." *Louisiana Life Magazine*, September/October 1981.

Ryan, Robert F. "Clementine Hunter: Robert F. Ryan, MD, Shares His Reminiscences of a Unique Folk Artist." *Raw Vision Magazine* Issue 24, pp. 54–59.

Schienman, Pamela. "Faith Ringgold/Bernice Steinbaum Gallery." *American Craft*. February/March 1989, pp. 73–74. A review of an exhibition held November 5–December 3, 1988.

Schmidt, Kirsten. "Hystercine Rankin: Blankets Made of Memories." *Crafts Report*, October 1997.

Schober, Maburl. "Stitches in Time." *Louisiana Life*, November/December 1982, pp. 107–112. Photo of Rosie Lee Allen and her *Around the World* quilt.

Actress Phylicia Rashad graces the cover of a major women's magazine because of her quiltmaking activities. This is the first time a Black woman has been featured on a U.S. magazine cover because of her quilting.

Schraffenberger, Nancy. "Warmth for Body and Soul." *Guideposts*, October 1984, pp. 24–29. Harriet Powers' Bible Quilt (Smithsonian) is among the various religious-themed quilts shown in article.

Seltzer, Anne-Marie. "Freedom Quilts of an Ex-Slave Document a Life." *Harvard Gazette*, March 10, 1989, pp. 3, 7. Bunting Fellow Gladys-Marie Fry curates exhibit featuring quilts by Elizabeth Anne Salter Smith.

"Sewing Comfort Out of Grief: The Oklahoma City Children's Memorial Quilt Exhibit (1996)." *Art/Quilt Magazine* no. 8, pp. 16–23. Photos of quilts by Alice Beasley, Penny Sisto, Michael Cummings, and Faith Ringgold.

Seymour, Liz. "A Stitch in Time: African-American Quilts." *Art & Antiques* vol. 18, September 1995, pp. 40–42.

Sherman, Mimi. "With an Eye to History." *Quilt Connection*, quilt periodical of the Museum of American Folk Art (New York), Fall 1989. Includes reference to a Black woman's signature on a Philadelphia, PA friendship quilt of 1844.

Short, Alvia Jean Wardlaw. "Strength, Tears, and Will: John Biggers' *Contribution of the Negro Women to American Life and Education*." *Callaloo* vol. 2, no. 1, pp. 135–143. The mural "Contribution" by Biggers includes image of a Black woman quilting.

Siegler, Bonnie. "Relax and Beat Stress the Way Phylicia Rashad Does!—And Make Her Christmas Quilt in a Weekend." *Woman's World*, November 5, 1996, pp. 17–18. In this cover story, the co-star of *Cosby* and *The Cosby Show* shares how she was inspired to quilt again after hearing a lecture on African American quilting in May 1996. Soon after Rashad and her daughter started taking quilting lessons from Ed Johnetta Miller. The article also includes instructions by Miller for an appliquéd and pieced quilt.

Slabber, Norma. "The Innovative Threads of South Africa." *Art/Quilt Magazine* Issue 11, pp. 24–27, 56. Describes the contemporary quilting community in South Africa. Mentions community based embroidery groups such as the Kaross Workers (P.O. Box 280, Letsitele 0885, South Africa) and the Mapula Embroidery Project (P.O. Box 28901, Sunnyside 0132, Pretoria, South Africa).

"Slave Quilts." *The New Yorker*, August 7, 1989, p. 32–33. Interview with Gladys-Marie Fry.

"Slave Quilts on Display at American Folk Art Museum." *Antique Gazette*, July 1989, pp. 10A–11A.

"Slave Shirt Woven for Booker T. Washington Museum." *Handweaver and Craftsman*, Summer 1968.

Slind-Flor, Victoria. "Quilts: Traditional and 'Mine'." *National Law Journal*, November 13, 2000. Quilt designer Barbara Brown is awarded $14,053 for unauthorized use of one of her quilt designs.

Smith, Janet Jo. "Heather Williams of New Haven, Connecticut." *Quilter's Newsletter Magazine*, May 1999, pp. 61–62. Includes photo of *Whoopi Goldberg* quilt and profile of quilter.

Smith, Shea Clark. "Kente Cloth Motifs." *African Arts* vol. 9, no. 1, pp. 36–39.

Sneed, Susan. "Faith Ringgold and Her Escapes." *SAGE, Student Supplement*, 1988, pp. 19–22.

"Some Patches of Material, a Bit of Thread, and a Whole Lot of Memories." *African American Parent Magazine*. August-September 1999. Profiles the *Wednesday Night Quilting Sisters* group, which meets at Hartford Memorial Baptist Church in Detroit.

"Something New—Patches for the Present." *Country Quilt*, Fall 1997, p. 27.

"Soul Sister: The Folk Art of Yvonne Wells." *Quilter's Gallery Magazine*, 1996 annual issue, p.28.

"Sources by LaVerne." *Soft Dolls & Animals!* August/September 2000, pp. 6–7. Photo of *Our Grand & Glorious Heritage* quilt made in 1992 by about 30 African American doll artists.

"Southern Cooperatives: Working to Save Rural America." *New South*, Winter 1967, pp. 1, 85. Freedom Quilting Bee featured.

Spears, Jeannie. "Quilts from South Africa." *Quilting Today: The International Quilt Magazine* vol 26, August/September 1991, pp. 25–28, 32–35. Includes profile of Lucille Chaveas.

"Spirits of the Cloth: African-American Story Quilts." *Art/Quilt Magazine* no. 6, p. 29. Review of the exhibit at the Wadsworth Atheneum. Photo of Barbara Pietila's *Haitian Dream* quilt.

Sterrett, N.B. "The Negro at the Charleston Exposition." *African Methodist Episcopal Church Review* vol. 19, no. 1, July 1902, pp. 463–466. Recounts exhibits at the South Carolina

Interstate and West Indian Exposition in Charleston, SC. Needlework, lacemaking, dressmaking, and sewing items were displayed by Avery Institute, Hampton Institute, Penn Normal and Industrial School and Scotia Seminary.

Stevenson, Amy Barton. "Smithsonian Quilt Collection." *Quilter's Gallery Magazine* vol. 51, January 1974, pp. 4–5. Early article about Harriet Powers *Bible Quilt*.

"A Stitch Beyond the Quaint Quilt." *American Visions*, April 1989.

Stremsterfer, Joanne. "'Girlfriends…' Portfolio Gallery and Educational Center June 17–July 31, 1995." *Art St. Louis*, Summer 1995, pp. 16, 20. Critical review of fifth annual juried exhibition *Girlfriends…*, which presented the works of five African American artists living in Missouri. Quilters included NedRa Bonds and Kyra Hicks.

"A Strip of History." *Family Circle Magazine*, May 15, 1979. Features Roland Freeman's collection of quilts made by Mississippi Black quilters.

"Story-Telling Quilts: Tales Drawn in Thread." *Quilt* (magazine), Summer 1984, p. 30. Includes photo of a Bible quilt by Lucile Degangi, who says she was inspired by a Harriet Powers quilt.

Swift, Joan. "Looking at African-American Quilts in Eli's Basement." *Calyx* vol. 15, no. 3, 1994–1995, p. 33.

Talley, Charles S. "African-American Improvisation." *Artweek* vol. 19, February 20, 1988, p. 3.

Tavormina, M. Teresa. "Dressing the Spirit: Clothworking and Language in *The Color Purple*." *Journal of Narrative Technique* vol. 16, no. 3, Fall 1986, pp. 220–230.

Teague, Phyllis E. "Melodie's Egyptian Quilt." *Quilt World*, January/February 1982, p. 43. Color photo of Melodie Grant and her unusual quilt made from tomb paintings.

Terrace, Lisa C. "Applique Quilt." *Bulletin* (Museum of Fine Arts, Boston) vol. 62, 1964, pp. 162–163. This article is about the Harriet Powers *Bible Quilt*.

Tesfagiorgis, Freida High W. "Afrofemcentrism and Its Fruition in the Art of Elizabeth Catlett and Faith Ringgold." *SAGE* vol. 4, no. 1, Spring 1987, pp. 25–32.

"Textures of Survival." *International Review of African American Art* vol. 16, no. 1, 1999, pp. 58–59. Donations sought to help pay for international textile symposium. Full-page color photo of *Women United: Facing the New Millennium* quilt by Charlotte Hill O'Neal.

Thompson, Joann. "Thoughts on Being a Black Quiltmaker." *American Quilter* vol. 8, no. 2, Summer 1992, p. 9.

Thompson, Robert Farris. "African Influences on the Art of the United States." In *Black Studies in the University: A Symposium*, eds. Armstead L. Robinson, Craig C. Foster, and Donald H. Ogilvie, pp. 128–177. New Haven: Yale University Press, 1969.

Tibbets, John C. "Oprah's Belabored *Beloved*." *Literature Film Quarterly* vol. 27, no. 1, 1999, pp. 74–76.

Tillman, Katherine Davis. "Afro-American Women and Their Work." *A.M.E. Church Review*, April 1895, pp. 477–499.

Tittus, Arzu. "Quilts' Messages Speak to the Heart." *Living Buddhism*, September 1997, pp. 52–57. Magazine cover also features one of Arzu's quilts.

Townsend, Louise O. "What Was New & News in Quilting 1969–1984." *Quilter's Newsletter Magazine*, Special Anniversary Issue, 1984, pp. 8–12, 14, 17–19. Year-by-year summary of major quilt events including 1982 Zamani Soweto Sisters Council quilt workshop and Roland Freeman's *Something to Keep You Warm* and Maude Wahlman's *10 Afro-American Quilters* 1984 exhibits.

Trillin, Calvin. "The Black Womens of Wilcox County Is About to Do Something." *The New Yorker*, March 22, 1969, pp. 102–108.

Twining, Mary. "African/Afro-American Artistic Community." *Journal of African Studies* vol. 2, Winter 1975–76, pp. 569–578.

Twining, Mary Arnold. "Black American Quilts: An Artistic Craft." In *The First National African-American Crafts Conference: Select Writings*, Memphis, TN: Shelby State Community College, 1979.

_____. "Echoes from the South: African-American Quiltmakers in Buffalo." *New York Folklore* vol. 10, Summer/Fall 1984, pp. 105–115.

Tyler, Jan. "Folks Warm Up to Arkansas Country Quilts." *Rural Arkansas*, publication of Arkansas Electric Cooperatives, November 1988, pp. 4–8. Includes account of a new African American quilt cooperative in Arkansas—Arkansas Country Quilts, Inc.

"Use of Altered Quilt Block Infringes Copyright." *National Law Journal*, April 3, 2000, p. B8.

Valentine, Victoria. "Fabric of Freedom: *Hidden in Plain View; The Secret Story of Quilts and the Underground Railroad.*" *Emerge Magazine* vol. 10, no. 4, February 28, 1999, p. 106.

Verdino-Sullwold, Carla Maria. "Stitched from the Soul." *Crisis* vol. 96, no. 9, November 1989, p. 10+.

Vlach, John Michael. "Quilts." *Black Collegian* vol. 8, May/June 1978, pp. 36–37. Photos by Roland Freeman.

Vogue magazine. Look in 1968 and 1969 issues for mentions about Freedom Quilting Bee.

Wagner-Martin, Linda. "Quilting in Gloria Naylor's *Mama Day*." *Notes on Contemporary Literature* vol. 18, no. 5, 1988, pp. 6–7.

Wahlman, Maude, and Ellen King Terry. "Black American Folk Art: Quilts." *Craft International*, May 1982, pp. 37–38.

Wahlman, Maude Southwell. "African American Quilts: Current Status." *Folk Art Finder* vol. 12, no. 1, 1991, pp. 7-9, 20-22.

_____. "African-American Quilts: Tracing the Aesthetic Principles." *The Clarion*, Spring 1989, p. 54.

_____. "African Symbolism in Afro-American Quilts." *African Arts* vol. 20, November 1986, pp. 68–76.

_____. "Religious Dimensions in Afro-American Folk Arts." *A Report*, The San Francisco Craft and Folk Art Museum newsletter, Spring 1986 issue. The entire 4-page issue devoted to various topics by Wahlman including: "African Charms," "Afro-American Folk Artists," and "Afro-American Quilters."

_____. "Religious Symbolism in African-American Quilts." *The Clarion* (Museum of American Folk Art), Summer 1989, pp. 36–44.

_____. "Religious Symbolism in Afro-American Folk Art." *New York Folklore* vol. 12, no. 1-2 , 1986, pp. 1–24.

Waldvogel, Merikay. "Design Inspirations: 1930 TVA Project Provides Images." *Quilter's Newsletter Magazine* vol. 226, October 1990, pp. 30–31. Story about wives of Black construction workers at the Tennessee Valley Authority (TVA) dam project. Photo of *TVA Quilt, 1934* designed by Ruth Clement Bond and made by Grace Reynolds Tyler included.

Wall, Marilyn. "Soul Sister: The Folk Art of Yvonne Wells." *Quilter's Gallery*, 1996, pp. 28–29.

Wamble, Michael. "Black Catholics Tell Their Stories Through Quilt, Video." *Catholic New World*, August 6–19, 2000. Cover story features photo of quilt completed by St. Sabinea Parish in Chicago.

Watts, Katherine, and Elizabeth Walker. "Joyful Improvisations: The Quiltmaking of Anna Williams." *American Quilter*, Winter 1997, pp. 36–40.

"What's New—and News—in Quilting." *Quilter's Newsletter Magazine* no. 86, December 1976, p. 5. Photo of *The American Slave Quilt*, also called *The Couples Quilt* from the

collection of Ronald and Marcia Spark. The quilt was featured in University of Arizona exhibit *A Walk Through the Attic*. The quilt was made by Jane Batson in the 1850s.

"When the Fabric Speaks." *International Review of African American Art* vol. 15, no. 4, 1999, pp. 27–29. Features Roland Freeman and Betty Tolbert.

Whitsitt, Sam. "In Spite of It All: Reading of Alice Walker's *Everyday Use*." *African American Review* vol. 34, no. 3, Fall 2000, 17 pages.

Wildemuth, Susan. "The Beautiful Bible Quilt: Telling the Story in Needle and Thread." *Quilt Magazine*, Spring 1998, pp. 50–51, 105. Article about two Harriet Powers quilts.

Wolff, Colette. "Quilting to Celebrate." *Quilter's Newsletter Magazine*, April 1981, pp. 24–25. Nineteen women from various ethnic groups meet to complete a quilt at New York's Elder Craftsmen organization.

"Women in Struggle Quilt Project." *The Flying Needle, National Standards Council of American*, February 1985, p. 17.

"The Work of Four Creative Expressions in Crocheting, Drawing, Sewing and Furniture." *About ... Time* vol. 11, May 1983, pp. 18–20.

"Wrapped in Pride: An Investigation into the Use of Kente." *Fiberarts* vol. 25, no. 5, March/April 1999, pp. 47–51.

Wynn, Toni. "This Work Meditative and Blessed." *International Review of African American Art* vol. 15, no. 4, 1999, pp. 3–15. Includes references and photos of quilts by Sandy Barrett Hassan, Dorothy Holden and Elizabeth Scott

Wysocki, Barbara. "Museum and Quilts." *Lady's Circle Art Quilts*, September 1994, pp. 56–61. Include photo of five African American quilts at the Smith Robertson Museum and Cultural Center in Jackson, MS.

Young, Cynthia Robinson. "Understanding Afro-American Quilts." *Friendship Knot: Newsletter of the East Bay Heritage Quilters' Guild* (Berkeley, CA), July 1986. Wonderful declarative article by a Black quilter. Reprinted in issue 5, Fall 1990 of the Women of Color Quilters Network Newsletter.

Young, Lynn Lewis. "QSDS Exhibits 1994." *Art/Quilt Magazine* no. 1, pp. 32–33. Review of exhibit at Quilt/Surface Design Symposium. *Clara's Garden* and *Take My Brother Home #3* by Michael Cummings were favorably received.

NEWSPAPER ARTICLES

Acosta, Mark. "Course Looks at Blacks' Legacy: Students at Poly High School in Riverside Try Out a Pilot African American Studies Course." *Press-Enterprise* (Riverside, CA), April 4, 1996, P. B1. Students make 6x6 quilt featuring African Americans Rosa Parks, Malcolm X, Michael Jackson, and Arthur Ashe.

Addoh, Carla. "Threads of a Culture: Scholar Finds History, Art in Quilt-Making." *North-Side Journal* (Woodson Terrace, MO), October 15, 1992, pp. 1, 12A. Review of exhibit *Hear My Quilt*. Profile of Cuesta Benberry.

"Adriene Cruz on 'Imani'." *Oregonian*, December 16, 1998, p. B1. Interview with Cruz. Detailed insights into quilt construction and symbolism.

"African-American Education." *Daily Camera* (CO), September 1, 1998, p. 2C. Rocky Mountain Quilt Museum exhibit featuring the Rocky Mountain Wa Shonaji Quilt Guild.

"African-American Museum Damaged by Thieves, Winter." *Columbian* (Vancouver), January 14, 1997, p. B5. Handmade quilts among items stolen from Tacoma Washington African American Museum.

"African-American Quilt Workshop Set." *Press-Enterprise* (Riverside, CA), January 13, 2000, p. B6. Theresa Polley-Shellcroft leads workshop.

Albertson, Karla Klein. "What Women Designers Did in 100 Years." *Philadelphia Inquirer*, November 17, 2000, p. E1. Book review. Includes mention of Black designers and quilters.

Albrecht, Robert. "Storyteller Weaves History with Quilts' Powerful Messages." *Columbus Dispatch* (Ohio), January 26, 2000. Black History Month 2000. Serena Wilson, a descendant of Ozella McDaniel Willams of Charleston, SC, shares her knowledge of signal quilts.

"Alice Johnson." *Buffalo News* (NY), July 6, 1996, p. C6. Obituary. Johnson was "(k)nown for her sewing talents, she enjoyed making quilts for family and friends and was known as 'Grandma' or 'Grannie' by her 86 grandchildren, great-grandchildren and great-great-grandchildren."

Allen, Kent. "The Gift of a Lifetime: 25 Receive MacArthur Grants." *Washington Post*, June 14, 2000, p. C01. Quilter and Smithsonian curator Deborah Willis receives a $500,000 MacArthur Fellows Program award.

Ament, Deloris Tarzan. "Art Quilts Exploring New Avenues." *Seattle Times*, June 24, 1993. Review of exhibit featuring Michael Cummings quilts at the Francine Seders Gallery.

Amirrezvani, Anita. "Colorful Quilts Break the Mold: Tompkins Draws on Odd Materials, African Traditions." *Contra Costa Times* (CA), August 1, 1997, p. T34. One person exhibit at Berkley Art Museum featuring Rosie Lee Tompkins.

_____. "Ringgold's Quilts Rework Art History." *Contra Costa Times* (CA), July 17, 1998, p. T32.

"Amish, African-American Quilts Tell the Story of Downtrodden Women." *The Press of Atlantic City*, September 24, 2000, p. H1. Exhibition review at People's Place Quilt Museum (PA).

Angaza, Maitefa. "Myrah Brown Green's Work Featured on 28th Annual International African Arts Festival Poster." *Our Time Press* (Brooklyn, NY), June 1999, pp. 4, 10.

Annas, Teresa. "Inquiring Minds: Exhibit Questions Cultural Presumptions." *Virginian-Pilot*, November 13, 1997, p. E1. Quilts by Dori Grace Udeagbor are featured in the exhibit *(re)search, (re)vision, (re)construct: a contemporary visual dialogue*.

Anstett, Patrician. "Sisterhood Under the Skin: Detroit Breast Cancer Survivors Reach Out to Other African Americans." *Detroit Free Press*, March 8, 1998, p. 1F. Quilter Clamay Lott deals with her breast cancer.

Arrington, Debbie. "For African-American Quiltmakers, Improvisation Is Everything When They Create a Work of Art…Piece by Piece." *Press-Telegram* (Long Beach, CA), March 3, 1996, p. J1. Interview with "britches" quilter Arbie Williams.

_____. "Stitching Together a Dream: Artist Faith Ringgold Fantasized About the Masters, Then Went Out and Became One." *Press-Telegram* (Long Beach, CA), February 25, 1997, p. D1. Extensive article.

"AT&T's Centennial Quilt to Be Unveiled." *Greensboro News & Record*, October 2, 1991, p.2. The 9' × 9' block quilt is entitled *Common Roots: The North Carolina Agricultural and Technical State University Centennial Study Quilt, 1891–1991*.

Auer, James. "Hitting the Real Big Time." *Milwaukee Journal Sentinel*, July 24, 1995, p. E1, E4. Quilter Gerald Duane Coleman unveils quilts at the Atkinson Library.

_____. "King Mural Draws on Multiple Skills." *Milwaukee Journal Sentinel*, October 4, 2000. Quilter Gerald Duane Coleman unveils his 12' × 9' commemorative textile piece *Two Kings*.

Baker, Kenneth. "Quilts Reveal a Pattern of African Roots." *San Francisco Chronicle*, January 15, 1988.

Baldwin, Tom. "Mandela Starts Third Decade in Prison." *Miami Herald*, December 23, 1984, p. 12D. South African police seize Winnie Mandela's bed quilt in 1983 presumably because it contained the African National Congress colors of red, black and green.

Barbieri, Susan M. "A Stitch in Minds: Thelma Buckner Teaches Young People to Sew, and in the Process They Learn About Life." *St. Paul Pioneer Press*, August 23, 1994, p. 1C. Thelma Buckner, director of the Piece by Piece Quilt Shop, teaches kids to quilt. Eighty neighborhood youngsters expect to make forty quilts.

Barfield, Deborah. "Black Women Get Worst of Old Age. 54 Percent are Widowed and Stranded Without Their Husbands' Incomes Since Many Worked Off the Books, Social Security No Help." *Beacon Journal*, October 17, 1993, p. A14. Edie Lieu Lane makes "colorful patch quilts" at $25 apiece to make extra money.

Barnes, Denise. "Quilting: Saving Stitch in Time." *Washington Times*, May 25, 1995, p. M4. Article features Raymond Dobard, Viola Canady, and Barbara Brown of the Daughters of Dorcas and Sons; Carol Williams of the Uhuru Quilters.

_____. "Quilts and Other Stitchery: Needle Craft Cuts Across Gender Lines." *Washington Times*, February 12, 1998, p. M4. Features quilters are Raymond Dobard and David Driskell.

Barry, Ann. "Quilt Show Reflects Vitality of African Tradition." *Miami Herald* December 3, 1989, p. 27H. Review of *Who'd A Thought It: Improvisation in African-American Quiltmaking*.

_____. "Quilting Has African Roots, a New Exhibition Suggests." *New York Times*, November. 16, 1989, p. B8. Review of *Who'd A Thought It: Improvisation in African-American Quiltmaking*.

Bathurst, Patricia. "Within the Folds of Her Quilts Lie Stories That Trace a Family's Lives." *Philadelphia Inquirer*, April 3, 1994, p. G6. Interview with Kathleen Lindsey of Seven Quilts for Seven Sisters.

Bayersdorfer, Fred. "Extraordinary Quilt Exhibit Weaves Tales of Family Ties as Well as Oppressive Bonds." *Virginian-Pilot*, November 11, 1999, p. W8. Review of *Communion of the Spirits: African-American Quilters, Preservers and Their Stories*.

Beadle, Michael. "A Stitch in Time." *Smoky Mountain News* (Cullowhee, NC), January 26–February 1, 2000. Solo exhibit of quilts by Marlene O'Bryant-Seabrook at Western Carolina University.

Bell, Elma. "Search for Discarded Heirlooms Leads to 'Light'." *Birmingham News*, January 13, 1998, p. 1D. Book review of *From Darkness to Light: A Modern Guide to Recapturing Historical Riches* warns black families to save quilts and other items.

Benberry, Cuesta. "A Heritage Preserved in Quilts." *St. Louis Post-Dispatch* (Commentary), March 6, 1998, p. C19.

Bennett, Marcia. "They Are What They Seam." *Pittsburgh Post-Gazette*, September 7, 1994, pp. 13, 17. Features quilts by Pittsburgh's African-American Quilters Guild.

Bentley, Rosalind. "Clementine Hunter: World Wakes Up to Her Images of Black Life." *Star-Tribune (Mpls.-St.Paul) Newspaper of the Twin Cities*, October 20, 1992, p. 1E.

_____. "How to Make an African-American Quilt." *Star Tribune* (Minneapolis, MN), February 22, 1997, p. 1E. *African American Quilt Day* exhibit featuring works by the Sabathani Quilting Group of south Minneapolis.

_____. "Mending Cultures." *Detroit News*, June 21, 1997. Article about Wilma Gary, a member of the Sabathani Quilting Group, and Remi Douah, a Michigan State University student documenting African American quilting in Minnesota.

_____. "Suggestions Offered for Beginning Quilt Collection." *Star Tribune (Mpls.-St.Paul)*, February 22, 1997, p. 2E. Suggestions by Maude Wahlman.

Bergen, Doug. "Quilt Made by Local Students Pieces Together Black History." *Press of*

Atlantic City, March 3, 1999, p. C3. This 17' × 11' quilt features images of Wally Amos, George Washington Carver, Shirley Chisholm, Michael Jordan and Jesse Ownes.

Berkowitz, Richard. "Quilt Offers Lesson in Courage: It Was Created by Cecilia Snyder Students. They Were Inspired by Six Black Achievers." *Philadelphia Inquirer*, May 25, 1995. p. N5. The quilt features images of Mary McLeod Bethune, Aretha Franklin, Lorraine Hansberry, the Rev. Dr. Martin Luther King Jr., Harriet Tubman and Malcolm X.

"Best Bet Friday." *The Fresno Bee* (CA), February 28, 1992, p. F1. "African-American quilt art by Dorothy Moore-Banks is featured in an exhibit in the university's Student Union at Fresno State University."

"Betty Venus Blue." *Chicago Tribune*, August 4, 1997, Metro, p. 7. Obituary of 46-year-old quilter. Two of Blue's quilts are in the Field Museum permanent collection.

Biank-Fasig, Lisa. "Quilts a Patchwork of Life: Much of Debra Calhoun's Work Reflects African-American Roots." *Beacon Journal*, February 18, 1994, p. D2.

Bibbs, Rebecca. "Quilter Sews Up Exhibit." *Indianapolis Star*, November 11, 1996, p. B3. Liz Wimberly sells ethnic-themed hand-sewn quilts from $35 to $200.

Bischoff, Dan. "She Who Flies Among the Stars." *Oregonian*, January 7, 1999, p. E10. Faith Ringgold interview.

"Black Archives to Play Host to Quilts Show." *Kansas City Star*, June 13, 1997, p. 21. *Patterns of Life: African-American Culture Explored Through Quilts*, features patchwork, and appliqué quilts by area artists NedRa Bonds, Kyra Hicks, Georgia Patton, and Sherry Whetstone-McCall.

"Black Culture in Spotlight at Conner Prairie Event." *Indianapolis News*, June 8, 1995, p. F7. Carolyn Mazloomi will present a lecture, *From the Country to the City—African American Quilts*.

"Black Quilters Emerging as Part of History." *Los Angeles Sentinel*, February 4, 1993, p. A-13.

"Black S. African Jailed for Slogans on Teacup." *Philadelphia Inquirer*, December 10, 1983, p. B6. Security police confiscate red, black and green quilt from Winnie Mandela. She was not charged.

"Blacks Leaving Mark on Design of Quilts: Black Quilt Makers." *Greensboro News & Record*, February 10, 1993, p. D6 (A). General information in response to St. Louis Art Museum exhibit *Hear My Quilt: 150 Years of African-American Quilt Making*.

Bleiberg, Laura. "How to Make an African-American Quilt Art: Improvisation Is a Defining Characteristic of the Process." *Orange County Register* (CA), February 25, 1996, p. F14. Exhibition review of *Who'd A Thought It: Improvisation in African-American Quiltmaking*.

Bohlin, Virginia. "Jackie's, John's Hammersmith Items Go Up for Sale." *Boston Globe*, October 8, 2000, p. G27. "Yellow Bill" quilt made in 1852 up for auction at Sotheby's.

Boulware, Dorothy. "The Making of an African-American Quilt." *Baltimore Afro-American*, January 24, 1998, p. B1. Quilts by eighty-two year old quilter Elizabeth Talford Scott on display at the Maryland Institute of Art.

Bourne, Kay. "Quiltmaker Ringgold Spins Historic and Colorful Yarns." *Bay State Banner*, April 15, 1993, p. 14.

Bozzo, John. "Back-to-Africa Movement Highlighted." *Daytona Beach News-Journal*, January 11, 1999, p. 5C. Bethune-Cookman College exhibit about AME Bishop Henry McNeal Turner includes example of a 19th century African American-made quilt.

Bradley, Carol. "Lands' End Helps Defuse Smithsonian Quilt Snit." *Chicago Sun-Times*, October 25, 1992. Lands' End contracts with the Freedom Quilt Bee to make quilts.

Brenna, Susan. "The Quilt's the Thing." *New York Newsday*, May 13, 1993, pp. 68–69. Color photos. New York Women of Color Quilters Network profiled.

_____. "A Quilting Culture in Harlem: New Works by Blacks Tell Tales Rich in Fabric and

Color." *St. Louis Post-Dispatch*, November 29, 1993, p. 3D. Peggie Hartwell and Marie Wilson describe *Dance Theater of Harlem* quilt. This report also appeared in the *Beacon Journal*, September 30, 1993, p. D5 and the *Greensboro News & Record*, October 24, 1992, p. D12.

Brenowitz, Stephanie. "Quilting Tacks on a Generation: The New Speed of Quilting Lures Younger Women." *Philadelphia Inquirer*, March 30, 1997, p. CH1. Ebony Rainbow Quilters featured.

Breton-Carrol, Beverly. "Artist Seams Quilting and History Together." *Tribune-Review* (Pittsburgh), September 21, 1997. Extensive profile of dollmaker and quilter Cathleen Richardson Bailey.

Brewer, Caroline. "Soaring Tribute—Montclair State Professor's Monument Honors Slaves Buried in Manhattan." *The Record* (Hackensack, NJ), February 13, 2000, p. L1. Interview with Lorenzo Pace, director of the Montclair State Art Gallery and quilter.

Britt, Donna. "Quilter Adds Her Colors to the Patchwork." *Washington Post*, August 23, 1994, p. B1. Donna Britt discusses Afrocentric quilts made by Barbara Brown, owner of the Quilt Connection. This article also appeared in the *The Fresno Bee* (CA), August 26, 1994, p. A2 and the *Detroit Free Press*, August 25, 1994, p. 9C.

Broadway, Bill. "Slave Artifacts Unlock Mystery of African Rites." *Oregonian*, August 24, 1997, p. A12. Interview with Gladys-Marie Fry.

Brockenborough, Pat. "Show Observes 20th Century Quilt Makers." *Paducah Sun* (KY), March 21, 1997, p. 8A. Photo of Cuesta Benberry and Joyce Gross at opening of exhibit *20th Century Quilts*.

Brown, Patricia Leigh. "A New Generation Discovers the Warmth of Quiltmaking." *Miami Herald*, July 14, 1996, p. 19H. Profiles African American quilting groups nationally.

_____. "Stitching Life's Thread and the Fabric of History into Quilts." *New York Times*, April 4, 1996, B1, B6. Extensive article on "reviving" an African American art form. Quotes from Daughters of Dorcas & Sons members as well as other quilting groups in New York and Detroit.

Brown, Tina A. "Fashion, Quilt and Contemplation: Creations with an African Flair." *Hartford Courant*, December 5, 1998, p. B3. Fashion designer Georgia Thomas remembers grandmother who quilted.

Bua, Elena. "Quilts Depict African-American Life." *Springfield Union-News* (Massachusetts), April 18, 1989.

Buckland, Tim. "Calcium Pupils Celebrate Diversity at Annual Fair." *Watertown Daily News* (NY), February 24, 1999, Local, p.28. Patchwork quilt by fourth-grader Danielle Pechon telling the history of Martin Luther King Jr.

Burch, Audra D. S. "A Glimpse of Black History Museums Eye Broward Woman's Precious Trove." *Miami Herald*, August 25, 1999, p. 1A. Constance Porter Uzelac safeguards family treasures including quilt collection. Her mother was Dorothy Porter Wesley. Her father was artist James A. Porter. Her stepfather was Charles Harris Wesley, a scholar and former university president.

Burchard, Hank. "The Quilts of Color." *Washington Post*, August 6, 1993, p. N53. Exhibit review of *Always There: The African American Presence in American Quilts*.

_____. "To a Man, Splendid Stitches in Time." *Washington Post*, February 6, 1998, p. N55. Exhibit review of *Man Made: African-American Men and Quilting Traditions*.

Burgdorf, Karl. "Mindful of the Future, S.C. State Closes Centennial Celebration." *Times & Democrat* (Orangeburg, SC), December 13, 1996. University unveils commemorative quilt by Marlene O'Bryant-Seabrook, class of 1955.

Burson, Pat. "Stitching a Cultural Patchwork: Exhibit Showcases the Work of African-American Quilt-Makers." *St. Paul Pioneer Press*, February 2, 1997, Pp.1B. *Who'd A*

Thought It: Improvisation in African-American Quiltmaking on exhibit at the University of Minnesota.

Busby, Marjean. "Personal Best" *Kansas City Star*, January 5, 1996, p. E3. Photo and profile of Evelyn S. Townsend with an embroidered elephant patch quilt.

_____. "Personal Best" *Kansas City Star*, August 16, 1996, p. E3. Photo and profile of Sherry Whetstone-McCall.

_____. "Personal Best" *Kansas City Star*, June 20, 1997, p. E3. Photo and profile of NedRa Bonds.

_____. "Personal Best" *Kansas City Star*, July 18, 1997, p. E3. Photo and profile of Georgia Patton with her 2,800-piece postage stamp quilt with a nine-patch border. Patton used a 3-cent stamp from an old letter as the pattern.

_____. "Personal Best" *Kansas City Star*, August 1, 1997, p. E3. Photo and profile of Kyra Hicks with *Black Barbie* quilt.

Butgereit, Betsy. "'Stigmata' Wins Author Praise: Ex-Alabama Woman Weaves Story of Reincarnated Teen." *Birmingham News*, September 22, 1998, p. 1D. Book review.

Cabot, Nancy. "*Parasol Vine* Quilt Created by Kentucky Negro." *Chicago Tribune*, June 4, 1936.

Cahill, Pat. "Afro-American Story Quilts Full of Surprises." *Springfield Union–News* (MA), July 13, 1989.

Cairns, Craig. "Quilts' Sale Revives Interest." *Chronicle-Tribune* (Marion, IN), July 24, 1995, p. A8. Cuesta Benberry presents lecture about *America's Cherished Quilts: The Harriet Powers Bible Quilts*.

Cardwell, Jewell. "Quilters Just Keep Bobbin' Along: Despite Problems of Their Own, Women in Ravenna Group Sew to Help the Disadvantaged." *Akron Beacon Journal*, February 14, 1997, p. D1. African American quilter Thelma Hazard is profiled.

Carter, Carmen. "'Dream Museum' Now Reality." *Cincinnati Post*, February 5, 1993, p. 1B. First-year operating funds for the Cincinnati African American Museum are raised by a quilt campaign in which contributors buy patches ranging from $30 to $3,000. The quilt campaign goal is $56,000.

Chandler, Carmen Ramos. "Students Donate Handmade Quilts." *Daily News of Los Angeles*, March 25, 1994, p. N3. Four quilts hand-colored by children and stitched together by their mothers donated to a homeless shelter.

Chappell, Kevin. "Classes Focuses on African-American Culture." *Charlotte Observer*, February 7, 1994, p.1. Ashbrook High students make quilts.

Charleston News and Courier, December 23, 1972, p. A1. Features quiltmaking by Johns Island Sewing Club. Photos included.

Chatfield-Taylor, Joan. "A Style Boost for Ghetto Industries." *San Francisco Chronicle*, February 9, 1970, p. 19. Interview with Hazel Blackman, a fashion designer and design firm owner. She mentions her work with a craft cooperative (the Freedom Quilting Bee) in Wilcox County, AL. Blackman is also a quilter.

"Children, Collegians Act Against Apartheid." *Beacon Journal* (Akron, OH), April 28, 1985, p. A8. Eighty children present a 10' × 6' quilt based on South Africa to TransAfrica.

"Children Find History Behind Patches." *Oregonian*, April 24, 1989, p. B8. *Mirandy and Brother Wind* and other quilt stories.

Christman, Jennifer. "Material Wealth: Quilts Made by Black Women." *Arkansas Democrat Gazette*, March 3, 1998, p. 4E. Review of *A Piece of My Soul: Quilts by Black Arkansas* exhibit.

Cillie, LaCheryl. "Hidden Treasures—Harriet Powers, Quilter and Storyteller." *New Pittsburgh Courier*, February 17, 1999, p. c12. Part two of a two-part series.

Clark, Michael D. "Railroad Had Stations in Ohio, KY: Historic Homes Havens to Slaves."

Cincinnati Post, October 27, 1997, p. 3A. Commemorative quilt depicting Underground Railroad housed at the Jeanne Beatte Butts House in Oberlin, OH.

Colby, Joy Hakanson. "African Americans Embrace the Old Craft of Quilting with a New Fervor." *Detroit News*, February 2, 1998. Features Michigan quilters, including members of the Wednesday Night Quilting Sisters.

"Cold Spring Show Weaves Quilting Theme." *Press of Atlantic City*, June 17, 1998, p. C3. Seven Quilts for Seven Sisters program.

"The Colored Fair Is Open: A Grand Parade Preceded the Opening. Some Interesting Relics Shown." *Dallas Daily Times Herald*, September 1, 1900, p.8. The Colored Fair and Cotton Exposition displays included "quilts and cushions and fancy doilies and what-not, all showing the colored people's love for gay colors." Zach Hughes displayed a homespun quilt made by his grandmother.

Comer, Andrea. "Giving Voice to a Culture: For 25 Years, Hartford's Craftery Gallery Has Been a Unique Purveyor of African American Art." *Hartford Courant*, September 21, 1997, p. H1. Ed Johnetta Miller curates *A Common Thread: Yesterday, Today and Tomorrow* featuring quilts by Adriene Cruz, Carolyn Mazloomi, Georgia Thomas, and Mary Wright's quilt for nephew Emmett Till.

"Compiling Quilt Exhibit Not a Black-and White Issue." *Greensboro News & Record*, August 8, 1993, p. D4. Washington, DC Anacostia Museum's African-American quilt show.

"Conference Seeks to Empower Black Women." *West County Times*, March 28, 1996, p. A3. *African American Women on Tour* quilt presented at conference.

"Congress to Sign Bedspread." *Detroit Free Press*, February 3, 1983, p. 2A. Senator Paul Tsongas, D-Mass., organized quilt signing. Handmade quilt from West Virginia with a traditional "Lone Star" design is sent to Winnie Mandela.

"Congressmen Give Winnie Mandela Signed Quilt." *Boston Globe*, March 18, 1983.

Conlan, Maureen. "Stitching Memories: Quilts Tell Story of Black History." *Cincinnati Post*, January 25, 1991, P. 1C. Exhibit review.

Conover, Kirsten. "National Endowment for the Arts Honors American Folk Artists." *Christian Science Monitor*, June 30, 1997, p. 15. Quilter Hystercine Rankin receives National Heritage Fellowship award of $10,000.

Cornelius, Kristin. "King Uncovered Country's Hatred." *Telegraph Herald*, January 18, 1996, p. A5. High school editorial compares Dr. Martin Luther King Jr's dream of a national community to a quilt.

Cotter, Holland. "Unexpected Vistas in Quilting by Men." *New York Times*, May 29, 1998. Art review.

Cotton, C. Richard. "A Cultural Canvas: Quilts Fuse Threads of Africa, America." *Commercial Appeal*, February 9, 1996, p. E12. Review of *An Exhibit of the Works of African-American Quilters from North Mississippi*. Quilter Walter Bates is featured.

Crebbin, Cindy. "Patching Together Some History." *Milwaukee Journal Sentinel*. April 2, 1998, Neighbors, p. 1. Profiles seventy-eight year old Ellen Mason, whose quilts were included in a local annual quilt exhibit.

Daniel, Jeff. "Threads of Connection: Multi-artist Textile Show Is Blend of Styles and Personalities." *St. Louis Post-Dispatch*, May 22, 1997, p. 21. Critical review of quilt exhibition featuring Francelise Dawkins, Kyra Hicks, and Sherry Whetstone-McCall.

Daniels, Diane. "Brewer, Mitchell About the Task of Educating Blacks." *New Pittsburgh Courier*, September 28, 1994. Profile of quilter Tina Brewer.

Davis, Marcia. "Black History Found in Bric-a-Brac." *St. Louis Post-Dispatch*, December 3, 1992, Style West, p.7. Profile of Black Ethnic Collectibles, an operation dedicated to preserving African American History and culture.

Davis, Merlene. "Pitfalls, Triumphs of Black History Highlighted in Poignant Exhibit." *Lexington Herald-Leader*, November 3, 1987, p. D1. Profile of Hanif Wahab's *The African Experience in America* exhibit at the University of Kentucky.

_____. "Quilter Specializes in Stitches in Time." *Lexington Herald-Leader*, November 28, 1999, p. J1. Profile of Joseph Broadus, a Texas quilter.

Davis, Tamainia. "Eyes on the Prize." *Washington Times*, August 29, 1994, p. C10. Profile of Roland Freeman.

Davis, Trish. "Amistad Story with a Local Twist: Historic Role of Town Gets Placed on Exhibit." *Hartford Courant*, July 18, 2000, p. B1. The city of Farmington's connection to the events of the Amistad slave ship. Story told through 24-block quilt completed by over 30 volunteers.

Day, Jeffrey. "*Family Tree* Centerpiece of Her Quilting Display." *Macon Telegraph and News*, January 15, 1988. Features quilt by Wini McQueen.

Dee, Jane E. "Artist Finds Expression, Success in Silk, Quilts." *Hartford Courant*, April 6, 1994, p. C4. Profile of textile artist Ed Johnetta Miller.

_____. "Hundreds Challenged to Live King's Dream." *Hartford Courant*, January 18, 2000, p. B1. African American churches honor Dr. Martin Luther King Jr. Quilt metaphor.

_____. "Quilts Created by Students Help to Celebrate Black History." *Hartford Courant*, April 4, 1994, p. C5. Elementary school students created a series of quilts that celebrate black history.

_____. "Students Hear Stories Behind Quilters' Art." *Hartford Courant*, March 22, 1996, p. B4. Elementary school children tour *Spirit of the Cloth: African-American Story Quilts* exhibit.

DeJesus, Rosalinda. "Quilting Students Piece Together Part of the Past." *Hartford Courant*, June 16, 1997, p. B1. Family Resource Center offers quilting class as part of its after-school programs.

Delatiner, Barbara. "What Quilting Means to Black Women." *New York Times*, January 26, 1992.

"Detroiter's Work Comes from Love of Quilting, Tradition." *Detroit Free Press*, September 28, 1997, p. 1F. Profile of quilter Ramona Hammonds.

Diamant, Kathi. "Fabric of History: African-American Quilters Are Preserved in Patchwork in a New San Diego Exhibit." *Press-Enterprise* (Riverside, CA), January 21, 2000, p. AA48. *A Communion of the Spirits: African-American Quilt Exhibition* on display at San Diego Historical Society Museum.

Dingmann, Tracy. "Quilters Piece Together Black History." *Albuquerque Journal*, February 1, 1998, p. D1. African American Quilt Show at a local cultural center.

Dishman, Laura Stewart. "Ringgold Uses Fabric as a Thread to Her Past." *Orlando Sentinel*, September 11, 1987.

"Divining Honors Artists." *Chicago Tribune*, February 2, 1992. *Divining: Sapphire and Crystal* exhibit opens at local art gallery. The show features works by fifteen Black women artists, including quilter Venus Blue.

Dodd, D. Aileen. "Library Promises Broward a Treasure." *Miami Herald*, March 16, 1998, p. 1BR. African-American Research Library and Cultural Center aims to become the national authority on black culture. Quilts planned for the décor.

Doerfler, Sue. "African American Quilts." *Arizona Republic*, March 15, 2000, p. G8. Call for heirloom quilts made before 1960 by African Americans for local quilt documentation day at the Carver Museum & Cultural Center.

_____. "Quilts Hang on Artistry, Heritage." *Arizona Republic*, April 5, 2000, p. G10. Deborah Johnson-Simon curates *Beyond Night Comforters: Contemporary African-American*

Quilters as Textile Artists at the George Washington Carver Museum and Cultural Center in Phoenix.

Dorsey, John. "Art & Identity; Elizabeth Catlett's Sculptures and Faith Ringgold's Story Quilts at the BMA Present Universal Truths and Tensions Through the Eyes of African-American Artists." *Baltimore Sun*, February 1, 1999, p. 1E.

_____. "Digging for Roots of a Southern Art." *Baltimore Sun*, June 16, 1996, p. 1J. *Signs and Symbols: African Images in African-American Quilts from the Rural South* exhibition at the Baltimore Museum of Art.

_____. "The Fabric of Memory: Elizabeth Talford Scott's Quilts Teem with History, Emotion, and Art." *Baltimore Morning Sun*, January 18, 1998, Arts, pp. 1F, 3F. Extensive article on 82 year old Scott, who is photographed in her studio. The article also reviews the opening of the solo exhibit *Eyewinkers, Tumbleturds and Candlebugs: The Art of Elizabeth Talford Scott.*

_____. "Painted Quilts Tell Many Stories at BMA Show." *Baltimore Sun*, November 17, 1987.

Drummond, Dee. "Heritage, Life Are Combined in Artist's Work." *Blade* (Toledo, OH), February 8, 1999, News Section Two, p. 9. Profile of Willis "Bing" Davis.

Dunn, Andrew. "Piecing Together the Past: Church's Youth Use Leisure Time to Explore Their History, Culture." *Tallahassee Democrat*, October 14, 2000, p. B1. Museum curator introduces students to slave quilts.

Dunnette, Paul. "Multicultural Center Proud of Quilt." *Oregonian*, October 17, 1996, Portland Zoner, p. 4. Multicultural Center completes a 16-square-foot quilt.

"Dynamic Quilt Exhibit at Black Gallery." *Herald-Dispatch* (Los Angeles, CA), July 20, 1996. Review of *Story Quilts: Photography and Beyond.*

Edwards, Norval. "Sharing His Wisdom: At 93, Afonso Biggs Still Has Plenty of Knowledge and Lessons to Share with Those Young and Old." *Ledger-Enquirer*, February 14, 1997, p. A3. Master cook shares history and collection of quilts made by slaves.

Eklund, Bridget. "Patchwork Stitched with Pride: West Chester Pupils Put Together Five Quilts with Personal Themes." *Philadelphia Inquirer*, February 19, 1999, p. B1. Fifth-graders contribute to patchwork quilts celebrating Black History.

Ellinger, Mickey. "Calif. Town/Park Cultivating Its History—and a Future." *Charlotte Observer*, February 20, 2000, p. 1G. Friendship quilt by Mrs. Gemelia Herring, one of Allensworth's oldest surviving residents, mentioned.

Ellis, Ralph. "Folk Art Exhibit Shows Work of Fayette Native." *Atlanta Journal-Constitution*, November 18, 1999, p. JM1. Nellie Mae Rowe exhibit. Rowe's mother, Louella Williams, quilted.

"Exhibit on Black Churches Opens." *State* (Columbia, SC), August 31, 1991, p. 7D. Joann Thompson designs *Jacob's Ladder* quilt made by South Carolina students featured in South Carolina State Museum exhibit.

"FAMU: AIDS Quilt Will Be Displayed." *Tallahassee Democrat*, November 20, 2000, p. D1. Florida A&M University displays a quilt featuring twenty-seven 3-foot by 6-foot panels, each commemorating the lives of people who have died of AIDS, including tennis star Arthur Ashe, rapper Eazy E, and TV newsman Max Robinson.

Farrish, Jean S. "Hands of Praise Celebrates the Work of Slave Artisans and Modern Artists." *New Pittsburgh Courier*, October 16, 1993, p. B6.

Fine, Mary Jane. "A Place to Dream—Artist Faith Ringgold's Vision of a Studio Takes Shape—Now It's Time for Painting and Quilting." *Record* (Hackensack, NJ), April 11, 1999, p. L1.

Fortune, Beverly. "KSU Exhibit to Feature Quilts Celebrating Black Heritage." *Lexington Herald-Leader*, March 7, 1997, Weekender, p. 8. Exhibit review of *Ebony Odyssey* at Kentucky Sate University.

Fox, Catherine. "Lives in Words and Pictures." *Atlanta Journal/Atlanta Constitution*, August 28, 1992, p. B2. Compares works by photographer and quilter Deborah Willis and artist Carrie Mae Weems.

_____. "Visual Arts Showcasing a Communal Tradition." *Atlanta Journal-Constitution*, September 4, 1998, Preview, p. Q8. *A Communion of the Spirits: African-American Quilters, Preservers and Their Stories* exhibit at the Atlanta History Center.

Frazier, Lisa. "AIDS's Somber Reminder: Quilt Holds Urgent Message for African Americans." *Washington Post*, December 1, 1999, p. B01. The AIDS Memorial Quilt travels to several historical Black colleges, including Howard University.

"Freedom Quilting Bee." *St. Louis Post-Dispatch*. October 13, 1968.

Freeman, Gretchen E. "'Afro-American Quilts' A Show of a Bold Craft." *New York Times*, February 3, 1983. Exhibit review.

Freeman, Judith. "Whitney Otto Writes Intelligent, Original First Novel." *Star-Tribune* (Mpls.-St.Paul), May 26, 1991, p. 9F. Book review of *How to Make an American Quilt*.

Friedman, Jane. "Not Your Grandmother's Quilt," *Washington Post*, October 7, 2000, p. C2. Review of *Spirits of the Cloth: Contemporary African American Quilt* exhibit at the Renwick Gallery.

Fulmer, John. "Quilter Discovers Folk-Art Gold African-American Culture Is Focus of OHR Center Event." *Sun Herald*, February 12, 1999, p. A4. Crossroad Quilters profiled.

Gallagher, Maria. "Quilts Qualify as Fine Art." *Charlotte Observer*, September 11, 1989, p. 8B. Exhibit review of *Family Traditions: Recent Works by Elizabeth T. Scott and Joyce J. Scott*.

Gash, Barbara. "Quilts Show Makers' Roots." *Detroit Free Press*, May 14, 2000, p. 6J. Exhibit of 12 quilts handmade by the Wednesday Night Quilting Sisters Ministry of the Hartford Memorial Baptist Church.

Gavon, Darlene. "Celebration: Fabric of Black Creativity Runs Through Exhibit." *Chicago Tribune*, March 13, 1988, Section 6. Carol Adams curates exhibit of African American made quilts at the Museum of Science and Industry. Works by the following were included: Fredericka Clark, Annie Dickerson, Julee Dickerson-Thompson and Lula Williams.

George, Helen. "Fabric of Life." *Pocono Record* (PA), November 9, 1998. Lifestyle Front Page. Profile of quilter Elizabeth Pemberton.

George, Lynell. "Patchwork Stories: By Combining Photography and Quilting, Three Artists Create a Unique Medium for Commenting on the Issues of the Past—and the Present." *Los Angeles Times*, July, 17, 1995, Life & Style, pp. E1, E3. Review of *Story Quilts: Photography and Beyond*, a three-person exhibit curated by Pat Ward Williams at Black Gallery, Los Angeles. Artists included Kyra Hicks, Dorothy Taylor and Deborah Willis. Color photo of *Made in the U.S.A*, a quilt depicting the Rodney King videotaped beating.

"Georgia Patton to Be Featured in the Black Heritage Quilt Show." *The Call* (Kansas City, MO), February 11, 1999. Over 300 people attend the 13th annual Black quilt show at Wyandotte County Historical Society and Museum in Kansas. A photo shows Patton and her two grandsons, Sidney and Sean, standing in front of quilts made by the grandsons.

Ghent, Janet. "Quilts That Retell Afro Culture's Story." *Oakland Tribune*, January 1, 1988.

Gittelsohn, John. "Quilts a Patchwork of Cultural Identity Art: The Museum Exhibit of Pieces by Black Americans Shows an African Influence." *Orange County Register* (CA), February 26, 1996, p. B1. Exhibit Review of *Who'd A Thought It: Improvisation in African-American Quiltmaking*.

Glanton, Dahleen. "Nurtured by the Civil Rights Movement, the Once-Thriving Freedom

Quilting Bee Now Is Coming Apart at the Seams." *Chicago Tribune*, November 11, 1997, Tempo, p. 1.

Glassman, Molly Dunham. "A Patchwork of African-American Pride." *Baltimore Sun*, February 18, 1994, p. 4E. Review of Faith Ringgold's book *Dinner at Aunt Connie's House*.

Glueck, Grace. "An Artist Who Turns Cloth into Social Commentary." *New York Times*, July 29, 1984.

"Good Morning, East Tennessee; Something Special We'd Like to Call to Your Attention." *Knoxville News-Sentinel*, August 6, 2000, p. A2. Rukiya Abdl Alim presents her *Story-telling Quilt* during a four-day arts festival.

Goodman, Ellen. "Black Women Doubly Burdened." *Oregonian*, October 12, 1995, p. D9. Essay mentions Maya Angelou's character in the movie *How to Make an American Quilt*.

Goodnight, Lisa. "Enthralled by the Fabric of Africa." *Record* (Hackensack, NJ), June 25, 2000, p. L1. Profiles African fabric expert Lisa Shepard.

Gottschalk, Mary. "African American Dolls, Quilts at Exhibit in Emeryville Today." *San Jose Mercury News* (CA), February 24, 1995, p. 1D. Quilts by Tara Herron, Cynthia Nicholas and Susie Surrell.

_____. "Fabrics Evoke African Themes." *Charlotte Observer*, August 26, 1995, p. 7E. Baby bedding available in West African designs.

_____. "Spirited Quilts." *San Jose Mercury News* (CA), August 31, 1998, p. 3C. *Tutwiler, Mississippi: An African-American Tradition* exhibit of contemporary African American quilts made by the Tutwiler Quilt Collective at the San Jose Museum of Quilts & Textiles.

Gragg, Randy. "Adriene Cruz Emerges from a Year of Deep Loss with a Show of Powerful Improvisation." *Oregonian*, September 19, 1999, p. E1. Extensive article.

_____. "Adriene Cruz: On the Limits of Portland's Art Scene." *Oregonian*, March 26, 1999, Arts and Entertainment, p. 6. Extensive interview with Cruz.

_____. "Colorful Quilts Capture $2,000 Prize for Adriene Cruz." *Oregonian*, November 21, 1992, p. C10.

_____. "Daydreaming in Color." *Oregonian*, April 25, 1994, p. C1. Adriene Cruz celebrates her heritage with vibrant quilts.

_____. "Death of an Art Angel: Cancer Claims Beloved African American Arts Supporter Charlotte La Verne Lewis at 65." *Oregonian*, August 20, 1999, p. F1. Lewis organized past community quilt projects.

_____. "For Most of Her Career, 62-Year-Old Faith Ringgold Quilts the Story of Black America." *Oregonian*, January 10, 1993, p. E1.

Graham, Renee. "Black Memorabilia: Should These Items from the Past Be Saved as Historic Relics or Destroyed as Offensive Junk." *Boston Globe*, November 7, 1992, Living, p. 29. Interview with Jeannette Carson, of Hyattsville, MD. Her memorabilia collection includes slave quilts.

Grau, Jane. "Not Grandma's Bedspread: African American Quilts Convey Spirits of Vision, Improvisation." *Charlotte Observer*, February 25, 2000, p. 25E. Exhibit review of *Spirits of the Cloth* at the Mint Museum of Craft + Design.

Green, Judith. "'Promise' Gives Vivid Snapshots of Black Man's Life." *San Jose Mercury News* (CA), February 3, 1996, p. 3E. "Still Headin' fo' da Promise Land" monologue. Two vignettes feature Tyrone, who has AIDS, and his father, a minister who has an epiphany when he finds Tyrone's panel on the AIDS memorial quilt.

Green, Loretta. "Quilts Emerge, Piece by Piece, Just Like Life." *San Jose Mercury News* (CA), September 23, 1996, p. 1B. Profile of Virginia R. Harris.

Greenhaw, Wayne. "'Quilting Bee' a Gentle Trek." *Atlanta Journal Constitution*, January 31, 1988. Review of *The Freedom Quilting Bee* book.

Griess, Karen. "NU Acquires World-Class Quilts." *Lincoln Journal Star*, April 25, 1997, pp. 1B, 7B. Robert and Ardis James donate their collection of quilts valued at more than $6 million to the University of Nebraska.

Griffith, Dorsey. "Premature Babies Reap What Jailed Teens Sew." *Sacramento Bee*, December 6, 1998. p. A1. Inmates at Preston Youth Correctional Facility sew nursery items.

Gutierrez, Lisa. "Patterns of Freedom Quilts Directed African-Americans Along the Underground Railroad." *Kansas City Star*, March 9, 2000, p. F1.

Hackett, Regina. "Dingus Elicits Ragged Grace from Childhood, History and Slavery in 'Mojo Hands' Artworks." *Seattle Post-Intelligencer*, July 6, 2000, p. E1. Profile of Marita Dingus.

Hale, David. "Quilts a Tribute to African-American Art Exhibit Pieces Stitch Together Functional Wares and African Culture." *Fresno Bee* (CA), January 18, 1999, p. E1. *African American Art on Quilts* exhibit at the African American Historical and Cultural Museum.

_____. "Quilts Showcase African-American Culture." *Fresno Bee* (CA), December 20, 1998, p. K5. *African American Art on Quilts* exhibit at the African American Historical and Cultural Museum.

Hall, Carol. "Have Sewing Machine—Will Travel. Claire Dunlap Carter—The Consummate Quilter." *Mountain Messenger* (Greater Greenbrier Valley, WV), January 24, 1989. Extensive article about Dunlap, her friendship with *Needlecraft Books's* Barbara Bannister of Michigan, and her contributions to the Women of Color Quilters Network.

Hamilton, Anne. "Bicycle Tours to Follow Freedom Trail." *Hartford Courant*, September 18,1998, p. B7. The Freedom Bicycle Tour was planned in conjunction with the creation of the *Freedom Trail Quilt*, created by quilters around the state.

_____. "Freedom Quilt to Get Finishing Touches." *Hartford Courant*, September 24, 1998. Community effort creates *Freedom Trail Quilt* for permanent display at the Museum of Connecticut History.

_____. "The Thread of Amistad History Squares in Quilt Depict Towns' Ties to Slave Ship." *Hartford Courant*, September 16, 1998, p. B1. A dozen quilt squares depicting scenes from Farmington's role in the Underground Railroad, sewn by the Farmington Historical Society, will be joined with others to create a giant Amistad quilt.

Hamilton, Elizabeth. "History of Freedom Trail Comes Together with Quilt." *Hartford Courant*, September 20, 1998, p. B2. Freedom Trail Quilt Blocks.

"Handmade Quilts Reflect 19th Century Designs." *Kansas City Star*, January 3, 1992, p. E4. The Smithsonian's National Museum of American History sells reproduction of 19th century quilts from its collection, including the *Bible Quilt* by Harriet Powers.

Hardee, Courtney. "'Lively, Dynamic' Designs 'Move' for Famous Quilter." *Birmingham News*, February 21, 1994, p1-1. Quilter Mozell Benson is profiled.

Harris, Betsy. "Quilts Break Rules: A Traveling Show at the IMA Reveals Exuberance, Bright Colors and Improvisation by African-Americans in a Fabric Medium." *Indianapolis Star*, February 1, 1991, p. C1. *Who'd A Thought It: Improvisation in African-American Quiltmaking* exhibit at the Indianapolis Museum of Art.

Hartup, Cheryl. "If These Quilts Were Music, They'd be Jazz." *Oregonian*, July 2, 1993, Arts and Entertainment, p. 35. *Who'd A Thought It: Improvisation in African-American Quiltmaking* exhibit at the Grant House Folk Art Center.

Hatfield, Julie. "Art of the Bedroom: Climbing for Cancer Fund; A Little Curl Talk." *Boston Globe*, January 16, 1995, Living, p. 45. *Sweet Dreams: Bedcovers and Bed Clothes* exhibit

at the Museum of Fine Arts. A rare appliqué bedcover made by 19th century African American craftswoman Harriet Powers, is featured.

"Hattiesburg Hosts Largest Quilt Event in State." *Sun Herald* (Biloxi, MS), October 1, 1995, Coast Living, p. H4. Quilt show features *Stitches of Color*, creative quilts made in the African tradition, by Rhea Boykins.

Hawes, Christine. "Patched Together: Modern Quilting Is Far More Than Just a Way to Keep the Family Warm. Quilters Now Use Their Craft as a Means of Self-Expression." *Sarasota Herald-Tribune* (FL), January 5, 1997, p.1E.

Hazelton, J.L. "Black Quiltmakers Earn Place in History." *Wichita Eagle*, March 7, 1993, p. 3F. The role of Black quilters in American quilt history is examined.

_____. "Quilting Tradition Fuses African, European Styles, Scholar Says." *Plain Dealer* (Cleveland, OH), February 8, 1993, p. 8F. Review of *Hear My Quilt: 150 Years of African American Quilt Making* curated by Cuesta Benberry.

Heithaus, Harriet Howard. "Quilts of Black South Reflect Ingenuity." *Fort Wayne—The Journal Gazette*, January 15, 1995, p. 1E. *Signs and Symbols: African Images in African American Quilts from the Rural South* exhibit at the Fort Wayne Museum of Art.

Hellekson, Diane. "A Stitch in Time: 'Always There' Explores the African-American Experience Through the Art of Quilting." *St. Paul Pioneer Press*, April 17, 1994, p. 1E. *Always There: The African-American Presence in American Quilts* exhibit at the Minnesota Museum of American Art.

Herman, Valli. "Quilts: Patch Past with Future." *Gary Post-Tribune* (IN), March 6, 1988, p. E1. Brief history of quilting.

Heyne, Diana. "Quilt Art Provides Patchwork of Stories." *Lexington Herald-Leader* (KY), February 24, 1991, p. C4. Review of *Stitching Memories: African-American Story Quilts* exhibit at the Taft Museum.

Hicks, Bob. "Cultural History a Museum for Alberta Street." *Oregonian*, July 30, 2000, p. E1. Details plan for an African American Museum in Portland. Museum to include display of community quilt by the late arts activist Charlotte Lewis.

Higgins Jr., Chester. "Boyhood Memories of Quilting Time in Alabama." *New York Times*, April 4, 1996, p. B6.

Hill, Sharon. "Quilt Wraps Around Generations of Friendship." *Washington Post*, June 1, 1989, p. J1. *Art from the Heart of the City* is the focus of a program aimed at uniting senior citizens and fourth-through sixth-grade students.

Hilson, Robert. "Quilt Maker Speaks Through Her Craft." *The Baltimore Sun*, December 4, 1993, p. 5B. Profile of Melody Healy.

Hirsh, Linda B. "Artist Makes Her Quilts with a Difference." *Hartford Courant*, September 24, 1996, p. B4. Deborah A. Simmons displays quilts at the Inner City Cultural Development project.

Hiskey, Michelle. "Historic Quilt a Feather in Atlanta's Cap." *Atlanta Journal-Constitution*, April 4, 1999, p. M1. Preview of *Georgia Quilts: Piecing Together a History* exhibit at the Atlanta History Center. Harriet Powers' second *Bible Quilt* on temporary loan from the Boston Museum of Fine Art.

"History Stitched into Slave Quilts' Intricate Design." *Miami Herald*, October 15, 1989, p.28H. *Stitched from the Soul: Slave Quilts from the Ante-Bellum South* on view at the Smithsonian Institution's Renwick Gallery.

Holck, Mary D. "Smooth as Silk: Dawkins Combines Talents in 'Silkollages'." *Sunday Gazette* (NY), date unknown—probably October/November 1993, Arts & Entertainment, pp. G1, G2. Extensive profile of quilter and fiber artist Francelise Dawkins. Includes review of *Womb-dancing*, a solo exhibition featuring forty works by Dawkins at the Schenectady Museum October 16–November 28, 1993.

Holt, Patricia. "Women's Common Threads." *San Francisco Chronicle*, September 29, 1987. Includes mention of Harriet Powers.

Horn, Marcia. "Wall Hangings Are Artist's Obsession." *Liberty Tribune* (MO), June 2, 1993, pp. 1–2. Profile of Sherry Whetstone-McCall, whose work was featured in a two-person exhibit at Ethnics Arts (Kansas City, MO).

Horwitz, Simi. "The Order in 'Law & Order.'" *Washington Post*, June 11, 1995, p. Y6. Interview with actor S. Epatha Merkerson, who plays Lt. Anita Van Buren on the award-winning drama series. Merkerson reveals her quilting passion.

Howe, Michele. "Cultural Patchwork." *Star-Ledger* (NJ), February 4, 2000, pp. 31–32. Review of New Jersey State Museum exhibit featuring works by the Ebony Rainbow Quilters.

Hunter, Ginny. "A Woman of the Cloth: Her Quilts Explore Cultural Themes." *Cincinnati Post*, April 24, 1997, Central Zone, p. 1. Profile of Carolyn Mazloomi.

Hurder, Wayne. "Freedom Quilting Bee." *Southern Courier* (Montgomery, AL), September 3-4, 1966, p.4.

Ikenberg, Tamara. "A Stitch in Time." *Journal-News* (Hamilton, OH), July 14, 1995, p. B1. Review of *Common Threads: African-American and Appalachian Quilts* at the Fitton Center for Creative Arts. Nellie Bly Cogan, event coordinator. This article also mentions African American Internet quilting activities.

"In the Galleries Artist Makes the Most of Numbers and Text-ure." *Fort Worth Star-Telegram*, February 11, 1996, Arts, p. 3. Artist Annette Lawrence's solo exhibit *Same Way* at Dallas art gallery.

"In Your Schools." *Birmingham News*, March 9, 1994, p. 3WX. Calloway Elementary school-teacher Damita Pitts' classroom wins honorable mention in a door decoration contest for *An African American Quilt*.

"International News in Brief: A Banned Black Nationalist Accepts a Special Quilt." *Philadelphia Inquirer*, March 18, 1983, p. A3. Helen Suzman presents Winnie Mandela with a quilt signed by twenty-six members of the U.S. Congress opposed to South Africa's apartheid policies.

Isaacson, Philip. "Cummings' Narrative Quilts Have Important Stories to Tell." *Maine Sunday Telegram*, February 1, 1998. Review of exhibit at Bates College Museum of Art. Fourteen quilts on display.

Jackson, Marie A. "Photo Historian Will Sign Book." *Detroit Free Press*, February 18, 2000, p. 6B. Jackie Napolean Wilson is author of *Hidden Witness*, a collection of photographs dating from 1840s through the Civil War. Includes photos of slaves and quilts.

"Jacquelyn Hughes Mooney: Cuddle Quilt *When I Think of You*." *New York Beacon*, July 14, 1999, p. 18.

James, Kyle. "Stitched Scraps Yield Fine Art: Richmond Woman Lets Her Colorful Quilts Talk for Her." *Contra Costa Times* (CA), July 17,1997, p. F1. Exhibit review of *Quilts by Rosie Lee Tompkins*, a one-woman show at the UC-Berkeley Art Museum.

Jeannechild, Penny. "Sew What's New? Quilting Lore and Workshop." *Philadelphia Inquirer*, March 11,1994, Features Weekend, p. 39. Exhibit *Community Fabric: African American Quilts and Folk Art* at the Philadelphia Museum of Art.

Jesse, Kathy Whyde. "Three Generations United in a Search for Beauty." *Dayton Daily News* (OH), date unclear—possibly September/October 1994–1996, pp. C1, C10. Profiles doll artist Delora Buford Buchanan, her mother Marietta Buford, who also makes dolls, and her father, "picture quilter" Paul Buford, Sr. These three had a group show at the Culture Works Gallery in Dayton, OH.

John-Hall, Annette. "African-American Legacy Stitched in Beautiful Quilts." *Arizona Republic*, March 20, 1997, Life section. Ebony Rainbow Quilting Sisters are featured.

_____. "African-American Quilters Stitch Their Legacy in Fabric." *Miami Herald*, March 16, 1997, p. 21H.

_____. "Blacks Learn Quilting Joys." *Sun Herald* (Biloxi, MS), March 16,1997, Coast Living, p. E6. Ebony Rainbow Quilting Sisters of Camden, NJ.

Johnson, Doug. "Native Preserves History of Blacks in Ozarks: Missouri Priest Works to Save Slave Cemetery, Post-Civil War School. His Goal Is Museum." *Akron Beacon Journal*, July 16, 2000, p. A8. Rev. Moses Berry's collection includes quilts. This article also appeared in *Times Union* (Albany, NY), July 16, 2000, p. A16.

Johnson, Jeneil. "Neonatal Unit Receives *Baby Dream Quilt*." *Michigan Citizen*, June 27, 1998, p. B4. Johnson & Johnson commissioned Jacquelyn Hughes Mooney to make quilts for hospitals nationally. The *Baby Dream Quilt* was donated to the Detroit Riverview Hospital. Mooney has also been artist-in-residence for the African American Women on Tour conference and its Dream Quilt series.

Johnson, Linda J. "Lexington Teacher Led Lessons for 30 Years." *Lexington Herald-Leader* (KY), May 22, 1998, p. B1. Miss Connie Mitchell's retirement marked with surprise quilt covered with painted handprints of every child and teacher at James Lane Allen Elementary School.

Johnson, Stephanie Jordan. "Quilts Have Many Threads." *Macon Telegraph*, February 6, 1996, Bibb Neighbors, p. 1. Wini McQueen explores black history through quilts at local schools.

Jones, Carleton. "Folklorist Stitches Together History of Black Quilt Making." *Baltimore Sun*, January 8, 1989. Also "Quilts Made by Blacks in Slavery." *Philadelphia Inquirer*, February 11,1989, p. D5. Interview with Gladys-Marie Fry.

Jones, Vanessa. "Writer Gains Access to Publishing World Through Story Quilts." *Greensboro News & Record*, November 16, 1993, p. D3. Faith Ringgold book reviews.

Justin, Neal. "An Artist's Greatest Work: Caring." *Chicago Tribune*, February 26, 1989, Home, p. 2. Interview with quilter Venus Blue.

Kaimann, Frederick. "African, African-American Art Is Featured at Museum of Art." *Birmingham News*, December 24, 1995, p. 8F. *Speaking in Forms: African and African-American Art from the Permanent Collection* exhibit at the Birmingham Museum of Art includes quilts by Chris Clark and Yvonne Wells.

_____. "Quilt Wizard Chris Clark Creates His Art with Cloth, Sewing Machine and Paints." *Birmingham News*, May 8, 1994, p. 1-1. Extensive interview with quilter Chris Clark.

Keeler, Guy. "Awake to the History of Quilts." *Fresno Bee* (CA), September 11, 1989, p. A10. Interview with Eli Leon.

Kellogg, Stuart. "The Art of Quilting." *Victor Valley Daily Press* (Victorville, CA), December 4, 1999.

Kemp, Kathy. "A Life in Fabric at 81, Nora Ezell Celebrates Art of Story Quilts with Her Book, 'My Quilts and Me.'" *Birmingham News*, March 4, 1999, p. 1E.

Kendall, Nancy. "Powerful Impressions, Stitch by Stitch." *Christian Science Monitor*, February 20, 1998. Profile of Michael Cummings.

Kerr, Robert. "African Style Quilts Hit Bright Riffs in Tradition of Black Art." *Commercial Appeal* (Memphis, TN), March 13, 1991, p. C1. Includes interview with Dr. Maude Wahlman, who was to lecture on *Mojo Working: Religious Symbolism in African-American Folk Art* at a local college.

Kiehl, Stephen. "Artists Add Their Touch to Kwanzaa Celebration." *Oregonian*, December 4, 1997, p. D2. Charlotte Lewis and Adriene Cruz organize show that includes quilts.

Kim, Lillian Lee. "Healthy Living: An AIDS Wakeup Call as the Virus Takes Its Toll in the Black Community, Panels of a Quilt Send an Urgent Message." *Atlanta Constitution*, October 19, 1999, p. B1. The AIDS Memorial Quilt.

Kirsch, Elisabeth. "All Jazzed Up: Improvisation and Imagination Set African-American Quilts Apart." *Kansas City Star*, February 25, 1999, p. E1. Exhibit review of *Scott Heffley's African-American Quilt Collection* at the Albrecht-Kemper Museum of Art in St. Joseph, MO.

Klefstad, Ann. "Fussy Presentation Subtracts from Strength of Fiber Show." *Duluth News-Tribune* (MN), November 24, 1996, p. 11E. Exhibit review of an African American quilt show at the Tweed Museum of Art.

_____. "Quilts, Folk Art Delight the Senses." *Duluth News-Tribune* (MN), November 10, 1996, p. 11E. Exhibit review of *Signs and Symbols: African-American Quilts* at the Tweed Museum of Art.

Koeppel, Fredric. "Quilts on Display Depict Passage of African Slaves." *Commercial Appeal* (Memphis, TN) May 10, 1992, p. G2. Ten quilts on display at the National Civil Rights Museum.

_____. "Sew and Tell: Quilts Uncover Blacks' Stories in Brooks Show Opening Today." *Commercial Appeal* (TN), April 14, 1991, p. G1. Exhibit review of *Stitching Memories: African-American Story Quilts* at the Memphis Brooks Museum of Art.

Koncius, Jura. "The Quilts That Struck a Nerve: Smithsonian Reproductions Spark a Passionate Protest." *Washington Post*, March 19, 1992, p. T08. American quilters are horrified when handmade copies of historic Smithsonian 19th century quilts appeared in a 1992 Spiegel catalog. In need of revenues, the Smithsonian Institution licensed the rights to reproduce items from its collection to a Chinese factory. Three reproduced quilts involved included Harriet Powers' 1886 *Bible Quilt*, a *Bride's Quilt* made in 1851 by a Carroll County bride, and a 1830 *Great Seal of the United States* quilt by Susan Strong, of Frederick County, MD. Pillow shams and small hooked rugs to match the reproduction quilts were also available. A fourth quilt design, a copy of an 1850 pattern called *Sunburst*, was introduced in a winter 1992 Chambers mail-order catalog. American quilters protested the historical quilts being reproduced and non-Americans producing the quilts. Viola Canady, founder of the Daughters and Sons of Dorcas, was quoted in the article. Senator Al Gore (D-Tenn), Hazel Carter, Virginia Gunn, and other quilt enthusiasts are quoted. The article also mentioned an October 1991 Sotheby's auction of an 1867 *American Pictorial Civil War* quilt, with forty squares illustrating scenes from freed slaves to Uncle Sam, to a New York dealer for $264,000. At the time, the price was a then record for an American quilt.

_____. "The Smithsonian's Truce Imported Copies Spark Agreement—and a New Protest." *Washington Post*, March 25, 1993, p. T06.

Kong, Dolores. "AIDS Quilt Ceremony to Recall, Honor 3." *Boston Globe*, May 25, 1993, Metro, p. 22. Sidney W. Borum Jr's colleagues remember him with a Kente quilt

Kruse, Joy. "Spirits of the Cloth." *Milwaukee Journal Sentinel*, March 28, 1999. Features interview with and photos of quilts by Sharon Kerry-Harlan and Zene Peer.

Lacy, John. "The Ethnicity of Traditional Art—and Its Masters." *Hartford Courant*, September 27, 1994, p. E1. Profile of quilter Laura Mae Hudson.

Lannon, Linnea. "Just Plain Folk: Old or New, Costly or Not, It's Hot Art." *Detroit Free Press*, March 13, 1988, p.1H. Includes mention of Clementine Hunter and folk quilts.

Larcen, Donna. "Death in Mississippi." *Hartford Courant*, May 29, 1997, Calendar, p. 32. Mentions exhibit *A Common Thread: Yesterday, Today and Tomorrow.*

Leavy, Pamela Griner. "Pieces Through Piecing." *St. Petersburg Times*, January 8, 1999, pp. D1–D2. Profiles 47-year old quilter Anthony Jones, who also teaches quilting workshops.

Levy, Jane. "Art of Her Own: Wini McQueen." *Macon Telegraph*, March 3, 1995, p. D1.

Lewis, Carol. "Saving Black History: A Heritage Center in Irving Will Preserve Part of

One of the State's Oldest African-American Settlements." *Fort Worth Star-Telegram*, June 14, 1999, News, p.1. Resident tells story of sleeping under quilts.

Lewis, Diane. "Celebrities Beat Art Museum in Sale." *Wichita Eagle*, October 25, 1998, p. 2D. Hot market for Faith Ringgold quilts at $75,000.

Lewis, Maggie. "Afro-American Quilts: Patching Together African Aesthetics, Colonial Craft." *Christian Science Monitor*, Sec B, December 1, 1982, pp. 6–9.

Libow, Gary. "Patching Together Freedom Trail's History." *Hartford Courant*, September 19,1998, p. B3. Community residents create group quilts to commemorate former slave Venture Smith.

Lindsey, Nedra. "Handwork and History Combine at Chesilhurst Elementary School: Seven Quilts for Seven Sisters Teaches about Slavery." *Philadelphia Inquirer*, November 13, 2000, p. B11.

Littlefield, Kinney. "Quiltmakers Step into the Spotlight." *Press-Telegram* (Long Beach, CA), June 16, 1991, p. A17. Exhibit review of *Who'd A Thought It: Improvisation in African-American Quiltmaking* at the Long Beach Museum of Art.

Lotozo, Eils. "The Fabric of Their Lives." *Philadelphia Weekly*, February 7, 1996, p. 47. *Block Party: The Art of Quilting* exhibit by the Quilters of the Round Table guild.

Louthan, Nadine. "Her Quilts Depict Struggle for Freedom." *Cincinnati Post*, May 9, 1991, Central Zone, p. 1. Profile of Carolyn Mazloomi.

Loyd, Johathan. "Quilt Exhibit Inspires and Awes." *Macon Telegraph*, February 11, 1997, p. D1. Museum of Arts and Sciences exhibit quilts by Hystercine Rankin.

Lucas, Sherry. "Artist Fuses Fun, Color in Her Many Works." *Clarion-Ledger* (Jackson, MS), June 8, 2000, pp. 1E–2E. Profile of Sarah Mary Taylor.

Mabry, Jennifer E. "Heritage Is All Sewn Up." *Baltimore Morning Sun*, January 25, 1998, p. 7K. Exhibit review of *A Maryland Family Reunion: An African American Culture History and Quilts* at the Maryland Historical Society.

Maley, Dan. "Artist Wini McQueen Pieces Together Exhibit." *Macon Telegraph*, April 12, 1996, p. D1. Wini McQueen's *N'zaazaa/Piecework* exhibit.

_____. "Sewing Roots: Tubman Exhibit Shows How Quilts Reflect African-American History." *Macon Telegraph*, September 29, 1995, p. D1. *Dream Quilts: Improvisations by African American Women* exhibit on display at the Tubman African American Museum.

Marks, Laura C. "Program Inspires Girls to Avoid Risky Behavior." *Hartford Courant*, August 17, 1995, p. B5. Program encourages Hispanic and African American girls to quilt.

Marlowe, Nancy. "Mass-Production Unravels Quilting." *Greensboro News & Record*, April 20, 1992, p. B2. Smithsonian quilt protest.

Marshall, Karne. "To Quilt Historian, Coverlets Are a Stitch in Time." *St. Louis Globe-Democrat*, December 8, 1982. Profile of Cuesta Benberry and her efforts to uncover African American quilting history.

Maschal, Richard. "'Spirits' Proves There's More to Quilts Than Cloth." *Charlotte Observer*, February 13, 2000, p. 1F. Exhibit review of *Spirits of the Cloth: Contemporary African American Quilts*.

Mason, Marilynne. "Sewing Together a Lost Tradition." *Christian Science Monitor*. November 29, 1993, Home Forum, p. 20. Review of exhibits *Signs and Symbols* by Wahlman and *Who'd A Thought It* by Leon.

Mayer, Barbara. "Black Designers Exhibit Talents in Showcase House." *Columbian*, August 9, 1998, p. F4. The Harlem United Show House, the first show house for Black interior designers. Quilts included in the décor.

Mays, Gary, and John Giangrasse Kates. "Quilting Works Its Way Back into America's Fab-

ric: For a High Impact, Groups Return to Low-Tech Medium." *Chicago Tribune*, May 23, 1996, News, p.1.

McAuliffe, Bill. "Connections: Quilting Through History." *Star Tribune* (Mpls.-St.Paul), August 2, 1999, p. 1B. Wilma Gary has researched African American quilting for twenty-five years.

McCleary, Frank. "Quilt Maps Out Route to Freedom." *Examiner* (Eastern Jackson County, MO), March 25, 1999. Teacher Jan Keeler makes replica quilt of *Sweet Clara and the Freedom Quilt*.

McCoy, Bett Norcross. "African-American Culture Promoted with Quilt Display." *Press of Atlantic City*, February 8, 1998, p. H5. Exhibit by Quilters of the Round Table.

McEnery, Mary Anne. "Pieces of the Black Experience—Nineties Trends Invigorate a Collectibles Market." *Record* (Hackensack, NJ), August 20, 1998, p. H1. Contemporary Black collectibles are a growing trend. Popular items include story quilts.

McFarland, Melanie. "Charlotte Lewis." *Oregonian*, November 10, 1995, p. AE3. Quilter Charlotte Lewis wins $2,500 Lilla Jewel Award for women artists.

McKim, Beverly. "The Fabric of the Artist's Work: Artist Invents New Medium." *Saratogian* (NY), January 16, 1993, p. C1. Profile of French Caribbean artist Francelise Dawkins and intricate fabric artwork named "silkollage."

Menzie, Karol V. "Of Recipes and Recollections: 'Our Family Table' Collects African-Americans' Stories." *Kansas City Star*, March 17, 1993, p. E1. Book review of cookbook with quilting motif.

"Midtown—What's Hot—Artist's Keepsakes Tell Story." *Kansas City Star*, July 5, 2000, City, p. 6. Exhibit *Deborah Willis: Tied to Memory* at the Kemper Museum of Contemporary Art.

Miele, Pamela Teehan. "A Black History Month Celebration for Families." *Boston Globe*, February 20, 2000, South Weekly, p. 13. Quilter Jeanette Spencer and the Black Gold Doll Club of New England at Fuller Museum of Art.

Miller, Lori. "Intricate Inspiration: Sumner Welcomes Wall Hanging." *Washington Post*, June 13, 1991, p. J8. Interview with Viola Canady.

Milloy, Courtland. "Warm Wishes Not Enough." *Washington Post*, October 26, 1997, p. B1. Political commentary about Daughters of Dorcas and Washington, DC public school's lack of heating.

Minis, Wevonneda. "Quilter Finds New Approach to Old Craft." *Post and Courier* (Charleston, SC), April 24, 1997. Profile of Marlene O'Bryant-Seabrook.

Miro, Marsha. "Artist's Imagination Shapes Collages of Vivid Colors." *Detroit Free Press*, February 21, 1988, p. 3G. *Something to Keep You Warm* at the Detroit Historical Museum.

_____. "'Quilting Time': Collagist Bearden Captures the Black Experience." *Detroit Free Press*, September 12, 1986, p. 1C. Romare Bearden's *Quilting Time* becomes a collage at the Detroit Institute of Arts.

Mobley-Martinez, T.D. "Picking Up the Threads: Black Quilters Tie Generations Together." *Albuquerque Tribune*, February 6, 1998.

"Modern-Day Quiltmakers Sewing up a New Tradition." *Daily News of Los Angeles*, March 26, 1997, p. L10. Ebony Rainbow Quilting Sisters of NJ.

"Modern Quilts Have Designs from Africa." *Baltimore Sun*, June 2, 1996, p. 3K. *Signs and Symbols: African Images in African-American Quilts from the Rural South* at the Baltimore Museum of Art.

Moore, Tina. "African-American Quilts Are Spread Out in Amish Country: Pennsylvania Gallery Has Display of the 'More Improvisational' Covers." *Akron Beacon Journal*, October 22, 2000, p. H6. The People's Quilt Museum in Intercourse, PA.

Morago, Greg. "An Exhibit in Sync with Hartford's Jazz Fest." *Hartford Courant*, July 24, 1997, Calendar, p. 32. Michael A. Cummings' *African Jazz* series.

Morell, Ricki. "New Status for Two Venerable Homes in Brookline: Group Works to Highlight Town's Anti-Slavery History." *Boston Globe*, March 26, 2000, City Weekly, p. 1. Mentions raffle of a replica of a 19th century quilt. Raffle to raise funds for the Brookline's Underground Railroad Committee efforts.

Moseley, Ray. "Her Quilt Was Subversive." *Detroit Free Press*, April 8, 1983, p. 1A. Security police raid Winnie Mandela's home and confiscate quilt.

Moses, Ellen. "Teen Lived Life of Faith." *Bradenton Herald* (FL), January 17, 1998, p. L1. Obituary for Charles Rhodes Jr., who suffered from sickle-cell anemia. His bed is filled with quilts made by his grandmother and friends.

Murphy, Eileen. "Great Scott: Artist Joyce J. Scott Kicks Down the BMA's Doors." *City Paper*, January 19, 2000. Review of Baltimore Museum of Art exhibit.

Murry, Terry. "Quilting a Fabric of Unity." *Oregonian*, September 25, 1996, p. D4. Employee at Eastern Oregon Correctional Institution begins a Cell Blocks Quilts project. The project includes panels by African Americans.

"Museum Asking for Loan of African-American Quilts." *Evansville Courier* (IN), September 24, 1992, p. B2. African American quilters are asked to lend their quilts to the Museum of the American Quilter's Society in Paducah, KY.

"Myrah Brown Green Spreads Her *American Universal Quilt*." *New York Beacon*, August 7, 1996, p. 14.

"N.C. Black Artifacts Sought." *Greensboro News & Record*, February 21, 1994, p. B4. Staff members of the North Carolina Museum of History in Raleigh visited homes in order to collect artifacts. Ella Williams-Vinson donated two quilts made by her mother.

Nancrede, Sally Falk. "African-American Quilter Sees Her Craft as a Storytelling Art That Preserves the Threads of the Past." *Indianapolis Star*, June 10, 1995, p. E1. Profile of Carolyn Mazloomi.

Neilson, Kenneth. "Langston Hughes Inspires a Quilt and Folk Art Window by Young Artists at P.S. 87." *New York Voice/Harlem USA*, April 29, 1998, p. 11.

New York Times, July 1969. References to Freedom Quilting Bee and the NY interior design firm Parish-Hadley appear at this time. The quilting cooperative had received an order to make patchwork quilts.

Newman, Carol. "Visits with Favorite Quilters." *Blue Valley Gazette* (Kansas), August 30, 1984, p. 7. Profile of Cuesta Benberry.

Nossiter, Adam. "Patches of Pride." *Atlanta Journal Constitution*, February 5, 1989. Freedom Quilting Bee featured.

Nuckols, Carol. "African-American Quilters Piece Together a Unique History." *Fort Worth Star-Telegram*, March 14, 1998, Home, p.1. Exhibit *African-American Quiltmakers: Piecing Our Past to Our Future* at The World Trade Center.

_____. "Handmade Heartfelt: Artist Anita Knox Stitches Her Love of Color, Texture and Humanity on a Canvas of Quilts." *Fort Worth Star-Telegram*, January 27, 1995, Life, p.1.

_____. "Jack and Jill of America Presents 25 Young Men." *Fort Worth Star-Telegram*, April 16, 1992, Life, p. 5. Event featured *Rites of Passage: A Second Generation of Excellence* quilt by Anita Knox.

Nugent, Karen. "Afro-Centric Art Graces Sisters' Lives: Exhibit Part of Black History Month." *Telegram & Gazette*, February 27, 2000, p. B5. Lee C. Parson and Meleen C. Parson Cort exhibit their work.

"Old Slave Mart Museum Owner Louise Graves Dies." *Post & Courier* (Charleston, SC), November 13, 1994.

Page, Jo. "Quilt Exhibit Confronts Black Social Issues." *Albany Times-Union*, May 14, 1989.

Patterson, Andrea. "Warmth, Beauty Sewn into Quilts." *Charlotte Observer*, February 10, 1989, York Observer, p. 1. Interview with quilter Mozell Benson.

Patterson, Tom. "Fabric Artists Stitch Images of African-American Life." *Charlotte Observer*, January 29, 1995, p. 1F. *Hand Me Downs: Innovation Within a Tradition* on exhibit at the Afro-American Cultural Center in Charlotte.

_____. "Finely Crafted Quilts a Lesson in Black History." *Charlotte Observer*, June 20, 1993, p. 1F. *More Than Just Something to Keep You Warm* on exhibit at the Afro-American Cultural Center in Charlotte.

_____. "From Roots to Branches: Artists Michael Harris Explores Transformation in Solo Diggs Exhibition." *Winston-Salem Journal*, February 7, 1999, p. E1. *Crossroads and Confluences: Journeys of Spirit* on exhibit at Winston-Salem State University's Diggs Gallery. Harris is also a quilter.

_____. "Images of Africa Echo in Exhibit at Cultural Center." *Charlotte Observer*, August 4, 1996, p. 1F. *Evidence of a Culture: Breaking the Silence* on exhibit at the Afro-American Cultural Center in Charlotte. Show includes quilts by Beverly Smith.

Paul, Laura. "Quilter Shares Her Craft and History: Vennie Dates Has Created Several Quilts Which Incorporate African-Americans and Their History." *Post-Tribune* (Gary, IN), March 26, 1997, p. B1.

Penn, Steve. "Exhibit Blends Jazz Images into Montage." *Kansas City Star*, February 11, 1999, p. 3. Michael Cummings' quilt *African Jazz* on exhibit at the Kansas City Jazz Museum.

_____. "Ties with Tanzania: Charlotte O'Neal Shares Her Perspective of African Life During Visit to Kansas City." *Kansas City Star*, August 10, 1998, p.10. O'Neal presented painted quilt to the city.

"People." *Sacramento Bee*, October 15, 1998, p. N2. Carolyn Hutchinson Gray's 100th birthday celebration includes a gift of a memory quilt.

"People to Look for in 1995." *Chicago Tribune*, date unknown, Home Section. Includes profile of Chicago textile artist and quilter Venus Blue, "whose quilts visually sing with the history of African-Americans." Blue was also the recipient of a Lila Wallace Reader's Digest fellowship.

Peoples-Salah, Dionne. "Ties That Bind: Quilters Piece Together African-American Tradition." *Flint (MI) Journal*, August 20, 1994, pp. B1–2. Review of the fifth annual quilt exhibit sponsored by the Flint Afro-American Quilters' Guild. Includes historical information about the guild.

Perkins, Pamela. "Girl Scout Troop Makes Quilt to Be Hung in Reproduction of Slave Ship *Amistad*, Girls Also Sew Stories of Their Own Families as Rite of Passage." *Commercial Appeal* (Memphis, TN), March 23, 2000, p. B3.

Perlman, Lee. "Teacher Tries to Preserve Arts of City's Early Blacks." *Oregonian*, May 20, 1993, p. E2. Richard Brown examines subjects such as quilt making, health remedies and gospel.

Peterson, Deborah. "Common Threads." *St. Louis Post-Dispatch*, November 8, 1992, Style, p. 1. Exhibit review with photos of *Hear My Quilt: 150 Years of African-American Quilts*.

Pierce, Susan. "Chattanoogans' Quilt to Hang in U.S. Embassy in Romania: Ambassador and Mrs. Edward Moses Requests "Memories of Childhood Quilts" by local Senior Neighbors Members." *Chattanooga News Free Press*, April 17, 1995.

Pionzio, Melissa. "Weaving Heritage, Unity in Show." *Hartford Courant*, February 3, 2000, p. B4. *Jubilee 2000* on exhibit at the Pump House Gallery features eight African American textile artists and quilters.

Potter, Karen. "The Doll Makers: Women on Death Row Find a Measure of Freedom in

Sewing." *Fort Worth Star-Telegram*, July 10, 1994, Life, p. 1. Inmates make 25 to 30 *Parole Pal* dolls per month. In 1993, the state made $14,060 from doll sales.

Pousner, Howard. "Ezell Stitches Up Tales in 18 to 1,800 Hours." *Atlanta Journal Constitution*, September 20, 1992, p. N04. Profile of Eutaw, Alabama quilter Nora Ezell, honored as a National Heritage Fellow by the National Endowment for the Arts.

Pressley, Leigh. "Quilt Exhibit Wraps up Heritage." *Charlotte Observer*, May 19,1998, P. 1L. *Memory & Spirit: African-American Quilts* on exhibit at the Gaston County Museum of Art & History.

Preston, Rohan B. "Deep Roots: Art by African-Americans Flowers in Chicago in Many Media and Many Styles." *Chicago Tribune*, February 2, 1996, Friday, p. 28. Work by quilt and fiber artist Venus Blue on display at the Satori Fine Art.

"Prints Portray Effect of Slavery's Legacy." *Macon Telegraph*, June 9, 1995, p. D1. Review of artist Michele Wood's work.

"Prisons in Missouri Start Requiring Inmates to Perform Service Projects: Women at Chillicothe Center Have Been Making Quilts for Organizations." *St. Louis Post-Dispatch*, December 17, 2000, p. D12. Black women prisoners included in program.

Puente, Veronica. "Group Has Its Eye on Historic School: The Black Historical and Genealogical Society Wants to Make It Its Headquarters." *Fort Worth Star-Telegram*, September 4, 1997, Metro, p.1. The former school would be a permanent home for the society's collection of quilts.

Pulfer, Mike. "'Cloth' Written as if Quilts Could Talk." *Cincinnati Enquirer*, December 26, 1998, pp. C1, C3. Review of Carolyn Mazloomi's book.

Pupino, Holly. "Maker Weaves Some of Herself into Each Quilt: Debra Calhoun Makes Sure Each Bedcover That She Crafts Tells a Story." *Akron Beacon Journal*, September 12, 1999, p. E6.

Qasawa, Karin Braedt. "Stitching Together a Family." *Post-Tribune* (Gary, IN), February 24, 1996, p. D3. Interview with quilter Vennie Dates.

"A Quilt Full of African-American History." *Akron Beacon Journal*, February 12, 1995, p. A4. Photograph of pupils at Allen Elementary School showing off an African American history quilt made by school secretary Pamela Huffman.

"Quilt to Mark A&T's Centennial." *Greensboro News & Record*, March 21, 1990, People & Places, p. 2. A group of North Carolina A&T State University supporters complete an elaborate 120" × 120" centennial quilt depicting the university's history. The quilt is to be on permanent display at the school's library.

"Quilter, Potter Among Winners of SC Folk Awards." *Evening Post* (Charleston, SC), April 6, 1989.

"Quilters Share Stories and Exhibit Their Works." *Winston-Salem Journal*, July 11, 2000, p. E5. Belinda Tate orgainzes "Quilt Stories Day" for local quilters and quilt owners to share art pieces. In addition, *Hollis Chatelain: Unraveling the Myths About Africa Through Quilts* on exhibit the Diggs Gallery of Winston-Salem State University.

"Quilting Bee Founder Is Remembered." *Wilcox Progressive Era* (Camden, AL), January 13, 1999. Obituary for Estelle Witherspoon, founder of the Freedom Quilting Bee. She died December 24, 1998.

"Quilting Is a Family Tradition: Four Generations Maintain Gift." *Kansas State Globe*, August 31–September 7, 1988, p. 5. Ninety-two year old Mrs. Juanita Patton is profiled. She hand-stitched a *Golden Treasure* quilt worth $1,500. The quilt was sewn with 14-karat gold thread.

"Quilts Express Cancer Survivors Feelings." *Journal Gazette* (Fort Wayne, IN), December 2, 1997, p. 1D. Exhibit of fifty quilts made by Black women cancer survivors at the Women's Cancer Center in Lutheran Hospital.

"Quilts Form a Textbook on Herstory: Traditional Works Reveal Women's Loves, Aspirations, Political Views." *Boston Globe*, February 26, 1989, Metro, p. 43. Interview with Gladys-Marie Fry.

"Quilts Made from Pieces of Life—Children at St. James AME Church Learn Making Quilts Can Be More Than a Useful Hobby." *Ledger-Enquirer* (Columbus, GA), February 19, 1996, p. B1.

"The Quilts of Wini McQueen." *Macon Telegraph and News* (GA), January 15, 1988.

Raabe, Nancy. "Tuscaloosa Woman's Quilts Part of American Fabric." *Birmingham News*, August 30, 1998, p. 1F. Interview with quilter Yvonne Wells. Larger Wells quilts typically sell for $6,000–$8,000 each, according to agent Robert Cargo.

Ramsey, Bets. "Researcher Joins Quilt Hall of Fame." *Chattanooga Times*, January 19, 1984, p. C9. Profile of Cuesta Benberry.

"Rare African-American Quilts Offered in Sotheby's Sale of Americana in NY." *New York Voice/Harlem USA*, October 11, 2000, p. 18.

Ratcliffe, Heather. "Program Simulates Perilous Journey Along Underground Railroad: Groups of Youngsters Learn Lessons of Freedom at the Old Courthouse." *St. Louis Post-Dispatch*, February 20, 2000, p. C9. As part of simulation, children learn to recognize safe houses by special quilts hung at each stop on the Underground Railroad.

Raynor, Vivien. "A Quilter's Hand with Dazzling Images." *New York Times*, August 23, 1992. Review of exhibit featuring quilts by Michael Cummings at the Hill Gallery in Kent. The *Children of Egungun* series is highlighted.

Reardon, Patrick T. "Quilters Use Their Needles to Prick Our Conscience about Social Issues." *Chicago Tribune*, February 19, 1998, Tempo, p.1. *Covering the Cause: Social Commentary in Quilts* exhibit at the Harold Washington Library Center in Chicago. Ten quilts by Venus Blue included in this show.

Reif, Rita. "Stitchery by Slaves Soars Free in a New Show." *New York Times*, July 16, 1989. Illus.

Reisner, Neil. "Black Cultural Center's Director Already Busy." *Miami Herald*, October 9, 1999, p. 1B. Interview with Arglenda Friday, director of Broward County's African-American Research Library and Cultural Center.

"Remember the Reason for the Season." *Jacksonville Free Press*, December 24, 1997, p. 1. Jacksonville historians create a quilt detailing area's Black history.

"Respected Quilter Serves Her Church, Community." *Detroit Free Press*, September 8, 1997, p. 2B. Obituary for quilter Effie Hayes.

Reuter, Laurel. "Quilts: Art Evolving from Domestic Life." *Grand Forks Herald*, April 5, 1991, p. 1C. Exhibit review of *The Definitive Contemporary American Quilt* at the North Dakota Museum of Art. Show included slave-made quilts.

Richards, Suzanne. "Boise-Eliot Students Fashion African Quilt." *Oregonian*, March 2, 1990, p. D2. Boise-Eliot Elementary School fifth-graders create an Adinkra quilt.

_____. "Diversity on Display." *Oregonian*, February 6, 1995, p. B2. *Visions: A Tribute to African American Artists* on exhibit at Gresham City Hall. Show included quilts by Carmenita Coleman.

_____. "The Fabric of One Family's Rich Lives." *Oregonian*, November 18, 1993, Portland Zoner, p.1. Interview with quilter Stephanie Parrish Taylor.

Richberg, Barbara. "Anna R. Jones, 92, Pioneer in Many Fields." *Philadelphia Inquirer*, April 5, 1995. Obituary. Anna Russell Jones was the first Black woman to graduate from the the Philadephia School of Design for Women. She was also a textile designer.

Rickford, Russell J. "Quilts Help Dramatize Slaves' Lives: A Troupe of Sisters to Perform at School." *Philadelphia Inquirer*, February 8, 1999, p. B1. Seven Sisters for Seven Sisters present *A Stitch in Time*, an educational production.

Riddle, Mason. "Diversity of Vision Offers Often-Overlooked Artists." *Star Tribune (Mpls.-St. Paul) Newspaper of the Twin Cities*, September 12, 1990, p. 1E. Exhibit review of *Diversity of Vision: Contemporary Works by African-American Women* at the WARM Gallery. Featured artists included Elizabeth Scott, Joyce Scott and Faith Ringgold.

Robb, Donna. "Students Bring a Little Bit of Africa to Classroom: Seventh-Graders Learn Cultures by Designing Quilt for Black History Month." *Akron Beacon Journal*, February 11, 1996, p. A1.

Rogers, Patricia Dane. "A Bible of Black History." *Washington Post*, March 19, 1992, p. T08. Some quilt authorities outraged to learn that Smithsonian will make Harriet Power's *Bible Quilt* available as a made-in-China reproduction.

_____. "Quilters' Protest Answered: Smithsonian Agrees to Label Imports." *Washington Post*, April 11, 1992, p. G01. Smithsonian responds to protests against the licensing of four of its antique American quilts for reproduction in China. Harriet Power's 1886 *Bible Quilt* is one of the quilts.

_____. "Quilts from the Clinton White House: At an Auction, as a Memento." *Washington Post*, November 14, 1996, p. T05. An African-motif quilt by textile designer Jack Lenor Larsen sold for $3,050.

Rome, Avery. "Peacework." *Philadelphia Inquirer*, February 16, 1992, Features Inquirer Magazine, p. 4. Interview with Roland Freeman.

Rose, Judy. "Pieces of Family History: Quilters Stitch Together Historic Tales of Black Families Settling in Michigan." *Detroit Free Press*, March 3, 1991, p. 1H. Overview of *African-American Quilt Making Traditions in Michigan* exhibit at the Michigan State University Museum.

_____. "Piecing Out African Traditions." *Detroit Free Press*, May 16, 1985, p. 1B. Quilt historian Cuesta Benberry to head workshop at local quilt show.

_____. "Quilts Old and New." *Detroit Free Press*, October 14, 1990, p. 1H. *The African American Quilt and Fabric Exhibition* at the Hartford Memorial Baptist Church has textiles that range from original African fabrics to contemporary quilts interpreting older designs.

Row, D.K. "Reggie Petry." *Oregonian*, October 20, 2000, Arts and Entertainment, p. 6. Interview with art gallery owner Reggie Petry. Mentions quilter Adriene Cruz.

_____. "Sewing and Reaping." *Oregonian*, December 16, 1998, p. B1. Profile of Adriene Cruz.

Sacek, Betty. "Heritage Threaded Through Quilting." *Gary Post-Tribune*, February 10, 1995, p. D3. Quilts owned by Elizabeth Cartwright and Mamie Davis are displayed at the John G. Blank Center for the Arts in Michigan City.

Salmon-Heyneman, Jam. "Black Artists Speak Their Peace with Folk Art." *Birmingham Post-Herald*, March 4, 1987.

Samuels, A. "Making the Transition from Cultural Statement to Macy's." *New York Times*, July 26, 1992. In 1991, U.S. sales of African and African-inspired fabrics are inspired by "afrocentric" fashions.

Sanchez, Mary. "Project Stitches Together Diverse Cultures: Youngster Read Stories, Make Patches About Their Folk Tales." *The Kansas City Star*, March 3, 1994, Zone/Midtown, p.1. Kindergartners through third-graders at Whittier School make quilts in celebration of Black History Month.

Schaden, Herman. "Folklife Festival Catches on with Capital Folks." *Washington Star*, August 6, 1967, p.11. The first Smithsonian Institution Folklife Festival is held. The Freedom Quilting Bee participated.

Schlegel, Sharon. "Reaping as They Sew." *Times* (Trenton, NJ), February 20, 2000, pp. AA, AA8. Profile of Ebony Rainbow Quilters exhibit at the New Jersey State Museum. Moving Tuskegee Airmen commemorative quilt photographed.

Schmitz-Rizzo, Margaret. "Kemper Museum Displays Artist's Keepsakes." *Kansas City Star*, July 5, 2000, p. B4. *Deborah Willis: Tied to Memory* on exhibit at the Kemper Museum of Contemporary Art.

"School by School News." *Fort Worth Star-Telegram*, March 17, 1998, Class Acts, p. 15. Students at Dunbar Sixth Grade Center make a quilt to commemorate Black History Month.

Schottler, Carl. "The Scotts Preserve in Stitches." *Baltimore Sun*, April 13, 1981, p. B1.

Schuckel, Kathleen. "Girls, Women Sew Up Bonds Through Quilts." *Indianapolis News*, August 4, 1995, p. A1. A summer program brings together girls and women to make quilts for poor single mothers.

Schwartz, Valarie. "Carr Court Quilting Exhibit Ties Together Life's Threads." *Chapel Hill News* (SC), February 13, 2000, p. A7. The Carr Court Quilting Circle held its first exhibit in 2000. The group also participated in the Amistad Quilt project.

Seelye, Katharine Q. "Thompson Sextuplets Finally Catch Nation's Attention." *Oregonian*, January 11, 1998, p. A17. USA's first African American sextuplets are ignored until a radio talk show and ministers take up their cause. Quilts are donated.

Selby, Holly. "A Portrait of a Driven 'Genius': By Piecing Together a History of African-American Photography, a Smithsonian Curator Developed a Close-up Look at Black Life—and Won a MacArthur Grant." *Baltimore Sun*, June 25, 2000, p. 3F. Profile of Deborah Willis.

_____. "Quilting Bee as Art Exhibit." *Baltimore Morning Sun*, February 5, 1998, Maryland Live, p. 27. Maryland Institute, College of Art hosts retrospective of Elizabeth Scott's quilts.

_____. "Quilts Have Much to Tell; Art: Barbara Pietila Stitches Together Family Stories With Fabric and Thread." *Baltimore Sun*, July 10, 1999, p. 1E. Interview with quilter Barbara Pietila.

Selix, Casey. "Pieces of Reconciliation: A Quilt Made by St. Peter Claver Rectory Parishioners Will Be Included Aboard a Replica of the Slave Ship Amistad." *St. Paul Pioneer Press*, March 22, 2000, p. 1B.

Seltzer, Anne-Marie. "Freedom Quilts of an Ex-Slave Document a Life." *Harvard Gazette*, March 10, 1989, p. 3., illus.

Sewell, Rhonda. "Designer Anthony Mark Hankins Is an Entrepreneur of Style Climbing Fashion's Ladder." *Blade* (Toledo, OH), April 16, 1998, Living, p. 46. Mr. Hankins' grandmother made quilts.

_____. "Past is Present: Upton Avenue Home Is a Tribute to Black History." *Blade* (Toledo, OH), May 18, 1997, p. E1. Renee Walton's house is decorated in homage to the Blacks of colonial America. The décor includes cotton slave quilts.

Shanahan, Marie K. "Teaching Girls How to Be Their Best." *Hartford Courant*, June 13, 1995, p. B4. Fourth- and fifth-grade girls from Martin Luther King Jr. Elementary School have made three quilts.

Shatzkin, Kate. "Quilts Bind Old, New Customs." *Baltimore Sun*, September 29, 1997, p. 1B. Quilting as a tool for recording African American history attracts younger women who use technology and modern designs. Focuses on members of the African American Quilters of Baltimore, whose quilts sell for $400 to more than $1,000.

Shaw, Karen L. "Authors Unlock Freedom Code in African Slave Quilts: Quilts That Guided Escapes Via Underground Railway Inspire Delray Beach Artist." *Daytona Beach News-Journal*, May 2, 1999, p. 3B. Artists Kim McKinney creates paintings celebrating African American slave quilts.

Shaw-Eagle, Joanna. "African Inspires Beauty in Crafts." *Washington Times*, April 9, 1995, p. D5. *Uncommon Beauty in Common Objects: The Legacy of African American Craft*

Art exhibit at the Renwick Gallery of the National Museum of American Art, Smithsonian Institution.

_____. "Piecing Together a Cultural Fabric." *Washington Times*, October 14, 2000, p. D1. Exhibit review of *Spirits of the Cloth: Contemporary Quilts by African American Artists* at the Renwick Gallery of the National Museum of American Art, Smithsonian Institution.

"Shelby State to Dole Out Honors." *Commercial Appeal* (Memphis, TN), January 25, 2000, p. B2. Shelby State Community College will honor Bertha Bacchus, a quilter whose quilts tell stories of African American history.

Sherrod, Pamela. "Pieces from the Past: Crafting Childhood Mud Pies Has Turned into an Art Form Worthy of Museum Exhibits." *Chicago Tribune*, September 19, 1993, Home, p.1. Artist Marva Lee Pitchford Jolly mentions her mother was a quilter.

Shinn, Dorothy. "Attendance, Sales of Books, Catalogs Soar: 'Faith Ringgold's French Collection and Other Story Quilts' Doing Great Business at Akron Art Museum." *Akron Beacon Journal*, February 1, 1998, p. D7.

_____. "Colorful Quilts Patch Together History: Exhibition Succeeds in Making Link Between African-Americans' Work and Textiles from Africa." *Akron Beacon Journal*, November 15, 1998, p. F4. Exhibit review of *Connecting Threads: African Textiles and the African American Quilt* at the Kent State University School of Art.

_____. "No Hidden Message in Works in Ringgold Quilt Paintings: Fine Akron Show Invites Viewer Understanding." *Akron Beacon Journal*, January 25, 1998, p. D1. Exhibit review of *Dancing at the Louvre: Faith Ringgold's French Collection and Other Story Quilts* at the Akron Art Museum.

_____. "Quilts That Can Warm the Soul: More Artists Find Them Best Means of Expression." *Akron Beacon Journal*, August 1, 1993, p. D4. Exhibit review of *The Old Made New: Story Quilts* by Michael Cummings at the Judith and Clifford Isroff Gallery.

Sidime, Aissatou. "Fabric of Life with Humble Scraps and Colorful Thread, Quilters Weave Magical Tales of Family, Culture and Tradition." *Sacramento Bee*, August 18, 1993, p. SC1. Interviews with several quilters. One subject is Ouida Braithwaite, who helped found the African American Quilters of Los Angeles in 1987.

_____. "Lifting the Veil: The Zora Neale Hurston Festival Features an Exhibit of Works by America's Leading Black Artists." *Tampa Tribune*, January 22, 1999, Baylife, p. 1. Faith Ringgold displays two quilts as part of the *Beyond the Veil: Art of African American Artists at Century's End* exhibit at the Cornell Fine Arts Museum at Rollins College.

Siskin, Diane. "A Quest for Quilts: Former Chattanoogan Bets Ramsey Curates Quilt Exhibit in Nashville." *Chattanooga News Free Press*, February 13, 2000, p. D1. "Passing It On: African American Quilt Making" exhibit features quilts by the late Lillian Beattie.

Skerritt, Andrew. "Seniors Devoted to Saving African Traditions of Quilting." *Herald Rock Hill* (SC), April 5, 2000, News Section. Liberty Hill Missionary Baptist Church *Quilting Bee* group teaches next generation.

Smith, Gail. "Bright Colors, Bright Hopes Fill Children's Art, Quilts." *Charlotte Observer*, February 20, 1991, Mecklenburg Neighbors, p. 14. The Afro-American Cultural Center exhibits quilts.

Smith, Linell. "Sunday Snapshots." *Baltimore Sun*, December 4, 1994, p. 4K. Interview with quilter Carole Yvette Lyles.

Smith, Patricia Beach. "From the Bookshelf: Quilts, Embroidery, Country Cottages." *Sacramento Bee*, September 4, 1993, p. CL10. Book review of *Signs and Symbols: African Images in African-American Quilts*.

"Something from Nothing: Museum of Arts & Sciences Exhibit Shows African-American

Resourcefulness." *Macon Telegraph*, January 22, 1999, Out & About, p. 13. *Make Do: African American Crafts in Central Georgia* exhibit features quilts.

"South Africa Seizes Papers of Journalist, Detained 2nd for Alleged Interference." *Boston Globe*, March 17, 1983. The raid came a day before a South African legislator was to present Winnie Mandela with a quilt sent to her by thirty-three United States Congressmen to replace one confiscated by security police. The confiscated blanket included the colors of the banned African National Congress.

"South African Blacks Implored to Cease Targeting Blacks." *Wichita Eagle-Beacon*, April 28, 1985, p. 3A. Eighty children present TransAfrica with a 10-by-6-foot quilt they had sewn showing their conceptions of South Africa.

"South African Police Seize 2 Journalists' Files." *Philadelphia Inquirer*, March 17, 1983, p. A3. The raid came a day before a South African legislator was to present Winnie Mandela with a quilt sent to her by 33 United States Congressmen to replace one confiscated by security police because it was the colors of the banned African National Congress.

Southerland, Alexis. "Empowering & Enhancing Quality of Life for Black Women: African American Women on Tour in Brooklyn." *New York Beacon*, August 5, 1998, p. 20. In each of the tour's six cities, quilter Jacquelyn Hughes Mooney encourages participants to contribute a quilt square to the tour's Dream Quilt series.

Sozanski, Edward J. "Another Rich Trove of Folk Art This One at the Art Museum to Establish the Roots of the Folk Art, the Curators Included African Textiles." *Philadelphia Inquirer*, February 27, 1994, p. H1. Exhibit review of *Community Fabric: African American Quilts and Folk Art* at the Philadelphia Museum of Art. The show included 61 quilts by 21 quilters.

_____. "Quilts by Slaves: The Imagination Comes Unshackled." *Philadelphia Inquirer*, August 21, 1989, p. E3. Exhibit review of *Stitched From the Soul* at the Museum of American Folk Art.

_____. "Straightforward Images of an American Folk Artist." *Philadelphia Inquirer*, August 26, 1993, p. E2. Exhibit review of *Clementine Hunter: American Folk Artist* at the Afro-American Historical and Cultural Museum.

Spratling, Cassandra. "Detroiter's Work Comes from Love of Quilting, Tradition." *Detroit Free Press*, September 28, 1997, pp. F1, F3. Profiles Ramona Hammonds.

_____. "One Family's Own Freedom Festival: Americans Hold Their Reunion in Canada to Connect to the History of the Underground Railroad." *Detroit Free Press*, July 4, 1999, p. 1G. Reunion includes the auction of a family quilt. Auction proceeds will provide seed money for the next reunion.

Stein, Jerry. "Black Art Expresses Diversity." *Cincinnati Post*, January 9, 1993, p. 1B. *Eight from Atlanta + One* exhibit features quilts from Michael Harris.

Sterling, Dana. "Quilted Tribute: Tulsan Sews Her Love." *Tulsa World*, November 11, 1999, Metro. Retired quilter and art teacher, Lahoma Smith Allen, creates a patchwork quilt filled with African symbols and quotes from James Baldwin, Martin Luther King, Jr. and Sojourner Truth. She gives the quilt to the parents of Jasper, Texan James Byrd, Jr.as a tribute to their son's life.

Stewart, George. "Tustin Woman Seeks Missing Photos of Africa." *Orange County Register*, June 1, 2000, Community, p. 4. Mildred Knapcik is hoping someone will find and return to her the photographs she took of South African women involved in a quilting project.

Stewart, Laura. "Season Openers for Art Usher in Parties, Programs and Receptions." *Daytona Beach News-Journal*, September 8, 1998, p. 2C. Maude Southwell Wahlman presents slides showing quilts she has collected and used as her dissertation topic.

Stone, Sherry. "Penn Teacher Traces Black History Through Quilting." *Philadelphia Tribune*, February 11, 1994, p. 5B.

Stonesifer, Jene. "A Patchwork of Youth." *Washington Post*, June 24, 1993, p. T24. *Sewing Our Stories: Quilts of Urban Youth* exhibit features quilts made by seventh graders at Paul Junior High School.

Stroud, Jerri. "From a Lone Quilter Came a Nationwide Network." *St. Louis Post-Dispatch*, February 2, 2000, p. E1. Carolyn Mazloomi, art quiltmaker.

_____. "Quilt Researcher Will Give Lecture on Black Quilters and Their Contributions." *St. Louis Post-Dispatch*, February 24, 2000, West Post, p. 1. Cuesta Benberry lectures on the diversity of quilts made by Black quilters at the Kirkwood Historical Society.

_____. "Quilts Area Seen as a Way to Build Diversity: Company Group Says it Creates a Supportive Work Environment." *St. Louis Post-Dispatch*, July 6, 1999, p. C6. The African-American Professional Employees Network at Protein Technologies sponsors an exhibit of quilts from employees' families.

_____. "Quilts Celebrate Black-and White Patchwork Pattern of America: Carolyn Mazloomi's Colorful Works Will Visit St. Louis this Month." *St. Louis Post-Dispatch*, February 2, 2000, p. E1. Interview with quilter Carolyn Mazloomi.

"Students' Quilt Lesson Covers It All: Class at Akron's Glover Elementary School Uses Many Skills While Telling its Stories on Comforter." *Akron Beacon Journal*, April 8, 1998, p. B3. Special education students create a quilt as a class project. Teacher inspired by Faith Ringgold story quilts exhibit.

Suzman, Helen. "Dropping In in South Africa: Your Hostess' Bedspread May Be Subversive." *Washington Post*, January 14, 1983, Editorial. South African parliament member describes visit to Winnie Mandela's home while Security Police were raiding the home. A crocheted bedspread in yellow, green and black colors was confiscated.

Tannehill, Carol. "African Americans' Patchwork Heritage Visual Jazz: Bold Patterns and Bright Colors Are Hallmarks of African-American Quilt-Making, a Social Tradition Shared by Generations of Women." *News-Sentinel* (Fort Wayne, IN), January 7, 1995, p. 7SU. *Signs and Symbols: African Images in African American Quilts from the Rural South* exhibit at the Fort Wayne Museum of Art.

_____. "A Mother's Legacy: Stitching Quilts on Long, Lazy Afternoons Is One of Gladys Wilson's Fondest Memories." *News-Sentinel* (Fort Wayne, IN), January 7, 1995, p. 9SU.

Taylor, Kerry. "Quilters Guild Continues Important Tradition." *Gary Post-Tribune*, December 31, 1992, Gary Neighbors, p. 3. The Gary Community Quilters Guild continues an important African-American tradition that predates the Civil War.

Teegardin, Carol. "Sweet Honey Stitches Up a Concert for the Quilt." *Detroit Free Press*, November 18, 1994, p. 3D. A cappella group Sweet Honey in the Rock will perform a special concert to raise money to bring a portion of the AIDS Memorial Quilt to Detroit.

Teeter, Bill. "Students Learn Black History Through Quilting." *Fort Worth Star-Telegram*, February 28, 1996, Metro, p.12. Carroll Peak Elementary School students have designed quilt blocks.

Temin, Christine. "African-American Quilts: Threads of Many Stories." *Boston Globe*, July 5, 1989, Living, p. 27. Exhibit review of *Stitching Memories: African-American Story Quilts* at the Williams College Museum of Art.

_____. "AIDS Through the Eyes of Visual Artists." *Boston Globe*, November 15, 2000, p. G1.

_____. "Quilts Get Their Day in the Sun in 'Stitching Memories' Show." *Wichita Eagle-*

Beacon, July 16, 1989, p. 7E. Exhibit review of *Stitching Memories: African-American Story Quilts* at the Williams College Museum of Art.

Thompson, Laquawn. "Teacher Honors Roots with Art." *Charlotte Observer*, August 27, 2000, p. 2B. Art teacher Beverly Smith creates quilts to tell the stories of her childhood and her culture.

Thompson, Nancy. "Quilters Sew Friendships, Share Stories, Techniques." *Hartford Courant*, July 13, 1997, p. B1. Profile of the Community Renewal Team's Craftery Gallery.

Thornberry, Katherine. "Black Quilters Find a Network: 'Spirit of the Cloth' Exhibition Opens." *San Jose Mercury News*, April 21, 1993, Extra 4, p. 1. Exhibit review of *Spirit of the Cloth: African-American Fiber Artisans* at the American Museum of Quilts and Textiles.

Thorne, Samuel. "Quilter's Labor of Necessity Becomes Fabric of Love." *Atlanta Journal/Atlanta Constitution*, March 6, 1994, Section M, p. 1:4. Features Alabama quilter Mozell Benson.

Thorson, Alice. "Bright Visions of Pain and Hope: Friends, Family, Race Are Emma Amos' Themes." *Kansas City Star*, July 21, 1994, FYI, pp. F1, F2. Review of the 10-year retrospective of *Emma Amos: Paintings and Prints 1982–92*. Amos often incorporated African prints as a quilted-like border in her works.

_____. "The Fabric of Our Lives: Books Trace History Through Quilts and Their Makers." *Kansas City Star*, February 21, 1997, p. E3.

_____. "'Mending a Broken Heart' with Art." *Kansas City Star*, December 18, 1998, Preview, p. 32. Exhibit review of quilter and artist Saundra C. Newsom's *Mending a Broken Heart* show at the Massman Gallery.

_____. "The Patchwork Memory of African-American Culture: Kemper Quilt Exhibit Looks at Racial Images and Their Origins." *Kansas City Star*, May 28, 2000. Pp. I1, I3. Exhibit review featuring Deborah Willis.

_____. "Up and Comers: Fresh Talents Emerging on the KC Scene." *Kansas City Star*, April 20, 1997, Star Magazine, p. 10. Seven Kansas City residents in the Arts are profiled. NedRa Bonds, a quilter, is featured. She is photographed in front of her quilt *Get Off Me*, depicting a Black woman hanging from a lace cross and reaching for a brass ring.

Toppman, Lawrence. "Afro-American Breaks Artistic Silence." *Charlotte Observer*, June 30, 1996, p. 4M. The Afro-American Cultural Center exhibits *Evidence of a Culture: Breaking the Silence*.

_____. "Gallery Features African American Artists in Show." *Charlotte Observer*, February 8, 1998, p. 2M. Kate Merrill and Susan Jennings celebrate Black History Month by turning over their gallery space to African-American artists. Quilts by Beverly Smith featured.

"Travelers' Calendar." *Denver Post*, February 1, 1998, p. T3. The Institute of Texas Culture exhibits *Heritage of a Stolen People: African American Story Quilts*.

Trebay, Guy. "Painted Story Quilts." *Village Voice*, January 27, 1987.

Tuhus, Melinda. "The Freedom Trail: A Giant Quilt Pays Tribute to People United in the Cause of Justice." *New York Times*, October 4, 1998, Connecticut Weekly Desk. Community effort to create commemorative quilt.

Tuynman, Carol. "Red Piano Too Celebrates Daily Life with Southern Summer Show." *Lowcountry Weekly* (St. Helena Island, SC), July 26–August 8, 2000. Artist Cassandra Gillens works on a series of twelve paintings of quilts named after family and friends.

Tyson, Janet. "Diamond-Quality Quilts: Never Mind the Pennant Race, These Baseball Fans Are Always on Pins and Needles." *Fort Worth Star-Telegram*, September 24, 1998, Life & Arts, p. 1. *Grand Slam: 20th Century Baseball Quilts* on exhibit at the Legends

of the Game Baseball Museum. *To Warm the Heart and Brighten the Spirit: Quilts and Their Stories* and *Quilts and Coverlets: Off the Bed and on the Wall* are two exhibits at the Dallas Museum of Art.

Umrigar, Thrity. "Quilts for the Ages: Black History Is Told to Some Local Families as They Unfold Colorful Quilts." *Akron Beacon Journal*, January 25, 1998, p. D1. Local quilters Debra Calhoun, Annie Green and Beatrice Mitchell are featured.

"Uncovering Artists—Local African-American Quilters Show Off Work at Tubman." *Macon Telegraph*, August 27, 1999, Out & About, p. 13. Review of *Home Quilts: African-American Quilts from Central Georgia* exhibit at the Tubman African American Museum.

"Up Front: Recommendations to Maximize Your Fun." *Sarasota Herald-Tribune*, April 23, 1999, Ticket, p. 3. Derek Washington's quilts on display at USF/New College campus. Article includes photograph.

Vanaman, Joyce. "Preserving History: Two Sisters Tell Story of Slavery with Their Quilts." *Press of Atlantic City*, February 26, 1994, P. C1. Kathleen Lindsey and Phyllis Walker perform *A Stitch in Time* program.

Van de Water, Ava. "Out of Africa: Home Furnishings Take a Cultural Cue from Clothing Designers, Are Making Colorful Splashes with Themes." *Press-Enterprise* (Riverside, CA), December 18, 1993, p. G1. Article mentions J.C. Penney's *African Origins* collection, which includes quilt wall hangings.

Varner, Lynn K. "Patchwork of Passion." *Seattle Times* (Northwest Weekend Insert), March 6, 1998, p. D4. Includes quilt by Lynette Gallon-Harrell.

Vaughan, John. "In Search of Cultural Artifacts: N.C. Museum of History Committee Stymied in Its Effort to Acquire Collectibles of Everyday African-American Life." *Charlotte Observer*, February 20, 1994, p.1B. Museum's African American Artifacts Search Committee seeks items. Ella Williams-Vinson donates two quilts made by her mother.

Voell, Paula. "Amherst Colony Museum Is Set for Arrival of Southern Quilters." *Buffalo News*, May 10, 1992, p. E2. *Quilts and All That Jazz*, a popular biennial show at the Amherst Colony Museum features quilts from Tutwiler, Mississippi. Quilts sold at prices from $170–$250.

Wallace, Lance. "African-American Art Show Enters Final Week." *Macon Telegraph*, March 29, 1999, p. A3. Exhibit review of *Make Do: African-American Crafts in Central Georgia* at the Museum of Arts and Sciences in Macon. Wini McQueen was the curator. Quilts by Fannie Toliver were included.

Wayne, Renee Lucas. "Quilts: The History Books You Can Sleep Under." *Philadelphia Daily News*, February 1, 1994, p. 30. Interview with researcher Cassandra Stancil.

Webb, Jo Ann. "Stitched in Bondage." *Chicago Tribune*. October 1, 1989, Home Section, pp. 18+.

Weintraub, Karen. "A 40-Foot-by-10-Foot Message to South Africa." *Philadelphia Inquirer*, October 8, 1989, p. B5. Forty foot by ten foot "wall of freedom" fabric panels constructed by the Burlington County chapter of Amnesty International to be mailed to Archbishop Desmond Tutu.

"Wellness Calendar." *Indianapolis Star/Indianapolis News*, August 12, 1999, p. F2. African American females who have survived cardiovascular disease or stroke are invited to participate in the American Heart Association's new educational program. Participants will design and create a Heart and Soul quilt.

"What's Up." *Denver Post*, February 19, 1996, p. E1. In honor of Black History Month, Koelbel Library will exhibit quilts created by members of the Rocky Mountain Wa Shonaji Quilt Guild.

"What's Up." *Denver Post*, January 2, 1997, p. D1. Twenty-four quilts made by six African

American women will be on display at the Aurora History Museum from January 7 to March 30, 1997 to commemorate the Rev. Martin Luther King Jr.'s birthday.

Whiting, Sam. "Crossroads Café Showcases African Quilts: U.S. Woman Starts Business for Artisans." *San Francisco Chronicle*, December 9, 2000, p. B1. Aminata Brown starts a business that employs twelve "kaya yo" as artisans making blankets.

Williams, Edgar. "Seamstress Sets Her Seal to Quilt." *Philadelphia Inquirer*, April 22, 1988, p. B6. Quilter Lorraine Mahan presents quilt Mayor Goode. The *First Black Mayor of Philadelphia* quilt is the thirty-first Mahan has given away. The quilt includes the Goode family tree.

Williams, Mara Rose. "Handmade Quilt Tells Freedom Story." *Kansas City Star*, March 4, 1999, Zone/Independence, p. 1. Teacher Jan Keeler makes a quilt similar to the one featured in the children's book *Sweet Clara and the Freedom Quilt.*

Williams, Mike, and Cassandra Spratling. "Atlanta Bestows Doctorates by the Dozens." *Detroit Free Press*, June 29, 1990, p. 2D. Nelson Mandela accepts thirty honorary doctoral degrees in a form of an eight foot by ten foot quilt onto which are woven the emblems of various colleges.

"Work of the Colored Women." *New York Times*, June 10, 1893. Review of needleworks by Black women at the 1893 World Columbian Exposition, including quilts.

"Works by Black Quilt-Makers Provide More Than Warmth." *Lexington Herald-Leader*, November 4, 1992, p. B1. Exhibit at Museum of the American Quilter's Society.

Young, Nellann. "Local Role in Underground Railroad to Be Explored." *Knoxville News-Sentinel*, August 7, 2000, p. A4.

Zimmer, William. "Black History Examined Through Myriad Patterns." *New York Times*, February 21, 1999, p. 16. Profile of needlework folk artist Denise Allen.

Zuckerman, Dianne. "Sew Show: Exhibit Highlights Work of Eclectic Quilters' Guild." *Denver Post*, September 18, 1998, p. E30. Rocky Mountain Wa Shonaji Quilt Guild exhibit.

DISSERTATIONS, THESES AND PAPERS

Beardslee, Karen Elizabeth. *Folk-Whole: The Bond Between Selfhood and Cultural Tradition in Contemporary American Literature.* Ph.D Diss. Temple University, 1998. AAG9910987. Examined texts include Whitney Otto's *How to Make an American Quilt* and Harriet Beecher Stowe's *The Minister's Wooing.*

Bickford, Kathleen E. *Knowing the Value of Pagne: Factory-Printed Textiles in Cote d'Ivoire.* Ph.D Diss. Indiana University, 1995. This paper is divided into two parts. The first reviews the history of textile trade and merchants in Cote d'Ivoire to date. The second part looks at Ivoirian consumers, especially women, and how they name the fabrics and the role the fabrics play in projecting wealth.

Biggers, John T. *The Negro Woman in American Life and Education: A Mural Presentation.* Dissertation. Pennsylvania State University, 1954. A black woman quilting is shown in the mural.

Blodin, Jill E. *The African-American Quilt Experience as Cultural Regionalism.* M.A. thesis. University of Illinois at Urbana-Champaign, 1996. OCLC: 37975291.

Brooks, Cheryl Melody. *Nineteenth and Early Twentieth Century African American Women's Quilt-Making: A Communicative Perspective.* M.A. thesis. Howard University, 1997. OCLC: 39949194.

Campbell, April. *Mrs. Arester Earl, Black Quilter.* Senior Essay, Yale College, 1978.

Cassel, Valerie Jean. *African-American Quilts—Legacy and Ethos: A Semiological Analysis.*

M.A. thesis. Howard University, 1992. This is a study of the African American quilt as a repository of African aesthetics and cultural expressions. Looks at the African American quilt as a European-American decorative tradition, which was embraced and redefined by African captives in America. Illustrations included.

Coleman, Janice. *Meditating Upon Means: The Black Seamstress in Nineteenth-Century American Literature.* Ph.D Diss. The University of Mississippi, 1998. This study is a response to Alice Walker's collection of essays in *In Search of Our Mother's Garden.* The focus is on the Black seamstress as artist, as marginalized figure, as storyteller, and as member of sewing circles in nineteenth-century American literature. AAG9921126.

Crawford, Lawrence. *A Twentieth Century Bricoleur.* Yale College, 1978.

DeVaul, Diane Louise. *Motherwork—Quilts and Art: A Material Culture Study.* Dissertation. University of Maryland, College Park, 1998. One section includes comparisons between a group of art quilters and a traditional quilt-style group. African American Dorothy Holden was involved in the art quilt group.

Elman, Erin. *A Stitch in the Canon: A Discussion of Five Contemporary Artists Who Have Been Influenced by Feminism.* M.A. thesis. The University of the Arts, 1997. Analyzes the relationship between feminism and contemporary art through a discussion of five artists who employ 'women's work' to explore issues of personal identity related to gender, race, class, ethnicity, and sexuality. Includes a historical evaluation of the 1970s feminist movement and critical artists, such as Faith Ringgold, who provide a context for examining the ways in which functional arts associated with needlework, knitting, sewing and materials associated with domesticity are employed by contemporary artists. AAC1384261.

Elsley, Judith Helen. *The Semiotics of Quilting: Discourse of the Marginalized.* Ph.D Diss. University of Arizona, 1990. Focuses on the quilting process as a paradigm for women finding their own voices when more traditional forms of communications—speaking and writing—were not freely available. Uses *The Color Purple* to help illustrate model. AAC9100040.

Farrington, Lisa A. *Faith Ringgold: The Early Works and the Evolution of the Thangka Paintings.* Ph.D Diss. City University of New York, 1997. Examines Faith Ringgold's early paintings from 1956 to 1973, in particular the thangka landscapes—the Feminist Series (1972) and the Slave Rape Series (1972–73). Links are made between the thangka period and Ringgold's later story quilts. AAG9720089.

Franklin, Delner. *Aunt Onie's Quilt.* Paper. Yale College, 1978.

Gunkel, Cassandra S(tancil). *Quilts and the Politics of Representation.* Paper. Presented at the African American Women's Institute 1999 conference at Howard University, Washington, DC.

Hardy, Frances Lee. *Quilting: An Autobiographical Inquiry into African American Women "Stitching Together" the Pieces to Educate Adolescent Black Females in Terms of Kinship, Voice and Creativity.* Ed.D Diss. University of South Carolina, 1998. AAG9918929.

Hazard, Peggy Jean. *Comforts of Home: African-American Quilts in Tucson, Arizona.* M.A. thesis. University of Arizona, 1993. Investigates influences on black quiltmaking aesthetics: African influences, quilt history, economics, mass media. Examines quilts by six contemporary African American women in Tucson, Arizona. AAG1352368.

Hess, Janet Berry. *Paternational, Community and Resistance: The African American Quilt.* M.A. thesis. University of Iowa, 1992. Explores the place of quilting traditions by American slaves.

Holmes, Peter. *Alice Bolling and the Quilt Fence: Afro-American Quilting in Rural Virginia.* Student Paper. Yale College, 1977.

Hunter, William R. *The Quilting of Culture: The Depiction of African American Community in the Novels of Gloria Naylor.* Ph.D Diss. Purdue University 1993. AAC9420847.

Irving, Sharon. *African-Canadian Quilts of Southern Ontario 1840–1920.* M.A. thesis. Cooper-Hewitt, National Design Museum and Parsons School of Design, 2000.

Krouse, Mary Elizabeth. *Gift Giving and Social Transformation: The Aids Memorial Quilt as Social Movement Culture.* Ph.D Diss. Ohio State University 1993. Researches the NAMES Project AIDS Memorial Quilt as social movement culture. It focuses primarily on the quilt's effects on the gay communities from which it originated. The work also examines the writings of African American women regarding their experiences with AIDS. AAC9325533.

Landsmark, Theodore Carlisle. *"Haunting Echoes": Histories and Exhibition Strategies for Collecting Nineteenth-Century African American Crafts.* Ph.D Diss. Boston University, 1999. Examines three private collections featuring 19th Century African American Crafts—Old Slave Mart Museum in Charleston, Acacia Collection in Savannah, and traveling exhibit Sankofa. AAT9923995.

Lerner, Loren. *A Cultural Illness: Women, Identity and Eating Problems in Faith Ringgold's "Change" Series.* M.A. thesis. Concordia University (Canada), 1999. AAT MQ43675.

Littrell, Mary Ann. *Ghanaian Wax Print Textiles: Viewpoints of Designers, Distributors, Sellers, and Consumers.* Ph.D Thesis, Purdue University, 1977.

Mason, Phillip Lindsay. *Cultural Influences on the Art and Crafts of Early Black American Artisans (1649–1865) Towards Implications for Art Education.* Ph.D Diss. The Ohio State University, 1983. The study examples cultural influences on the decorative arts and painting of early Black American artisans as a curriculum resource in art education. Categories include woodcarving, basketry, furniture-making, pottery, quilting, and painting. AAG8311776.

McDonald, Mary Anne. *Because I Needed Some Cover: Afro-American Quiltmakers of Chatham County, North Carolina.* M.A. thesis, University of North Carolina at Chapel Hill, 1985.

Nielsen, Ruth. *The History and Development of Wax-Printed Textiles Intended for West Africa and Zaire.* Master's Thesis. Michigan State University, 1974.

Parisi, Dominic. *Conversations with Black Women Who Live and Quilt in Eastern Kentucky.* M.A. thesis, Afro-American Studies, Yale University, 1979.

Phipps, Rebecca. Unpublished research in African American quilting in the Kansas City metro area. Phipps is a former curator at the Wyandotte County Historical Society and Museums (Bonner Springs, KS). She also curated the annual Black Heritage Quilt Show in 1999–2000 at the Wyandotte County Historical Museum. This annual exhibit celebrating African American quilts in the Kansas City area started in 1989.

Plumer, Cheryl. *African Textiles; An Outline of Handcrafted Subsaharan Fabrics.* East Lansing, MI: African Studies Center, Michigan State University, 1970.

Przybysz, Jane Ellen. *Sentimental Spectacle: The Traffic in Quilts (Quiltmaking, Craft History).* Ph.D Diss. New York University 1995. Explores how women have used quilts to negotiate historically specific class, gender, and civic identities. AAI9609236.

Richardson, Jeri Pamela. *The Freedom Quilting Bee Cooperative of Alabama: An Art Education Institution.* Ed.D Diss. Indiana University, 1969. Survey of the Freedom Quilting Bee Cooperative. AAG7007982.

Roach, Margaret Susan. *The Traditional Quiltmaking of North Louisiana Women: Form, Function, and Meaning.* Ph.D Diss. University of Texas, Austin 1986. Examines patchwork quilt form, function and meaning. Based on fieldwork with over forty rural north Louisiana White and Black women with various quiltmaking experience. Also uses Alice Walker's short story "Everyday Use" as a literary model. AAG8700267.

Shepard, Suzanne Victoria. *The Patchwork Quilt: Ideas of Community in Nineteenth Century American Women's Fiction*. Ph.D Diss. State University of New York at Binghamton, 1995. Patchwork-quilt fiction uses realistic detail, with metaphors such as the hearth, home, kitchen, garden and the quilt to express feminine ideas about community. AAI9528051.

Stancil, Cassandra A. *Nancy Riddick's Quilts: A Model for Contextualizing African American Material Culture*. Ph.D Diss. University of Pennsylvania 1995. Examines African American material culture using twenty surviving quilts of Nancy Hughes Riddick (1869–1966), the daughter of a former slave and free woman. Demonstrates the dynamic ways black communities were stratified along belief and class lines from Reconstruction through modern Civil Rights era. AAI9532284.

Standefer, Richard Manning. *A Separate Piece: "Difference" and the Black Aesthetic in the Historiography of the Slave-Made Quilt*. University of Delaware, 1995.

Taylor, Carrie E. *Patchwork of Diversity: African-American Quilts in the South Carolina Quilt Survey*. Master's thesis. (School unknown), Dept. of History: Museum Studies, December 1994. Paper seeks to draw conclusions from the 113 African American quilts identified in the South Carolina Quilt Survey conducted by the McKissick Museum in 1983. Women who met at the James Island Senior Citizen Nutrition Program created many of the quilts from Charleston County, SC.

Thompson, Joann. *The Quilt as a Product of Meaning Making in a Middle School Classroom*. Ph.D Diss. University of South Carolina, 2000. Students from three historically Black public schools make a quilt to illustrate their schools' history. AAT 9969529.

Twining, Mary. *An Examination of African Retentions in the Folk Culture of the South Carolina and Georgia Sea Islands*. Ph.D Diss. Indiana University, 1977.

Wahlman, Maude Southwell. *The Art of Afro-American Quiltmaking: Origins, Development and Significance*. Volumes I, II and III. Ph.D Diss. Yale University 1980. Seven traits that seem to distinguish African American quilts from the Anglo-American tradition: 1) an emphasis on vertical strips; 2) bright colors; 3) large designs; 4) asymmetry; 5) improvisation; 6) multiple-patterning; and 7) symbolic forms. AAG8300050.

Woods, Yolanda. *New World African Conjurers Who Edify and Heal the Community*. Ph.D Diss. University of Missouri, Columbia, 2000. Hood's paper attempts to "read" the quilts and quilting production of four African American women from the Midwest within a Womanist theoretical framework. The quilters profiled include NedRa Bonds, Kyra Hicks, Edna Patterson-Petty, and Sherry Whetstone-McCall. AAT9974639.

Wyche, Evangeline. *Black Women as Artists in the Southern United States: The Quilts of Tommie McMullen*. Paper. Yale College, 1978.

Young-Minor, Ethel A. *"To Redeem Her Body": Performing Womanist Liberation (Zora Neale Hurston, May Miller, Ntozake Shange, Anna Deavere Smith)*. Ph.D Diss. Bowling Green State University 1997. This study reconsiders African American female voices in performance. Places the contemporary voice in an artistic lineage that begins with non-traditional performance space—including the legacy of Harriet Powers' *Bible Quilt*. AAG9820930.

GRANT PROGRAMS

The National Quilting Association, Inc., a non-profit organization established in 1970, awards grants annually to encourage organizations, institutions, chapters, and individuals to pursue and further quiltmaking through education, craftsman-

ship and documentation. Grant applications are due October 15. Applications are available by sending a SASE to:

The National Quilting Association, Inc.
Grant Program
P.O. Box 393
Ellicott City, Maryland 21414-0393
(410) 461-5733 email: nqa@erols.com

Selected National Quilt Association Grant and Scholarship program recipients with projects related to African American quilting, quilters, or quiltmaking include:

1995 • "She Sews What She Knows: Memories Wrapped In a Quilt"—a video project focusing on African American quilters by Esperanza G. Martinez and Linda Roennau, New York City.
1996 • "African Skies and Southern Soil—An Autobiographical/Cultural Documentation Narrative Quilt Series" by Peggie Lois Hartwell. Ten quilt series to record, in fabric, her childhood in South Carolina, the farm experience, African American churches, recreation and folk customs.
1997 • "Monograph on African-American Quilter Lorraine Mahan—Research and Text Preparation" by Dr. Cassandra Stancil Gunkel. In-depth interview with Mrs. Mahan and historical research in the communities where she has lived. Mrs. Mahan is one of seventy-five quilters Dr. Gunkel has documented since 1994 as primary researcher of the South Eastern Pennsylvania African-American Quilt Project.
 • "Research of African-American Quilting Groups and Guilds" by Christina E. Johnson, Philadelphia, PA. In-depth research into at least twenty-five African American quilting groups by interviewing and photographing members and their quilts.
1998 • "Many Cultures and One Art"—a quilt exhibit by 70-member Central Kentucky Homemaker Quilt Guild, Frankfort, KY. Exhibit celebrating the multi-cultural environment in Kentucky—with a focus on African American culture and Japanese quilts. The exhibit was held March 1998 at Kentucky State University in Frankfort.
2000 • "African American Quilt Bibliography and Survey" by Kyra E. Hicks.
 • "Quilt Panel Making Workshops at Historically Black Colleges and Universities" by the Names Project Foundation—AIDS Memorial Quilt. The AIDS Quilt toured fifteen historically Black colleges and universities to promote AIDS and HIV infection awareness.

Quilter's Guild of Dallas, Inc.—Endowment Project Grant Program—funds projects that will have a long-term impact on preserving the heritage and art of quilts and quilt making. Grant applications are due by December. In March the grant committee awards the funds. For an application, send a SASE with two first-class stamps to:

Endowment Committee—Quilter's Guild of Dallas
c/o Ruth Cottrell
1113 Westbrook Drive
Irving, TX 75060-3535

Selected past grants recipients with projects related to African American quilting, quilters, or quiltmaking include:

1993 • Award to Jack Brockette and Jacob Hani for a project with the Dallas Independent School District to include quilt making in the curriculum with other subjects such as math. One curriculum component connects quiltmaking with African American heritage in poetry and art.

TELEVISION, VIDEOS, FILMS AND SLIDES

Alabama Experience: With Fingers of Love. 30 minutes. University of Alabama Center for Center for Public Television, No date. Video. Features the Freedom Quilting Bee of Wilcox County Alabama. Video can be purchased for $21, shipping included, from The University of Alabama Center for Public Television, PO Box 870150, Tuscaloosa, AL 35487 or by calling 1-800-463-8825. A grades 9–12 teacher guide on *With Fingers of Love* by Carolyn Hales is available at www.cptr.ua.edu/alex/studyguides/fingers.htm. [Web site accessed September 9, 2001.]

Armstrong, Linda Connelly (director). *Nellie's Playhouse.* 14 minutes. Memphis, TN: Center for Southern Folklore. No date. Color VHS video and 16mm film. Profile of folk artist Nellie Mae Rowe.

Astro Video Services (producers). *American Art Forum— "African American Art"— Program #403.* This national PBS-TV weekly series originated in Chicago, IL. This segment included interview with quilt historian Cuesta Benberry and Dr. Schroeder Cherry, of the Baltimore Museum of Art, who taught art to children using African American puppets he created. The original broadcast date of program was September 25, 1990.

Crosby, David and Patricia Crosby (ill.). *Teacher's Guide to Crossroads Quilters: Stitching the Community Together.* Atlanta, GA: Southern Arts Federation, n.d. (1999). This 28-page guide is available for $5.00 plus shipping from Mississippi Cultural Crossroads, 507 Market Street, Port Gibson, MS, 39150. Telephone: 601-437-8905.

Crumlish, Rebecca (director). *The Silver Needle: The Legacy of Elizabeth and Joyce Scott.* 30 minutes. Washington, DC: Osiris Production, 1990. Video.

Doblmeier, Martin (producer/writer). *Creativity: Touching the Divine.* 60 minutes. Alexandria, VA: Journey Films, 1994. Video. Explores how people from various fields, diverse ethnic and spiritual background experience the divine roots of creativity. Includes profile of quilter Carole Y. Lyles. Video can be purchased online at JourneyFilms.com for $19.95.

Faith Ringgold. 6 minutes. New York: Random House, 1991. Color video, sound.

Feast for the Soul. This video documentary includes an interview with quiltmaker Sandy Benjamin-Hannibal.

Ferrero, Pat. *Hearts and Hands: A Social History of Nineteenth-Century Women and Quilts.* 58 minutes. San Francisco, CA: Ferrero Films, No date. 16mm and video. Includes profiles on Harriet Tubman and Elizabeth Keckley.

_____. *Quilts in Women's Lives.* 28 minutes. San Francisco, CA: Hearts and Hands Media Arts, 1979. 16mm and Video. Interview with seven quilters, including Nora Lee Condra, an African American quilter from Mississippi.

Ferris, Bill (producer). *Made in Mississippi— Black Folk Arts and Crafts.* 20 minutes. Yale University Media Design Studio, 1975. Video. Artists and craftspeople, including quilter, discuss their work and how each learned the tradition.

Ferris, William, Jr., and Judy Peiser (interviewers). *Four Women Artists.* 25 minutes. Memphis: Center for Southern Folklore, 1977. 16mm film. Includes interviews with artists

from Mississippi—quilter Pecolia Warner, writer Eudora Welty, painter Theora Hamblet, embrodierer Ethel Mohamed. Center for Southern Folklore, PO Box 226, Memphis, TN 38101. Phone: (901) 525-3655.

Freeman, Linda (producer). *Faith Ringgold Paints Crown Heights.* 28 minutes. Distributed by Home Visions, L & S Video Enterprises, Chappaqua, New York. 1995. Color video, sound.

_____. *Portrait of an Artist Faith Ringgold: The Last Story Quilt.* 28 minutes. Distributed by Home Visions, L & S Video Enterprises, Chappaqua, New York. 1991. Color video, sound. To order, contact Linda Freeman at L & S Productions. Phone: (914) 238-9366.

Goldsmith, Jan T., and John O. Goldsmith (producers). *Not Your Usual Black History Special.*, 43 minutes. Naples, FL: Goldsmith Productions, 1991. Videocassette. First show in the *Picture This America* series. Discusses achievements and contributions by American Blacks. This video features segments on boxer Joe Louis, early black filmmakers, actor Todd Duncan, the Civil War Colored Regiment and slave quilts.

Harriet Powers: Afro-American Quilt, 1895–1898. Set of 20 slides. Museum of Fine Arts, Boston. Available for $40.00 online at http://store.yahoo.com/mfa/095a.html.

Heiser, Steve (Director). *Missing Pieces: Contemporary Georgia Folk Art.* 28 minutes. Portland, OR: Odyssey Productions for the Georgia Council for the Arts and Humanities, 1976. Includes references to two Harriet Powers quilts.

Killen, Rosemary (producer). *Tar Beach with Faith Ringgold.* 15 minutes. Distributed by Scholastic, New York, 1994. Color video, sound.

Martinez, Esperanza, and Linda Roennau (producers). *The Cloth Sings to Me.* 16 minutes. Video, 1995. Distributed by Filmmakers Library, 124 East 40th Street, New York, New York 10016. Phone: 212-808-4980. The video features "ebullient women quilters who display their colorful creations." Includes interviews with textile historian Floris Cash, art historian Willis "Bing" Davis and quilters Valerie Jean Bailey, Hazel Blackman, Adrienne Cruz, Marcia Goldman, Peggie Hartwell, Betty Leacraft, Mary McAllister, Aline Moyler, and Marlene O'Bryant-Seabrook.

_____. *Memories Wrapped in a Quilt.* Approximately 15 minutes. Video, 1993. Briefly history of African American quilting. Interviews with Michael Cummings, Peggie Hartwell, Betty Leacraft, and others.

_____. *The Spirit of the Individual.* 22 minutes. Video, 1997. Distributed by Filmmakers Library, 124 East 40th Street, New York, New York 10016. Tel: 212-808-4980. Features quilters Michael Cummings and Peggie Hartwell.

McDaniel, Akua (writer and producer). *Bearing Witness: Personal Interviews with Contemporary African American Women Artists.* Atlanta, GA: Spelman College, 1996. Video.

_____. *In the Spirit of the Cloth: Spelman Faculty and Staff Quilt Stories.* Atlanta, GA: Spelman College, 1998. Video.

McMorris, Penny (producer). *Quilting II.* (A production of WBGU-TV) Bowling Green, OH: Bowling Green State University, 1982. This was a 13-part TV program series that had an accompanying Guide book. Both Guide and individual program videos can be purchased. Program #9—"Afro-American Quilts" featured Cuesta Benberry, Gladys-Marie Fry and Maude Wahlman. See pp. 53–57 in the Guide.

Most, Caroline, Erika Pafumi, and Roderick Hawkins (co-producers). *Uncommon Threads.* Student video for course entitled "Long Format Video Production," Louisiana State University, Professor Robert McMullen. Fall 1996. Documentary featuring Baton Rouge quilter Anna Williams.

Mrs. Powers and Miss Smith: A Film on Southern Cultural History. A dramatic film for public television and non-theatrical use. No date. Possibly available from the Visual Press at the University of Maryland, College Park. A September 22, 1994 *Bay State Banner*

article (p. 4b) says the film is about Harriet Powers and Jennie Smith, the woman who recorded Powers' quilt descriptions.

The Piecemakers: Portraits of African American Quilters. 28 minutes. Video features an oral history interview with four Black quilters from the Mississippi Delta region: Amanda Malone of Holly Springs, MS; Nora Ezell of Greene County, AL; Ruby Adams of Etta, MS; and Yvonne Wells of Tuscaloosa, AL.

Piper, Sean (writer and producer). *Puttin' on the Massa*. Unfinished 35mm short film as of July 23, 2000. Play about a black slave's quest for freedom through the use of secret code quilts.

Quilting: The Fabric of America. Produced for Better Homes and Gardens, Meredith Publications, Des Moines, IA by Walter J. Klein Co. Ltd., 6311 Carmel Road, Charlotte, NC 28211-2087. Video includes interview with quilt historian Cuesta Benberry.

Quilts Like My Mama Did. The McKissack Museum Folk Arts Program produced both a video and slide-audiotape presentation featuring African American quilters from the Pawley's Island area of South Carolina.

The Quilts of Wini McQueen. Museum of Arts & Sciences video, 1988. Akua McDaniel contributed to "Critique of Wini McQueen: Family Tree Quilt" segment.

Reading Rainbow, a PBS-TV program series for children. *The Carousel*. Video hosted by LeVar Burton. *The Carousel* by Liz Rosenberg is about two sisters who search for memories about their mother. Burton also explores other ways children share the legacies passed on to them. Quilter Peggie Hartwell explains the process of making a quilt and tells how she is passing the tradition on to her grandniece.

Reading Rainbow, a PBS-TV program series for children. *The Patchwork Quilt*. 30 minutes. Video hosted by LeVar Burton. *The Patchwork Quilt* by Valerie Flournoy is narrated by Isabel Sanford. Burton also features children at the Boston Children's Museum learning to make patchwork quilts.

Simply Quilts— "Designs with Dye" Program #430. Featured Cuesta Benberry, who explains the importance of proper quilt care and Anita Holman Knox, who demonstrates how to create designs with dye and wax, 1998. Weller Grossman, producer. *Simply Quilts* is a TV series shown on the Home and Garden Cable Network.

Simply Quilts— "Underground Railroad Clue Quilts" Program #540. Featured *Hidden in Plain View: A Secret Story of Quilts and the Underground Railroad* co-author Jacqueline Tobin and quilter Serena Wilson.

Stitch in Time: History of Quiltmaking in West Virginia. Video, 20 minutes, 1995. Available from WSWP TV, P.O. Box AH, Beckley, WV 25802, 1-800-278-1290. Tape is $12.00. Includes profile of an African American quilter Claire Carter of Gap Mills, WV. She shares memories and quilts from her grandmother Mariah June Ross Dunlap (1863–1954).

Wood, Peter, and Richard Ward (producers). *Afro-American Tradition in Decorative Arts*. 20 minutes. New Perspectives. Durham, NC: North State Public Video, 1987. Video. Quilting, pottery, metal-works, basketry, and woodcarving are featured. North State Video, PO Box 3398, Durham, NC 27702 Phone: (919) 682-7153.

SPEECHES, PLAYS AND MUSIC

Armah, Esther. "Sewing Up Family Matters." *The Weekly Journal*, February 23, 1995, p. 15. American writer Michael Miller's play, *A Patchwork Quilt,* opens at the Polka Theatre in Wimbledon London (UK). The children's play covers four generation of a Black family.

Bembry, Celeste Lea. *Glory! In the House.* Live recording featuring soprano soloist Ms. Bembry at Westminster Presbyterian Church, Los Angeles, CA, June 9, 1996. Cassette cover art features *Boxes #2*, quilt by Kyra Hicks.

Benberry, Cuesta. "Before *Always There*: Its Historical Underpinnings." 1994 speech. Reprinted in *Expanding Quilt Scholarship: The Lectures, Conferences and Other Presentations of Louisville Celebrates the American Quilt.* Shelly Zegart and Jonathan Holstein, eds. Louisville, KY: The Kentucky Quilt Project, Inc., 1994, pp. 87–92.

Clark, Chris. *Untitled Quilt.* On *Laser's Edge American Sampler*, Homeweek, AL: Laser's Edge, 1999. The cover art for this jazz sampler CD features an appliquéd quilt of a Black couple dancing by folk artist Chris Clark. Laser's Edge, 2825 18th Street South, Homewood, AL 35209.

"Cuesta Benberry Accepts Induction into Quilter's Hall of Fame." *Quilter's Newsletter Magazine*, issue 159, February 1984, p. 23. Reprint of Benberry's acceptance speech. She is the fourteenth member inducted.

Howell, Jr., Gene. *Augusta Lee.* Unpublished play, 1998. This play, set in 1937, is a re-telling of the "Arachne" myth from the viewpoint of a 19-year-old Black woman. The play takes place in a hidden valley named "New Thebes" in Arkansas, between Pine Bluff and Cedar Serious. Community members include African Americans and Native American (Osage) veterans from WW1. A staged reading of this play took place in August 1999 at Venue 9, San Francisco, CA. Playwright Howell is re-writing the play as of 2000.

In Process (musical group). *In Process*, Washington, DC, 1990. Recording of songs based on African American oral traditions. Includes song "Patchwork Quilt." Recorded at Masterworks Studio, Farifax, VA.

Jackson, Jesse. 1988 Democratic Convention. Keynote Address. July 19, 1988 at the Democratic Party Convention in Atlanta, GA. "Excerpts from Jackson's Speech: Pushing Party to Find Common Ground." *New York Times*, July 20, 1988, p. A18.

> Common Ground. America is not a blanket woven from one thread, one color, one cloth. When I was a child growing up in Greenville, South Carolina, my grandmama could not afford a blanket, she didn't complain, and we did not freeze. Instead she took pieces of old cloth—patches, wool, silk, gabardine, crockersack—only patches, barely good enough to wipe off your shoes with. But they didn't stay that way very long. With sturdy hands and a strong cord, she sewed them together into a quilt, a thing of beauty and power and culture. Now, Democrats, we must build such a quilt.

Jones, Abe B. "Gate City Actress Brilliantly Brings Three Roles to Life." *Greensboro News & Record*, February 16, 1990, Weekend, p. 16. Local ensemble performs Alice Walker's *Everyday Use.*

Jones, Carridder. *The Faded Quilt.* This play involves three generations of women, including the matriach who passes along the family's story of moving from slavery to freedom. The play's title is a metaphor for aging. The play was performed at the University of Louisville (KY) on June 13, 1999.

Jones, Shannon Lenora. "*Harriet's Return*: Claremont Students Attended Play." *Precinct Reporter*, March 12, 1998, p. A3. Actress Debbie Allen stars in a one-woman play about Harriet Tubman. One scene involves Harriet Tubman making a quilt to win the heart of her husband-to-be.

Kennedy, Sharon. *The Patchwork Quilt & Other Stories from Around the World*, Rounder Kids CD 8080, 1998. The headline recording is a story about a sister searching for her twin during slavery time.

King, Coretta Scott. "Launching of the Historically Black Colleges and Universities AIDS Memorial Quilt Initiative." Keynote Address. Woodruff Library—Atlanta University Complex, Atlanta, GA, October 18, 1999. King speaks about the AIDS health crisis in America and Africa. She also fondly remembers the quilts her mother made. King also mentions contributing to one of the AIDS Memorial Quilt panels for a close friend who died of the disease. A transcript of the speech is available from the AIDS Memorial Quilt Web site at http://www.aidsquilt.org/Newsite/pr_corettakhbcu.htm. [Accessed September 9, 2001.]

Masullo, Robert A. "*Ma Rose* Weaves a Rich Family Tapestry." *Sacramento Bee*, March 23, 1990, p. SC3. *Ma Rose* play features three generations of Black women. A 100-year old quilt is referenced in the play. Cassandra Medley is playwright.

Meadows, Karen Jones, playwright. *Harriet's Return: A Tale Based Upon the Life of Harriet Tubman*. This biographical drama follows Tubman from childhood to old age. In one scene, a local conjure woman suggests Harriet take a piece of fabric from John Tubman's clothing and sew the fabric into the center of a quilt in order to catch John as a husband. The quilt would bind the two in marriage.

Miller, Cathy. *One Stitch at a Time*, Music CD, 2000. This Canadian songwriter has created an all-quilting song CD. "Follow the Stars to Freedom" is a song inspired by the quilts slaves used to follow the Underground Railroad into Canada and freedom. To order the CD, contact Cathy Miller, 1464 Cranbrook Place, Victoria, British Columbia, V8P 127, Canada. Or, read more at http://www.nucleus.com/~cmiller/onestitch.htm. [Accessed September 9, 2001.]

Sweet Honey in the Rock. "Patchwork Quilt." Lyrics and music by Michelle Lanchester, 1992. On *Down in the Delta* soundtrack, Virgin Records America Inc., 1998.

_____. "Patchwork Quilt." On *In This Land* recording, EarthBeat! Records, 1992.

Walker, Alice. "Watch for Me in the Sunset or the Color Purple." In *The Same River Twice*, pp. 60–136. New York: Scribner, 1996. First screenplay written by Walker for the motion picture production of *The Color Purple*. Quilting is a more promient activity in this screenplay than in the final film version.

Washington, Booker T., "The Atlanta Cotton States' Exposition Address of 1895." In *The Booker T. Washington Papers: The Autobiographical Writings*, vol. 3. Harlan, Louis R., ed., Urbana: University of Illinois Press, 1972, pp. 583–587.

> Gentlemen of the Exposition, as we present to you our humble effort at an exhibition of our progress, you must not expect overmuch. Starting thirty years ago with ownership here and there in a few quilts and pumpkins and chickens... remember the path that has led from these to the inventions and production of agricultural implements, buggies, steam-engines, the management of drug stores and banks, has not been trodden without contact with thorns and thistles.

Well, Shelley Kies. "Interview with Anna Williams." Oral history taped April 1998. Transcript available from the T. Harry Williams Oral History Center, Louisana State University.

FICTION AND POETRY

Beecher Stowe, Harriet. *The Minister's Wooing*. New York: Derby and Jackson, 1859. Chapter 30 "Quilting."

"The Century Quilt." In *Afro-American Writing Today: An Anniversary Issue of the Southern Review*, ed. James Olney. Baton Rouge: Louisiana State University Press, 1985. Poem.

Church, Teresa L. "Piecing Yesterdays for Today and Tomorrow." In *Sauit Mpya: The Literary Journal of the Black Cultural Center*. Chapel Hill, NC: University of North Carolina, Spring 2001. Church's poem was inspired by her maternal grandmother's quilt blocks, which Church found when visiting her family home in 1990, nearly two decades after her grandmother passed away. Church is also a quilter.

Clark, Beverly. *The Price of Love*. Columbus, MS: Genesis Press, Inc., 1999. Indigo Sensuous Love Stories. Brenda Davis tries to overcome a painful past when attorney Gil Jackson enters her life. Brenda works at the local fabric store called the Quilt Lodge.

Clifton, Lucille. *Quilting: Poems 1987–1990*. Brockport, New York: BOA Editions Ltd., 1991.

Colcock, Erroll Hay. *De Patch-Wu'k Quilt*. Unpublished, 1970. Fictional story of South Carolina plantation life before and after the Civil War. The story is narrated by a Black woman and written entirely in Gullah. The story can be ordered from the South Carolina Historical Society, 100 Meeting Street, Charleston, SC 29401.

Dash, Julie. *Daughters of the Dust*. New York: Viking Penguin, 1997.

Dixon, Melvin. "Aunt Ida Pieces a Quilt." In *Brother to Brother: New Writings by Black Gay Men*. Boston: Alyson Publications, Inc., 1991, pp. 145–147. Poem.

Dunbar, Paul Laurence. "The Quilting" poem. In *The Complete Poems of Paul Laurence Dunbar*. Apollo Edition. New York: Dodd, Mead & Company, 1913.

Forman, Ruth. "Venus' Quilt." In *360° A Revolution of Black Poets*, eds. Kalamu ya Salaam and Kwame Alexander, pp. 66–67. New Orleans: Black Words/ Runagate Press, 1998.

Giovanni, Nikki. "Hands: For Mother's Day" poem. In *The Selected Poems of Nikki Giovanni*, pp. 245–247. New York: William Morrow and Company, Inc., 1996.

_____. "My House" poem. In *My House*. New York: William Morrow and Company, Inc., 1972.

_____. "Stardate Number 18628.190" poem for *Essence* magazine's 25th anniversary issue. In *The Selected Poems of Nikki Giovanni*, pp. 19–20. New York: William Morrow and Company, Inc., 1996.

Hamilton, Betsy. "The Quiltin' at Old Mrs. Robertson's." *Harper's Weekly*, February 1884.

Harper, Michael, and Anthony Walton, eds. *Every Shut Eye Ain't Asleep: An Anthology of Poetry By African Americans Since 1945*. New York: Little, Brown & Co, 1994. Cover of book features quilt by Faith Ringgold.

Hausman, Gerald, and Kelvin Rodriques. *African-American Alphabet: A Celebration of African-American and West Indian Culture, Custom, Myth, and Symbol*. New York: St. Martin's Press, 1996. See Q—Quilt on pp. 141–144. Includes poem by Terri Lynne Singleton "We Call Your Name, Harriet Powers."

Heidish, Marcy. *A Woman Called Moses: A Novel Based on the Life of Harriet Tubman*. Boston: Houghton Mifflin Company, 1976. Includes references to a quilt made by Harriet Ross and John Tubman on pp. 87, 105, 106–108, and 149.

Hemphill, Essex. "When My Brother Fell." In *Brother to Brother: New Writings by Black Gay Men*. Boston: Alyson Publications, Inc., 1991. Poem.

Here to Dare: 10 Gay Black Poets, ed. Assotto Saint. New York: Galiens Press, 1992. Book cover features quilt detail by Michael Cummings.

Hopkins, Pauline Elizabeth. *Contending Forces: A Romance Illustrative of Negro Life North and South*. Reprint of 1900 edition. Carbondale: South Illinois University Press, 1978. Chapter 8 is entitled "The Sewing Circle."

Jahannes, Ja Arthur. "Hand Me Down My Mother's Work." 1990. Roland Freeman commissioned the poem. He also designed a quilt based on the poem. Full text for the poem appears in *Communion of the Spirits* on page 109.

Jenkins, Beverly. *Vivid*. New York: Avon Books, 1995. In this romance novel, Dr. Vivid

Lancaster, a black doctor in 1876, sets up practice in Niles, Michigan. She must over-
come objections from Mayor Nate Grayson and the "Quilt Ladies."

Martin, Reginald. *Dark Eros: Black Erotic Writings*. New York: St. Martin's Griffin, 1997.
Book cover features *Jo Baker's Birthday* quilt by Faith Ringgold.

McMillan, Terry. "Quilting on the Rebound." In *Calling the Wind: 20th Century African-
American Short Stories*, pp. 597–608. New York: Harper Perennial, 1993. Also in *I Hear
a Symphony: African Americans Celebrate Love*, eds. Paula Woods and Felix Liddell,
pp. 34–49. New York: Doubleday, 1994.

McPherson, Sandra. *Beauty in Use*. West Burke, VT: Janus Press, 1997. Illustrations by
Claire Van Vliet. Limited edition, handmade poem book. $450. Includes several poems
inspired by African American quilters and quilt. Poems include: *Ester Mack's Utility
Quilt with the Light in It, Mrs. Longmire Builds a Picket Fence Quilt & Talks to It, Black
Quilt from the 60's, Tents of Armageddon Quilt, Black Improvisation, 1980s* and *Cen-
ter: Strip and Medallion Quilt, 1890 by Mrs. Longmire.* These poems can be read on-
line from U.C. Davis' literary e-magazine *Spark*, issue 4, June 1998. See interview with
McPherson on http://wwwenglish.ucdavis.edu/Spark/issue4/sandyint.htm. Look at
"Back Issues" section for poems. [Accessed September 9, 2001.]

_____. "Center: Strip and Medallion Quilt, 1890, by Mrs. Longmire, African-American
Seamstress for Her Town in Maryland." *Kenyon Review* vol. 12, no. 4, Fall 1990, pp.
71–73. Two poems included.

_____. *The God of Indeterminacy: Poems*. University of Illinois Press, 1993. Quilt by Yvonne
Wells on cover. Poems include *Holy Woman: Pecolia Warner* and *Willia Ette Graham's
Infinity Log Cabin Quilt, Oakland, 1987.*

Mitchell, Felicia, ed. *Words and Quilts: A Selection of Quilt Poems*. Quilt Digest Press, 1996.
This book contains photos of quilts by Ida Jacobs, Sarah Mary Taylor and Yvonne
Wells.

Moore, Lenard D. "Homage to the Quiltmaker—for L. Teresa Church." Circa 1999. Unpub-
lished poem created as an assignment given to the Carolina African American Writ-
ers' Collective (CAAWC).

Morrison, Toni. *Beloved*. New York: Alfred A. Knopf, 1987. Seth, an escaped slave, is
haunted by the spirit of her two-year old daughter, Beloved, who Seth kills rather than
see her also enslaved. In the book Seth, Beloved, and Baby Suggs work together on an
orange-colored quilt and strengthen their relationship together.

Naylor, Gloria. *Mama Day*. New York: Vintage Books, 1989. One scene describes Mama
Day and Grandmother Abigail making a double wedding-ring quilt from family cloth-
ing scraps for Cocoa and George.

Nelson, Alice Dunbar. "I Sit and Sew" poem. In *Caroling Dusk: An Anthology of Verse by
Negro Poets*, ed. Countee Cullen, p. 73. New York: Harper & Brothers, 1927.

Newsome, Mary Effie Lee (1885–1979). "The Quilt" poem. In *Caroling Dusk: An Anthology
of Verse by Negro Poets*, ed. Countee Cullen, p. 58. New York: Harper & Brothers, 1927.

Otto, Whitney. *How to Make an American Quilt*. New York: Villard Books, 1991. Novel about
the friendships of women involved in a sewing group. This novel was made into a major
motion picture (1995) staring Maya Angelou, Winona Ryder and Alfre Woodard.

Perry, Phyllis Alesia. *Stigmata*. New York: Hyperion. 1998. The story of Elizabeth DuBose,
a black woman from Alabama, who has endured fourteen years in various mental hos-
pitals. Her "mental illness" stems from being possessed by long-dead family members
after she receives a quilt made by her grandmother.

Peterkin, Julia. *Black April*, Indianapolis, New York: Bobbs-Merrill, 1927, See chapter XIII
for "The Quilting" pp. 159–179. A novel about South Carolina plantation life. May
also have been published by Grosset and Dunlap, New York.

Price, Nelson. "Emulating Riley Brings Senior Writer Recognition." *Indianapolis Star,* November 5, 1999, p. E1. Article excerpts a portion of 82 year old Glenda Walker's poem *Quilt-Stompin' Time.*

Reed, Ishmael, and Al Young. *Quilt.* Berkeley, CA: The Authors, 1981. Compiled fictional works. Published volumes 1–5. Quilt is used as a cultural symbol.

Reynolds, Betty. *Quilts, Quilters, Quilting, and Patchwork in Fiction in Adult Fiction.* Bibliography. The book list has been an ongoing project since 1995. The twenty page listing is available online at http://www.nmt.edu/~breynold/quiltfiction_adult.html. [Accessed September 22, 2002.]

Ringgold, Faith. "The Street Story and Quilt." *Shooting Star Review* vol. 2, no. 2, Summer 1988, pp. 19–22. Short story.

Rollston, Adelaide R. "Mammy Hester's Quilts." *Harper's Bazar,* August 24, 1889, p. 614. This story was reprinted in Benberry's & Crabb's *A Patchwork of Pieces: An Anthology of Early Quilt Stories, 1845–1940.*

Saint, Assoto. *Spells of a Voodoo Doll.* New York: Masquerade Books, Inc., 1996. Collection of black gay poetry. Includes poem *The Quilt.*

Scott, Avery. "The Quilt of the Negro." Poem. Reproduced on http://PoeticPen.virtualAve.net/quilt.html. [Accessed August 20, 2002.]

Sedgwick, Miss. C.M. "The Patch-Work Quilt." *The Columbian Lady's and Gentleman's Magazine,* March 1846. Reprinted in *A Patchwork of Pieces: An Anthology of Early Quilt Stories 1845–1940.*

Seiblers, Timothy. "A Quilt in Shades of Black: The Black Aesthetic in Twentieth Century African American Poetry." In *A Profile of Twentieth Century American Poetry,* eds. Jack Myers and David Wojahn, pp. 158–189. Carbondale: Southern Illinois University Press, 1991.

Shockley, Evie. "The Quilter—for L. Teresa Church." Circa 2000. Unpublished poem created as an assignment given to the Carolina African American Writers' Collective (CAAWC).

Smith, Effie Waller. "The Patchwork Quilt." In *Rosemary and Pansies.* Boston: Gorham Press, 1909. This poem is also available at http://www.WomenInKentucky.com. Click on the Literature section. [Accessed August 20, 2002.]

Walcott, Derek. *The Caribbean Poetry of Derek Walcott & the Art of Romare Bearden.* New York: Limited Editions Club, 1983. Walcott is a Nobel Prize winner poet. Bearden personally designed the silkscreen fabric for the book cover. Limited edition size of 2,000.

Walker, Alice. "Everyday Use." In *In Love and Trouble: Stories of Black Women,* pp. 47–59. New York: Harcourt Brace Jovanovich, 1973. Story about a mother and two sisters. A patchwork quilt is used to symbolize how each woman sees the world.

_____. *The Color Purple.* New York: Harcourt Brace Jovanovich, 1982. Quilting theme is threaded throughout the novel. In fact, Celie makes a *Sister's Choice* quilt.

Walker, Margaret. *Jubilee.* Boston: Houghton-Mifflin, 1966. This slave narrative novel was inspired by Walker's own family history. The novel sold more than one million copies. In chapter 54, six quilts are completed in a quilting party scene.

CHILDREN'S BOOKS

Bial, Raymond. *With Needle and Thread: A Book About Quilts.* Boston: Houghton-Mifflin, 1996. See pp. 38–39 for African American quilting section. Includes photo of Pauline Pelmore of Champaign, IL with a satin quilt.

Edelman, Marian Wright. *Stand for Children*. New York: Hyperion Books for Children, 1998. Wright is the president and founder of the Children's Defense Fund. A version of Edelman's "Stand For Children" speech at a 1996 rally at the Lincoln Memorial is presented in this book. Adrienne Yorinks has illustrated each page with various photo transfer and appliquéd quilts.

Edwards, Pamela Duncan, and Henry Cole (ill). *Barefoot: Escape on the Underground Railroad*. New York: HarperCollins Juvenile Books, 1999. Ages 4–8. A boy, escaping from slavery, is helped by animals in the forest, including fireflies that light up a quilt hanging outside a safe house.

Evert, Jodi, ed., *Addy's Craft Book*. Middleton, WI: Pleasant Co., 1994. Includes pattern for appliquéd pillow featuring a black girl jumping rope. Book includes photo of a Harriet Powers *Bible Quilt*.

Flournoy, Valerie, and Jerry Pinkney (ill.). *The Patchwork Quilt*. New York: Dial Books for Young Readers, 1985. Using scraps cut from the family's old clothing, Tanya helps her grandmother make a beautiful quilt. When her grandmother falls sick, Tanya and other family members work together to complete the quilt.

Giovanni, Nikki, and Larry Johnson (ill.). *Knoxville, Tennessee*. New York: Scholastic, Inc., 1994. Story based on a poem about enjoying summer. The book cover features a young girl sitting on a blue quilt.

Greenwood, Barbara, and Heather Collins (ill.). *The Last Safe House: A Story of the Underground Railroad*. Buffalo, New York: Kids Can Press Ltd., 1998. Fictional story of a St. Catharines, Canadian family whose lives are changed when they are asked to help young Eliza Jackson escape from slavery. Book includes cookie and dollmaking instructions. Scrap quilting is mentioned in the context of sewing.

Grifalconi, Ann. *Osa's Pride*. Boston: Little, Brown & Co., 1990. Osa's grandmother tells her a tale about the sin of pride and helps Osa gain a better perspective on what things are important. An appliquéd blue cloth is a key element in the story.

Grimes, Nikki, and Ashley Bryan (ill.). *Aneesa Lee and the Weaver's Gift*. New York: HarperCollins Children's Book Group, 1999. Thirteen interrelated poems celebrate a girl's love of weaving.

Haskins, Francine. *Things I Like About Grandma*. San Francisco: Children's Book Press, 1992. A young black girl tells of her close relationship with her grandmother—includes quilting session with grandmother. Haskins's vibrant illustrations include many patchwork-like designs.

Holt, Kimberly Willis, and Leonard Jenkins (ill). *Mister and Me*. New York: Putnam Publishing Group, 1998. Touching novel about Jolene, a young girl who works through her difficulties of accepting "Mister," the man her mother will soon marry, by making a quilt. Appropriate for ages 9–12.

Hopkinson, Deborah, and James Ransome (ill.). *Sweet Clara and the Freedom Quilt*. New York: Alfred A. Knopf, Inc., 1993. Young Clara, a slave and seamstress on Home Plantation, pieces together a scrap quilt that is also a map to escape to freedom. The book also includes easy instructions for making maps.

Hurmence, Belinda. *Slavery Time When I Was Chillun*. New York: G. P. Putnam's Sons, 1997. Narrative stories sometimes include references to quilting among the slaves.

Johnson, Dolores. *Now Let Me Fly: The Story of a Slave Family*. New York: Aladdin Paperbacks, 1993. Fictionalized account of the life of Minna, kidnapped as a girl in Africa, as she endures the harsh life of a slave on a Southern plantation in the 1800s and tries to help her family survive. At the story's end, Minna tells of teaching her last child, Kate, to "make beautiful quilts" and continue to dream of freedom.

Johnston, Tony, and James E. Ransome (ill). *The Wagon*. New York: Tambourine Books,

1996. A young slave boy dreams the wagon he's helped build is a glorious freedom chariot. Abraham Lincoln is portrayed as a troubled soul who "(s)ees the Country ripped to rags, as if two furious folks was tugging at a beautiful quilt."

Jonas, Ann. *The Quilt*. New York: Greenwillow Books, 1984. A young Black girl's new patchwork quilt recalls old memories and provides nighttime adventures.

Kordich, Diane D., Jennifer Fiore, and Stevie Kack. *Images of Commitment: Faith Ringgold*. Crizmac, 1994.

LoPinto, Celia, ed. *Stitch Me a Story: A Guide to Children's Books with a Quilting Theme*. Self-published. 3044 Franklin Street, San Francisco, CA 94123. 1994, updated and expanded edition 1999. This 74 page guide lists over 120 summaries of children's books.

McGill, Alice, and Michael Cummings (ill). *In the Hollow of Your Hand: Slave Lullabyes*. Boston: Houghton Mifflin, 2000. Each song is accompanied by Michael Cummings' quilted illustrations. Book includes a 13-song CD.

McKissack, Patricia, and Fredrick McKissack. *Christmas in the Big House, Christmas in the Quarters*. New York: Scholastic, 1994. Historically based story of Christmas from two viewpoints during slave times. Among gifts given to slave children were hand-sewn items such as quilts (p.43, p.66). Includes full-page painting of children sleeping on a pallet covered with a patchwork quilt (p. 47). Illustrated by John Thompson.

McKissack, Patricia, and Jerry Pinkney (ill.). *Mirandy and Brother Wind*. New York: Alfred A. Knopf, 1988. To win first prize in the Junior Cakewalk, Mirandy tries to capture the wind for her partner. One attempt is to capture Brother Wind by throwing a quilt over him. Beautiful watercolor patchwork quilt illustrations.

McKissack, Patricia, and Scott Cook (ill.). *Nettie Jo's Friends*. New York: Aldred A. Knopf, 1989. Nettie Jo needs a sewing needle to make a new dress for her rag doll, Annie Mae. Nettie Jo seeks assistance from Miz Rabbit, Fox, and Panther.

Mitchell, Rhonda. *The Talking Cloth*. New York: Orchard Books, 1997. Pre-School/Early Reader. Aunt Phoebe shares the origin of adinkra cloth with her young niece, Amber.

Myers, Walter Dean. *At Her Majesty's Request: An African Princess in Victorian England*. New York: Scholastic Press, 1999. See p. 79 for a reference to the Princess' sewing skills and to her making slippers for Prince Albert and Queen Victoria.

Nicholas, Evangeline, and Diana Magnuson (ill.). *These Old Rags*. Bothell, WA: Wright Group, 1997. A young girl learns family history from a patchwork quilt.

Petry, Ann. *Harriet Tubman: Conductor on the Underground Railroad*. New York: Thomas Y. Crowell, 1955. See chapter 9 "The Patchwork Quilt" for description of quilt Harriet Tubman made in anticipation of her wedding.

Pomerantz, Charlotte, and France Leesac (ill.). *The Chalk Doll*. New York: JB Lippincott, 1988. Endearing story of a mother relating her Jamaican childhood to her daughter. The mother and daughter end the story by handsewing a cloth doll.

Porter, Connie, and Dahl Taylor (ill.). *Addy's Wedding Quilt*. Middleton, WI: Pleasant Company Publications, 2001. Addy makes a wedding quilt for her parents, who plan a church wedding even though they "jumped the broom" while slaves.

Reynolds, Betty. *Quilts, Quilters, Quilting, and Patchwork in Fiction for Children and Young Adults*. Bibliography. The book list has been an ongoing project since 1995. The twenty-plus page listing is available online at http://www.nmt.edu/~breynold/quiltfiction_kids.html. [Accessed September 9, 2002.]

Ringgold, Faith. *Aunt Harriet's Underground Railroad in the Sky*. New York: Crown Publisher, 1992. With Harriet Tubman as her guide, Cassie, retraces the steps escaping slaves took on the Underground Railroad. On her trip, Cassie is to look for a safe house with a star quilt out front. She is soon reunited with her brother, Be Be, on the one hundredth anniversary of Harriet Tubman's first trip to freedom.

_____. *Dinner at Aunt Corrine's House*. New York: Hyperion Books for Children, 1993. The story is based on Ringgold's 1986 *The Dinner Quilt* story quilt.

_____. *Tar Beach*. New York: Crown Publishers, 1991. A young girl, Cassie Louise Lightfoot, dreams of flying above her Harlem home, claiming all she sees for herself and family. Based on the quilt *Tar Beach* by Faith Ringgold. The quilt is in the collection of the Solomon R. Guggenheim Museum, New York.

_____. *Tar Beach Book and Doll Package*. New York: Crown Publishers, 1994. Package includes 32-page miniature hardcover book and 13-inch cloth Cassie doll with knitted hair and removable clothing.

Ringgold, Faith, Linda Freeman and Nancy Roucher. *Talking to Faith Ringgold*. New York: Crown Publishers, 1995.

Rosales, Melodye. *'Twas the Night B'fore Christmas: An African-American Version*. New York: Scholastic Inc., 1996. A retold version of a holiday classic by Rosales, who also illustrated book. Patchwork and log cabin quilts are included in many scenes, including Santa climbing down the chimney with "(a) big quilt-wrapped bundle." A must-have for your holiday family reading.

Rutberg, Becky. *Mary Lincoln's Dressmaker: Elizabeth Keckley's Remarkable Rise from Slave to White House Confidante*. New York: Walker & Co., 1995. Appropriate for grades 6 to 10.

Scott, Ann Herbert. *Big Cowboy Western*. New York: Lothrop, Lee & Shepard Co., Inc., 1965. Five year old Martin receives a cowboy hat and a holster with two silver guns for his birthday. He pretends to tame the West by shooting at an old red quilt hanging from one apartment balcony.

Sills, Leslie, and Ann Fay, eds. *Inspirations: Stories about Women Artists: Georgia O'Keeffe, Frida Kahlo, Alice Neel, Faith Ringgold*. Albert Whitman, 1988. 56 pages. For ages 9 to 12.

Sinnott, Susan. *Welcome to Addy's World: 1864*. Middleton, WI: Pleasant Company Publications, 1999. Book describes condition of African Americans in the North and South during and immediately after the Civil War. Sections of interest include pp. 16–17 *Mrs. Lincoln's Dressmaker*; pp. 32–33 *Religion*, which includes photo of Harriet Powers' *Bible Quilt*; pp. 56–57 *Mending the Nation Piece by Piece*, which features Faith Ringgold's *The Sunflowers Quilting Bee at Arles* quilt.

Sterling, Dorothy. *Freedom Train: The Story of Harriet Tubman*. New York: Doubleday & Company, Inc., 1954. Harriet Ross dreams of making a quilt as colorful as one her mother made (p. 23). Later Ross makes a quilt soon after she marries John Tubman (p. 53). Harriet Tubman takes the quilt with her when she runs away to freedom and leaves it as a gift to a Quaker woman, who helps her to escape (p. 62).

Stroud, Bettye, and Felicia Marshall (ill.). *Down Home at Miss Dessa's*. New York: Lee & Low Books, 1996. In 1940s South, two young sisters care for an elderly neighbor, Miss. Dessa. The girls spend the day enjoying many activities, including assisting Miss. Dessa in making a quilt for her daughter in New York.

Vaughan, Marcia, and Larry Johnson (ill.). *The Secret of Freedom*. New York: Lee & Low Books, 2001. Great Aunt Lucy tells how she and her brother, Albert, learned to read codes in quilts on a journey to escape slavery.

Willard, Nancy and Tomie dePaola (ill.). *The Mountains of Quilt*. New York: Harcourt Brace Jovanovich, 1987. Four Magicians lose their magic carpet, which eventually finds its way into the center of a grandmother's quilt. One of the magicians is The Magician of the Mountains of Detroit—a Black child.

Wood, Michele. *Going Back Home: An Artist Returns to the South*. San Francisco: Children's Book Press, 1996. Written by Toyomi Igus. Wood's illustrations are strongly influenced by quilting and patchwork designs.

Wright, Courtni C., and Gershom Griffith (ill.). *Journey to Freedom: A Story of the Underground Railroad*. New York: Holiday House, 1994. Joshua and his family, runaway slaves from a tobacco plantation in Kentucky, follow Harriet Tubman on the Underground Railroad to freedom. At one point, a quilt hanging outside on a porch railing signals that the house is "safe" for the runaways.

TEACHERS' GUIDES AND CURRICULA

African and African American Resources at the Smithsonian. Free brochure available by calling (202) 357-2700 or sending an e-mail message to viarc.info@ic.si.edu includes references to Harriet Power's Bible Quilt.

Alabama Experience: With Fingers of Love. Video about the Freedom Quilting Bee group. A teacher's guide for grades 9–12 for the video *With Fingers of Love* by Carolyn Hales is available at www.cptr.ua.edu/alex/studyguides/fingers.htm. [Accessed September 9, 2001.]

Blandy, Doug, and Elizabeth Hoffman. "Resources for Research and Teaching about Textiles as a Domestic Art." *Art Education* vol. 44, no 1, January 1991, pp. 60–71. Includes resources for teaching about Navajo weaving and African American quilting.

Brown, Elsa Barkley. "African American Women's Quilting: A Framework for Conceptualizing and Teaching African American Women's History." Describes the qualities of African-American quilts. Explains how to organize a classroom to reflect the polyrhythmic structure of the African American culture and its quilts. In *Black Women in American: Social Science Perspectives*, Chicago: University of Chicago Press, 1990. Also found in *Signs: Journal of Women in Culture and Society*, vol. 14, #4, 1989, p.921-929.

Crosby, David. *Teacher's Guide to Crossroads Quilters: Stitching the Community Together*. Atlanta, GA: Southern Arts Federation. Teacher's guide to quilting as a folk tradition. Includes Hystercine Rankin's memories of learning to quilt as a child. Available for $5 from the Mississippi Cultural Crossroads, 507 Market Street, Part Gibson, MS 39150. Phone 601-437-8905.

Dangelas, Sarah. *Quilting in American Culture*. Course Curriculum. 1999. Proposed graduate course syllabus by University of Maryland, College Park Ph.D. student. The course topics include overview of quilting history, creolization and identity, quilts as women's work, quilting as community, national quilt projects, quilts as art, and quilt scholarship. Several examples of African American quilting are included. The curriculum, course schedule and assignments are available at http://www.wam.umd.edu/~dangelas/school/quilture/syllabus.html. [Accessed September 9, 2001.]

Goldsmith Production. *Slave Quilts: Stitched from the Soul Lesson Plan*. Lesson plan to accompany quilting segment in "Not Your Usual Black History Special" from the Picture This America video series. Plan available at http://www.ptamerica.com/quilts.htm. [Accessed September 9, 2001.]

Hill, Doris A. *From Bondage to Freedom: A Story Told in Art*. Course Curriculum. Education and Computer Connection Newsletter. Proposed program for middle school students. Links to various Web sites featuring African American visual arts as well as quilting. See http://www.nvo.com/ecnewletter/frombondagetofreedom/. [Accessed September 9, 2001.]

Roach, Susan. "Documenting Quiltmaking." *The Louisiana Folklife Program*, 1999. Folklorist provides step-by-step insights into collecting information on quilters, the quilt,

and quiltmaking process. This four-page document is available at http://www.crt.state. la.us/folklife/main_documenting_quilt.html. [Accessed September 9, 2001.]

Robeson, Patricia King. *Geography—Economics Lessons—Sweet Clara and the Freedom Quilt.* Montgomery County Public Schools (MD), 1996. This fifth-grade lesson plan includes references to slavery, the Underground Railroad, and map making. This plan includes downloadable worksheets for students and is available at http://www.mcps.k12.md.us/ curriculum/socialstd/grade5/sweet_clara.html. [Accessed September 9, 2001.]

Sherertz, Sylvia. *The Art of the Quilt.* Yale-New Haven Teachers Institute 1995. 12 p. Contents of Curriculum Unit 95.04.04 include the history of quiltmaking, African connections in quilting, Harriet Powers, examples of quiltmaking in the African American community, and making your own story quilt. There is an art activities component to each topic. Visit http://www.cis.yale.edu/ynhti/curriculum/units/1995/4/95.04.04. x.html. [Accessed September 9, 2001.]

Starry Crown. Course Curriculum. North Texas Institute for Educators on the Visual Arts, 1999. Lesson plan based on John Biggers' *Starry Crown* painting, which relies heavily on quilting visual cues. Plan is available at http://www.art.unt.edu/ntieva/artcurr/ african/starry2.htm. [Accessed September 9, 2001.]

Stephens, Reggie. *Quilt.* Lesson plans based on *Quilt,* a 1900 African American quilt by a member of a Georgia family named Drake. The quilt is in the permanent collection of the High Museum of Art in Atlanta. The eleven-page lesson plan is for grades five through middle school. Copy available from the museum.

INTERNET AND DIRECTORY RESOURCES

As early as 1993, I have been communicating with other African American quilters across the U.S. via the Internet. From 1994–1996, I was involved with a now defunct Prodigy discussion group devoted to African American quilting. We often participated in fabric swaps and round robins. Today there are several Web sites and discussion groups with information on African American quilting. Each Web site and discussion group listed below was accessed September 9, 2001, unless otherwise noted.

Discussion Groups

African American Art Quilters—http://groups.yahoo.com/group/AAartquilt. This discussion group shares information on techniques, marketing, exhibition opportunities in art shows, galleries, museums, and other topics of interest. Quilter and author Carole Y. Lyles moderates this discussion group, which was founded December 13, 1998. Registration, while free, is required to post messages.

African American Quilters—http://forums.delphi.com/AAQuilters/start. A discussion group for African American quilters addressing design, fabric, and other topics of interest. This group started January 3, 2000 and appears to have exisited for only one year.

African American Quilters—http://clubs.yahoo.com/clubs/africanamericanquilters. Discussion group for African American quilters, quilt enthusiasts, and fiber artists to share ideas, advice, photos, and swap fabrics. Juanita, who started the discussion May 17, 1999, moderates the board.

America Online—African American quilting bulletin board can be found following the

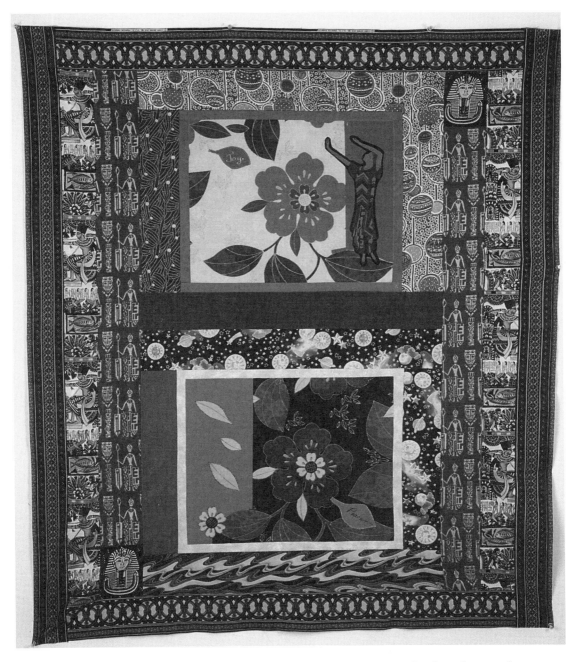

Prodigy African Core Progressive Quilt Top, 1994. Cotton fabrics. Glenda Coleman of Forestville, MD, organized a five-round progressive. Each participant received at the end of the progressive a unique quilt top based on the progressive's instructions. No two tops were alike. Collection of the author. Photograph by David Smalls.

path: Lifestyles, Ethnicity, African American Message Boards, Arts, Entertainment and Sports, African American Quilters. [Web site accessed February 25, 2001.]

Black Cloth Doll Making—http://groups.yahoo.com/group/blackclothdollart. Discussion group for African American cloth dollmakers. Shares insights for creating, sculpting, and costuming cloth dolls as well as tips for finding appropriate skin colors, hair, and face painting techniques shared. Angela Huggins founded this group on November 13, 1998. Some doll makers are also quilters. Registration is required to post messages.

H-Quilts—http://www2.h-net.msu.edu/~quilt/. H-Quilts is a moderated Internet discussion forum dedicated to providing an exchange of information about quilting research and documentation. At times, there are discussions around topics involving African American quilting. H-Quilts is affiliated with the Alliance for American Quilts and the American Quilt Study Group. Registration is required to participate.

QuiltEthnic Bulletin Board—http://www.quiltethnic.com/wwwboard/wwwboard.shtml. Post your questions or messages about multi-cultural quilting topics. No registration is required.

General Information

African American Interactive History Quilt—http://exit3.i-55.com/~delzie/. Deborah Elzie has created a virtual alphabetical quilt where one can click on a letter and explore aspects of black history. Click on "R" and link to Faith Ringgold's website.

Amistad Friendship Quilt Project 1999–2000—http://www.mc.cc.md.us/Departments/amistad/. Mary Staley, from Montgomery College's Art Department (Takoma Park, MD), organized the national Amistad Friendship Quilt Project. The site highlighted samples of the hundreds of quilt blocks sent in for the bunks on the newly constructed *Amistad* schooner. The site also provided links to more information about the Amistad Incident of 1839. [Web site under construction as of September 9, 2001.]

Friends of Freedom Society—Underground Railroad Quilt—http://www.fofs-oura.org/quilt.htm. Site of the Ohio Underground Railroad Association. Visit the site to see both an underground railroad map quilt as well as story quilt.

M. Deans House of Design, Phillipines—http://www.mdeans.com/oprah.html. *Oprah's Quilt* is a wallhanging quilt, embroidered, beaded and completed in trapunto. This beautiful twenty-nine square inch quilt was made as a gift to Oprah Winfrey. The quilt won a Miniatures Quilt Magazine award.

Michigan's African American Quilters—www.sos.state.mi.us/history/museum/techstuf/civilwar/quiltmag.html. Article and photos about the 1991 exhibition *African American Quiltmaking Traditions in Michigan*.

Oblate Sisters of Providence—http://www.LouisDiggs.com/oblates/. Comprehensive resource about the Oblate Sisters of Providence, a congregation of African American nuns founded in Baltimore, Maryland in 1829. The nuns started a school and orphanage for black girls. Sewing and needlework activities were part of the school's curriculum. Under Mother Mary Elizabeth Lange's leadership (1832–1835), girls sewed and embroidered church vestments to make money for the school. Mother Theresa Catherine Willigman (1885–1897) taught domestic science, tapestry and sewing. The sewing tradition continued into the 20th century. Mother Mary of Good Council Baptiste (1967–1977) spent hours daily sewing aprons for fund-raising purposes.

QuiltEthnic.com—www.QuiltEthnic.com. Most comprehensive website resource for African American quilting. Site has fiber related art, craft, and textiles information for various ethnic groups including: African, Chinese, Haitian, Japanese, Korean, Native American, South American and African American. Helpful tools include: Bul-

letin Board, Exhibitions listing, Guilds, Online Network links, News, Retreats and Symposiums listing. Site created by quilter Gwendolyn Magee. Launched July 1999.

Quilters and Quilt Projects

Allen, Denise—http://www.ExpressToSuccess.com/denise_allen.htm. Needlework folk artist who incorporates quilting themes in her pieces. Visit web site to view *Early American 18th Century Negro Shakers Quiltin' In the Kitchen* and *Family Ties.*

Cummings, Michael—www.MichaelCummings.com. Spend hours leisurely enjoying story quilts by Michael Cummings. You can also purchase original quilts, signed posters, and art throws (*Take My Brother Home #2, African Jazz #10*) online.

Green, Earling M.—www.earlinegreen.com/index.htm. Artist creates quilts, fertility figures and vessels.

Hicks, Kyra—www.ElecVillage.com/kyra.htm. Highlights of African American quilters in the news. Her brother, Wayne Hicks, has updated the site without complaint since it was launched June 1998.

Mazloomi, Dr. Carolyn—http://www.mindspring.com/~mazloomi/. You can seemingly hear the music from the quilts on this site by Carolyn Mazloomi. Learn more about the Women of Color Quilters Network projects. You can also order *Spirits of the Cloth: Contemporary African American Quilts* directly from the author.

Mooney, Jacquelyn Hughes—www.RhythmnHues.com. Mooney was artist-in-residence for African American Women on Tour events from 1995–2000.

O'Bryant-Seabrook, Marlene—http://www.awod.com/gallery/rwav/marlobs/quilters.html. Charlotte, South Carolina quilter shares memories and photos of her quilting friends.

O'Neal, Charlotte—http://www.habari.co.tz/uaacc/. This native of Kansas City, Kansas has lived for over 30 years in Tanzania. O'Neal is an artist, quilter, and community activist. She has exhibited her quilts in Africa and America.

Ringgold, Faith—www.artincontext.org/artist/ringgold. Approachable site for both children and adults. Learn more about the artist, view dozens of quilts and listen to *Anyone Can Fly.*

Smith, Mary Louise, New York quilter and founder of Quilters of Color Network New York—http://community-2.webtv.net/MARYLOUISESMITH/MARYLOUISESMITH/index.html. Fascinating variety of quilting styles and subject matter.

Whetstone-McCall, Sherry—www.QuiltDancer.com. Kansas City art quilter. Fascinating appliquéd miniature quilts and wallhangings.

Quilt Performances

Adrienne Heard—Email: HeardMgt@aol.com. Griot/Oral Historian. Performs "Aunt Rosie's Mother's Quilts," a blend of stories which incorporates the Underground Railroad.

Seven Quilts for Seven Sisters—www.SevenQuilts.com. Performance art which takes place during slavery times. Blends early African American quilt history. Information for scheduling performances available online. Be sure to check out the bio page!

AFRICAN AMERICAN OWNED QUILT STORES

Cherry's Quilt Shop, Cherry Henderson, owner; 4320 Wichita Street, Fort Worth, TX 76119; (817) 531-0074. Open since 1985. Features quilts and pillows made by Henderson.

Crafters, Quilters Etc., Ana McCabb, owner; 390 East 6th Street, San Bernardino, CA 92410; (909) 381-1844. Specializes in embroidery and quilt classes.

Ethnic Quilts and Fabrics, Earthleen Briggs, owner; 2609-07 Lemon Grove Avenue, Lemon Grove, CA 91945; (619) 461-0783. Specializes in African fabrics and machine quilting.

Quilt-N-Stuff—Everything for the Quiltmaker and Fabric Art, Madeline Shepperson, owner; 5962 Richmond Highway, Alexandria, VA 22303; (703) 836-0070. Fabric and sewing machine store. Quilting and sewing classes year-round.

OTHER RETAIL RESOURCES

African Mosaic Quilt Kit—www.CulturedExpressions.com. All-in-one kit includes over 200 pre-cut 2" fabric squares and instructions for a watercolor quilt featuring African cotton prints.

American Quilts, Inc.—www.AmericanQuilts.com. Frank Geeslin, P.O. Drawer 200, Upton, KY 42784-0200; (877) 531-1619 (toll free). Over 1,200 hand, machine, Amish quilts and tops available for sale online. Occasionally has African American made quilts available for sale. Will also buy African American made quilts.

eBay.com. One the most visited Web sites in America. This online auction site is filled with quilting-related items for sale. Frequently African American quilts and books are available.

Hard-to-Find Needlework Books—email: hardtofind@needleworkbooks.com. 96 Round-wood Road, Newton Upper Falls, MA 02464-1217; (617) 969-0942. The largest book-store devoted to needlearts: bargello, craft magazines, crewel embroidery, crochet, cross stitch, dolls and dollmaking, embroidery, fashion, knitting, lacemaking, needle-point, sewing, tatting, textiles, weaving and quilting.

Harlem Textile Works—www.HarlemTextileWorks.org. 6 Edgewood Avenue, Room 106, New York, NY 10030; (212) 491-4538. Non-profit organization teaches fabric design and silkscreen techniques to young people. Quilts, pillows, tablecloths and other tex-tile items for sale.

Quilt Connection, P.O. Box 465, Odenton, Maryland 21113. Mail order Afrocentric quilt patterns available for sale. Among the orginal quilt patterns are *Underground Rail-road Quilt, Appliqued Adinkra Quilt, African American Story Quilt* and *African Logs*. Send business-size SASE to request order form.

Sheila Williams—www.SheilaWilliams.com. Computer and Quilting Software Consultant. P.O. Box 891085, Temecula, CA 92592

Slotin Folk Art Auctions, 5967 Blackberry Lane, Buford, GA 30518; (770) 932-1000. Slotin Folk Art Auctions present a Fall and Spring auction annually. Sometimes African American made quilts are included.

Unique Spool—www.UniqueSpool.com. 407 Corte Majorca, Vacaville, CA 95688; (707) 448-1538. Fabric store that specializes in puppets, fabrics and patterns from Africa and other countries. Offers a monthly African Fabrics Club.

AFRICAN AMERICAN QUILTING ORGANIZATIONS

The following list includes both past and present quilting organizations in thirty American states and territories. This list was compiled from various books and articles on African American quilting, my own experience with the selected groups listed, Internet searches and responses to a questionnaire I sent to several hundred

quilters in 2000. Mailing addresses are listed, where possible. Many times the mailing address for a quilting guild is the home of one of its members. In such cases the mailing address usually changes each year as guild responsibilities rotate among members and is therefore not included here.

National Organizations

Black Quilt News. Biannual publication devoted to sharing news about and for African American quilters since 1999. For subscription information contact: Black Quilt News, P.O. Box 465, Odenton, MD 21113-0465.

Group for Cultural Documentation. Roland Freeman, President; 117 Ingraham Street, NW, Washington, DC 20011. In 1996, Roland Freeman and the Group for Cultural Documentation conducted the First National Photodocumentary Survey of African American Quilters resulting in the publication of *A Communion of the Spirits: African American Quilters, Preservers, and Their Stories*. In 1999, the organization hosted *Common Threads: Creating a Cloth of Empowerment*, an international symposium on the role of textile collectives in women's empowerment and recent research on African American Quilters.

National Association of African American Quilters. Now defunct organization founded April 1993 at the first African American Quilters Conference in Lancaster, PA. Board members included Meloyde Boyd, Belinda Crews, Cleo Dailey, Carole Y. Lyles, Ed Johnetta Miller and Barbara Pietila. The organization's motto was "Each One, Teach One." Over 125 members. At least two volumes of the *North Star News* newsletter were published. The organization also offered a blue and white "National Association of African American Quilters" cloisonné pin to its members in 1994. The second Annual African American Quilting Exhibition and Conference was held in Lancaster, PA in April 1994. The exhibition included quilts by Gerry Benton, Michael Cummings, Cleo Dailey, Carolyn Mazloomi, and Julieann McAdoo. The third Annual African American Quilting Exhibition and Conference was held at Bowie State University, Bowie, MD, on June 22–25, 1995.

Society for the Preservation of African American Quilt Art. P.O. Box 230254, Ansonia Station, New York, New York 10023. Esperanza Martinez and Linda Roennau have co-produced documentary videos about the African American quilting experience as part of the Society's mission.

Storytellers in Cloth Retreats. 1305 Fifth Avenue, Neptune, New Jersey 07753. Gloria Douglas, Donna Harris and Michelle Lewis founded Storytellers in Cloth. The organization hosted its sixth annual African American quilting retreat in 2001 in Southbury, CT. Past retreat workshops have been led by Sandy Benjamin-Hannibal, Sandy Bright, Barabara Brown, Florence Field, Myrah Brown Green, Anita Knox, Sherry Whetstone-McCall, and Juanita Yeager. Activities at this three-day retreat have included quilt workshops, ugly fabric auctions, jazz bunches, trips to local fabric stores, and block exchanges.

Women of Color Quilters Network. Dr. Carolyn Mazloomi, Coordinator; 5481 Oldgate Drive, West Chester, Ohio 45069. The Women of Color Quilters' Network was formed as a result of an ad Carolyn Mazloomi placed in the February 1986 issue of Quilter's Newsletter Magazine. WCQN founding members, Claire E. Carter, aRma Carter, Cuesta Benberry, Melodye Boyd, Michael Cummings, Peggie Hartwell, and Marie Wilson, each responded to Mazloomi's small ad requesting correspondence with other black quilters.

Objectives of the Women of Color Quilters Network—founded 1986:

1. Foster and preserve the art of quiltmaking among women of color.
2. Research quilt history and document quilts.
3. Offer expertise in quiltmaking techniques to enhance the skills of all quilters of color.
4. Offer authentic, handmade, African American quilts and fiber art to museums and galleries for exhibition.
5. Assist in the writing of grant proposals related to quilt making for those persons who may have such a need.
6. Aid members who wish to sell personally created work at the best price possible.
7. Host quilting workshops and act as consultant for organizations seeking African American lecturers and teachers.
8. Provide advice and services for quilt restoration and repair.

Newsletter features included news of local Black quilting exhibits, calls for submissions, quiltmaking tips, member profiles, original essays by Black quilters, recommended reading lists about African American quilting, pattern and article reprints and membership address listings. There was even an "In Memoriam" section to commemorate noted persons who died during the year and were connected to African American quilting. California quilter Shirley K. Grear and the late Florida quilter Rhonda Mason were among those who contributed articles to the newsletter.

Thanks to the efforts of former museum librarian Edith Wise, a near-complete set of past Women of Color Quilters Network newsletters (1987—Summer 1993) is located at the American Folk Art Museum Library, New York. There were sixteen issues of the newsletter from 1987—Summer 1995. Carolyn Mazloomi (1987—Summer 1992, Summer 1995) and Sandra German (Winter 1992—Winter 1994) served as editors. The newsletter is no longer published.

Local Organizations

Alabama

Freedom Quilting Bee (Wilcox County), 4295 County Road 29, Alberta, AL 36720. Founded in 1966. In 1969, the cooperative was commissioned by du Pont for $2,500 to create a quilt for a department store promotion. The patchwork quilt was twenty feet wide by forty-four feet long—at that time the largest quilt in the world. In 1997, the Pine Burr Quilt, sewn by members of the Freedom Quilting Bee, was designated as the Official Quilt of Alabama (Acts of Alabama, No. 97—111.0. A copy of the resolution is available at http://www.archives.state.al.us/emblems/st_quilt.html. Members of this cooperative continue to make quilts, aprons, and other items. See photos of the cooperative at workhttp://www.RuralDevelopment.org/FQB.html.
Clinton Community Club of the Retired Senior Volunteer Program (Eutaw)

Arizona

Cocoa Quilters (Phoenix). Meets at the George Washington Carver Museum and Cultural Center in Phoenix.
Onyx Quilting Club (Tucson). Founded by Mae Bell Bledsoe in 1992.

Arkansas

Arkansas County Quilts, Inc. (Lexa). This African American quilting cooperative was founded in 1986 by Graffie Jackson and Jean Johnson.

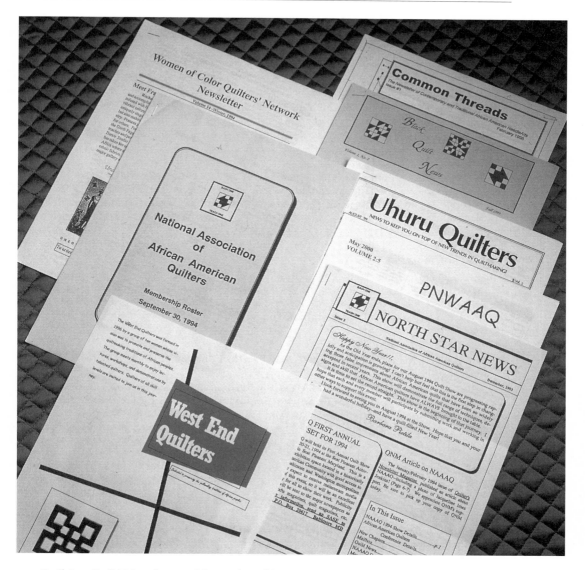

Quilting Guild Newsletters. Women's, African American art and community history are all captured in quilt guild newsletters. These ephemeral records are testimony to the range of African American quilting activities.

The Modern Priscillas (Fayetteville). A 1920s African American social club, which also participated in quilting activities.

California

African American Quilters of Los Angeles, PO Box 781213, Los Angeles, CA 90016–9213. Founded in 1986 by Ouida Braithwaite and Carolyn Mazloomi. This guild at one time offered a logo pin for members. Meets each third Sunday.

Kindred Spirits (Palmdale). Founded by Mary Brewer in March 1998. The group changed its name in 1998 from the Antelope Valley African American Quilt Bee. The guild's newsletter is titled *North Star*.

Negro History Club of Marion City and Sausalito. Created the *Harriet Tubman Quilt* (1951) and the *Frederick Douglass Quilt* (1953) in the permanent collections of Robert W. Woodruff Library, Atlanta University Center.

San Diego People of Color Quilt Guild, 730 Cotton Street, San Diego, CA 92102. Meets the fourth Saturday of the month September–June at the Malcolm X Library on Market Street. See fabulous group photo at: http://www.geocities.com/SoHo/Exhibit/1077/

Colorado

African American Quilters and Collectors Guild (Denver). Founded in 1988.

Rocky Mountain Wa Shonaji Quilt Guild (Swahili for "people who sew"), PO Box 200535, Denver, CO 80220-0535. Founded February 1994 by Mary Brewer, Gwinn Downton, Bettye Everett, Josie McKinnick and Helen Thobhani. Meets first Saturday of every month at the Park Hill Branch Library in Denver.

District of Colombia

Daughters of Dorcas and Sons. Founded by Viola Canady and Etta F. Portlock in 1980. Meets every Tuesday at 10am at the Calvary Episcopal Church at 820 Sixth Street, NE.

Helping Hand Club of the Nineteenth Street Baptist Church, Washington, D.C. Active in 1948. See booklet edited by Norah M. Diuguid.

Georgia

Ben Hill United Methodist Church Quilters, 2099 Fairburn Road, Atlanta, GA 30303; (404) 344-0618

Reynoldstown Quilters of Atlanta. Meets at the Reynoldstown Community Center. Visit http://www.planetpatchwork.com/tvqmain/vq12main.htm for profile and photos.

West End Quilters of Atlanta (Late 1990s—no longer existing); Deborah Grayson, President. Projects included completing an *African Coin Quilt*. Published monthly newsletter called *The Nsaa*, translated as "she who does not know the real design will turn to an imitation."

Illinois

The Happy Hookers and Quilting Sisters groups are mentioned in a March 13, 1988 *Chicago Tribune* article.

Needles and Threads Quilters Guild of Chicago. Founded in 1992. This guild participated in the the 2000 Amistead Quilt Project.

The Undercover Quilters. Founded December 2000. Founding members include Juline McClinton, Kathy Mitchell, Shirley Smith, Pamela Tabor, and Trish Williams.

Indiana

Fantastic Finishers, c/o Ambridge Community Center, 2822 West 4th Avenue, Gary, IN 46404.

Gary Community Quilters Guild. Founded by Cheryl Tobert in 1992. Group now inactive.

Sisters of the Cloth Quilting Guild (Ft. Wayne, IN)

Kansas

Jolly Sixteen Art Club, Kansas City, KS. Founded October 6, 1926 and held a club meeting as late as February 14, 2001. Club motto is "Cherish As We Go." Sixteen women started

the club as a creative outlet from housework and children. The Club focused on art, crochet, embroidery and other needleworks. Georgia Irvin Hunt (1897–1990) was a charter member and served many years as president. Mary Blair, who was 89 when she passed away, joined the Club in 1931 and served many years as Secretary and Treasurer. Her daughter, Violet C. Jones, continues to serve as Club President. The Club meets once a month and hosts an art exhibit every two years. Over the years, meeting notes about the Club appeared in the black Kansas City newspapers. Quilts by Club members have been featured in past Annual Black Heritage Quilt Shows at the Wyandotte County Museum (KS).

Kentucky

Sankofa Seam Alliance (Louisville). Founded in 2000.

Louisiana

Red Stick Quilters (Baton Rouge). Founded in 1984 by Daisy Anderson Moore.

Maryland

African American Quilters of Baltimore, PO Box 20617, Baltimore, MD 21223. Founded by Barbara Pietila.

North Star Quilters Guild, Annapolis. Mentioned in Women of Color Quilters' Network Newsletter Summer 1989, Issue 3.

Uhuru Quilters Guild of Prince George's County, MD; PO Box 936, Clinton, MD 20735-0936. Meets the third Saturday of each month at the College Park Community Center, College Park, MD. Publishes *Uhuru Quilters* newsletters to members.

Massachusetts

Sisters in Stitches (Boston). Meeting since 1999 on the third Saturday of each month.

Michigan

Bryant Family Quilting Club.

Flint Afro American Quilters Guild. Founded in 1987.

The Quilting Six Plus (Detroit).

Wednesday Night Quilting Sisters (Detroit). Founded by the late Dr. Sarah Carolyn Reese in 1984. Meets at Hartford Memorial Baptist Church

Willing Workers (Detroit). Founded November 30, 1887. Mrs. Delia Barrier served as Club President for at least forty years. The Club, which was affiliated with the National Association of Colored Women as late as 1933, raised funds through the sewing and selling of quilts. The fifty-member club also belonged to the Needle Work Guild of America.

Minnesota

Piece by Piece Quilt Shop, Thelma Buckner, Director; 175 Victoria Street North, St. Paul, MN 55104-7200. This ten-year old program, located in a predominately Black community, teaches neighborhood children six years and older to quilt. The shop is open eight hours a day, five days a week. Buckner uses the "quick quilt" method where a specific color is selected for the quilt's center and complementary colors are added all around until the quilt is complete.

Sabathani Quilting Group (South Minneapolis)

Mississippi

Tutwiler Mississippi Quilts—Tutwiler Community Education Center, 301 Hancock Street,

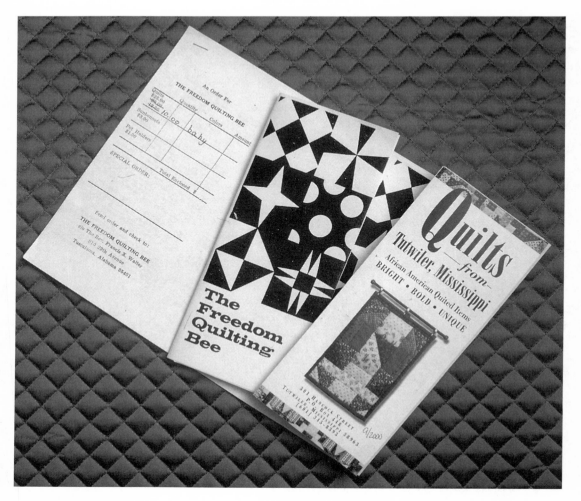

Order Forms. Some African American quilting groups, such as the Freedom Quilting Bee and the Tutwiler Quilters, generate revenues by selling their quilts and other needlearts nationally. The Freedom Quilting Bee order form is not dated, though it is probably from the late 1960s or early 1970s. It offers $25 quilts and $3 sunbonnets. Collection of the author. Photograph by David Smalls.

PO Box 448, Tutwiler, MS 38963; (601) 345-8393. Send SASE for brochure about group and price list for quilts, quilted bags, pot holders, table runners, place mats, and wall hangings. The Tutwiler quilters were featured in a September 1990 *60 Minutes* segment.

Mississippi Cultural Crossroads Quilters (Port Gibson, MS), 507 Market Street, Port Gibson, MS 39150; (601) 437-8905. In 2000, Mississippi Cultural Crossroads held their 13th Annual Pieces and Strings Quilt Contest. The Crossroads Quilters sold over $30,000 worth of quilts in 2000. Visit www.win.net/~kudzu/crossroa.html or http://www.arts.state.ms.us/crossroads/quilting/quilting2.html for profile and photos.

New Jersey

Ebony Quilters of New Jersey, 550 Proposed Avenue, Franklinville, NJ 08322. Founded by sisters Jacqueline I. Jenkins and Barbara Imes-Jordan in 1994.

Nubian Heritage Quilters Guild, P.O. Box 25005, Newark, NJ 07101

New York

African American Quilters of Bedford-Stuyvesant, c/o Virginia Hall. Meets at the Bedford Library

Bridgeview Quilters Guild (Brooklyn). Founded 1998. This guild participated in the Amistad Quilt Project.

Ebony Quilters of Southeast Queens, Carolyn Lewis, Chairman

Gates Avenue Young Girls and Young Women Quilting Circle, c/o Community Service Society, 105 East 22nd Street—Room 901, New York, NY 10010. Contact: Edith Moore

Gotham Quilters (1983–1984). Eight quilters featured in Grudin's *Stitching Memories* catalog on pp. 90–91.

Quilters of Color Network of New York, Inc., Rhona Triggs—Chair. Meets the fourth Saturday of each month. Email: QuiltersOfColor@hotmail.com. Guild news available on http://Members.tripod.com/~QCN

Rockdale Village Quilters

Sepia Rainbow Quilters

Women of Color Quilters' Network, New York chapter.

North Carolina

Carr Court Quilters (Chapel Hill). Founded by Margaret Stone in May 1998. Meets every Friday morning at the Carr Court Resource Center. In 1999, this guild received an $800 Orange County Arts Commissions grant.

African American Quilting Circle (Research Triangle). Meets first Saturday of each month. Contact Bhoward@afrucabews.org for more information.

Ohio

Oberlin Senior Citizens. Created 1982 *Underground Railroad* quilt featured in Grudin's *Stitching Memories* catalog on pp. 47–49.

Sacred Sisters and Brothers Mentoring Group (Columbus). Group of young people who quilt, among other activities.

Pennsylvania

African American Heritage Quilters Guild (Pittsburgh). Founded in 1989.

Friendly Quilters (Buck County)

Quilters of the Round Table (Philadelphia). Founded by Christina E. Johnson in 1993.

Rhode Island

St. Martin DePorres Quilting Club of Providence. Featured in 1981 exhibit sponsored by the Rhode Island Black Heritage Society.

South Carolina

Johns Island Sewing Club. Mentioned in December 23, 1972 article in the *Charleston News and Courier* article on page A1.

Quilting Bee of Liberty Hill Missionary Baptist Church (Catawba)

Tennessee
Senior Neighbors of Chattanooga, 10th & Newby Street, Chattanooga, TN 37402

Texas
Blue Triangle Quilt Guild (Houston)

U.S. Virgin Islands
Sisterhood in Support of Sisters in South Africa—SISA, P.O. Box 24966, G.B.S. Christiansted, St. Croix, USVI 00824-0966. Founded in 1984 by Dr. Gloria I. Joseph. This non-profit group supports the Zamani Soweto Sisters of South Africa.

Virginia
54-40 African American Quilting Guild (Hampton). Founded March 1993. For information on the guild's history, activities, membership, community service activities, visit http://www.5440quilters.com.
Friends Who Quilt (Chesapeake). Founded in 1999. Meets the second Saturday of each month at the Northampton Community Center in Hampton, VA.

Washington
Pacific Northwest African American Quilters, 14134 110th Avenue N.E., Kirkland, WA 98034. Founded May 1997 by Gwen Maxwell-Williams gwenmw@aol.com. Monthly meetings, retreats, small group and charity projects. One special project for 2000 was a *Tribute to Jacob Lawrence* quilt challenge. Publishes a monthly four-page newsletter, *PNWAAQ*. Visit the group at http://pnwaaq.tripod.com/quilters.html.

QUILTING AND OTHER NEEDLEART PATTERNS

This section features three types of references. First, patterns for quilts and quilt blocks with African or African American themes are listed. Next, patterns for other types of needlearts such as cloth dollmaking, crochet, embroidery and needlepoint with African American themes are listed because quilters sometimes adapt these patterns to quilt blocks. Finally, references for using African fabrics or symbols in needlearts are included as many Black quilters incorporate these materials into their quilts.

"African Bedroom." *McCall's Needlework & Crafts*, Fall/Winter 1968-1969, pp. 116–117.
Alice Brooks. *Chef*, pattern 5328. Days-of-the-week towel transfers of black chef working in kitchen. No date.
_____. *Mammy*, pattern 554, pattern 5250. Days of the week transfer patterns. No date.
_____. *Mammy and Pickaninny Dolls*, pattern 5247. 14 inch dolls. 10 cent retail price. No date.
American Women Appliance Cover-Alls. From the Sewing Centipede, P.O. Box 216, Midway City, CA 92655, 1991. Booklet includes patterns to cover toasters, sewing machines, and other appliances with likeness of Betsy Ross, Mississippi Mammy, and others.
Benberry, Cuesta. "White Perceptions of Blacks in Quilts and Related Media." In *Uncoverings 1983*, ed. Sally Garoutte, pp. 59–74. San Francisco: American Quilt Study Group, 1984. Article includes names of various Aunt Martha's patterns including *Little Brown Koko* ca. 1935 and *Little Black Sambo* ca. 1930.

Birmingham, John. "Crafting a Life." *Butterick's Make It!*, 1992. Quilter and dollmaker Peggie Hartwell is profiled. African American rag doll pattern and instructions are included.

Boone, Ronke Luke. *Sewing with Fancy Prints.* Self-published. RL Boone, P.O. Box 3276, Falls Church, VA 22043, 1998. This how-to book provides instructions and tips for sewing with brightly colored African fancy prints. http://www.excitestores.com/stores/rlboone/rlboone.html [Accessed September 13, 2001.]

_____. *Sewing with Mudcloth: A How-To Guide for Novices and Experienced Sewers.* Self-published. RL Boone, P.O. Box 3276, Falls Church, VA 22043. 12-page booklet.

Cabot, Anne. *Mammy with Child*, pattern 5166. *Anne Cabot's Needlecraft Corner.* Embroidery transfer pattern for quilt block, chair cover, or tablecloth. No date. No price. Available from Mrs. Anne Cabot of New York.

Carter, Hazel. "Cuesta's Choice." *Quilters' Journal* no. 23. *Cuesta's Choice* is a block pattern Hazel Carter designed to commemorate Cuesta Benberry's induction into the Quilter's Hall of Fame in 1983. Two-page block pattern and instructions.

Colonial Patterns, Inc. 340 West 5th Street, Kansas City, Missouri 64105-1235. Phone (816) 471-3313. Makers of Aunt Martha's Hot Iron Transfers. The retail prices varied over the years the patterns were printed. At times the artwork was updated and the pattern name remained the same.

> *Clever Tea Towels*, 3341. Seven Black girls for each week day—dialect language. 15 cents. No date.
>
> *Cross Stitch Mammy*, 9327. Mother and child for each weekend, plus hot pad. No date.
>
> *Humorous Embroidery Motifs*, 9947. Seven jungle children for each day. 15 cents. Also available for 19 cents. No date.
>
> *Jemima and Sambo Panholder Set*, C8837. This "numo" set comes also with pattern for a "juicy watermelon for a pocket" to hold the panholders. 10 cents. No date.
>
> *Mommy's Little Angel*, 3917. Seven little Black girl designs for each day of the week. No date on packaging.
>
> *Pickaninnies for Tea Towels*, 3178. Seven Black girls—dialect language, household chores, plus one for a matching potholder. No date. Back of packaging encourages consumers to "adore (the) cunning Cannibal motifs in AUNT MARTHA'S pattern 9947."

Dendel, Esther Warner. *African Fabric Crafts: Sources of African Design and Technique.* Devon, England: David and Charles, 1974. Also published by Taplinger Publishing Company of New York. Chapters on appliqué, embroidery, looping, adinkira symbols, and cloth dolls. Worth locating a copy for one's library.

England, Kaye. *Voices of the Past: A History of Women's Lives in Patchwork.* Santa Monica, CA: ME Publications, 1994. Profile of Harriet Tubman, Underground Railroad Conductor, and mentions her patchwork quilt, on pp. 32–33. Includes pattern to make a 12" *Harriet Tubman* quilt block designed by Kaye England.

_____. *Voices of the Past, Volume II.* Includes a *Madam C. J. Walker* stencil pattern. Kay England's shop is Quilt Quarters, 1017 West Main, Carmel, Indiana 46032.

England, Kaye, and Mary Elizabeth Johnson. *Quilt Inspirations from Africa: A Caravan of Ideas, Patterns, Motifs, and Techniques.* Lincolnwood, IL: The Quilt Digest Press, 2000. Book includes sixteen illustrated patterns.

Eva and Topsy Panholders, pattern C9875M. Modern Handcraft, Kansas City. No date. This pattern was given free with a $1.00 annual subscription to Workbasket. Topsy is a Black character.

Gallery of Crochet and Knitting: New Easy to Make Gift Ideas, Star Book no. 89, 1953. 10

Little Brown Koko books. Little Brown Koko books, coloring books, old advertisements and quilt block patterns are sometimes available for sale on ebay.com. Collection of the author. Photograph by David Smalls.

cents retail price. This 15-page booklet includes pattern for *Black Pappy & Mammy* crochet dolls.

Hadley, Sharon. "Aunt Jemima Toaster Cover." *Crochet World*, September/October 1979, pp. 12–17. Pattern for toaster cover involves both sewing and crochet work. Article listed on front cover. 75-cent retail price for magazine.

Holcombe, Martha. *Dixie Sonshine*, pattern P87000. Miss Martha Originals, P.O. Box 5038, Glencoe, AL 359905, 1985. Full size patterns for 15", 13", 11", 9" and 6" cloth dolls, including quilt babies.

Horton, Roberta. *Calico and Beyond: The Use of Patterned Fabric in Quilts*. Lafayette, CA: C & T Publishing, 1986. Chapter five is titled "Afro-American Quilts." Readers may cringe while reading statements from the book such as "Viewers may grant that the Afro-American quilts are exciting and colorful but the workmanship often doesn't quite live up to the usual standards of excellence" or "Often what feels appropriate in an Afro-American quilt is what you've previously rejected for quilt use."

Crochet World magazine and two crochet potholders. This 1978 issue of *Crochet World* is one of the few craft magazines to feature an African American–theme needlework piece on its cover. I do not believe any quilting magazine has ever featured an African American-made quilt on its cover. Collection of the author. Photograph by David Smalls.

_____. *The Fabric Makes the Quilt*. Concord, CA: C & T Publishing, 1995. Instructional book for using ethnic prints to inspire quilts filled with color, textures, and pattern.

_____. *Plaids and Stripes: The Use of Directional Fabric in Quilts*. Concord, CA: C & T Publishing, 1997. Chapter five is entitled "African American Quilts" on pages 59–81.

Hunt, Blanche Seale. *Little Brown Koko Coloring Book*. Topeka, KS: Capper Publications, Inc., 1941. 24 p. The simple pictures in this coloring book can be used to design quilt blocks.

Hunt, Blanche Seale, and Dorothy Wagstaff (ill.). *Little Brown Koko*. New York: American Colortype Company, 1940. In October 1935 the Little Brown Koko character first appeared in *The Household Magazine*. Each month a new short story appeared. The central characters are Little Brown Koko, his mother who is called Mammy, a young girl friend Snooky, and his pet dog Shoog. Dialog uses degrading dialect. Readers used the story's illustrations as patterns for quilt blocks.

_____. *Little Brown Koko Has Fun*. New York: American Colortype Company, 1945.

Hunt, Blanche Seale, Sybil Fudge (ill.), and Jody Hawkins (ill.). *Little Brown Koko At Work and Play*. Athens, AL: C.E. I. Publishing Co., 1959.

_____. *Little Brown Koko Pets and Playmates*. Athens, AL: C.E. I. Publishing Co., 1959.

Innes, Miranda. *Rags to Rainbows: Traditional Quilting, Patchwork, and Appliquéd from Around the World.* New York: Dutton Studio Books, 1993. Includes section on African pieced quilts on pages 14–19.

_____. *Traditional Quilts from Around the World: 18 Easy Patchwork, Quilting and Applique Projects to Make by Machine.* Collins & Brown, 1999. Includes eighteen projects, including an African pieced quilt.

Kendon, Jane. *Cross Stitch Samplers.* London: B.T. Batsford, Ltd., 1986. Includes pattern for a 87" × 117" square *African Sampler*, which includes elephants, drums, masks, butterflies and an African couple.

Kilcrease, Opal. "Fashion Dolls in Crochet." *Crochet World*, September/October 1978, pp. 28–33. 60 cents retail price. Cover features Black doll couple. Pattern included. This magazine issue is a "must have" for one's historical needlework collection.

Kilgore, Treva. "Historical Doll: Harriet Tubman The Girl Called Moses." *Crochet World*, March/April 1983, pp. 18–19. Includes pattern and color photo of completed 8" doll.

LaVallee, Florence. "Mammy Toaster Cover." *Stitch 'n Sew*, May 1968, pp. 24–25. 15 cents retail price. Pattern and instructions. The drawing of a "mammy" figure is on the magazine cover.

Levie, Eleanor. *Great Patchwork: Working With Squares and Triangles.* Meredith Press, 1995. Book cover features quilt by Carole Y. Lyles. Pattern for quilt included.

Little Black Sambo, pattern X-518. This hot iron transfer pattern was mentioned in Nancy Cabot's Chicago Tribune Quilt Column. No date. A listing was also reprinted in *Dutch Girl Quilting Scrapbook No. 69*, p. 8. No date.

Little Brown Koko, pattern C9040. Capper's Reader Service, Topeka, Kansas. Aunt Martha's Numo Hot Iron Transfer, circa. 1939. Pattern includes twelve transfers featuring Little Brown Koko character. Finished quilt will measure 39" × 51".

"Little Brown Koko Contest." *Household Magazine*, April 1941. Readers were encouraged to complete a riddle about Little Brown Koko and Mammy's "chocklit" cake. The riddle winner would win $175 in cash and a 118-piece dinnerware set. One could also order a Little Brown Koko transfer embroidery pattern for a dime.

Lynch, Carolyn, and Barbara Bockman. *Virginia Is For Quilt Lovers: A Pattern Book for the Virginia Quilt.* Merryfield, VA: Quilters Unlimited of Northern Virginia, 1991. Includes patterns for *Booker T. Washington National Monument* and former governor *Douglas Wilder* six-inch blocks.

"Make These for Christmas." *Country Gentleman* (magazine), October 1948, p. 183. Features "Susie," a Black girl used as a sewing doll or pin cushion. Readers are encouraged to write for pattern 1248-CG, 35 cents retail price.

Marston, Gwen. *Liberated Quiltmaking: Intuition, Emotion and Technical Skill.* Paducah, KY: American Quilter's Society, 1996. This 191-page book introduces quilters to distinctive processes for creating original quilts. Includes brief mention of African American utility quilts.

Mayfair Needle-Art Design. *Great Big Mammy Doll*, pattern 169. From the Lebanon Daily News, Needlework Department, New York. No date.

McCall. *At Your Service*, 1131. Four appliquéd designs for dish towels. Design C is a "mammy" sitting down with a mixing bowl. Design D is a Black butler serving drinks. No date. 25 cents retail price.

Opposite: Little Brown KoKo Quilt, made by Jeannie Cuddy, Mankato, MN, about 1940. Cotton, appliqué, embroidery, and hand quilting. The quilt blocks are patterned after illustrations from Blanche Seale Hunt's Little Brown Koko stories. Collection of Cuesta Benberry. Photograph by David Smalls.

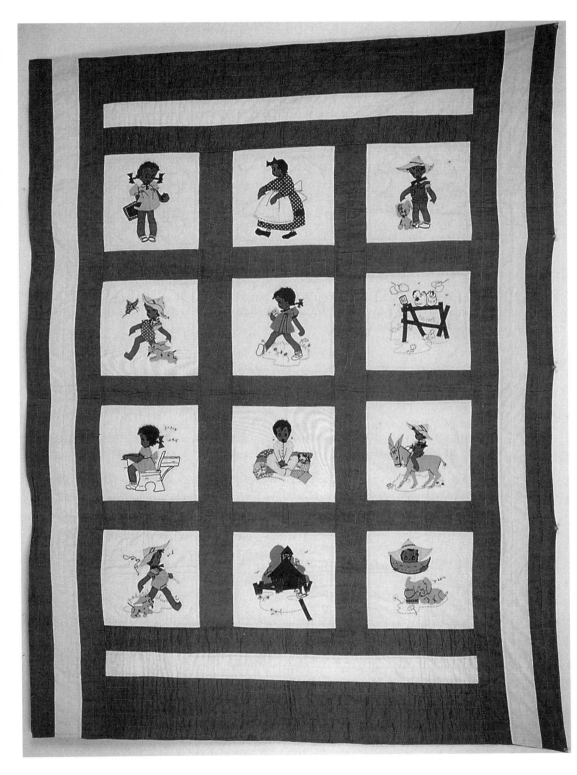

_____. *The Doll Family*, pattern 821, 1940. Pattern and directions for a white family and a "mammy" holding the baby. The father doll measures 10¼". The mother doll measures 9¾". The daughter doll measures 7". The "mammy" doll measures 9".

_____. *Mammy Designs in Cross-Stitch for Tea Towels*, pattern 674. Seven patterns—one for each day. No date, may be pre-1951. 25 cents retail price.

_____. *Sambo and Miranda*, pattern 1068. Pattern for two 18" high stuffed boy and girl dolls. No date. 35 cents.

Museum of Fine Arts, Boston. *A Pattern Book, Based on Applique Quilts by Mrs. Harriet Powers, American, 19th Century*. Boston: Museum of Fine Arts, 1973.

"National Afghan Contest." *Herrschners, Inc. Catalog 1262/F1*, December 2000, pp. 66–67. The first place embroidered crochet afghan winner is African American C. Michelle Jones of Victorville, CA for her *Just Add Love and Water* afghan. The pattern for this multi-cultural spread is available as a kit (MG200420) or pattern book (MG342055). Herrschners has sponsored this contest since at least 1995. Herrschners, Inc., 2800 Hoover Road, Stevens Point, WI 54492. Toll-free (800) 441-0838.

Newbill, Carol Logan. *The Olympic Games Quilts: America's Welcome to the World*. Birmingham, AL: Oxmoor House, Inc., 1996. The segment "Simply... Congratulations" focuses on Huisha Kiongozi's quilt of the same name. Includes pattern for quilt. See pp. 32–35. Other African American quilts include *African Stars (p. 96)* and *African-American Kente Cloth Quilt* (p. 114).

"The North Star." *Kansas City Star* (newspaper), June 1, 1938. Quilt pattern by Mrs. Paul Schmidt, Coldwater, KS. Four-pointed star pattern was reprinted in the Women of Color Quilters' Network Newsletter issue #2, 1988 with a note about the significance of the "North Star." Harriet Tubman used the star to guide slaves to freedom. Frederick Douglass published his abolitionist newspaper under the name North Star.

"The North Star." *Kansas City Star* (newspaper), March 9, 1949. Quilt pattern submitted by 10-year old William Johns of Fontana, KS.

"The North Star." From "Nancy Page Quilt Club," a syndicated newspaper column in the 1930s by Florence LaGanke. Eight-point star quilt pattern. Reprinted in the Women of Color Quilters' Network Newsletter issue #5, Fall 1990.

"The North Star." Quilt pattern by Laura Wheeler, Needlecraft Service of New York (syndicated needlework pattern service). No date. Twelve-point star quilt pattern. Reprinted in Women of Color Quilters' Network Newsletter issue 3, Summer 1989.

Pickaninny Doll Tea Towels, pattern E914. Eight different hot iron transfers featuring a Black girl doing various domestic chores. Shares pattern space with "New Angel Crib Quilt" transfers. Potentially from Modern Handcraft, 3954 Central Street, Kansas City 2, MO in the 1940s. No date or price.

Pickaninnies Play on Towels, pattern 522. From Modern Handcraft, Westport Station, Kansas City, MO. No date or price. Mail order pattern. Monday is laundry date. Tuesday is ironing day. Wednesday is sewing day. Thursday is grocery-shopping day. Friday is cooking day. Saturday is dish washing day. Sunday is not pictured.

Shepard, Lisa. *African Accents: Fabrics and Crafts to Decorate Your Home*. Krause Publications, 1999. Instructions for forty African-inspired projects, including a quilted wall-hanging.

Simplicity. *Black and White Dolls*, pattern 7247, 1975. Pattern for 20" tall Causaian and Black girl and boy dolls.

_____. *Piccaninny Dolls*, pattern 7329, 1947. Simplicity iron-on transfer pattern for Black girl and boy dolls.

Simpson, Grace. *Quilts Beautiful: Their Stories and How to Make Them*. Winston-Salem,

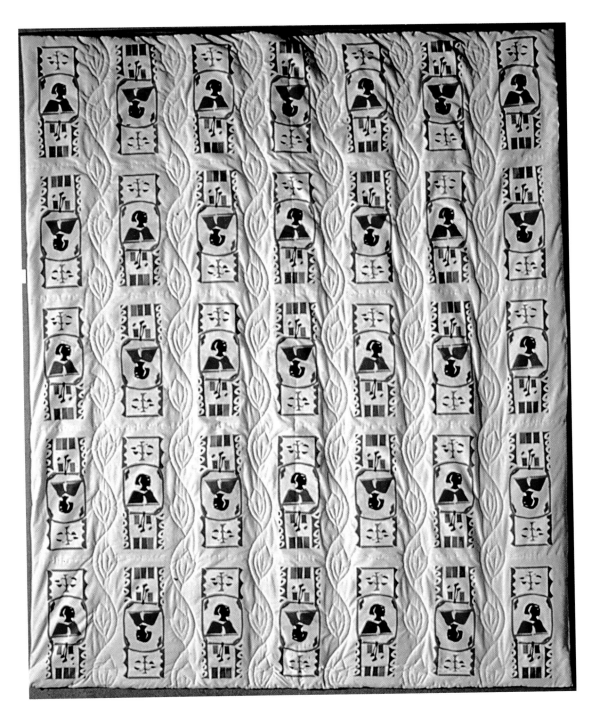

Untitled quilt by Romare Bearden, 1976. 94" × 76" screen print, pieced by Olga Alexander, hand quilted by the Ohio Amish. (Collection of Andrew Stasik. ©Romare Bearden Foundation/Licensed by VAGA, New York, New York.)

A

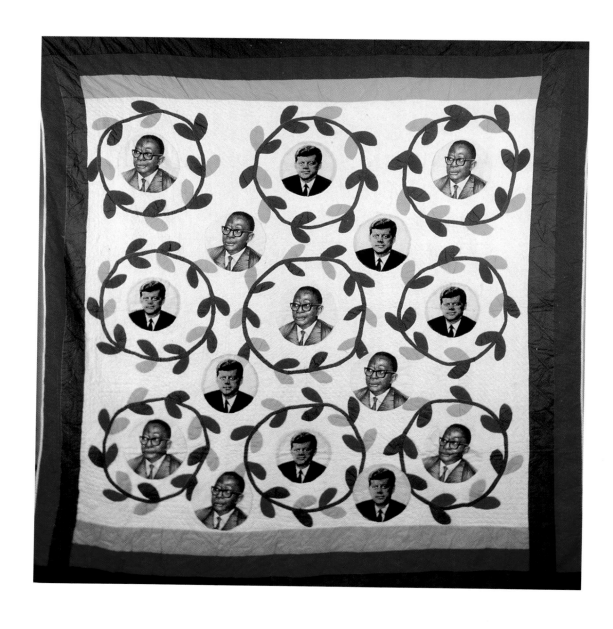

Cotton quilt, 86" × 90", by Mrs. Jemima Parker. Portraits of Liberian President William Tubman and JFK. Gift to President and Mrs. Kennedy. (Photograph courtesy of the John F. Kennedy Library.)

B

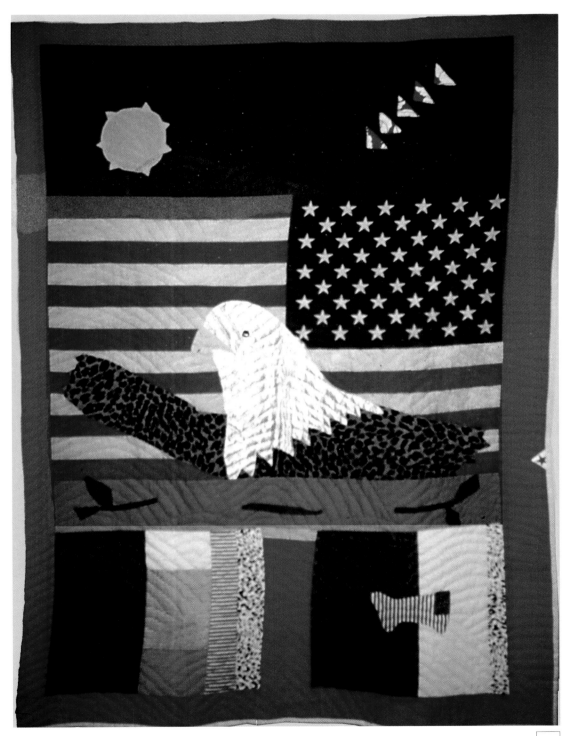

What So Proudly We Hail. Quilt by Tuscaloosa, Alabama, quilter Yvonne Wells, 1991.

C

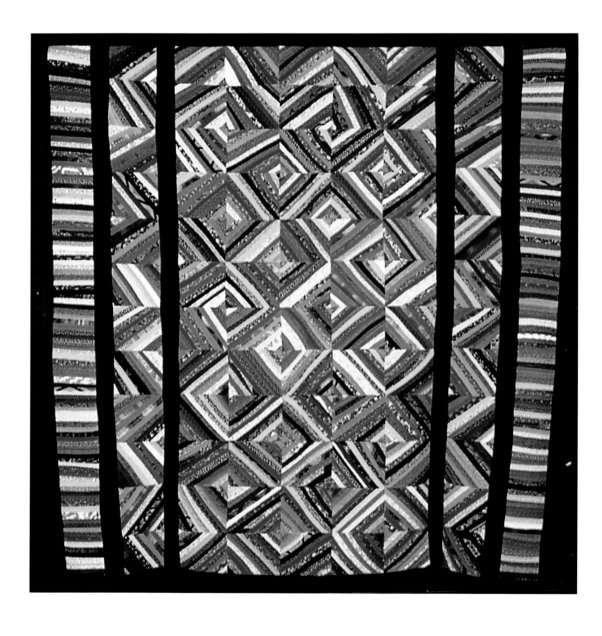

D

String by Gustina Atlas, 1995. (Permanent collection of the Mississippi Cultural Cross-roads. Photograph by Patricia Crosby.)

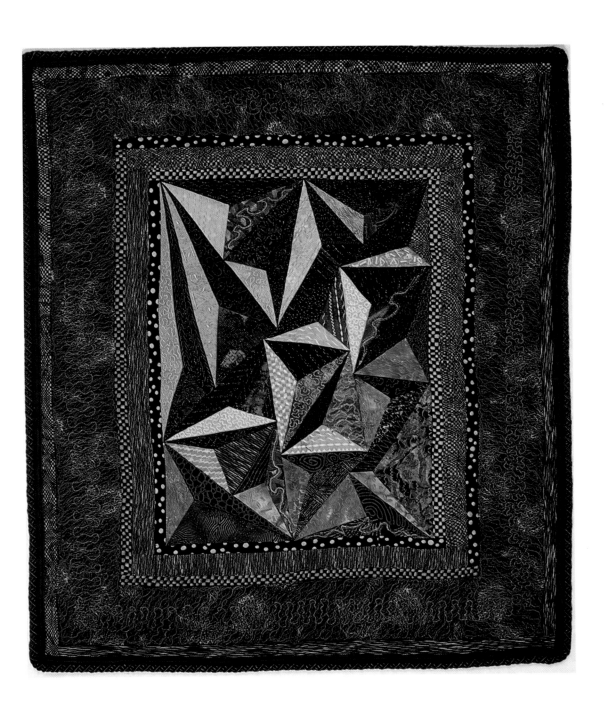

Hot Ice by Gwendolyn Magee. (Photograph by Judy Smith-Kressley. Collection of the artist.)

E

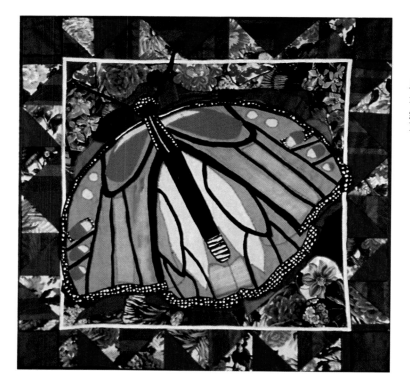

Butterfly by Michael Cummings, 4' × 4', 2000. (Photograph by Karen Bell. City of New York Collection.)

Celebrating Venus and Serena, But Don't Forget Althea by Dindga McCannon. 36" × 37". (Collection of the artist.)

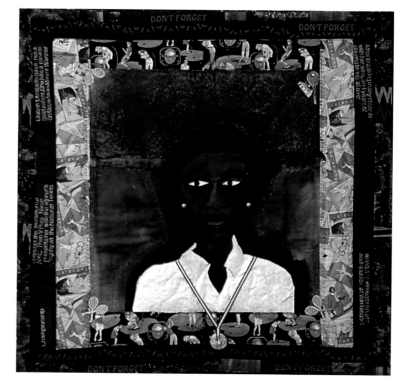

F

Baby in Tub by unknown quilter. Cotton quilt, 86" × 59". This quilt was purchased on eBay.com in 2000. More than a dozen bids pushed the price of this quilt above the reserve of $350. Both contemporary and historical African American–made or themed quilts can be purchased from various online auction web sites. (Collection of the author.)

G

Top left: *Woman and the Rooster* by Kyra E. Hicks, 1996. 74" × 65". Text reads: "At night I dance among the stars, & think of you." (Photograph by David Smalls. Collection of the artist.)

Three fabric samples: Upper right, *Hip-Hop Heaven* (Princess Fabrics, Inc., also available with a white background). Lower left, *Love Imani Faith* (Hi-Fashion Fabrics, Inc.). Lower right: *Women Wearing Turbans* (Timeless Treasures for Hi-Fashions, Inc., also available in a brown and rust pallet).

NC: Hunter Publications, 1981. *I Have a Dream* quilt pattern on pages 88–90. Quilt includes thirty 13" blocks. Pattern reprinted in Women of Color Quilters' Network Newsletter issue #3, summer 1989.

Southern Mammy Quilt. Country House Quilts, Zionsville, IN. 28" × 28" quilt block pattern. No date. Note: This pattern is similar to pieced quilt featuring Black figures in Robert Bishops' book *New Discoveries in American Quilts.*

Southern Roots series. Available from Green Apple Inc., 720 Kittiwake Lane, Murrells Inlet, SC 29576 or online at http://www.stitching.com/greenapple/. Selected African American-theme needlepoint designs available include: The Baptism—SR628, Buffalo Solider designs—SR677 and SR680, Children of Southern Roots series I—SR537, II—SR626, III—SP669, Mother and Child—SR670, Southern Roots series I—SR529, II—SR536, IV—SR607, V—SR608.

Superior Transfer Pattern. *Mammy*, pattern 106. Seven days a week pattern. No date.

Tillett, Leslie. *African Art in Needlework: Motifs Inspired by African Culture.* New York: Thomas Y. Cromwell, 1979. Includes forty projects.

Turner, Diana Oliver. *African Needlework Designs: Charted for Easy Use.* New York: Dover Publications, 1976.

"Turtle Auction Block." *Traditional Quilter*, July 1999, pp. 48–49. Included is a pull-out pattern for a pieced and stuffed *Turtle Quilt* similar to the one that sold for $12,650 at a Sotheby's auction. The original quilt is thought to have been made by a Southern Black woman.

"Underground Railroad." *Capper's Weekly—Booklet #108 Centennial Quilts*, circa 1960. Quilt pattern. Fifty-four 12-inch square blocks are needed to complete this quilt.

Vogart. *Topsy and Eva Doll*, pattern 157. Doll pattern for one doll that flips upside-down to reveal second doll face. No date.

Walker's Hot Iron Transfer Pattern. *Colored Mammy*, pattern 66. Towl-a-Day envelope featuring fourteen cross stitch designs for kitchen towel "colored mammy" series. No date.

Whetstone-McCall, Sherry. *Balloons, Butterflies, and Bees.* Self-published, 1997. Original appliqué wallhanging pattern of a Black girl in a flowery garden. Finished piece approximately 12" × 12." Retail price $10. Available directly from artist at: 7009 N. Corrington Ave., Kansas City, MO 64158.

Williamson, Jenny, and Pat Parker. *Quilts on Safari.* Cape Town, South Africa: Triple T. Publishing, 1998. Distributed by Quilters Resources, Inc., P.O. Box 148850, Chicago, IL 60614. This 96-page book contains full-color photos of over thirty African-inspired quilts. Complete instructions for ten quilts, such as *Mandela Leads The Way*, and an African cloth doll are also included.

Willis, W. Bruce. *The Adinkra Dictionary.* Washington, DC: The Pyramid Complex, 1998. Many African American quilters use adinkra symbols in their quilts.

Wolfrom, Joen. *Color Play: Easy Steps to Imaginative Color in Quilts.* Concord, CA: C & T Publishing, 2000. Includes over seventy vibrantly colored quilts including Gwendolyn Magee's *Jewel Fire* quilt.

VISUAL ARTS

The following list includes references to comics, fine art paintings, posters, photographs and murals with African American quilting and sewing as a central theme in the work.

American Folklife Center, Library of Congress. *Quilting Photos File*. The Center has several ephemeral files on quilting, include one of photographs with quilts as subject matter. Many are black and white photos from the 1930s and 1940s. Several show African Americans with quilts.

Bearden, Romare (1912–1988). Painter and mixed-media artist. Many of Bearden's works incorporated fabrics or included a quilting motif. These include:

> *Miss Mamie Singleton's Quilt* (1978). From the *Profile/Part 1: The Twenties* series. A woman sits on the floor washing herself. A patchwork quilt covers a nearby bed.
> *Patchwork Quilt* (1969). A Black woman readies herself for a bath. Collage of paper and paint. Collection of Sheldon and Phyllis Ross, Birmingham, MI.
> *Patchwork Quilt* (1970). Nude woman is reclining on a colorful quilt. Cut-and pasted cloth, paper and paint. Museum of Modern Art, New York.
> *Quilting Time* (1981). Lithograph of a Black man and woman working together on a quilt.
> *Quilting Time* (1985). A group of seven women and girls at a quilting party. A man with a guitar sits with them. Mosaic-glass mural in the Detroit Institute of Arts collection.

Biggers, John (1924–2001). Painter, sculptor, and printmaker. Many of Biggers works include graphic geometric images reminiscent of patchwork quilting. Selected pieces include:

> *The Contribution of Negro Women to American Life and Education* (1953). Mural located at the UWCA Blue Triangle Branch in Houston, TX. One subject in the mural is a black woman sewing a quilt.
> *East Texas Patchwork, Paris Texas* (1986)
> *Ma Biggers Quilting* (1964) Charming sketch of older woman quilting. The Holy Bible lies on table stand.
> *Quilting Party* (1980–81). Acrylic on canvas painting features two female figures from the *Shotgun Series*.
> *Three Quilters* (1952). Three older women are holding a quilt.

Campbell, Leroy (B. 1956). Painter.

> *Corn Bred*. Painting and poster of man sitting on wooden porch with two women standing behind him. A colorful patchwork border frames the central characters.
> *You Reap What You Sew*. Painting and poster of Black woman in bed sewing a story quilt.

Clark, Chris (B. 1958). Quiltmaker. *The Faces in Our Community (quilt)*. 16" × 24" benefit poster for the Cooper Green Hospital Foundation, 1998.

Coleman, Gerald Duane. Milwaukee artist and quilter. Many of Coleman's paintings include quilted attachments. In the early 1980s, several greeting cards were produced featuring quilted paintings. These included *In the Beginning There Was a Dance* (1981), *I Told Jesus* (1983), and *Enchanted Dress* (1984).

Conrad, Paul. "Jesse Jackson's Grandmother's Quilt." In *Los Angeles Times*, July 21, 1988. Political cartoon based on comments Jackson made at the 1988 Democratic Convention.

Cummings, Michael (B. 1945). Quiltmaker.

> *Haitian Mermaid #4*. 30" × 23¼" poster, signed limited edition—500 edition size, 1997.
> *Take My Brother Home*. 36" × 24" poster, open edition, 1993.

Favorite, Malaika (B. 1949). Painter and printmaker. Her work includes *A Quilt Study of Women of Color*, a series of ten oil paintings on wood panels.

Fichter, David. *The Freedom Quilt Mural* (1988). This mural depicts sixteen men and women who have committed their lives to non-violent struggles for peace and justice. Featured in the mural are Nelson Mandela, Rigoberta Menchu, Fannie Lou Hamer, Martin Luther King, Jr., Rosa Parts, Harriet Tubman and others. This mural is located at the American Friends Service Committee Atlanta office building. View the mural at: http://www.afsc.org/sero/mural.htm. [Accessed September 9, 2001.]

Gatewood-Waddell, Alice. Painter. Her works include *The Quilt* (2000), a graphic print featuring a Black woman surrounded by a flowing quilt.

Gilliam, Sam (B. 1933). Abstract artist. In 1975, he created *The Great American Quilt Series*, a handmade paper piece incorporating cloth, buttons, and pigment.

Goodnight, Paul (B. 1946). Painter. Popular contemporary artist. His works that include quilting themes:

> *Links and Lineage* (1986). Original painting commissioned by Massachusetts Middlesex chapter of the Links, Inc. Available as a poster. Hallmark Cards, Inc. licensed the image to use as a greeting card cover during the 1990s.
> *Patches.* Young girl is concentrating on sewing a patchwork quilt. Offset lithography, open edition.
> *The Quiltmakers* (1987). Inspirational image of several generations of female quilters.

Gwathmey, Robert (1903–1988). Painter. Two of Gwathmey's works that include quilting theme are: *The Quilt* (1977) and *Mother and Child* (1980), from the collection of the Columbus Museum of Art (OH).

High Museum of Art. *Church Picnic Story Quilt.* 42" × 37½" poster, open edition, 1988. Quilt by Faith Ringgold.

Honeywood, Varnette (B. 1950). Painter. This Spelman College graduate sometimes incorporates quilting patterns in her works. Examples of this include *A Century of Empowerment*, a painting that includes a double wedding ring quilt pattern; *I Do Thee Wed*; and *She Who Teaches, Learns*.

Krimmel, John Lewis (1786–1821). Painter. Krimmel was among the first American artists to paint African Americans in an exaggerated and distorted fashion as illustrated in the *Quilting Frolic* (1813). This painting shows a white family preparing to dine after a quilting party. A young Black servant girl, cleaning after the quilting party, and Black violin player are present.

Lawrence, Jacob (1917–2000). Painter. Painting with quilting or sewing themes include:

> *The Seamstress* (1946). Painting of a Black woman guiding red fabric through a sewing machine.
> *Vaudeville* (1951). Painting, of two stage performers, incorporates geometric patchwork designs.
> *Woman Sewing* (1948). A solidary Black woman dressed in red sits handsewing.

McKinney, Kim. Contemporary Painter. Her works include *The Parasol Girls Follow the North Star* from the African Slave Quilt series.

McPherson, Sandra. *McPherson African American Quilt Collection CD.* Poet Sandra McPherson has collected African American quilts since the late 1980s. The CD includes images from her collection, including quilts by Arbie Williams and Bara Byrd. $19.95 plus shipping. Sandyjmc@mindspring.com.

National Black Arts Festival 1992. *Mother Africa's Children.* 36" × 24" poster, open edition. Featuring quilt designed by Roland Freeman. Quilted by Viola Canady of Washington, DC.

Neal, Alice (1916–1985). *The Mary Bright Commemorative Quilt.* Poster based on a quilt with the same name. Mary Bright was a quilter and Neal's mother. The 1956 quilt was included in the *Stitching Memories: African-American Story Quilts* exhibition.

Parker, Jonathan (B. 1952). Painter. Parker's body of work includes painted quilt images, including *Quilt of Dances* (1992), *Hope in Haiti* (1994), and *Hairdos* (1998).

Pippin, Horace (1888–1946). Painter. The 1943 oil painting *Domino Players* shows an older woman quilting while three others play dominoes at the kitchen table. This piece is in the Phillips Collection, Washington, DC.

Porter, Mattie. *Beautiful Star* quilt used as poster design for Smithsonian Folklife Festival, Washington, DC, 1986. See Bets Ramsey's paper "The Land of Cotton," page 23 in *Uncoverings—1988* for details on the poster.

Reynolds, Patrick M. "The Quilt Code." *Flashbacks*, nationally syndicated Sunday comics strip. April 16, 2000. This two-panel strip illustrated two slave women making a coded quilt to assist runaway slaves. The strip encouraged viewers to read the book *Hidden in Plain View—A Story of Quilts and the Underground Railroad.*

Ringgold, Faith. *Church Picnic, Sunflowers Quilting Bee at Arles,* and *Tar Beach 2* are among the 24" × 36" posters manufactured by Shorewood Fine Arts Products in the late 1990s.

_____. *Faith Ringgold: A Twenty-Five Year Survey.* Poster featuring *The Purple Quilt* (1986), inspired by Alice Walker's *The Color Purple* novel. The poster measures approximately 46" × 33". Publisher unknown. Ringgold's 25th anniversary exhibition opened in 1990.

Saunders, Alonzo. *Quilt of Quilts.* This 24" × 36" poster features a Black woman in rocking chair hand quilting.

Scott, John T. (B. 1940). Sculptor, painter, printmaker and recipient of a MacArthur Fellows award. In 1994, he created the silkscreen print *Just Quilting.*

Shepard, Sophie. "Viney's Conversion and Courtship." *Harper's Weekly,* April 21 and 28, 1883, pp. 241, 246; 261–262. Includes wood engraving illustration of an African American quilting party in 1883. The original illustration, *The "Brothers" Assisted in the Quilting,* is now owned by the Historic New Orleans Collection, 533 Royal Street, New Orleans, LA, 70068.

Smith, Frank (B. 1939). Artist. In 1986, he created *Improvisation From a Patch Quilt,* a mixed media on canvas piece.

Welty, Eudora. *One Time, One Place.* New York: Random House, 1971. The photo, *Hat, Fan and Quilts,* shows a Black woman standing in front of quilts.

Williams, Mary Lyde Hicks (1866–1959). Painter. Williams created a series of paintings about plantation life. Two with African American quilting themes include: *Quilting* (painted between 1890 and 1910), showing a group of women working around a quilting frame and *The Nursemaid* (1905) showing a Black woman attending to a baby covered by a quilt. Both pieces are in the collection of the North Carolina Museum of History, Raleigh.

MISCELLANEOUS EPHEMERAE AND COLLECTIBLE ITEMS

Advertisements and Mail Order Catalogs

Bloomingdale's (New York, NY)

Full-page bedroom decorating advertisement appears in a June 1969 *New York Times* issue. A Double Wedding Ring quilt by Freedom Quilting Bee is featured.

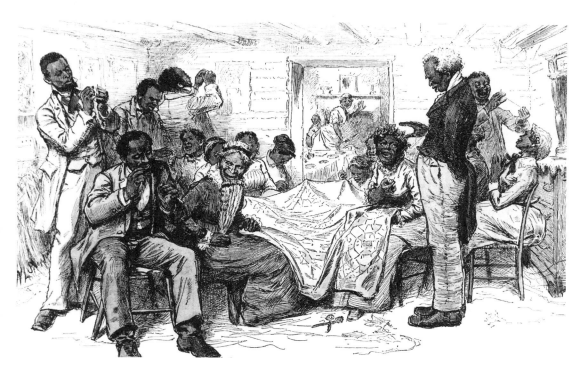

The "Brothers" Assisted in the Quilting. This wood engraving appeared in *Harper's Weekly*, April 21, 1883, issue. Courtesy of The Historic New Orleans Collection, accession number 1979.122.

Carol and Gene Rappaport (Millersville, PA)

Strip African American Quilt from Indianapolis, circa 1920, appeared in a full-page ad. *Folk Art Magazine*, Spring 1993, p. 16.

Coming Home by Land's End

1992 Christmas edition catalog. See p. 34 for the American Eagle quilt layout. Photo of members of the Freedom Quilting Bee included. This is one of the catalogs highlighted in the 1993 Smithsonian quilt reproduction controversy.

David A. Schorsch Inc.

Advertisement in *Maine Antique Digest* (June 1993) for a drawing by Marriet McGreath of Montpelier, IN featuring Black folks at a country auction. An "African American bird quilt" is featured in the drawing.

Eastman Kodak Company

Next to a card that reads "Mama says there's a little piece of all of us in this quilt" is a photograph of an older woman with a child holding a quilt. New York quilter Michael Cummings created one of the quilts in this full-page ad. The ad appeared in *Ebony* (7/87), *Essence* (6/87, 7/87), and *Black Enterprise* (6/87).

Frank J. Miele Contemporary American Folk Art Gallery (New York, NY)

Family Ties: Needlework by Denise Allen. Exhibit ad. *Folk Art Magazine*, Spring 2000, p. 28.

Gallerie Americana (Chicago, IL)

Half-page vertical ad of 19th century embroidery piece featuring a Black family at the dinner table. *The Clarion*, Summer 1989, p. 79.

Gilley's Gallery and Frames (Baton Rouge, LA)

Melrose Quilt, circa 1960, by Clementine Hunter is featured in half-page ad. *Folk Art Magazine*, Summer 2000, p. 28.

Hallmark Cards, Inc. (Kansas City, MO)

The right hand of an African American quilter stitches a patchwork quilt in a full-page ad for *Mahogany* greeting cards from Hallmark. *Essence*, September 1999, p. 157.

Ricco/Maresca Gallery (New York, NY)

Red and black *African-American Quilt*, circa 1910–1920, appeared in a full-page inside front cover ad. *Folk Art Magazine*, Spring 2001.

Robert Cargo Folk Art Gallery (Tuscaloosa, AL)

The Great American Pastime: Homage to Babe Ruth Quilt by Yvonne Wells is featured in full-page ad. The ad also mentions Wells' attendance at an exhibition of Alabama folk artists in Venice, France. *Raw Visions*, Summer 2000, p. 21.

Mule Quilt by Betty Rogers in 1998 appeared in full-page ad. *Folk Art Magazine*, Spring 1993, p. 24.

Me Masked Quilt (1993) by Yvonne Wells. Full-page ad.

Yesterday: Civil Rights in the South (1989) by Yvonne Wells. Full-page ad.

Seagram Americas—Absolut Vodka Arts Program

Quilt of a jazz scene. The base player strums on instrument shaped like an Absolut bottle. Quilt by Michael Cummings. *Black Enterprise*, September 1997.

Smithsonian Institution

"Quilters and Their Stories." *Smithsonian Magazine*, February 1999. Magnificent photo of Adriene Cruz with her quilt *Dunumba*. Advertisement to promote Roland Freeman's book *A Communion of the Spirits*.

Spiegel Catalog

1992 catalog include reproductions of three 19th century quilts from the Smithsonian Institution collection: The *Great Seal of the United States* quilt by Susan Strong in 1830, the *Bride's Quilt* by a Maryland quilter in 1851, and the *Bible Quilt* by Harriet Powers in 1886.

Tracy Goodnow Art & Antiques (Sheffield, MA)

African-American Quilt, circa 1910, featuring red crosses on a white cotton background, appeared as full-page ad. *Folk Art Magazine*, Winter 2000/2001, p. 8.

Tyson Trading Co. Art & Antiques (Micanopy, FL)

Untitled African American patchwork quilt featured in full-page ad. *Folk Art Magazine*, Spring 2000, p. 14.

Quilt Calendars. Traditional and contemporary African American quilts are showcased year-round. Collection of the author. Photograph by David Smalls.

Calendars

African American Quilts. 2001 Wall Calendar. Good Books, P.O. Box 419, Intercourse, PA 17534. Quilts from an exhibit entitled *Amish Quilts and African American Quilts: Classics from Two Traditions* at the People's Place Quilt Museum.

African-American Story Quilts 2000 by Yvonne Wells. Calendar. Thirteen quilts in this monthly calendar. Viesti Collection, P.O. Box 449, Durango, CO 81302.

The Alice Walker Calendar for 1986, San Diego: Harcourt, Brace, Jovanovich, 1986. This engagement-style calendar features a detail *The Color Purple* quilt made by Alice Walker on the page opposite the week of December 1–7.

America Hurrah. *Quilts*. Calendar. Longmeadow Press, 1992. Sarah Ann Wilson's 1854 *Black Family Album* quilt is featured in on the cover as well as for month of September.

Avon. *A Stitch in Time 1987*. Calendar. Longmeadow Press, 1987. Sarah Ann Wilson's 1854 *Black Family Album* quilt is featured in February.

Guild Pins. Membership pins from the 54-40 African American Quilting Guild of Virginia and the now defunct National Association of African American Quilters. Collection of the author. Photograph by David Smalls.

Folk Art Calendar 1992, New York: Workman Publishing Co. Quilt by Yvonne Wells included on September 23.

Kraft Foods. *1997 Calendar of African American Art*, Chicago: WGCI-AM/FM. The Krafts Food page features Peggie L. Hartwell's *African Skies and Southern Soil* quilt.

Nelson, Cyril and Carter Houck. *The Quilt Engagement Calendar Treasury*. New York: E. P. Dutton, Inc., 1982. Includes full-page photo of a Log Cabin variation quilt that includes Black people figures (p. 64).

Collectibles

The American Girl Collection

"… Addy Walker, a courageous girl determined to be free in the midst of the Civil War in 1864. Addy's story is one of courage and love—love of family and love of freedom." There are several books in the Addy series by Connie Porter. The Addy character sews and engages in other needlearts. Collectible Addy accessories include:

> Family Album Quilt—a 18.5″ × 18″ nine-patch appliquéd (printed) quilt—inspired by a 1850s design. Sku #ADAQ, $20. Summer 1999 American Girl catalog. This quilt design was inspired by Sarah Ann Wilson's 1854 *Black Family Album* quilt.
> Needlework Kit & Lamp—includes needle book, hoop, and embroider apron. Sku #ACAG, $18.

African American Quilting Guild Pins

54–40 African-American Quilting Guild of Virginia. Red, black and green cloisonné pin. Mid-1990s.

Afro-American Quilters of Los Angeles. Membership logo pins offered in the 1990s.

Daughters of Dorcas and Sons Quilters—Washington, DC. Circa 2000.

National Quilters Association of African American Quilters. Blue and white cloisonné pin. Circa 1994.

Uhuru Quilters Guild est. 1994. Gold pin with red, black and green X with a heart center. Circa 2000.

Daddy's Long Legs.

Penny—DK97E. Two-piece 9″ figurine set featuring a young Black girl sewing a quilt. Her cat sits near her. *1999 Daddy's Catalog*. The Country Fair Series. $29.95.

Greeting Cards

Faith Ringgold Quilts. Boxed set of twenty notecards featuring four quilts by Ringgold. New York: Galison Books, 1994.

Hallmark Cards, Inc. Kansas City, MO. In the 1990s, Hallmark licensed several African American quilts or used quilting imagery on various greeting cards. A sample of these cards include:

African Jazz #10 quilt by Michael Cummings featured on a blank $1.95 card. Sku # 195MHC862.

"Celebrating Our Friendship," a $2.25 card featuring *Soul Sisters III* by Yvonne Wells. Sku # 225MHF29.

"For a Wonderful Aunt," a $2.95 birthday card from 1998. *Flowers in a Vase* quilt by Yvonne Wells. Sku #295MHB223.

"Grandmother, Your Love is Snuggly Warm," a $1.95 Mother's Day greeting card featuring *Clara's Garden* quilt by Michael Cummings. Sku # 195SMD 98-1.

"In Praise of Our Mothers," a $1.95 Mother's Day card featuring *Soul Sisters II* quilt by Yvonne Wells. Sku # 195SMD995.

"Links and Lineage" (1986) painting by Paul Goodnight. Image was made into a blank Hallmark card sometime pre-1992. $1.50. Sku# 150PRF4774.

"Little Bits of Love," a $2.50 Birthday card for Mother from 1999. Features *African American Quilt* piece from the Scott Heffley collection, Kansas City, MO. Sku # 250MHB61.

"Sisters of Soul…," a $1.95 Mother's Day card featuring *Soul Sister I* quilt by Yvonne Wells. Sku # 195SMD1007.

"To Celebrate the Sisters," a $1.95 greeting card featuring *Soul Sisters III* quilt by Yvonne Wells. Sku # 0195SMD963

"On Your Wedding Day," a $2.50 card from 1997. *Wedding II*, quilt by Yvonne Wells. Sku # 250MHW25.

"What Appears as a Failure is Simply a Stepping-Stone to Realizing Success," a $1.95 inspirational card in the *Acts of Faith* line by Iyanla Vanzant, had a patchwork and beaded quilt motif. Sku # 195MHC316.

Women of Color Quilter's Network. Boxed set of twenty blank notecards featuring four quilts by Ed Johnetta Miller. New York: GMG Publishing Group, 1998.

Ephemerae

Funeral Program. "In Loving Memory of Mary Ellen "Mimi" Webb." Service held on December 30, 2000. A.A. Rayner & Sons, Chicago, IL. Miss Webb was born in 1920. She was a founding member of the New York chapter of the Women of Color Quilters Network. She was a dollmaker, children's book illustrator, seamstress, librarian, and expert quilter. She was one of the quilters who worked on the 1993 *Dance Theater of Harlem* quilt. The order of service included a viewing of Miss Webb's quilts and other artwork.

Senator Paul Tsongas Collection—Foreign Policy Issues, South Africa, Box 95A, Folder 13 "South African: Winnie Quilt Mandela." University of Massachusetts Lowell Center for Lowell History, Lowell, MA. The file contains background materials about the 1983 quilt signed by Members of Congress for Winnie Mandela. Items include:

Letter to "Dear Colleague" from Paul Tsongas dated January 26, 1983. Requests fellow members participate in a public signing of a quilt for Winnie Mandela. The quilt was to replace a red, black, and green bedspread confiscated by the South African police. The "Lone Star" pattern handmade quilt was made in West Virginia. The African American Institute, Governor and Mrs. Jay Rockefeller, and the West Virginia Department of Culture and History participated in this effort.

List of 45 Senators and Representatives who signed the quilt. Members included Representatives George W. Crockett, Jr., Mervyn Dymally, William Gray III, Gus Savage, Pat Schroeder, Louis Stokes and Senators Bill Bradley, John Glenn, Nancy Kassebaum, Edward Kennedy and Daniel Moynihan, among others.

Photo of five members signing quilt. No date or names.

CHAPTER 3

Museums and Galleries with African American Quilts

BACKGROUND

Lisa Turner Oshins of the Library of Congress American Folklife Center conducted a massive survey to locate and describe quilt collections in museums, archives, libraries, universities, corporations, and other public institutions. From late 1985 though mid-1987, Oshins analyzed 1,224 completed surveys. More than twenty-five thousand quilts were tabulated from survey respondents. The survey results were published in the landmark *Quilt Collections: A Directory for the United States and Canada* (Acropolis Books, 1987).

Oshins identified approximately one hundred and thirty (130) African American-made quilts in just 26 different institutions. This was less than one percent of all the quilts uncovered!

Fifteen years have passed. Have U.S. cultural centers continued to preserve African American quilts? Are museums collecting the broad range of quilts sewn by African American quiltmakers? Are galleries promoting works by Black quilters? I undertook a survey to answer these questions.

METHODOLOGY

From August to November 2000, I mailed "African American Quilts in Museum Collections" and "African American Quilts in Galleries" questionnaires to over 400 facilities nationally. The institutions included those specifically iden-

tified in Oshins's work as having African American quilts or research materials, presidential libraries, African American museums, galleries and cultural centers as well as historically Black college museums. Internet and other secondary research methods were used to identify additional institutions.

MUSEUM COLLECTION KEY FINDINGS

The following information comprises the most comprehensive listing to date of institutions and galleries that are interested in promoting or preserving African American quilts.

One hundred (100) institutions have African American quilts or quilt materials in their permanent collections. These facilities are located in 31 different states as well as in the District of Columbia. One museum in the United Kingdom is also included. Five hundred and eighty-five (585) quilts are identified from survey respondents and other research methods. Sixty-five percent of all the quilts identified are in only seven museums:

- International Quilt Study Center—University of Nebraska, Lincoln, NE . 160 quilts
- Old State House Museum—Little Rock, AK . 85 quilts
- Smith Robertson Museum—Jackson, MS . 41 quilts
- Old Capital Museum of Mississippi—Jackson, MS 39 quilts
- Michigan State University Museum—East Lansing, MI 27 quilts
- American Folk Art Museum—New York, NY 20 quilts
- Kansas African American Museum—Wichita, KS 10 quilts

It is cause for celebration that to date 585 African American–made quilts have been identified vs. 130 quilts in 1987. However, let us look closer at the number of institutions collecting African American–made quilts or related items. When the top seven museums are removed, less than one hundred institutions nationally have African American–made quilts in their permanent collections. These museums own, on average, two quilts each.

Three facilities house important African American oral quilt histories, documentation or ephemeral materials:

- American Folklife Center at the Library of Congress maintains ephemeral files.
- McKissick Museum (Columbia, SC) has about 250 recorded quilt histories from various African American quilters in South Carolina. A video, *Quilts Like My Mama Did*, was also produced.
- Michigan State University Museum (East Lansing, MI) has 40 oral histories and hundreds of photographs documenting Michigan African American quilters.

Respondents to the museum survey provided a range of detailed information. Most museums provided the minimum data on specific quilts: quilt title, quilt-

maker name, year quilt completed, and identification number. Other museums sent photocopies of the quilts or provided background stories on how the museum acquired the quilts. I have attempted to categorize the 585 quilts in permanent collections. These estimates are based on limited information. However, the estimates provide directional insights into how the African American quiltmaking story is or is not being preserved in our cultural institutions.

- 4% quilts made prior to 1865
- 4% quilts made between 1866 and 1899
- 16% quilts made between 1900 and 1949
- 22% quilts made between 1950 and 1969
- 54% quilts made between 1970 and 2000

GALLERIES: KEY FINDINGS

Thirty galleries in 17 states occasionally or frequently exhibit African American-made quilts. In addition, several galleries represent African American quiltmakers on a regular basis. At least two galleries (Jeanine Taylor Folk Art Gallery in Florida and Portfolio Gallery in Missouri) are actively seeking new quiltmakers to represent. Many galleries sell quilts both in person and online.

MUSEUMS WITH AFRICAN AMERICAN QUILTS

African American Museum in Philadelphia

701 Arch Street
Philadelphia, PA 19106
(215) 574-0380
www.AAMPmuseum.org
Terrie Rouse, President

Permanent collection includes an 1898 quilt by Jessie B. Lewis and two quilts by Mira Jane Trucluel made between 1850–1900. This museum also houses the Ann Russell Jones Collection of Textiles. Jones was the first Black woman to graduate from the Philadelphia School of Design for Women.

African Arts Museum of SMA Fathers

Society of African Missions
23 Bliss Avenue
Tenafly, NJ 07670
(201) 894-8611
Robert Koenig, Director

Collection includes a few Liberian pieced quilts as well as other African textiles, wrappers, and costumes.

Afro-American Cultural Center

401 North Myers Street
Charlotte, NC 28202
(704) 374-1565
www.aacc-charlotte.org
John Moore, Director

Collection includes the *Wanda Montgomery Memorial Quilt* to honor the center's former director. The center has previously exhibited African American quilts.

American Craft Museum

40 West 53rd Street
New York, NY 10019
(212) 956-3535
Marsha Beitchman, Registrar

Permanent collection includes Faith Ringgold's 1988 *Shades of Alice* quilt, three

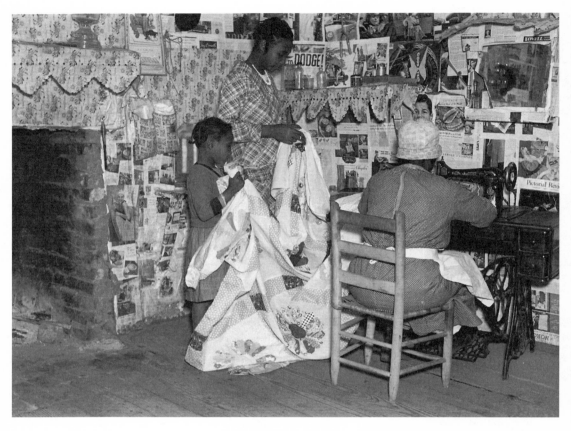

Quilter Jorena Pettway uses a sewing machine to make a quilt. Jennie Pettway stands nearby with an unnamed little girl. Gees Bend, Alabama, April 1937. This photograph is interesting because it demonstrates the use of a sewing machine in quiltmaking and the use of a traditional quilt pattern. This area of Alabama is where the Freedom Quilting Bee was formed in the 1960s. Arthur Rothstein, photographer. (Farm Security Administration–Office of War Information Photograph Collection, Library of Congress, Washington, D.C.)

1934 Tennessee Valley Authority appliqué quilts designed by Ruth Clement Bond and made by Rose Marie Thomas, and quilts by Carolyn Mazloomi, Michael Cummings, Peggie L. Hartwell, and Elizabeth Talford Scott. The American Craft Museum also has photographs and slides of African American quilts and quilters available upon request.

American Folk Art Museum
Library and Administrative Offices
555 W. 57th Street #1300
New York, NY 10019

(212) 977-7170
www.FolkArtMuseum.org
Stacy C. Hollander, Senior Curator
 The American Folk Art Museum has twenty African American quilts in its permanent collection. These are primarily variations of traditional quilt patterns from fourteen different Alabama, Georgia, and Mississippi quiltmakers during the 1970s–1990s. The museum library has the only known bound copy of past Women of Color Quilters' Network newsletters (vol. 1 1987–1990, vol. 2 1990–1993).

American Folklife Center

Library of Congress—LJG-49
101 Independence Avenue SE
Washington, DC 20540-4610
(202) 707-5510
http://lcweb.loc.gov/folklife
Margaret Bulger, Director

The Folklife Center has several ephemeral files on American quilting, quilt photographs, quilt songs, and African American quilting. The files on Black American contributions include an impressive variety of past exhibit announcements, articles, quilting guild newsletters and even old Freedom Quilting Bee quilt order forms. Many of the quilt photo are from the 1930s Farm Security Administration files.

American Museum and Gardens in Britain

Claverton Manor
Bath, England BA2 7 BD
United Kingdom
0122 546 0503
www.bath.co.uk
William McNaught, Director

Permanent collection includes an 1860 quilt named *Chalices* by slaves on Mimosa Hall Plantation, Texas. Slides of the quilt are available upon request.

Amistad Research Center

Tulane University—Tilton Hall
6823 St. Charles Avenue
New Orleans, LA 70118
(504) 865-5535
www.tulane.edu/~amistad
Brenda Square, Director of Archives

Permanent collection includes *La Amistad, 1999* by Cecelia Pedescleaux and a 1979 quilt by Carolyn Mazloomi. The center also has vertical files on African American quilting.

Archives of American Minority Cultures

Gorgas Main Library—Special Collections
University of Alabama
Tuscaloosa, AL 35487-0266
(205) 348-5512
www.lib.ua.edu

Charles B. Osburn, Dean of Libraries

Oshin's *Quilt Collections* (1987, p. 18) references a taped interview with quilters and thirty-one slides from an annual Freedom Quilting Bee event in the early 1980s.

Atlanta History Center

130 West Paces Ferry Road NW
Atlanta, GA 30305-1366
(404) 814-4053
www.atlhist.org
Susan Neill Doutt, Curator of Textiles and Social History

The Atlanta History Center permanent collection includes two slave-made quilts circa 1820-1865 and two quilts made in Georgia between 1920–1940.

Autry Museum of Western Heritage

4700 Western Heritage Way
Los Angeles, CA 90027-1462
(323) 667-2000
www.Autry-Museum.org
Laela French, Registrar

The permanent collection includes a quilt by Carolyn Mazloomi.

Avery Research Center for African American History

125 Bull Street
College of Charleston
Charleston, SC 29424
(843) 727-2009
www.cofc.edu/library/averyinst.html
Curtis Franks, Director of Museum

Fry's *Stitched From the Soul* (1990, p. 23) references a quilt made circa 1845–1853 by Johanna Davis.

Birmingham Civil Rights Institute

520 Sixteenth Street North
Birmingham, AL 35203
(205) 328-9696
http://bcri.bham.al.us/
Dr. Lawrence J. Pijeaux, Jr., Director

The institute's collection includes *A Tribute to the Civil Rights of Alabama 1954–1989* by Nora Ezell, *The Greatest Teacher of All* by Carolyn Mazloomi (1995), and *Time:*

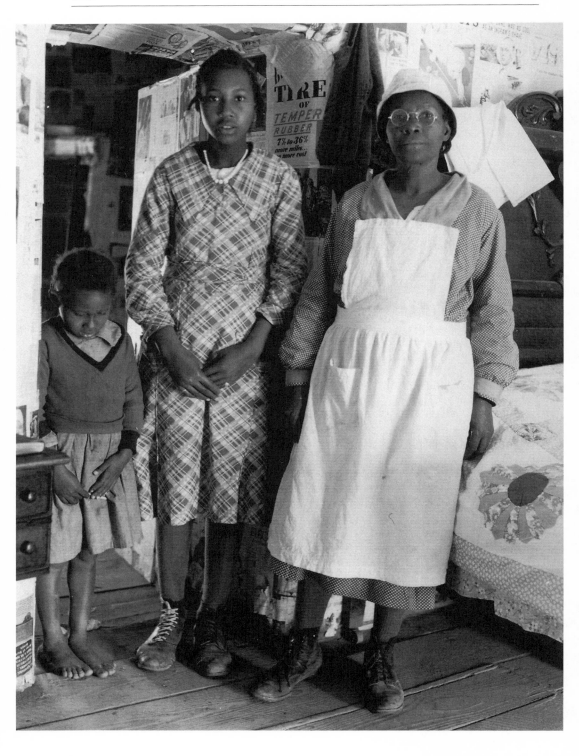

A Commemorative Quilt by Anne Ruth Jenkins (1998).

Birmingham Museum of Art

2000 8th Avenue North
Birmingham, AL 35203
(205) 254-2566
www.artsbma.org/index.html
Gail Trechsel, Director

The museum collection includes at least five African American quilts. Included are *Proverbs Quilt* by Yvonne Wells (1988), *Five Loaves and Two Fishes* by Chris Clark (1993), *Star of Bethlehem* quilt by the Freedom Quilting Bee (1968), *Civil Rights Quilt* by Nora Ezell (1993), and *Pine Burr* quilt by Lucy Mingo (no date). The museum's collection also includes over 300 quilts donated by Robert Cargo. The museum is in the process of cataloging these quilts. Many may be by African American quilters.

Bronzeville Children's Museum

96th Street and Western Avenue
P.O. Box 428250
Evergreen Park, IL 60805
(708) 636-9504
Peggy A. Montes, President

The museum's collection includes *Chicago's Historic Black Artists Story Quilt*, a 1999 quilt made by children.

California Afro-American Museum

600 State Drive
Exposition Park
Los Angeles, CA 90037
(213) 744-7432
www.caam.ca.gov
Jamesina E. Henderson, Executive Director

Permanent collection includes Los Angeles native Michael Cumming's 1979 *Springtime in Memphis at Night* quilt and an untitled quilt by Laconia Marie Wilson made around the 1960s-1970s.

Cape Fear Museum

814 Market Street
Wilmington, NC 28401-4731
(910) 341-4350
www.co.new-hanover.nc.us/cfm
Barbara Rowe, Curator

Permanent collection includes four quilts/quilt tops by Ida Chestnut Mosley made between 1898 and 1952. Fabric from three of the quilt tops came from dresses made at a seamstress shop on North 6th Street in Wilmington. The collection also includes oral histories and photographs of African American quilters.

Center for Southern Folklore

119 South Main Street
Memphis, TN 38103
(901) 525-3655
Jody Peiser, Director

Oshin's *Quilt Collections* (1987, p. 179) references African American quilts in the center's collection of seventy-five quilts at that time. One piece was an American flag quilt by Pecolia Warner.

Charles H. Wright Museum of African American History

315 East Warren Avenue
Detroit, MI 48201-1443
(313) 494-5813
Nubia Wardford, Assistant Registrar

The museum's permanent collection includes four quilts dating from the 1930s to 1999.

Charleston Museum

360 Meeting Street
Charleston, SC 29403-6297
(843) 722-2996
Jan Hiester, Registrar

The Charleston Museum, founded in 1773, is America's first museum. The permanent collection includes an 1815 slave-made

Opposite: **Quilter Jorena Pettway stands nearest bed with a traditional Dresden plate quilt. Gees Bend, Alabama, April 1937. Arthur Rothstein, photographer. (Farm Security Administration–Office of War Information Photograph Collection, Library of Congress, Washington, DC)**

trapunto dresser cover, an 18th century African American-made unfinished trapunto piece, and an 1828 chintz mosaic with trapunto piece. Slides and prints of trapunto dresser cover are available upon request.

Chase Manhattan Bank

Art Program
410 Park Avenue
New York, NY 10022
 Oshin's *Quilt Collections* (1987, p. 131) references two African American quilts among seventy-eight quilts in the Chase Manhattan Bank collection at that time.

Chief Vann House Historic Site

82 Highway 225N
Chatsworth, GA 30705
(706) 695-2598
Jeff Stancil, Director
 The permanent collection includes an *Indian Head Dress* or *Turkey Track* pattern quilt. The cotton cover was made by a slave on the Carters Quarters (Rock Spring) Plantation in Murray County, GA around 1840.

Cincinnati Art Museum

953 Eden Park Drive
Cincinnati, OH 45202
(513) 639-2995
www.CincinnatiArtMuseum.com
Cindy Amneus, Associate Curator Costumes and Textiles
 Permanent collection includes an 1849 *Star of Bethlehem* quilt by 'Aunt Peggy.'

Clark Atlanta University Art Galleries

223 James P. Brawley Drive
Trevor Arnett Hall, 2nd Level
Atlanta, GA 30314-4391
(404) 880-6102
www.CAU.edu/ArtGallery
Tina Dunkley, Director
 Permanent collection includes a strip quilt circa 1935 donated by Ty and Jean Tyson.

Columbus Museum

1251 Wynnton Road
Columbus, GA 31906
(706) 649-0713
www.ColumbusMuseum.com
Tom Butler, Director
 Permanent collection includes *Lone Star* quilt by Angeline Pitts made circa 1875-1910.

Department of Archives and Special Collections

JD Williams Library
University of Mississippi
University, MS 38677
(662) 915-5933
www.OleMiss.edu
Thomas Verich, University Archivist
 Oshin's *Quilt Collections* (1987, p. 131) references the William R. Ferris, Jr., Collection, which included several hundred photographs of quilts and quiltmakers, mostly of Pecolia Warner of Mississippi.

Field Museum

1400 S. Lake Shore Drive
Chicago, IL 60605-2496
(312) 922-9410
 Two quilts by textile artist Betty Venus Blue are on permanent display in the Africa exhibit area.

Fort Wayne Museum of Art

311 E. Main Street
Fort Wayne, IN 46802
(219) 422-6467
www.fwmoa.org
Sachi Yanari-Rizzo, Associate Curator
 Permanent collection includes *Tar Beach 2*, a silkscreen on silk piece by Faith Ringgold.

Golden Pioneer Museum

923 10th Street
Golden, CO 80401
(303) 278-7151
www.GoldenPioneerMuseum.com
Elinor Packard, Director
 Permanent collection includes a coverlet woven by slaves on the Robert's Station Plantation near Macon, GA sometime between 1808 and 1860

Great Plains Black Museum

2213 Lake Street
Omaha, NE 68110
(402) 345-2212
Bertha Calloway, Director
 Freeman's *A Communion of the Spirits* (1996, p. 233) references quilts in the museum's collection.

H.T. Sampson Library

Jackson State University
1400 Lynch Street
Jackson, MS 39217
(601) 968-2123
http://ccaix.jsms.edu/~gadmappl/tour/hts.html
Dr. Lou-Helen Sanders, Director of Services
 The library, which opened in 1998, had on permanent display six quilts made specifically for the library by Gustina Atlas, Loraine Harrington, Geraldine Nash and Hystercine Rankin. Sadly, in 2000, two of the quilts were stolen.

Hampton University Museum

Huntington Building
Hampton, VA 23668
(757) 727-5308
www.hampton.edu
Jeanne Zeidler, Director
 Permanent collection includes *Big Woman* quilt by Sarah Mary Taylor and *The African American Independence Celebration of America*, a 1994 quilt made by the North Newport News Community Center Seniors.

High Museum of Art

1280 Peachtree Street NE
Atlanta, GA 30309
(404) 733-4400
www.high.org
Michael Shapiro, Director
 Permanent collection includes a 19th century *Snake Quilt* by an unknown African American woman from eastern North Carolina; *Bible Scene Quilt* by members of the Drake Family on Thomaston, GA circa 1900; and two Faith Ringgold quilts—*Sonny's Bridge* and *Church Picnic Story Quilt.* The museum also has an 11-page curriculum plan by Reggie Stephens for teaching students about the *Bible Scenes Quilt.*

Historic Carson House

1805 Highway 70W
Marion, NC 28752
(828) 724-4640
Nina Greenlee, Director
 Permanent collection includes an 1880 quilt named *The Marseilles* by Kadella, an 1839 quilt *Crazy Patch* by Em, John Logan's slave, and an 1830 quilt *Blazing Star* by Sarah Kadella's daughter. Send a SASE for a Historical Carson House brochure, which includes photo of the Kadella quilt. The Carson House is open to the public May 1–October 1.

Illinois State Museum

Spring & Edwards Street
Springfield, IL 62706-5000
(217) 782-7387
www.museum.state.il.us
Janice T. Wass, Curator
 Permanent collection includes a 1993 taped interview with quilter Anna Borders.

Indianapolis Museum of Art

Textiles & Costumes Collection
1200 West 38th Street
Indianapolis, IN 46208-4196
(317) 920-2660
www.ima-art.org
Niloo Paydar, Curator
 Permanent collection includes a 1991 quilt by Estelle McCray and *I've Got an Ace Up my Sleeve*, a 1995 quilt by Carolyn Mazloomi.

International Quilt Study Center

University of Nebraska—Lincoln
Dept. of Textiles, Clothing & Design
234 Home Economics Building
Lincoln, NE 68583-0838
(402) 472-6549
www.ianr.unl.edu/quiltstudy
Carolyn Ducey, Curator
 The Center recently acquired the Robert and Helen Cargo Collection of 156

African American quilts worth $500,000. Professor Robert Cargo started collecting Alabama quilts in the late 1950s. Since 1980, he has concentrated more on African American quilts from the state. The collection acquired by the Center represents more than 32 quilt makers including Nora Ezell, Roberta Jemison, Dennis Jones, Mary Lucas, Jeff Martin, Mary Maxtion, Lureca Outland, the RSVP Club, Katherine Summerville, Sarah Mary Taylor, Mattie Thompson, Yvonne Wells, and Lucile Young. The quilts were all made in the 1900s to 1996. In addition, the Center collection includes two quilts by Faith Ringgold and two quilts by Anna Williams Jones.

Jimmy Carter Library & Museum

441 Freedom Parkway
Atlanta, GA 30371
(404) 331-3942
http://CarterLibrary.galileo.peachnet.edu
Nancy Hassett, Registrar

Permanent collection includes a quilt created and donated by Philadelphia quilter Lorraine A. Mahan. The White House received the quilt in April 1979. The story quilt has the names Jimmy and Rosalyn Carter appliquéd onto the quilt top. There is a peanut plant with four roots leading to the names and birth dates of the Carter's four children. The text "President of the United States" appears in a circle with stars around the edges and an eagle with arrows and olive branch. There is also a prayer appliquéd onto the quilt. It reads, "A Prayer for Patience o God of infinite patience. Help us to follow in the footsteps of thine own son, who bore with patience the sins of the world. Fill our hearts with this goodness. In all of life's journey, may we possess our souls in patience. Amen."

John F. Kennedy Library and Museum

Columbia Point
Boston, MA 02125
(617) 929-4521
Elizabeth Stapleton-Roach, Registrar

The JFK Library and Museum Collection includes two quilts from Liberia. One is a patchwork red and green cotton fabric quilt with portraits of JFK and William Tubman. The second is an 88" × 100" silk quilt with U.S. and Liberian flags. This quilt was a gift of Liberian President William Tubman, who served from 1944-1971. The JFK collection also includes a large number of handwoven textiles and handstitched costumes from Africa.

Kansas African American Museum

601 North Water
Wichita, KS 67201
(316) 262-7651
James Barnes, Curator

Permanent collection includes approximately 10 quilts from the mid 1950s–1980s. Quilt patterns include Nine Patch, Hole in the Barn, and a unique eagle design.

Kent State University Museum

PO Box 5190
Rockwell Hall
Kent, OH 44242-0001
(330) 672-3450
www.Kent.edu/museum
Jean Druesdow, Director

Permanent collection includes Elizabeth Hobbs Keckley's *Mary Todd Lincoln* quilt circa 1850-1875. Elizabeth Hobbs Keckley (1824–1907) was born a slave and later purchased freedom for herself and her son from money earned as a seamstress. Mrs. Keckley worked in the White House during the Lincoln presidency. The quilt is believed to contain scraps from the dresses she made for Mary Todd Lincoln.

Louisiana Division of the Arts

Louisiana Folklife Program
PO Box 44247
Baton Rouge, LA 70804-4247
(225) 342-8180
www.crt.state.la.us/arts/folklife/index.htm
Maida Owens, Director

Collection includes two African American quilts: *Around the World* by Rosie L. Allen and *Strip Quilt with Tie Strings* by Rosie Jackson.

Louisiana State Museum

751 rue Chartes
New Orleans, LA 70116
(504) 568-6968
http://lsm.crt.state.la.us
James Sefcik, Director

Collection includes a late 19th century Log Cabin Silk quilt made by Dolly Jackson, a Georgia slave. The quilt was placed on loan to the Museum in 1928.

McKissick Museum

University of South Carolina
Bull and Pendleton Street
Columbia, SC 29208
(803) 777-7251
www.cla.sc.edu/MCKS/
Karen Swager, Collections Manager

Permanent collection includes eight quilts by Anna Byrd, Carrie Coachman, and Thomas Mack. The museum's Folklife Archives includes approximately 250 forms about quilts made by African American quilters during a survey conducted in the mid-1980s.

Metropolitan Museum of Art

American Decorative Arts Department
1000 Fifth Avenue at 82nd Street'
New York, NY 10028
(212) 535-7710
www.metmuseum.org

Permanent collection includes "Star of Bethlehem" pattern variation quilt by "Aunt Ellen" and "Aunt Margaret," slaves of the Marmaduke Beckwith Morton family about 1837-50. This silk and cotton quilt was made near Russelville, KY. The collection also includes Faith Ringgold's 1985 *Street Story Quilt.*

Michigan State University Museum

Michigan Folk Arts Archive
Michigan State University
East Lansing, MI 48824-1045
(517) 355-6511
http://museum.cl.msu.edu/index.html
Marsha MacDowell, Curator of Folk Art

The Michigan State University Museum collection includes twenty-seven Afri-

can American quilts encompassing nineteen different quilt makers such as Mary Atkins, Deonna Green, Carole Harris, Lethonee Jones, Willie Maddox, Myla Perkins, Ione Todd, and Lula Williams. The museum also has forty oral histories and hundreds of photographs of Michigan African American quilters. There is also one quilt from Liberia in the collection.

Milwaukee Art Museum

750 North Lincoln Memorial Drive
Milwaukee, WI 53202
(414) 224-3200
Russell Bowman, Director

Permanent collection includes *Lone Star Quilt* by Alice Thomas Morris circa 1935. There are a number of museum support groups, including the African American Art Alliance. Among its goals, the Alliance supports the African American Art Acquisition Committee for the museum.

Mint Museum of Craft and Design

220 North Tryon Street
Charlotte, NC 28202
(704) 337-2000
www.MintMuseum.org
Martha Mayberry, Registrar

Permanent collection includes *Gathering of Spirits* (1997) by Carolyn Mazloomi.

Mississippi Museum of Art

201 East Pascagoula Street
Jackson, MS 39201
(601) 960-1515
www.MSMuseumArt.org
Kathy Greenberg, Registrar

Permanent collection includes two 1991 quilts by Sarah Mary Taylor, *Everybody* and *I Love Everybody*, *On the Farm* by Anne Dennis and *Noah's Ark* by Otesia Harper.

Museum of American Quilter's Society

215 Jefferson Street
PO Box 1540
Paducah KY 42002-1540
Dorisanna Conner, Curator
(270) 442-8856

www.QuiltMuseum.org

The Museum's permanent collection includes *Lilies of Autumn* quilt by Juanita Gibson-Yeager and *Discovery* by France-lise Dawkins. An Anna Williams quilt is planned for purchase in 2001.

Museum of Arts and Sciences

4182 Forsyth Road
Macon, GA 31210-4806
(912) 477-3232
www.masmacon.com
Michael Brothers, Director

Three 1987 quilts by Wini McQueen in permanent collection: *Adinkra Aduru, Family Tree*, and *Turtle Quilt*.

Museum of Connecticut History

231 Capitol Avenue
Hartford, CT 06106
(860) 757-6535
www.CSLib.org
Dean Nelson, Director

The Museum collection includes four *Connecticut African American Freedom Trail* quilts made in 1999 by 112 quilters.

Museum of Early Southern Decorative Arts

PO Box 10310
924 South Main Street
Winston-Salem, NC 27108-0310
(336) 721-7300
http://store.yahoo.com/oldsalemonline.mesda.html
Paula Locklair, Director

Permanent collection includes a "Courthouse Steps" variation quilt by Ann Hester Isaac (circa 1880-1930).

Museum of Fine Arts

Avenue of the Arts
465 Huntington Avenue
Boston, MA 02115-5523
(617) 267-9300
www.mfa.org/home.htm
Elizabeth Ann Coleman, Curator

The Museum of Fine Arts owns the *Pictorial Quilt* also known as the *Bible Quilt* by Harriet Powers circa 1895–1898. The museum also sells slides of the quilt in a set of twenty and a set of forty.

Museum of Florida History

500 S. Bronough Street R.A. Gray Building
Tallahassee, FL 32399-0250
(850) 488-1484
www.dos.state.fl.us/dhr/museum/quilts
Susan Olsen, Director

Florida Quilt Heritage Project recorded approximately 6 quilts by African Americans. Permanent collection includes two quilts by Dorothy Iona Wright (circa 1950) and one by Sally Jones (circa 1947).

Museum of International Folk Art

Museum of New Mexico
PO Box 2087
Santa Fe, NM 87504-2087
(505) 476-1200
www.moifa.org
Bobbie Sumberg, Curator

The permanent collection includes two African American made quilts—one by Lucinda Toomer (circa 1975) and a slave made pre-1860 quilt.

National Afro-American Museum and Cultural Center

PO Box 578
1350 Brush Row Road
Wilberforce, OH 45384
(937) 376-4944
Wendy Felter, Director

The museum collection includes a quilt by Carolyn Mazloomi.

National Civil Rights Museum

450 Mulberry Street
Memphis, TN 38103-4214
(901) 521-9699
www.CivilRightsMuseum.org
Barbara Andrews, Collections

The only quilt in the collection is *Tryin' to Grab a Piece of the Pie* by Carolyn Mazloomi (1991).

National Museum of American Art

Smithsonian Institution
8th and G Street, NW

Washington, DC 20560-0210
(202) 357-2156
www.AmericanArt.si.edu
Dr. Elizabeth Broun, Director

The museum collection includes *Coke Covers the World* by Otesia Harper 1992. Gift of Herbert Waide Hemphill, Jr. Slides and oral history from Mrs. Harper available. The collection also includes *The Bitter Nest, Part II*, a 1988 quilt by Faith Ringgold.

National Museum of American History

Smithsonian Institution
Division of Textiles—MRC 617
Washington, DC 20560-0617
(202) 357-1889

Permanent collection includes six African American quilts, including the Harriet Powers 1886 *Bible Quilt*; *Sugar Loaf*, a pieced cotton quilt from the late 19th century made by Diana DeGodis Washington Hine who is said to have been born a slave at Mt. Vernon in 1793; a pieced cotton quilt top with crosses, triangles, and stars made by Betty West of Washington, DC circa 1879; a counterpane appliquéd with crossed tulips made by Ann, a sixteen year old Virginia slave in 1840; a "Feathered Star" pattern quilt of the late 19th century made by Texas slaves; and a quilt top appliquéd and embroidered by Frances M. Jolly as late as 1860. Slides and color transparencies are available upon request.

New Orleans Museum of Art

1 Collins Diboll Circle
PO Box 19123
New Orleans, LA 70179-0123
(504) 483-2630
www.noma.org
Paul Traver, Registrar

Permanent collection includes three quilts by Louisiana artist Clementine Hunter—One is a pictorial with scenes from Melrose Plantation, another is an abstract chevron pattern quilt, and the last is a pictorial quilt with figures and houses.

Newark Museum

49 Washington Street
PO Box 540

Newark, NJ 07101-0540
(973) 596-6550
www.NewarkMuseum.org
Mary Sue Sweeney Price, Director

The Newark Museum permanent collection includes six African American-made quilts from the 1920s–1950s. One of the quilts, *Pine Burr* made by Nellie Mae Brown of Nashville in 1951, was a gift to the museum by former Secretary of State Laura Hooks, whose father, Earl Hooks, was a collector of African American folk art.

North Carolina Museum of History

4650 Mail Service Center
Raleigh, NC 27699-4650
(919) 715-0200
http://nchistory.dcr.state.nc.us/
Janice Williams, Director

The permanent collection includes eight quilts acquired as early as 1964. Specifically, the collection includes a 1907 Log Cabin quilt by Patience White, a quilt by Mary Barnes (circa 1875–1900), a 1958 strip funeral quilt by Margaret Irene Wicker, two 1935 strip quilts by Eliza Rogers Arrington, two 1935 strip quilts by Lella Sneed, and a 1931 pinwheel child's quilt by an unknown quilter.

Norton Family Center

225 Arizona Avenue
Santa Monica, CA 90401
(310) 576-7700
Susan Cahan, Director

Permanent collection includes *Wanted: Douglass, Tubman and Truth*, a 1997 quilt by Faith Ringgold.

Oakland Museum of California

1000 Oak Street
Oakland, CA 94607
(510) 238-3404
www.museumca.org
Dennis Power, Executive Director

The museum collection includes two quilt tops by Elsie Preston circa 1890.

Ohio Historical Society

1982 Velma Avenue
Columbus, OH 43211-2497

Leslie Ann Floyd, Registrar

Permanent collection includes an 1872 appliquéd quilt by Phebe Cook of Edison, Ohio. Mrs. Cook made this quilt for her granddaughter, Blanche Corwin Kelly. The quilt includes twenty-four framed appliquéd blocks of people, animals, and domestic activities. The quilt depicts individuals known to the quilter, granddaughter, and community, including figures of African Americans.

Old Capital Museum of Mississippi History

PO Box 571
Jackson, MS 39205-0571
(601) 359-6920
www.mdah.state.mu.us
Cindy Cable, Registrar

Permanent collection includes thirty-nine African American quilts acquired since 1962. The quilts were generally made in Mississippi with a few exceptions. Six quilts were made during the 1800s. Fifteen quilts were made in the 1970s. The remaining quilts are from the decades, 1920–1980, with the exception of 1960. Roland Freeman's 1978 exhibit, *Something to Keep You Warm*, opened at this museum.

Old Slave Mart Museum

6 Chalmers Street
Charleston, SC 29482
(843) 722-0079

Oshin's *Quilt Collections* (1987, p. 173) references eight African American quilts on continuous display at the time. The Museum is currently closed for renovations.

Old State House Museum

300 W. Markham Street
Little Rock, AR 72201-1423
(501) 324-9658
www.OldStateHouse.com
Bill Gatewood, Director

Permanent collection includes eighty-five quilts by Black Arkansans between 1890 and 1996. Many of the quilts are included in Cuesta Benberry's book *A Piece*

of My Soul: Quilts by Black Arkansans. The museum also has oral histories from Black quilters.

Oregon Historical Society

1200 SW Park Avenue
Portland, OR 97205-2843
(503) 222-1741
www.ohs.org
Marsha Matthews, Director

The society collection includes a 1976 *Afro-American Bicentennial Quilt*.

Oregon State University

Horner Collection—formerly Horner Museum
Corvallis, OR 97331-4501
(541) 737-1000

Oshin's *Quilt Collections* (1987, p. 160) references one African American quilt in the museum's collection of sixty-eight quilts. The Horner Museum closed in June 1993. The Horner Collection had more than 60,000 artifacts, photos and documents. In July 1998 the university reached an agreement, in principle, with the Benton County Historical Society to manage the collection once a new facility was built. In June 2000 the Historical Society closed and the public was directed to contact the Benton County Historical Museum in Philomath, OR for additional information. It is unclear where the former Horner Museum quilt collection is now located.

Panhandle-Plains Historical Museum

WTAMU Box 60967
2401 Fourth Avenue
Canyon, TX 79016
(806) 651-2244
www.wtamu.edu/museum
Walter R. Davis, Jr., Director

The Museum collection includes *Ship's Wheel*, an 8-point blazing star pattern made by a slave circa 1860.

Philadelphia Museum of Art

Benjamin Franklin Parkway and 26th Street
Philadelphia, PA 19130

(215) 763-8100
www.PhilaMuseum.org
Dilys Blum, Curator

Permanent collection includes three African American quilts—*Tar Beach 2* by Faith Ringgold; an untitled quilt by Marie Hensley circa 1900-1910; and an untitled quilt by a Mrs. Durham of Mobile, AL, in 1940.

Philip Morris Companies, Inc.

120 Park Avenue
New York, NY 10017
(212) 880-4104

The collection includes Faith Ringgold's 1980 quilt, *Echoes of Harlem*.

Pine Hills Culture Program

College Hall, Room 112
Hattiesburg, MS 39406-5175
Carolyn Ware, Director

The collection includes taped interviews and photos of Mississippi African American quiltmakers.

Quilter's Hall of Fame

PO Box 681
Marion, IN 46952
(765) 664-9333
www.comteck.com/~quilters
Hazel Carter, President

The Quilter's Hall of Fame (QHF) is presently constructing a museum. Quilt historian and 1983 Quilter's Hall of Fame inductee Cuesta Benberry announced in 1987 that she would donate her 800+ piece *Cloth Quilt Block* collection to QHF.

Renwick Gallery

Smithsonian American Art Museum
Washington, DC 20560-0510

At the close of 2000, the museum purchased contemporary quilts by Michael Cummings, Virginia Harris, Gwen Magee, Carolyn Mazloomi, and Ed Johnetta Miller.

Robert W. Woodruff Library

Atlanta University Center
111 James P. Brawley Drive SW
Atlanta, GA 30314

(404) 522-8980
www.auctr.edu
Karen Jefferson, Head, Archives/Special Collections

The Woodruff Library collection includes the *Harriet Tubman Quilt* (1951) and *Frederick Douglass Quilt* (1953). Designed by Ben Irvin and made by the Negro History Club of Marin City and Sausalito, CA these quilts are on permanent display in the library. The quilts were donated from the Howard Thurman Educational Trust.

Rocky Mountain Quilt Museum

1111 Washington Avenue
Golden, CO 80410
(303) 277-0377
www.RMQM.org
James Prochaska, Director

The Museum's 250-piece quilt collection does not include any African American-made quilts. However, the collection does include a baseball-theme quilt with a Black baseball player image. The Museum hosted the 1998 Rocky Mountain Wa Shonaji Quilt Guild Invitational.

Saint Louis Art Museum

Forest Park
1 Fine Arts Drive
St. Louis, MO 63110-1380
(314) 721-0072
www.slam.org

The permanent collection includes *Jo Baker's Birthday,* a 1993 quilt by Faith Ringgold. The funds for this purchase were given in honor of quilt historian Cuesta Benberry.

San Jose Museum of Quilts & Textiles

110 Paseo de San Antonio
San Jose, CA 95112-3639
(408) 971-0323
www.sjquiltmuseum.org/index.htm
Jane Przybysz, Director

The Museum collection includes an African American–made yo-yo quilt purchased in 2000.

**Schomburg Center for
Research in Black Culture**

515 Malcom X Blvd.
New York Public Library
New York, NY 10037
http://web.nypl.org/research/sc/sc.html
Howard Dodson, Director

The center's permanent quilt collection includes *Springtime in Memphis* by Michael Cummings, *Wisdom Wish* by Adriene Cruz, and *Yekk's Song* by Dindga McCannon.

Seagram Americas

Absolut Vodka Arts Program
800 3rd Avenue
New York, NY 10022

House of Seagram Collection includes *Absolut Jazz Quilt*, a 1997 quilt by Michael Cummings. This quilt was commissioned for the Absolut Vodka ad series and has appeared in a September 1997 *Black Enterprise* magazine advertisement.

Smith Robertson Museum

528 Bloom Street
PO Box 3259
Jackson, MS 39202-4005
(601) 960-1457
Turry Flucker, Curator

The Museum's permanent collection includes forty-one African American–made quilts donated by Roland Freeman and Dr. Bill Ferris.

**Solomon R. Guggenheim
Museum of Art**

1071 5th Avenue at 89th Street
New York, NY 10128
(212) 423-3500
www.guggenheim.org

The Museum's permanent collection includes the well-known *Tar Beach*, a 1988 Faith Ringgold quilt.

**Spelman College
Museum of Fine Arts**

350 Spelman Lane SW
Box 1526
Atlanta, GA 30314-4399

(404) 681-3643
M. Akua McDaniel, Director

The Museum's permanent collection includes *Groovin' High*, a quilt by Faith Ringgold.

Spencer Museum of Art

University of Kansas
Mississippi Street
Lawrence, KS 66045
(785) 864-3112
www.ukans.edu/~sma/index.html
Andrea S. Norris, Director

The Spencer Museum of Art has a renowned quilt collection, which includes only one African American–made quilt, *Flag Story Quilt*, a 1985 piece by Faith Ringgold.

Tennessee State Museum

505 Deaderick Street
Nashville, TN 37243-1120
(615) 741-2692
Lois Riggins-Ezzell, Director

The permanent collection includes a Princess Feather variation slave-made quilt circa 1850–1860. In addition, the museum has some quilt pieces that have not yet been cataloged, which were sewn by an African American during the 1940s.

Tennessee Valley Authority

Historical Collection
400 West Summit Hill Drive
Knoxville, TN 37902-1499
865-632-2101
Mike Dobrogosz, Contact

Permanent collection includes *Uncle Sam's Helping Hand*, a 1934 quilt by Rose Lee Cooper. The quilt was made in appreciation to the TVA, one of the first federal organizations to hire African Americans in management positions at the same pay as Causasian managers. This quilt features the hand of "Uncle Sam" lifting a black man, who is holding a guitar. This quilt seems similar to one in *Soft Covers For Hard Times: Quiltmaking & The Great Depression* by Merikay Waldvogel. The quilt in *Soft Covers* is a 1934 quilt designed by Ruth Clement Bond and made by Rose Marie Thomas (page 81).

University Museums

The University of Mississippi
PO Box 1848
University, MS 38677
(662) 915-7073
www.olemiss.edu/depts/u_museum/
Bonnie J. Krause, Director

The museum's permanent collection includes two quilt tops made in the 1970s–1980s by Pecolia Warner and three other quilts by Amanda Gordon, Ruby Adams, and Arester Earl.

Valentine Museum

1015 E. Clay Street
Richmond, VA 23219-1590
(804) 649-0711
http://valentinemuseum.com/index1.html
Colleen Callahan, Curator of Costume & Textiles

Permanent collection includes three slave-made quilts—one pieced quilt circa 1800 and two quilts circa 1850.

Wadsworth Atheneum Museum

600 Main Street
Hartford, CT 06103
(860) 278-2670
www.wadsworthatheneum.org/
Carol Dean Krute, Curator

Permanent collection includes Carolyn Mazloomi's quilt, *The Family #4,* and *Spirit of the Cloth,* by Ed Johnetta Miller.

William Grant Still Arts Center

2520 S.West View Street
Los Angeles, CA 90019
(323) 734-1164
James Burks, Director

The center regularly exhibits quilts from the African American Quilters Association. The museum collection includes a 1995 quilt *Tribute to Linda Fergerson* by Dorothy Taylor.

William Hammond Mathers Museum

Indiana University
601 East Eighth Street
Bloomington, IN 47408
(812) 855-6873
www.indiana.edu.mathers/home.html
Geoffrey Conrad, Director

The museum's collection includes eight Gullah quilts by Eva Cohen, Lucille LaBord, Ada Magwood, and two unnamed quilters. Slides are available upon request.

William R. and Clarice V. Spurlock Museum

University of Illinois—College of Library Arts & Sciences
600 South Gregory Street
Urbana, IL 61801
(217) 244-0510
www.spurlock.uiuc.edu/
Debra Schrishuhn, Registrar

In the mid-1970s, the World Heritage Museum (predecessor to the Spurlock Museum) collected African American cultural materials. The permanent collection includes eight quilts—two by Victoria Frazier of Burton, SC and six with printed sewn-in tags that say "Freedom Quilting Bee of Alberta, Alabama." The six quilts use traditional patterns such as *Courthouse Steps, Crazy Patch, Coat of Many Colors, Bear's Paws, Double T,* and *Grandmother's Choice.*

Williams College Museum of Art

15 Lawrence Iall Drive, Suite 2
Williamstown, MA 01267-2566
(413) 597-2429
www.williams.edu/WCMA
Diane Agef, Registrar

The permanent collection includes Faith Ringgold's *100 Years at Williams College 1889-1989* quilt.

Witte Museum

3801 Broadway
San Antonio, TX 78209-6396
(210) 357-1889
www.WitteMuseum.org
Michaele Haynes, Curator of History & Textiles

The museum's collection includes an 1850 *Ohio Star* or *Lone Star* quilt attributed to slave owned by Mrs. Jane Greer Jackson of Lebannon, TN.

Wyandotte County Historical Society and Museum
631 North 126th Street
Bonner Springs, KS 66012-9046
(913) 721-1078
Paul Goudy, Executive Director
 Permanent collection includes a *Double Wedding Ring* quilt by Mary Blair, founder of the Jolly Sixteen Art Club. The museum has hosted an *Annual Black Heritage Quilt Show* every year since 1987. The society also has access to oral histories and past research papers on African American quilting. As of 2001, the museum closed for reorganization. It is not known when the museum will open again.

GALLERIES SHOWCASING AFRICAN AMERICAN QUILTS

ACA Galleries
529 West 20th Street–5th Floor
New York, NY 10011
(212) 644-8300
www.ACAGalleries.com
Jeffrey Bergen, Director
Gallery represents Faith Ringgold.

America Oh Yes!
PO Box 3075
17 Pope Avenue, Executive Part #4
Hilton Head Island, SC 29928
(843) 785-2649
www.AmericaOhYes.com

Laura Carpenter, Director
2020 R Street, NW
Washington, DC 20009
(202) 483-9644
Mary McAndrew, Manager
 American Oh Yes! has two gallery locations. Its Web site includes a section devoted to African American quilts, including covers by Annie Dennis, Luella Pettway, Sarah Mary Taylor and other quilters. Quilts by Chris Clark are included in the Folk Art section.

Anton Haardt Gallery
2714 Coliseum Street
New Orleans, LA 70130
(504) 897-1172
www.AntonArt.com
Anton Haardt, Owner
 Gallery specializes in Southern folk art. The gallery shows pieces from Southern quilters, including Rosie Hurst of Montgomery, Alabama.

Artisans' Gallery
PO Box 256
Mentone, AL 35984
(856) 634-4037
www.FolkArtisans.com
Matt Lippa, Owner
 Gallery specializes in folk art, antiques, and outsider art. Artisan's Gallery also sells African American made quilts in-store and on its Web site.

Attic Gallery
1101 Washington Street
Vicksburg, MS 39183
(601) 638-9221
www.SoutherNet.com/Attic
Lesley K. Silver, Owner
 The gallery occasionally exhibits African American quilts, including those by Alabama artist Chris Clark and the Mississippi Cultural Crossroad Quilters.

Bradiggins Arts & Crafts Gallery
103 West King Street
Hillsborough, NC 27278
(919) 732-7746
www.Bradiggins.com
Jacquelin Liggins, Owner
 This gallery frequently exhibits African American-made quilts. Featured artists have included Valerie Jean Bailey of New York and Cynthia H. Catlin of California.

Cheryl Sutton & Associates/ The Sutton Collection
303 Swiss Lake Drive
Cary, NC 27513

(919) 468-8800

Cheryl Sutton, Owner

The Sutton Collection frequently displays contemporary African American art quilts. It has represented works by Chris Clark, Michael Cummings, Carolyn Mazloomi, Dinga McCannon , and Ed Johnetta Miller.

Columbia City Gallery

Rainier South Avenue
Seattle, WA 98118
(206) 760-9843

The Columbia City Gallery represents the work of over twenty local artists. Works include painting, photography, fiber arts, glass, sculpture, and ceramics. This cooperative gallery has previously shown works by Almerphy Frank-Brown and Gwen Maxwell-Williams.

Community Artists' Collective

1501 Elgin Avenue at LaBranch
Houston, TX 77004-2834
(713) 523-1616

Michelle Barnes, Founding Director

Occasionally displays and offers for sale quilts by African Americans. The Collective offers workshops on various needle-arts, including quilting and dollmaking. In 1995, the collective sponsored an exhibit, *In The Tradition: Quiltin', Snappin', and Chattin'*, dedicated to John Biggers.

Erin Devine Gallery

620 East Market Street
Louisville, KY 40202
(502) 587-0106
www.VineGallery.com

Erin Devine Gallery hosts about a dozen exhibits annually. The gallery represents works by fiber artists and quilter Gwendolyn Kelly, whose works can be viewed on the gallery's Web site.

Frank J. Miele Gallery

1086 Madison Avenue
New York, NY 10028
(212) 249-7250
www.AmericanFolkArt.com

Frank J. Miele, Owner

The gallery specializes in contemporary American folk artists and represents needlework artist Denise Allen.

Gilley's Gallery

8750 Florida Boulevard
Baton Rogue, LA 70815
(225) 922-9225
www.eatel.net/~outsider
Shelby Gilley, Owner

Gilley's Gallery, established in 1978, specializes in Southern folk art, especially works by Clementine Hunter. The gallery advertised *Melrose Quilt,* a 1960 quilt by Hunter in the Summer 2000 issue of *Folk Art* magazine. Gilley recently published *Painting By Heart: The Life and Art of Clementine Hunter, Louisiana Folk Artist.*

Ginger Young Gallery

5802 Brisbane Drive
Chapel Hill, NC 27514
(919) 932-6003
www.GingerYoung.com

The Ginger Young Gallery specializes in folk art, outsider, visionary, and self-taught art from the Southeastern United States. Occasionally the gallery offers African American folk art quilts for sale.

Grinnell Fine Art Collections

800 Riverside Drive, Suite 5E
New York, NY 10032
(212) 927-7941

Ademola Olugebefola and Pat Davis, Co-Directors

The gallery represents quilts by Dindga McCannon and occasionally exhibits African American quilts.

Hammonds House Galleries

503 Peeples Street SW
Atlanta, GA 30310-1815
(404) 752-8730
www.HammondsHouse.org
Ed Spriggs, Director

Hammonds House Galleries and Resource Center of African American Art is Georgia's only independent fine art

museum dedicated to presenting art by peoples of African descent. The gallery continuously exhibits African American quilts. Previous shows included quilts by Lynn Marshall-Linnmeirer and Adriene Cruz. The gallery currently represents fiber artist Julia Wilkins.

Hearne Fine Art

500 East Markham Street, Suite 110
The Museum Center
Little Rock, AR 72201-1756
(501) 372-6822
www.HearneFineArt.com
Garbo & Archie Hearne, Owners
 Hearne Fine Art first opened in 1988 as Pyramid Gallery. The gallery frequently sells African American story quilts and represents Phyllis Stephens, a fifth-generation quilter.

Jeanine Taylor Folk Art Gallery

314 Hannibal Square
Winter Park, FL 32789
(407) 740-0991
www.JTFolkArt.com
Jeanine Taylor, Owner
 This gallery specializes in contemporary folk art. The gallery has shown works by Carrine M. Porter. Taylor is open to representing African American quilters from Florida.

Main Street Gallery

PO Box 641
641 Main Street
Clayton, GA 30525
(706) 782-2440
Jeanne Kronsnoble, Owner
 This gallery specializes in contemporary folk art primarily from the Southeast. Represents works by quilter Chris Clark.

Mississippi Cultural Crossroads

507 Market Street
Port Gibson, MS 39150
(601) 437-8905
www.win.net/~kudzu/crossroads
Patty Crosby, Director

This community quilt organization sold over $30,000 worth of quilts in 2000.

National Conference of Artists Gallery

3011 West Grand Blvd.
The Fisher Building, Suite 216
Detroit, MI 48202
(313) 875-0923
Shirley Woodson, President
 The gallery occasionally exhibits African American quilts—especially during its *Annual Holiday Show*. Quilts by Ed Johnetta Miller, Mildred Thibodeaux, and Elizabeth Youngblood have been featured.

Portfolio Gallery and Educational Center

3514 Delmar Boulevard
St. Louis, MO 63103
(314) 533-3323
Robert A. Powell, Executive Director
 Occasionally host African American quilt exhibits. Sponsors annual *Girlfriends* exhibit to promote Black women artists in all visual disciplines. Open to representing quilters.

Quilts from Tutwiler Mississippi

Tutwiler Community Education Center
301 Hancock Street
Tutwiler, MS 38963
(601) 345-8393
 The quilt program, started in 1988, helps African Americans in the Mississippi Delta area use quilting skills to support themselves and family. Send SASE for brochure and quilt order form. Handcrafted items include twin, full, queen, and kind sized quilts; table runners; place mats; wallhangings; pot holders, and more.

Red Piano Too Art Gallery

853 Sea Island Parkway
St. Helena's Island, SC 29920
(843) 838-2241
Elayne Scott, Director
 Represents quilter and tailor Thomas Mack and painter Cassandra Gillens, who recently completed a series of twelve paint-

ings of quilts named after elders and ancestors.

Ricco/Maresca Gallery

529 West 20th Street—Third Floor
New York, NY 10011
(212) 627-4819
www.RiccoMaresca.com
Roger Ricco and Frank Maresca, Owners

The gallery specializes in American outsider, folk art, contemporary, and photography arts. Occassionally African American quilts are available for sale.

Robert Cargo Folk Art Gallery

2314 Sixth Street
Tuscaloosa, AL 35401
(205) 758-8884
Robert Cargo, Owner

Represents Yvonne Wells. Extensive collections of African American quilts from Alabama available for sale.

Rosehips Gallery

51 Sang Road
Cleveland, GA 30528
(706) 865-6345
www.RosehipsArt.com
Barbara Brogdon, Owner

Gallery specializes in contemporary folk art and Southern folk pottery. Gallery has represented Alabama quilter Chris Clark.

The Gallery at Studio B

140 West Main Street
Lancaster, OH 43130
(740) 653-8424
Patti Bell, Owner

Studio B is a custom framing and fine art gallery. The Gallery at Studio B features four major shows annually. Occasionally quilts by Anna Williams are exhibited.

Thirteen Moons Gallery

652 Canyon Road
Santa Fe, NM 87501
(505) 995-8513
www.ThirteenMoonsGallery.com
Mary Anhaltzer, Owner

Thirteen Moons Gallery occasionally exhibits African American quilts. It has previously shown works by Alice M. Beasley and Virginia Harris. See Web site for virtual gallery tour of artists' quilts.

Tyson's Trading Company

505 North East Cholokka
Micanopy, FL 32667
(352) 466-3410
Jean & Ty Tyson, Owners

This gallery specializes in textiles from the 18th–20th century as well as one-of-a-kind handmade pieces. The gallery frequently displays African American–made quilts.

Visionary Art

4516 El Dorado Drive
Gardendale, AL 35071-2608
(800) 934-8464
www.VisionartArt.com
William Doss, Owner

Visionary Art is an online art gallery primarily focused on outsider art. The gallery features several Chris Clark quilted wallhangings.

CHAPTER 4

African American Quilters and Internet Usage

This paper was presented at the *Constructing Cyberculture(s): Performance, Pedagogy, and Politics in Online Spaces* conference at the University of Maryland–College Park, April 6, 2001.

BACKGROUND

Betty Rovedo and Jim Burchell were among the first to document African American Internet quilting activities.[1] They wrote an article describing various quilting discussion groups on major online service providers in 1996 (i.e., America Online, CompuServe, Delphi, eWorld, GEnie, Microsoft Network and Prodigy).

The article introduced readers to the Prodigy Crafts Board and a then ongoing African American Fabrics discussion topic. Within the African American Fabrics discussion topic, Prodigy subscribers shared information about African American quilting activities nationally and participate in fabric swaps and round robins featuring ethnic prints. I was a Prodigy "Special Contributor," or volunteer, in this discussion topic from 1994–1996 and often facilitated conversations among subscribers.

I have not been able to find any other information in popular quilting magazines, journals, published scholarly reports or commercial studies that describe African American quiltmaking activities as related to the Internet.

Quilter's Newsletter Magazine and International Quilt Market/Festival, a division of Quilts, Inc. jointly funded a comprehensive study of the U.S. quilting market in 2000, 1997, and 1994. The studies estimated the total size and value of the U.S. quilting market and profiled the "Dedicated Quilter" as one who spends over $500 per year annually on quilting-related purchases.

165

The *Quilting in America 2000* study examined computer ownership and Internet usage by quilters.[2] Key findings included:

- 76 percent of dedicated quilters—those who spent over $500 annually on quilting-related purchases—owned a computer.
- 70 percent of dedicated quilters had accessed the Internet in the last 30 days.
- The primary reasons for visiting quilting Internet sites included: searching for quilting products (58 percent), learning new tips and techniques (57 percent), receiving free quilt patterns (53 percent), and getting free block patterns (50 percent)

No past *Quilting in America* study results are publicly available by race or ethnicity of quilter.

OBJECTIVES

The objectives of this primary research were to (1) build a basic profile of quilters on the Internet, (2) describe Internet quilting activities and their relative importance, and (3) uncover similarities and difference between African American quilters and other quilters.

METHODOLOGY

On June 10, 2000, I launched the *Quilting and Internet Usage Survey 2000* through Zoomerang.com. The survey was Internet based only. No paper copies of the survey were available. I sent a personalized email to two hundred and six (206) quilt enthusiasts requesting that they complete the survey. In addition, I posted the survey's unique Web site location (URL) on several quilt-related bulletin boards and discussion groups such as the Quilt History list, National Online Quilters, America Online (AOL) quilting bulletin board, and three different African American quilting discussion groups. I also sent the URL to more than 200 quilt enthusiasts using old-fashioned first class mail. The editor of "Nine Patch News," an exclusive quilt publication for AOL members, announced the survey's URL in its July 15, 2000, issue.

In total nine hundred and seventy (970) persons voluntarily responded to the online survey over fifty-three days (June 10–August 2, 2000). Women completed 99 percent of the surveys. Some of the respondents, estimated to be less than ten quilters, lived outside the United States. Nine percent of the respondents checked African American as their ethnicity.

The results are not meant to project a national average because my methodology did not seek to reflect American households in a scientific manner. However, the survey does provide detailed insights into quilters on the Internet and their activities. And, for the first time, a profile of African American quilters' use of the Internet in their quilt activities is uncovered.

Demographics of Quiltmakers on the Internet

Table 1. Age of Quiltmakers

	African American Quilters	Total Respondents*
Under 18 years	0%	0%
18 to 34	3.7%	7%
35 to 44	30.5%	25%
45 to 54	45.1%	40%
55 to 65	17.0%	23%
Over 65 years	3.7%	5%
Declined to answer	0%	1%

Total may exceed 100 percent due to rounding.

• The average age of dedicated quilters (those who spend more than $500 annually on quilting) is 55 years according to the industry study *Quilting in America 2000*. Quilters responding to this online survey skewed younger with an average age range of 45 to 54 years.

• 79.3 percent of African American quilters on the Internet are 54 years and younger, with the majority (45.1 percent) being 45 to 54 years.

Table 2. Quiltmaking Experience by Year Range

	Year Started Quilting	African American Quilters	Total Respondents*
Less than a year	2000	10.8%	5%
1 to 2 years	1998–1999	10.8%	8%
3 to 5 years	1995–1997	18.1%	18%
6 to 10 years	1990–1996	37.4%	24%
11 to 20 years	1980–1989	14.5%	27%
21 to 35 years	1965–1979	7.2%	14%
More than 36 years	Pre–1964	1.2%	3%

Total may not equal 100 percent due to rounding.

• African American quilters on the Internet are entering quiltmaking at a higher percentage than all other respondents; 21.6 percent of African American quilters have two years or less experience quilting vs. 13 percent for all respondents.

• More than one-third of African American respondents started quilting in the last 6 to 10 years vs. 24 percent for all respondents. These African American quilters (37.4 percent) learned to quilt between 1990 and 1996. During this time four major African American quilt exhibits, with accompanying books, toured nationally:

 1. *Stitched From the Soul: Slave Quilts from the Ante-Bellum South* by Dr. Gladys-Marie Fry—1990
 2. *Stitching Memories: African–American Story Quilts* by Eva Ungar Grudin—1990

3. *Always There: The African-American Presence in American Quilting* by Cuesta Benberry—1992
4. *Signs and Symbols: African Images in African-American Quilts* by Dr. Maude Southwell Wahlman—1993

Collectively, these travelling exhibitions may have influenced a new generation to learn how to quilt.

Quilters received news of African American quilting activities from two national organizations. The Women of Color Quilters' Network (WOCQN) was formed in 1985. By 1993, the WOCQN Newsletter reached 450 members.[3] In 1993, the now defunct National Association of African American Quilters was founded. The first African American Quilters Conference was held in Lancaster, PA that year. The organization communicated to its 125+ members through its newsletter *The North Star News*. The September 1994 roster listed members in twenty-six states as well as the District of Columbia, Canada, and the Netherlands. The newsletters from both organizations helped Black quilters feel a part of a larger community.

Today there is no national newsletter or publication that regularly disseminates information about African American quilting. I believe there is a correlation between quiltmaking participation and availability of targeted and relevant information about the craft. More research is needed, though, to substantiate this correlation.

• Black quilters with twenty-one or more years experience are half as likely to be represented as all respondents.

Two major events helped shape American quilting during 1965–1979. First, *Abstract Design in American Quilts* opened at the Whitney Museum of American Art in New York in 1971. This exhibit is acknowledged to have positioned quilts as "high" art. The second event was the 1976 Bicentennial, which helped renew American interest in quiltmaking and other past needlework activities. Neither event focused on African American quilting, *per se*, to the extent that the exhibits of the early 1990s would.

• The industry survey *Quilting in America 2000* reveals that the dedicated quilter had 11.2 years quilting experience. Many (27 percent) respondents to this online survey had in the range of 11 to 20 years quiltmaking experience.

Table 3. Average Number of Hours per Month Spent on Quilting, by 8 Hour Increments

Per Month	African American Quilters	Total Respondents
0–8 hours	15.7%	13%
9 to 16 hours	26.5%	25%
17 to 32 hours	19.3%	22%
33 to 40 hours	14.5%	17%
41 to 56 hours	12.0%	8%
More than 57 hours	12.0%	15%

- Generally, there are no significant differences between African American quilters on the Internet and total respondents in the number of hours spent per month quilting.
- A quarter of all respondents spent an average of 9 to 16 hours per month on quilting.
- 24 percent of African American quilters on the Internet spend more than 40 hours per month quilting. More research is needed to understand the motivations (e.g., casual vs. professional) for spending this amount of time on quilting.

Table 4. Quiltmaking Skill Level, Self-Selected by Respondents

	African American Quilters	Total Respondents*
Beginner	19.5%	14%
Intermediate	47.6%	49%
Advance	26.8%	29%
Expert	4.9%	7%
Master	1.2%	2%

*Total may exceed 100 percent due to rounding.

- The majority of Black quilters (47.6 percent) on the Internet defined their skill level as Intermediate.
- 19.5 percent of Black quilters on the Internet defined themselves as Beginners. Coincidentally, 21.6 percent of Black respondents have two years or less experience quilting (Table 2).
- The industry study *Quilting in America 2000* revealed that 88 percent of dedicated quilters have Intermediate or Advance skill levels. 74.4 percent of African American quilters on the Internet have intermediate or advance skill levels vs. 78 percent for total respondents. It is unclear why there is at least a ten-percent difference between skill levels of online vs. offline quilters.

Table 5. Needlecrafts Actively Engaged in by Quilters (multiple responses possible)

	African American Quilters	Total Respondents
Quilting	100.0%	100%
Sewing	68.3%	66%
Dollmaking	36.6%	13%
Embroidery	28.0%	34%
Crochet	25.6%	26%
Beading	23.1%	15%

(Table 5, continued)	African American Quilters	Total Respondents
Knitting	20.7%	21%
Cross-Stitch	15.9%	34%
Smocking	3.7%	5%
Weaving	3.7%	3%
Tatting	-	3%

- 68.3 percent of African American quilters on the Internet sew in addition to quilting. The industry survey *Quilting in America 2000* reported that 65 percent of dedicated quilters also sew.
- African American quilters are half as likely to cross-stitch as other quilters.
- African American quilters are almost three times more likely to engage in doll-making than other quilters. In addition, African American quilters are 50 percent more likely to do beadwork than other quilters.

 Well-known quilters who also exhibit handmade dolls include Faith Ringgold of New York, Joyce Scott of Baltimore, and NedRa Bonds of Kansas City, Kansas.

 Other nationally exhibited African American quilters who incorporate dolls into their quilts include Cathleen Richardson Bailey of Pennsylvania, Kianga Hanif of Georgia, and Francine Haskins of Washington, DC. New York quilter and Urban Doll Tribe founder Lisa Curran used dozens of palm-sized cloth dolls as an inner border in her quilt *Indigo Grounding* (1999).

 More research needs to be conducted to understand why there is a connection between quilting and dollmaking or beading among African American quilters on the Internet. Black quilters may consciously study these crafts from an American perspective or to learn from other cultures (e.g., African dollmaking and Haitian beaded flags). It will be interesting to understand how, if at all, one craft influences the others.

Table 6. Quiltmaking Style Preferred by Quiltmakers

	African American Quilters	Total Respondents
Only traditional	6.0%	5%
Prefer traditional	9.8%	36%
Equally like traditional and contemporary	57.3%	42%
Prefer contemporary	15.9%	12%
Only contemporary	11.0%	5%

- By an overwhelming margin, most African American quilters on the Internet show equal preference for traditional and contemporary quiltmaking styles. The industry survey *Quilting in America 2000* reports that 49 percent of dedicated quilters prefer both traditional and contemporary quilt styles. As in the offline world, most (42 percent) respondents to this online survey prefer both traditional and contemporary styles.

• 26.9 percent of Black quilters on the Internet prefer or only make contemporary quilts vs. 17 percent for total respondents.

• A mere 15.8 percent of African American quilters on the Internet prefer or only make traditional style quilts vs. 41 percent for total respondents.

More research is needed to understand if there is a statistical difference in style preferences between African American quilters who participate in quilt-related Internet activities vs. Black quilters who have not yet accessed the Internet.

Table 7. Items Quiltmakers Currently Own or Plan to Buy Within 12 Months (multiple responses possible)

	African American Quilters Own Now	*Total Respondents Own Now*	*African American Quilters Plan to Buy in Next 12 months*	*Total Respondents Plan to Buy in Next 12 months*
Traditional Tools				
Scissors	100.0%	100%	14.6%	15%
Rotary cutter	100.0%	99%	15.8%	12%
Rulers	97.5%	99%	21.9%	22%
Steam Iron	97.5%	98%	12.2%	10%
Sewing machine	96.0%	99%	19.5%	15%
Shelving/Storage	80.5%	87%	17.0%	22%
Frames/Hoops	80.5%	81%	14.6%	11%
Serger	34.0%	36%	7.3%	7%
Quilt rack	31.7%	46%	15.8%	9%
Consumer Electronic Tools				
Personal computer	91.5%	97%	8.5%	3%
Color printer	84.0%	90%	9.7%	7%
Scanner	64.6%	68%	22.0%	19%
Quilt design software	41.5%	45%	24.3%	28%
Digital Camera	30.5%	27%	31.7%	33%

• African American quilters on the Internet generally own the same quiltmaking tools as all other quilters. Minor exceptions include quilt racks and shelving/storage items. Black quilters are almost twice as likely to purchase quilt racks in the next year as total respondents.

• 19.5 percent of Black quilters plan to buy a sewing machine in the next 12 months vs. 15 percent for total respondents.

• Personal computer ownership is unusually high in this survey. Respondents could complete the survey only via Internet access. This limitation could have influenced the computer ownership results.

The U.S. Department of Commerce reports that 32.6 percent of African American households owned a computer by August 2000, up from 23.2 percent in December 1998.[4] Overall, 51.0 percent of U.S. households owned computers during the same time in 2000, up from 42.1 percent in December 1998. African American ownership lags behind the national average, but is increasing at a greater rate. African American household computer ownership increased by an astonishing 40.5 percent rate compared to 21.1 percent national increase.

The industry study *Quilting in America* 2000 reports that 76 percent of dedicated quilters own a personal computer. One can surmise that computer ownership has become an important tool for quiltmakers since the level of computer ownership within the quilt community exceeds computer ownership nationally.

African American quilters on the Internet are more than twice as likely to purchase a computer as total respondents. 8.5 percent of Black quilters plan to buy a computer within the next 12 months vs. only 3 percent for total respondents.

- African American quilters on the Internet use quilt design software and other consumer electronics at a level similar to all quilters.

- 13 percent of total respondents checked an "Other" option and typed in responses. Many quilters plan to buy lighting items like Ott lights or light boxes, or install halogen lighting. Multiple quilters plan to buy additional cutting mats, quilting machines, or furniture for their sewing rooms.

QUILTMAKERS AND INTERNET USAGE

Before we examine how quiltmakers use the Internet, it is useful to have a context for how Americans are accessing the Internet. The U.S. Department of Commerce released the following figures:[5]

- 41.5 percent of U.S. households had Internet access by August 2000, up from 26.2 percent in December 1998. Access to the Internet for African American households, while low, has soared. *23.5 percent of African American households had Internet home access during the same time in 2000, up from 11.2 percent in 1998*

- Male (44.6 percent) and female (44.2 percent) use of the Internet reached parity for the overall U.S. population in 2000. *In the Black community, slightly more women (30.5 percent) than men (27.9 percent) use the Internet*

- As of August 2000, 44.4 percent of the U.S. population use the Internet, up from 32.7 percent in December 1998. The rest of the U.S. population has not yet used the Internet. *29.3 percent of Black individuals use the Internet as of August 2000, up from 19.0 percent in December 1998.*

AFRICAN AMERICAN INTERNET DESTINATIONS

African American quilting information is available in cyberspace. Quilt Ethnic.com is the most comprehensive Web site resource on this topic. Mississippi quilter Gwendolyn Magee launched the site in July 1999. The site features links to both historical and contemporary Black quilting content, exhibits, local guilds, and a bulletin board.

African American Art Quilters, an online discussion group, shares information on quilting techniques, marketing, and exhibition opportunities. Maryland artist Carole Y. Lyle moderates this group at http://groups.yahoo.com/group/ Aaartquilt. Lyle founded the group on December 13, 1998. Other African American discussion threads are on America Online.[6]

Black quilters are also promoting their works online. For example, one can purchase original quilts and signed quilt posters from New York artist Michael Cummings at www.MichaelCummings.com. Contemporary quilters Mary Louise Smith and Sherry Whetstone-McCall share a fascinating variety of quilting styles and subject matters on their personal Web sites.

THE WORLD WIDE WEB

Technically the Internet is composed of "all servers, routers, telephone lines, satellites, and other communications instruments used to convey Internet-based electronic data, including Web sites, e-mail messages, and newsgroups."[7]

In the early 1990s, Tim Berners-Lee, an English researcher in Switzerland, introduced software and networking protocols that enabled users to navigate easily around the Internet using point and click commands or hyperlinks. Thus the World Wide Web was born.[8] In October 1993, Marc Anderssen and a small group of University of Illinois students released the first Web browser software called Mosaic. Mosaic allowed users to access Web documents on the Internet.

> At that time, there were only 50 computers in the world that hosted and served up Web documents. By mid-1994 there were 1,500 Web servers, and by mid-1995 tens of thousands of such computers were hosting an even larger number of individual Web sites created by companies, newspapers, magazines, universities, and government agencies. In the blink of an eye, hundreds of thousands of Web sites appeared.[9]

Quilting Web sites are among the thousands that now appear.[10] Let's return to the Quilting & Internet Usage Survey 2000 results, seven years after the World Wide Web was introduced, to see how quilters use the Internet in their quilting activities.

Table 8. Quiltmakers' Years
of Experience on the Internet

	Year Started Using Internet	African American Quilters	Total Respondents
Less than one year	2000	8.4%	5%
1 to 2 years	1998–1999	19.3%	19%
3 to 5 years	1995–1997	35.0%	43%
6 or more years	Pre–1994	37.3%	33%

• A significant number of quilters (43 percent) have three to five years experience on the Internet.

• Slightly more African American quilters (37.3 percent) have been on the Internet six or more years than total respondents (33 percent).

Table 9. Average Time per Month Spent
on Internet Quilting Activities (Eight-Hour Increments)

Per Month	African American Quilters*	Total Respondents*
0 to 8 hours	57.3%	42%
9 to 16 hours	25.6%	26%
17 to 32 hours	6.1%	17%
33 to 40 hours	6.1%	7%
41 to 56 hours	2.4%	3%
More than 57 hours	2.4%	4%

*Total may not equal 100 percent due to rounding.

• The majority of African American quilters on the Internet (57.3 percent) and a significant number of total respondents (42 percent) spend up to 8 hours per month on Internet quilting activities.

• The industry study *Quilting in America 2000* reports that the average dedicated quilter spends 2.1 hours each week visiting quilting Web sites.

Table 10. Expectations for Time Spent
on Quilt-Related Internet Activities in the Next 12 Months

	African American Quilters	Total Respondents*
Spend more time?	39.8%	19%
Spend same amount of time?	48.2%	70%
Spend less time?	3.6%	6%
Don't know	8.4%	4%

*Total may not equal 100 percent due to rounding.

• Nearly 40 percent of African American quilters anticipate spending more time on quilt-related online activities next year. This suggests that Black quilters are still exploring the Internet looking for relevant activities in which to participate.

• The majority of total respondents (70 percent) have decided to spend the same amount of time on Internet quilting activities in the next year. This suggests that their Internet habits are established.

Table 11. Participation in Internet Quilting Activities (multiple responses possible)

	African American Quilters	Total Respondents
Surf the web for new quilt-related sites	82.5%	86%
Return to visit favorite quilt sites	80.7%	93%
Email quilt friends	69.8%	71%
Member of at least one quilt listserv	47.0%	67%
Buy quilt supplies online	43.3%	51%
Buy fabrics online	42.1%	53%
Participate in quilt discussion groups	33.7%	52%
Participate in online fabric swaps	19.2%	30%
Participate in online round-robins	16.9%	14%
Maintain a personal quilt Web site	10.8%	10%
Maintain a public or commercial quilt Web site	3.6%	5%
Sell own quilt patterns online	2.4%	2%
Sell own quilts online	1.2%	3%

In general, African American quilters and total respondents participate in similar Internet quilting activities. The major differences are related to intensity.

• The most popular Internet activity for African American quilters is surfing the web for new quilt-related sites. 82.5 percent of Black quilters continue to explore the Web looking for new sites having relevant content related to their craft. Nearly 81 percent of African American quilters return to favorite Web sites.

• Emailing quilt friends is the third most popular Internet activity for Black quilters. While email is popular, communicating though listservs or discussion groups is less popular. More research is needed to determine why participation rates vary. One can suppose, though, that lack of awareness of how to participate in a listserv or discussion group is a factor.

• At least 40 percent of African American quilters on the Internet have purchased quilt items or fabrics online.

• Overwhelmingly, quilters on the Internet are using the medium to purchase quilt items and fabrics vs. setting up shop to sell personally-made quilts or patterns.

QUILTERS INTERNET EXCHANGE MODEL

The *Quilting & Internet Usage Survey 2000* sought to uncover how quilters use the Internet in their quilting activities, if at all. My first assumption was that Internet activities could fall into four major categories that may be of relative importance to quilters. These four categories were:

1. Gathering quilting information—using the Internet as a data collection tool
2. Providing a sense of quilting community—using the Internet as a virtual sewing bee
3. Presenting one's quilts to others—using the Internet as a "show and tell" tool or virtual gallery
4. Buying and selling quilt items—using the Internet as a marketplace

Through an open-ended question, quilt respondents uncovered two Internet influences not anticipated. *Quilters on the Internet were being changed by the medium itself.* Many reported that having access to an online quilt community had led to 1) increased personal skills and 2) higher level of self-confidence about quilting and computer/Internet usage.

The chart below summarizes the major ways quilters interact with the Internet in their quilting activities.

Quilters Internet Exchange Model

	Inward Flow of Information	*Outward Flow of Information*
Personal/ Internal Changes	QUILTER'S SPIRIT Minimal or no change by some Skills increase Renewed passion for craft	QUILTER'S REACTIONS Confidence to tackle quilt or computer projects increases Increase openness to use Internet beyond quilting
Self-directed Actions	GATHERING INFORMATION 1–to–1 relationship Email quilt friends Surfing Web sites Search engine research	PRESENTING QUILTS OUTWARDS 1–to–many relationship Builds personal quilt Web site Uploads quilt images to Web
Multiple Touch Points	SENSE OF COMMUNITY Many–to–1 Bulletin boards, discussion groups Quilting email newsletters	ECOMMERCE/NON-MONETARY TRANSACTIONS Many–to–Many Shopping or auctions Round-robins, fabric swaps Charity quilt projects

The next charts examine how important various activities are to quilters. Presumably, quilters will spend more time and attention on those areas of importance.

Table 12. Importance of "Gathering Quilting Information" to Your Quilting Internet Activities

	*African American Quilters**	*Total Respondents**
Not at all important	2.4%	1%
Not very important	4.8%	4%
Neutral	4.8%	11%
Somewhat important	31.3%	40%
Extremely important	56.6%	43%

*Totals may not equal 100 percent due to rounding.

• More than 80 percent of African American quilters and total respondents find that gathering quilting information is somewhat or extremely important to their quilting Internet activities.

Surfing for quilt-related Web sites and emailing quilt friends are popular activities that involve gathering information. The high importance level for information and relatively low participation in quilt discussion groups for African American quilters suggest that Black quilters may not have sufficient information on where quilt discussion groups are located.

Table 13. Importance of "Providing a Sense of Quilting Community" to Your Quilting Internet Activities

	*African American Quilters**	*Total Respondents**
Not at all important	4.8%	5%
Not very important	6.0%	10%
Neutral	27.7%	23%
Somewhat important	32.5%	34%
Extremely important	28.9%	29%

*Totals may not equal 100 percent due to rounding.

• More than 60 percent of African American quilters and total respondents consider the use of the Internet as somewhat or extremely important to providing a sense of quilting community.

Table 14. Importance of "Presenting My Quilts to Others" to Your Quilting Internet Activities

	*African American Quilters**	*Total Respondents*
Not at all important	21.7%	34%
Not very important	28.9%	23%
Neutral	27.7%	22%
Somewhat important	15.6%	14%
Extremely important	6.0%	7%

*Totals may not equal 100 percent due to rounding.

- More than half (50.6 percent) of African American quilters and (57 percent) total respondents do not find the Internet as important for presenting their quilts to others.

 More research is needed to understand how quilters define "Presenting My Quilts to Others" in the context of Internet activities. Presumably, a quilter can email a friend or post a message describing his or her latest quilt. A quilter could take "presenting" to mean providing a digital image of one's quilts. In this case, it will be interesting to see how the affordability of digital cameras and/or scanners or the ease of using Web site development software to build personal Web sites will change this importance rating in the future.

- 21 percent of quilters on the Internet rated presenting their quilts to others as somewhat or extremely important to their Internet quilting activities. At present, 10 percent of quilters on the Internet have a personal quilt Web site.

Table 15. Importance of "Ability to Buy and Sell Quilt Items" to Your Quilting Internet Activities

	African American Quilters*	Total Respondents*
Not at all important	10.8%	25%
Not very important	16.9%	15%
Neutral	30.1%	17%
Somewhat important	22.9%	23%
Extremely important	19.2%	19%

*Totals may not equal 100 percent due to rounding.

- 42 percent of African American quilters and total respondents rate the ability to buy and sell quilt items as somewhat or extremely important to their Internet quilting activities. According to Table 11, more quilters are purchasing quilt supplies and fabrics on line than using the Internet to sell personally made quilt items.

- 30 percent of African American quilters on the Internet compared to 17 percent of total respondents are neutral on the importance of buying and selling quilting items.

 An interesting area for future research is to investigate the relative importance of online auctions to Internet quilting activities. On eBay.com, one the nation's most popular Web sites according to the Internet research firm Media Metrix (www.MediaMetrix.com), there are hundreds of quilt-related auctions daily. One can find handmade or machine quilts, old quilt magazines and pattern books, quilt racks, and more. Oftentimes African American-made quilts are available for sale. As quilters gain more Internet experience as well as access to items such as digital cameras and scanners, it will be interesting to see how auction sites impact Internet quilting activities.

Conclusions

The *Quilting and Internet Usage Survey 2000* achieved its primary goals of building a basic profile of quilters on the Internet as well as describing the relative importance of various Internet quilting activities. Moreover, for the first time, a profile of African American quilters' use of the Internet in their quilt activities is uncovered:

African American Quilters on the Internet Summary

- 45.1 percent are 45 to 54 years old.
- More than one-third started quilting in the last six to ten years or between 1990 and 1996.
- 26.5 percent spend an average of 9 to 16 hours per month quilting.
- Most (47.6 percent) define their quiltmaking skill level as Intermediate.
- The top three needlecraft activities engaged in are: quilting, sewing, and doll-making.
- By an overwhelming margin, most (57.3 percent) show equal preference for traditional and contemporary quiltmaking styles. 26.9 percent prefer or only make contemporary quilts.
- Generally Black quilters own the same traditional and consumer electronic quilt-making tools as all other quilters.
- The majority (57.3 percent) spends zero to 8 hours per month on Internet quilting activities.
- 48.2 percent expect to spend the same amount of time on quilting Internet activities in the next year.
- The top three Internet quilting activities: surfing the web for new quilt-related sites, returning to visit favorite quilt sites, and emailing quilt friends.
- 87.9 percent rate "Gathering Quilting Information" as somewhat or extremely important to their Internet quilting activities.
- 61.4 percent rate "Providing a Sense of Community" as somewhat or extremely important.
- 50.6 percent rate "Presenting My Quilts to Others" as not very or not at all important.
- 42.1 percent rate "Ability to Buy and Sell Quilt Items" as not very or not at all important to their Internet quilting activities.

Recommendations for Quilt Magazines

- At present, there is no national vehicle that communicates news of the African American quilting world. Consider offering a regular column featuring African

American quilting news to help nurture future generations of quilters and sub-
scribers. A magazine's subscriber base may increase if African American quilters
feel that the magazine consistently has targeted quilting information for them.

• Include periodic articles about incorporating dollmaking and beading into quilts.
Include beginner or intermediate level patterns that are contemporary in style.

RECOMMENDATIONS FOR QUILT-RELATED WEB SITES

• Overwhelmingly African American quilters on the Internet are looking for quilt-
ing information and a sense of community. Include regular updates on the
African American quilting world (e.g., national and local exhibits, quilt guild
listings, new books, profiles of African American quilters, photos of quilts, links
to African American Web sites).

• Anticipate that African American online purchases will increase over time.
Include relevant eCommerce items on your site (e.g., ethnic fabrics, books about
African American quilting, dollmaking, beading).

• African American quilters are still exploring the Internet. Online fabric and quilt
stores that carry ethnic or African American theme prints should proactively
contact web masters of African American Web sites to request links to these
online stores.

RECOMMENDATIONS FOR MANUFACTURERS OF QUILT-RELATED TOOLS

• African American quilters on the Internet generally own the same quiltmaking
items as all quilters. Magazine and Internet ads for quilt-making items should
reflect the cultural diversity of quilters.

• Quilt software developers should include designs that are culturally sensitive and
contemporary in style (e.g., figural designs of diverse cultures, African-influenced
design and symbols) to attract a broader market.

RECOMMENDATIONS FOR QUILT GUILDS

• To increase potential membership and to broaden the guild's reach, quilt guilds
should consider developing a Web site or simple Web page with basic informa-
tion about the guild. A simple Web presence would be accessible at any time—
a feature valued by Internet quilters.

• African American quilting guilds should contact Web sites that list guilds nation-
ally and send their group's basic information for inclusion. One site that lists
Black guilds nationally is www.QuiltEthnic.com/guilds.html.

RECOMMENDATIONS FOR MUSEUM COLLECTIONS

• An important residual effect of hosting African American quilt exhibits and incorporating quilting activities is that some Black museum visitors start to quilt. Continue to offer quilt demonstrations when hosting quilt exhibits.

• Permanent museum collections should reflect the range of African American quiltmaking style preferences.

• In addition to traditional quiltmaking tools, museums should also collect, present and preserve the artifacts of Internet quilting activities (e.g., Web site pages, fabric swap bundles, round robin projects, quilt patterns).

RECOMMENDATIONS FOR QUILT HISTORIANS

• Diaries and letters have been used to show the role of quiltmaking in a quilter's life. Quilt historians should also examine the roles that email and online quilt discussion groups play in quilters' lives.

• Quilt historians should develop and communicate standards for collecting, presenting, and preserving the artifacts of Internet quilting activities (e.g., Web site names, Web site content, fabric swaps, round robin projects, quilt patterns).

• Quilt historians should develop and communicate standards for incorporating the Internet in quilt history bibliographies.[11]

• Continued research and documentation is needed to record how the Internet and personal computer usage is affecting African American quilters' and all quilters' sense of self and quiltmaking activities *over time*. I predict the effects will be as profound as when the sewing machine was introduced.

Notes and References

1. Rovedo, Betty and Jim Burchell, "Your Computer Quilting Neighborhood: Online Services and the Internet," *Quilter's Newsletter Magazine*, April 1996, Issue 281, pp. 40–43.

2. Executive summaries of *Quilting in America* are available from Tina Battock, Primedia Publications (303) 273-1321 or Nancy O'Bryant, Quilts, Inc. (713) 781-6264.

3. German, Sandra K., "Surfacing: The Inevitable Rise of the Women of Color Quilters' Network." *Uncoverings 1995*, ed. Laurel Horton (American Quilt Study Group, 1994), p. 157.

4. Economic and Statistics Administration and National Telecommunications and Information Administration, *Falling Through the Net: Toward Digital Inclusion— A Report on Americans' Access to Technology Tools* (Washington DC: U.S. Department of Commerce, October 2000).

5. Economic and Statistics Administration and National Telecommunications and Information Administration, *Falling Through the Net: Toward Digital Inclusion— A Report on Americans' Access to Technology Tools* (Washington DC: U.S. Department of Commerce, October 2000).

6. The path to America Online African American quilting conversations: Lifestyles—Ethnicity—African American Message Boards—Arts, Entertainment and Sports—African American Quilters.

7. "Basic Terminology," *Internet Basics: Smart Computing Learning Series Magazine*, vol. 6, issue 1, p. 19.

8. Spector, Robert, *Amazon.com Get Big Fast: Inside the Revolutionary Business Model That Changed the World* (New York: HarperCollins, 2000), p. 22–23.

9. Feather, Frank, *Future Consumer.com: The Webolution of Shopping to 2010* (Toronto, Ontario: Warwick Publishing Inc., 2000), p. 39.

10. Heim, Judy and Gloria Hansen, *Free Stuff for Quilters on the Internet*, 2nd Edition (Lafayette, CA: C & T Publishing, 1999). Excellent resource for locating quilting related Web sites. Unfortunately, the book does not include any references to African American, Hispanic, or Asian American quilt Web sites.

11. An excellent resource that will be helpful to the quilt historian is *Art Information and the Internet: How to Find It, How to Use It* by Lois Swan Jones (Phoenix, Arizona: The Oryx Press, 1999).

CHAPTER 5

African American Quilters and Fabric Purchasing: Spending $40.3 Million on Fabric

BACKGROUND

One million African American quilters spent an estimated $118.9 million on quilt-related expenditures in 2000. The most passionate, dedicated quilters invested at least $500 per year on quilting. These dedicated Black quilters spent an estimated ***$40.3 million*** on fabric purchases alone.

Jo-Ann Stores, Inc., one of America's leading fabric and craft retailers, operates more than 900 stores nationally. For fiscal year 2001, Jo-Ann Stores reported earnings of $55.9 million. Just consider—African American quilters spent $40.3 million on fabric or the equivalent of 73 percent of Jo-Ann Stores' corporate earnings!

KEY FINDINGS

African American quilters *do* have significantly different fabric purchasing habits than other quilters. Fabric store retailers and fabric manufacturers need to understand these differences if they are to satisfy Black quilters' needs and generate incremental revenues. While the industry study *Quilting in America 2000* reports that dedicated quilters spent $667 per year on fabric for quiltmaking, it says nothing about the fabric purchasing habits of one million African American quilters.

183

This chapter reveals details about quiltmaker fabric purchasing habits. For the first time, we will learn that:

- Black quilters regularly purchase 100 percent cotton, African prints, and batiks for their quilt projects.

- The top four fabric designs regularly purchased by Black quilters include: African prints (85.2 percent), abstracts (73.9 percent), solids (63.6 percent), and geometrics (60.2 percent). This differs substantively from the top four selections by total respondents: floral prints (77 percent), solids (56 percent), geometric (56 percent), and holiday prints (49 percent).

- 73 percent of African American quilters overwhelmingly purchase their fabrics from national chain fabric stores and specialty quilt shops.

- 67.8 percent of Black quilters always or frequently agree with the statement "I buy fabrics that represents my culture" vs. only 17 percent of total respondents. We learn that culturally relevant designs are very important to Black quilters.

METHODOLOGY

On January 21, 2001, I launched the *Quilters and Fabric Purchasing Survey 2001*, a web-based survey through Zoomerang.com. I emailed the unique survey URL to selected respondents of the *Quilters and Internet Usage 2000* survey. I also posted the URL to several quilt-specific discussion groups such as Quilt History, About.com, Yahoo, Prodigy, America Online *Nine Patch Newsletter* users, and selected Black quilting boards.

My initial goal of 500 respondents was reached within approximately seventy-two hours. On February 13, 2001, just twenty-four days after launching the fabric purchasing survey, 1,400 quilters had enthusiastically responded. Six percent of the respondents checked African American as their ethnicity.

Let's see how one million African American quilters potentially spent an estimated $40.3 million on fabric for quiltmaking!

HOME FOR QUILTERS ON THE INTERNET

Given the Internet's worldwide reach, respondents were asked to indicate the region of the country in which they lived.

Table 1. Region of Country Live

	African American Quilters	*Total Respondents*
South or DC—USA	39.8%	18%
West—USA	26.1%	30%
Northeast—USA	18.2%	22%
Midwest—USA	15.9%	23%
Outside of the USA	0%	7%

- 39.8 percent of African American quilters on the Internet reside in the District of Columbia or Southern states of Alabama, Arkansas, Delaware, Florida, Georgia, Kentucky, Louisiana, Maryland, Mississippi, North Carolina, Oklahoma, South Carolina, Tennessee, Texas, Virginia, or West Virginia.
- 30 percent of quilters on the Internet reside in Western states of Alaska, Arizona, California, Colorado, Hawaii, Idaho, Montana, Nevada, New Mexico, Oregon, Utah, Washington, or Wyoming.

QUILTERS AND FABRIC PURCHASING MECHANICS

To understand overall fabric purchasing behaviors, let's start by reviewing the average dollars spent and yards bought per store visit.

Table 2. How Much Do You Typically Spend per Yard of Fabric for Your Quilting Projects?

	African American Quilters	*Total Respondents**
$1 to $2 per yard	1.2%	2%
$3 to $4	20.2%	17%
$5 to $6	28.6%	24%
$7 to $8	33.3%	42%
$9 to $10	14.3%	11%
More than $10 per yard	2.4%	5%

Total exceeds 100 percent due to rounding.

- One-third of African American quilters on the Internet spend between $7 and $8 per yard on fabric. This suggests that, on average, Black quilters spend the same amount per yard as all quilters. In fact, the industry study *Quilting in America 2000* reported that dedicated quilters paid an average of $6.91 per yard on fabric, up 3.4 percent from $6.68 in 1997.

Table 3a. How Many Yards of Fabrics Do You Purchase per Month for Your Quilting Projects?

	African American Quilters	*Total Respondents*
1 to 2 yards	18.4%	15%
3 to 4 yards	32.2%	30%
5 to 6 yards	12.6%	22%
7 to 8 yards	11.5%	9%
9 to 10 yards	8.1%	9%
More than 10 yards per month	12.6%	11%
None, I use fabric from my fabric stash	4.6%	4%

- 50.6 percent of African American quilters on the Internet purchase between one and four yards of fabrics per month for quilting activities. On the other hand, 52 percent of total respondents purchase between three and six yards of fabric per month.

- From the *Quilters and Internet Usage Survey 2000*, we learned that African American quilters on the Internet are entering quiltmaking at a higher percentage than all other respondents. 21.6 percent of African American quilters have two years or less quiltmaking experience vs. 13 percent for all respondents. Beginner quilters may purchase less fabric as they start in the craft. The higher proportion of beginning Black quilters may be one factor for why Black quilters purchase fewer yards per month than total respondents. More research is needed, however.

- Interestingly, 4.6 percent of Black quilters and 4 percent of total respondents do not buy fabric on a monthly basis. Instead they select from a previously purchased fabric reserve, affectionately know as the "fabric stash."

An estimated one million African American quilters actively engage in the craft. Let's look at the fabric market in terms of quilters per buyer segment.

Table 3b. African American Quilters by Fabric Buyer Segments

	Yards Purchased Per Month	Percent Segment	Est. Number of Quilters per Segment
Light Buyers	1 to 4	50.6%	509,839
Medium Buyers	5 to 8	24.1%	242,828
Heavy Buyers	9 or more	20.7%	208,571
Participates Without Buying	uses fabric stash	4.6%	46,349
Est. Black Quilting Population		100.0%	1,007,587

- Half a million Black quilters on the Internet are Light Buyers who purchase between 12 and 48 yards per year.

- 20.7 percent of African American quilters or 208,000 quilters are Heavy Buyers. These quilters invest in at least 108 yards of fabric annually.

- More research is needed to determine which Buyer segment is most profitable for fabric store retailers.

Table 4. How Much Would You Estimate to be the Value of Your Fabric Stash?

	African American Quilters	Total Respondents*
Less than $500	22.7%	17%
$500 to $1,499	20.5%	26%
$1,500 to $2,499	23.9%	19%

	African American Quilters	Total Respondents*
$2,500 to $4,999	13.6%	16%
$5,000 to $7,499	13.6%	10%
$7,500 to $10,000	2.3%	5%
More than $10,000	3.4%	5%
I don't have a fabric stash	0%	0%

*Total may not equal 100 percent due to rounding.

Most quilters in America treasure their fabric stash. This collection of cherished purchased, swapped, and gift fabrics is subjectively assigned worth based on actual prices paid, sentimental value, and estimated replacement costs. Some quilters consider selected fabrics in their stash to be priceless if the fabrics are so old as to be irreplaceable.

It is important for retailers to understand that a stash means quilters are stockpiling fabric. Attractive fabric displays and appealing fabric designs may encourage quilters to impulsively add to their personal fabric stashes. In general, Black quilters stockpile fabric in a similar manner as total respondents.

• 23.9 percent of African American quilters on the Internet valued their fabric collection between $1,500 and $2,499.

• *Quilting in America 2000* estimated the average value of a dedicated quilter's fabric stash to be $2,407, up 43 percent from $1,685 in 1997.

KINDS OF FABRICS PURCHASED

A quilter will purchase fabrics for a variety of reasons such as quilt pattern requirements, fashion, impulse, price, perceived scarcity, and personal tastes. The following outlines preferred fabrics purchased by quilters on the Internet.

Table 5. What Type of Fabric Do You Regularly Purchase for Your Quilting Projects? (multiple responses possible)

	African American Quilters	Total Respondents	Variance*
100% Cotton	98.9%	98%	0.9%
African print	85.2%	12%	73.2%
Batiks	62.5%	48%	14.5%
Hand-dyed fabric	43.2%	33%	10.2%
Mud or Kuba cloth	22.7%	2%	20.7%
Cotton/Poly blend	12.5%	7%	5.5%
Silk	11.4%	7%	4.4%
Brocade	9.1%	2%	7.1%
Flannel	6.8%	28%	-21.2%

(Table 5, continued)	African American Quilters	Total Respondents	Variance*
Wool	4.6%	3%	1.6%
Polyester	1.1%	1%	0.1%
Other	n/a	7%	n/a

Variance refers to the difference between Black quilters and total respondents.

- 100 percent cotton, African prints, batiks, and hand-dyed cloths are the most frequently purchased quilting fabrics by African American quilters. This is important to understand. A fabric store that does not offer African prints or batiks is losing potential revenues from its Black quilting consumers.

- Black quilters purchase a greater variety of fabrics for their quiltmaking than total respondents. More than half of Black quilters regularly purchase three different types of fabrics for quiltmaking. This contrasts sharply from total respondents, who regularly purchase only 100 percent cottons for quiltmaking. It would be erroneous for a fabric store buyer to assume the 100 percent cotton display will satisfy the quiltmaking needs of Black quilters.

- African American quilters are more open to stitching both contemporary and traditional quilts than other quilters (*Quilters and Internet Usage 2000* survey, Table 6). Contemporary designs probably allow for a greater variety of fabric types to be used. Well-known African American quilters who consistently incorporate a variety of fabrics into their quilts include Ed Johnetta Miller of Hartford, Gerald Duane Coleman of Milwaukee, and Dindga McCannon of New York.

- The most frequently mentioned "Other" fabrics purchased were PDCs (prepared for dying cottons) and Asian prints.

Table 6. What Type of Fabric Designs Do You Regularly Purchase for Your Quilting Projects? (multiple responses possible)

	African American Quilters	Total Respondents	Variance
African prints	85.2%	15%	70.2%
Abstract	73.9%	47%	26.9%
Solids	63.6%	56%	7.6%
Geometric	60.2%	56%	4.2%
Floral prints	55.7%	77%	-21.3%
Novelty	40.9%	48%	-7.1%
Holiday prints (e.g., Christmas, Valentines)	37.5%	49%	-11.5%
Animal prints	37.5%	26%	11.5%

	African American Quilters	Total Respondents	Variance
Whimsical	34.0%	41%	-7.0%
Scenic/landscape	33.0%	31%	2.0%
Paisley	30.7%	38%	-7.3%
Juvenile prints	30.7%	37%	-6.3%
Stripes	29.6%	25%	4.6%
Plaids	18.2%	41%	-22.8%
Country/folk art	14.8%	39%	-24.2%
Toile	8.0%	6%	2.0%
Commemorative prints (e.g., George Washington, Malcolm X)	8.0%	5%	3.0%
Other	n/a	19%	n/a

- The top four fabric designs regularly purchased by Black quilters include: African prints (85.2 percent), abstracts (73.9 percent), solids (63.6 percent), and geometrics (60.2 percent). This differs substantively from the top four selections by total respondents: floral prints (77 percent), solids (56 percent), geometric (56 percent), and holiday prints (49 percent).

- Frequently novelty, whimsical, holiday, and juvenile prints incorporate Caucasian human characters into the fabric's design. Black quilters tend to regularly purchase less of these designs than total respondents, probably because the designs do not adequately embody Black characters, reflect ethnic specific holidays or cultural traditions. I believe there is a significant business opportunity for fabric manufacturers to design African American-theme fabrics in these categories.

- African American quilters are significantly less likely to purchase plaids and country/folk art fabrics than total respondents.

- The most frequently cited "other" fabrics designed purchased were Asian prints, tone-on-tone, and historic reproduction fabrics from the 1930s and Civil War.

Table 7. Where Do You Regularly Purchase Fabrics for Your Quilting Projects? (multiple responses possible)

	African American Quilters	Total Respondents	Variance
National chain fabric store (e.g., Jo-Ann Fabrics)	73.8%	62%	11.8%
Specialty quilt store	72.7%	81%	-8.3%
Specialty fabric store	54.6%	35%	19.6%
Quilt show or convention	52.3%	41%	11.3%
General merchandiser (e.g., Wal-Mart)	45.5%	36%	9.5%

(Table 7, continued)	African American Quilters	Total Respondents	Variance
Internet fabric store	33.0%	44%	-11.0%
Mail order	27.3%	28%	-0.7%
National chain craft store (e.g., Michael's)	14.8%	8%	6.8%
Street Vendor	13.6%	2%	11.6%
Wholesaler	8.0%	5%	3.0%
Other	n/a	7%	—

• African American quilters tend to purchase fabrics from a wider range of merchants than total respondents. More than half of Black quilters regularly buy fabrics from at least four different types of merchants vs. just two types by total respondents.

In Tables 5 and 6, we saw that African American quilters buy specific kinds of fabric for quiltmaking and that these fabrics are different from what other quilters purchase. Black quilters may be purchasing fabrics from so many types of stores because no one type is currently satisfying their needs completely.

We will see later that 75 percent of African American quilters always or frequently agree with the statement "I buy fabric whenever I see it—I may not see it again." The concept of scarcity may influence Black quilters to be open to different vendor types.

On the other hand, fabric manufacturers, which develop fabrics for Black quilters, have a variety of distribution channels to reach African American quilters.

• 73 percent of African American quilters on the Internet overwhelmingly purchase their fabrics from national chain fabric stores, such as Jo-Ann Fabrics and Crafts (990 stores) and Hancock Fabrics (436 stores), and specialty quilt shops (highly fragmented, one or two owners per store).

• 33 percent of Black quilters regularly buy quilting fabrics on the Internet vs. 44 percent for total respondents.

According to the 2001 study by the Cultural Access Group, *Ethnicity in the Electronic Age: Looking at the Internet Through Multicultural Lens*, African Americans research their purchases online (54 percent) at a higher rate than they actually make online purchases (31 percent). Forty-nine percent (49 percent) of Black online users felt discomfort with using credit cards online compared to 16 percent for general market consumers.

There is an opportunity to expand the number of Black quilters who regularly buy fabrics online, in part, by implementing tactics to ensure credit card safety at specific fabric store Web sites and communicating the safety measures to consumers.

• 45.5 percent of African American quilters and 36 percent of total respondents regularly buy fabrics from general merchandisers such as Wal-Mart (1,693 stores).

Currently Wal-Mart does not sell fabrics online. However, the merchandising giant could change quilting industry dynamics for fabric purchasing should it decide to offer quilting fabrics online at the lowest prices.

- 13.6 percent of Black quilters purchase fabrics from street vendors. In the African American community, it is common to find street vendors in urban settings or at local arts festivals selling African fabrics.
- The three most frequently listed "other" shopping channels were eBay.com, second-hand stores, and yard sales.

Table 8. Have You Purchased Fabric Online in the Last Six Months?

	African American Quilters	Total Respondents
Yes	38.6%	51%
No	61.4%	49%

- 38.6 percent of African American Quilters on the Internet have recently made an online fabric purchase vs. 51 percent of total respondents.
- The ten most frequently mentioned favorite online fabric stores included: TheBestKeptSecret.com, BigHornQuilts.com, ConnectingThreads.com, eBay .com, eQuilter.com, Fabric.com, Hancocks-Paducah.com, KeepsakeQuilting .com, LunnFabrics.com, and QuiltWorks.com.

ATTITUDES TOWARDS FABRIC PURCHASING

Quilters were asked to rate a series of statements reflecting their general feelings toward various aspects of purchasing fabrics for quiltmaking projects. The ratings ranged from (1) Always to (5) Never.

Table 9. "I Buy Fabric with a Specific Quilt Project in Mind"

	Always	Frequently	Sometimes	Rarely	Never
African American Quilters	9.1%	15.9%	48.9%	22.7%	3.4%
Total Respondents	5.0%	33.0%	46.0%	14.0%	2.0%

- 25 percent of Black quilters always or frequently buy fabric with a specific quilt project in mind vs. 38 percent of total respondents. This suggests Black quilters may simply enjoy purchasing fabrics—regardless of the quilt project in mind. Some quilters are inspired to make a quilt after seeing a particularly moving fabric design.

Table 10. "I Buy Fabric
Whenever I See It—I May Not See It Again"

	Always	Frequently	Sometimes	Rarely	Never
African American Quilters	19.3%	55.7%	20.4%	2.3%	2.3%
Total Respondents	18.0%	44.0%	26.0%	10.0%	2.0%

- 78 percent of African American quilters always or frequently will buy a particular fabric when they see it for fear of not seeing the design again vs. 62 percent for total respondents. Black quilters may consider certain fabric designs to be in scarce supply, thus may buy fabric at any opportunity.

Table 11. "I Prefer to Shop Alone to Buy Fabrics"

	Always	Frequently	Sometimes	Rarely	Never
African American Quilters	23.0%	42.5%	24.1%	9.2%	1.2%
Total Respondents	24.0%	35.0%	28.0%	10.0%	3.0%

- 65.5 percent of Black quilters on the Internet always or frequently prefer to shop by themselves when buying fabrics vs. 59 percent of total respondents.

Table 12. "I Buy Fabrics
That Represent Multi-Cultural Images"

	Always	Frequently	Sometimes	Rarely	Never
African American Quilters	13.8%	36.8%	37.9%	10.3%	1.2%
Total Respondents*	3.0%	14.0%	31.0%	33.0%	18.0%

Totals may not equal 100 percent because of rounding.

- 50.6 percent of African American quilters on the Internet always or frequently buy fabrics that represents multi-cultural images vs. only 17 percent of total respondents.

Table 13. "I Buy Fabric That Represents My Culture"

	Always	Frequently	Sometimes	Rarely	Never
African American Quilters	22.6%	45.2%	26.2%	4.8%	1.2%
Total Respondents	3.0%	14.0%	31.0%	32.0%	20.0%

- 67.8 percent of Black quilters always or frequently agree with the statement "I buy fabric that represents my culture" vs. just 17 percent of total respondents. This suggests that Black quilters are more receptive to fabrics that incorporate

cultural cues. In fact, Black quilters are more likely to buy fabrics that represent their culture vs. fabrics representing multi-cultural images. It is important for fabric designers and manufacturers to understand this point. There is likely more incremental revenue for designing African American theme fabrics for Black quilters vs. assuming Black quilters will be satisfied with fabrics with multi-cultural images.

Table 14. "I Admit to Being Addicted to Fabric Shopping"

	Always	*Frequently*	*Sometimes*	*Rarely*	*Never*
African American Quilters	48.3%	19.5%	17.2%	6.9%	8.1%
Total Respondents	48.0%	21.0%	17.0%	8.0%	6.0%

• 67.8 percent of African American quilters on the Internet admit to a fabric shopping addiction. Can you imagine the incremental sales opportunities if Black quilters' fabric needs were fully satisfied?

CONCLUSIONS

The *Quilters and Fabric Purchasing Survey 2001* achieved its goals of illuminating quilter buying behaviors and revealing African American quilters' unique fabric purchasing patterns.

African American Quilters and Fabric Purchases Summary

• 39.8 percent of African American quilters on the Internet reside in Southern states or the District of Columbia.
• 33.3 percent typically spend between $7 and $8 per yard on fabric.
• 50.6 percent are Light Buyers of fabrics and purchase between one and four yards of fabric per month.
• 20.7 percent are Heavy Buyers and purchase more than nine yards per month.
• 23.9 percent have a fabric stash valued between $1,500 and $2,499.
• 38.6 percent have made an online fabric purchase within the last six months.
• 100 percent cotton, African prints, batiks, and hand-dyed cloths are the most frequently purchased quilting fabrics.
• African prints (85.2 percent), abstracts (73.9 percent), solids (63.6 percent), and geometrics (60.2 percent) are the top four designs regularly purchased.
• 73 percent regularly purchase fabrics for quiltmaking at national chain stores and specialty quilt shops.

- 78 percent always or frequently buy a particular fabric when they see it for fear of not seeing the design again.

- 65.5 percent always or frequently prefer to shop by themselves when buying fabrics.

- 50.6 percent always or frequently buy fabrics that represent multi-cultural images.

- 67.8 percent always or frequently buy fabrics that represent their culture.

What are the Next Steps?

The fabric design, manufacturing, and retail communities can learn from the Social Expressions industry on how to develop products for African American quilters. Hallmark Cards, Inc. is the leading manufacturer of greeting cards. In 1987, Hallmark introduced Mahogany, a promotional offering of sixteen cards, aimed at Black consumers. Consumer research helped position the cards. Culturally relevant artwork and text were employed instead of simply placing a black-face on current greeting card designs. Hallmark advertised in leading African American publications such as *Ebony* and *Essence* magazines letting consumers know the cards were available.

Hallmark invested five years introducing new Mahogany cards each summer. The line was a sales success. Black consumers purposely visited Hallmark Card shops to buy the cards. By 1991, Hallmark expanded Mahogany to a year-round offering featuring everyday and holiday greeting cards. Today the Mahogany brand offers more than 800 cards for African American consumers. Mahogany licenses text from best-selling authors such as Iyanla Vanzant and Bishop T.D. Jakes. Some cards even featured quilts designed by Michael Cummings and Yvonne Wells. The Mahogany brand is now worth millions. There are lessons we can learn to increase the estimated $40.3 million Black quilters spend on fabric for quilt-making.

Recommendations for Fabric Manufacturers

- Obtain senior management commitment to explore how adding African American theme designs can increase company revenues. Conduct at least two different focus groups. First, listen to Black quilters to understand first-hand how culture affects fabric purchasing. Ask how the current fabric line is or is not satisfying the Black quilter's needs. Second, listen to your key retail accounts to gain insights into their African American quilter (and sewing) consumer base. Is there an opportunity to design exclusive African American designs for a key account or national chain?

- Commit design and production resources to developing African American theme fabrics through in-house development or licensing.

- Consider designs that explore African American cultural traditions within family, religion, heroes, and celebrations. Design specifically for Black quilters instead

of taking a middle-of-the-road approach with multi-cultural designs. Expand novelty, whimsical, juvenile, and holiday model lines to reflect Black heritage images.

Examples of potential fabric designs: Black baby and alphabet prints, African American Santa and angel patterns, and Black praying hands motifs. Consider creating commemorative prints and toiles. Imagine the sales potential for fabrics based on the 40th Anniversary of the March on Washington in 2003, the 15th anniversary of Nelson Mandela's prison release in 2005, the 30th anniversary of Kwanzaa in 2006, the 25th anniversary of the publication of Alice Walker's novel *The Color Purple* in 2007.

Design religious theme fabrics for African American quilters for year-round sales opportunity. Market researcher Susan Mitchell found that 41 percent of African Americans strongly agree that they carry their religious beliefs into other areas of their lives, versus just 25 percent for Caucasians (*American Attitudes*, New Strategist, 2000). Many Black quilters, such as Carole Lyles of Maryland, use quilting as an outlet for their spirituality.

• Commit to advertising your African American designs in quilt publications to let both quilters and retailers know your designs are available. In this survey, respondents were asked which magazines they regularly read. *Quilter's Newsletter Magazine* and *American Quilter* are the two primary publications online quilters regularly read. African American quilters also read more sewing/ textile-related publications, such as *Threads*, *Fiberarts*, and *Piecework*, than total respondents. Consider advertising there, too.

Table 15. Which of the Following Magazines Do You Regularly Read? (multiple responses possible)

	African American Quilters	*Total Respondents*
Quilter's Newsletter Magazine	64.8%	74%
American Quilter	55.7%	49%
O, The Oprah Magazine	36.4%	12%
Quilt	34.1%	29%
Threads	33.0%	23%
Quilting Today	30.7%	27%
Quilt World	30.7%	22%
Traditional Quiltworks	23.9%	21%
Art/Quilt Magazine	20.5%	14%
Traditional Quilter	19.3%	23%
Fiberarts Magazine	19.3%	8%
Miniature Quilts	15.9%	23%
Martha Stewart Living	14.8%	13%
Piecework	13.6%	11%

	African American Quilters	Total Respondents
Soft Dolls and Animals Magazine	11.4%	4%
International Review of African American Art	9.1%	1%
Quilts Japan Magazine	5.7%	3%

Recommendations for Fabric Store Merchants

• Conduct focus groups with your African American quilting customers to ensure your store is satisfy their needs and you are maximizing store sales.

• Request culturally relevant designs from your key fabric vendors—especially in product areas such as novelties, whimsical, juvenile, and holidays.

• Expand your quilting fabric selections to include African prints, mud or Kuba cloths.

• Ensure in-store quilt displays include designs that incorporate African prints to encourage fabric sales.

• National fabric stores should offer African prints and African American theme prints on their Web site to test the demand for these items and understand where geographically to add to in-store inventory.

• Fabric stores with Internet sales should strive to encourage trust of African American consumers by offering relevant cultural fabrics to foster online store visits (education) and promote the site's secure credit card transaction processing (trust).

Recommendations for Quilt Magazines

• Create a special issue or section devoted to African American quilting. Include articles by and about Black quilters, showcase specialty quilt stores that succeed at attracting Black quilters, educate readers about using African prints in quilts. Increase revenues by promoting this issue or section to potential fabric manufacturer advertisers.

Recommendations for Quilt Historians

• Systematically collect and document fabrics that reflect African American culture to assist with future appraisal efforts.

Recommendations for African American Quilters

• Speak to the store owner or fabric buyer at your favorite quilt shop and request they stock African American theme fabrics.

• Find out which manufacturer produces your favorite quilting cottons. Many times the name appears on the fabrics edges. Write to the manufacturer's president and vice presidents of marketing and design and request more culturally relevant fabrics for your quilting needs.

African American Theme Fabrics

Just what are African American theme fabrics? These are designs which illustrate Black American sensibilities and concepts. The emphasis is on American experiences versus imagery from the African continent.

African American theme fabrics are seldom seen in today's specialty quilt stores and fabric department of mass merchants such as Wal-Mart. No major fabric manufacturers consistently offer African American theme prints on an annual basis for Black quilters.

Following are photographic details of African American theme fabrics. Each print is 100 percent cotton and in the author's collection, unless otherwise noted. Photographs are by David Smalls of Kansas City, MO.

Best Friends. Hoffman International Fabrics (25792 Obrero Drive, Mission Viejo, CA 92691), about 1997. Text: "Many flowers come out in Spring," "I'll pick you some flowers" and "A bunch of flowers." This charming print was also available with a beige background. The girls' dresses were in a muted, rust pallet.

Black Santa Claus. V.I.P. Prints. Cranston Print Works Company (1381 Cranston Street, Cranston, RI 02920-6789), about 1999. Collection of Sherry Whetstone McCall, who remembers purchasing the last few yards of this 100 percent cotton fabric from an Oklahoma Wal-Mart store. Santa Claus represents an evergreen design concept—one that can be updated each year for decades. Sadly, many Christmas retail seasons pass with this type of design not available to Black quilters.

Love Imani Faith. Hi-Fashion Fabrics, Inc. (483 Broadway, New York, NY 10013), about 1997. Design #M1025. Text: "Love, Imani, Faith, Umoja, Unity." This fabric highlights selected Kwanzaa principles. Kwanzaa, a communal holiday to celebrate the year's first fruits, is practiced December 26 to January 1. Each day represents one of the seven principles: Umoja (unity), Kujichagulia (self-determination), Ujima (collective work and responsibility), Ujamaa (cooperative economics), Nia (purpose), Kuumba (creativity), and Imani (faith). (See color plate H.)

Praying Hands. Fit to Print for Hi-Fashion, Inc. (483 Broadway, New York, NY 10013), about 1997. Design—Africa CM1023. This rare, vibrant print celebrates African American religious icons such as praying hands and the dove of peace. The red, black, and green candles in the kinara make this print appropriate for Kwanzaa as well. This religious fabric would have been suitable for year-round sales.

Women Wearing Turbans. Timeless Treasures for Hi-Fashions, Inc. (483 Broadway, New York, NY 10013), about 2000. Design—wKenta CM1946. This print was also available in a brown and rust pallet (Design—Gwen C1946). This fabric is interesting for its focus on adult women. Usually only African fabrics show adult black women in various activities. Past American fabrics with adult black women imagery have shown "mammy" figures or angels. There have also been cartoon-like images on fabric. In the early 1990s, Elinor Peace Bailey doll designs, including black adult dolls, appeared on fabric. Women-to-women relationships such as mother/daughter and sisterfriend/girlfriend are important in the Black community. These relationships, however, are rarely illustrated in American fabrics. (See color plate H.)

Mischief Makers. Hoffman International Fabrics (25792 Obrero Drive, Mission Viejo, CA 92691), about 1997. This delightful all-over print features African American children at the beach. The distinction of focusing on only Black imagery makes this fabric design rare. I believe many Black quilters would prefer baby and juvenile prints that celebrate positive aspects of Black lifestyles to a multi-cultural design approach.

Ballet Dancers. Fabric Traditions, N.T.T. Inc., about 1999. 100 percent cotton with glitter highlights. This charming juvenile print demonstrates a multi-cultural approach to design. African American characters are included with other races. This approach is typically used for including images of Black children in fabric designs.

Hip-Hop Heaven. Princess Fabrics, Inc. (462 Seventh Avenue, 7th Floor, New York, NY 10018), about 1995. Collection of Joanna Banks. This print was also available with a white background. (See color plate H.)

Hip-Hop Heaven. Princess Fabrics, Inc. (462 Seventh Avenue, 7th Floor, New York, NY 10018), about 1995. Collection of Joanna Banks.

Space Jams—panel. Warner Bros., about 1996. Close-up of a 36" × 45" panel. Warner Studio released the live action and animated movie *Space Jam* starring basketball superstar Michael Jordan and Looney Tunes cartoon favorites in November 1996. At least three fabric designs were introduced. This panel illustrates Jordan playing against the Nerd-luck "Monstars." (*SPACE JAM*, characters, names and all related indicia are trademarks of and ©Warner Bros. Michael Jordan, SFX Sports.)

Space Jams—Red Background. Warner Bros., about 1996. This fabric featured Michael Jordan with Looney Tunes characters Bugs Bunny and Elmer Fudd. (*SPACE JAM*, characters, names and all related indicia are trademarks of and ©Warner Bros. Michael Jordan, SFX Sports.)

Space Jams—M Print. Warner Bros., about 1996. The Space Jams prints focused on basketball great Michael Jordan. One can imagine fabric manufacturers licensing NBA, NFL, MLB, NASCAR, and other sports superstars for future prints to accompany the annual generic sports fabrics introduced each year. (*SPACE JAM*, characters, names and all related indicia are trademarks of and ©Warner Bros. Michael Jordan, SFX Sports.)

Peanuts—All Star Sports—Soccer. Licensed to Concord Fabrics, Inc. (1359 Broadway, New York, NY 10018), 2000. Design #5569B. Also available with a light green background (Design #5569G). The Franklin character appeared again on a 100 percent cotton skirt print, *A Charlie Brown Christmas* (Design #5592B), and on the Halloween print *The Great Pumpkin* (Design #5585M). (Courtesy of United Feature Syndicate, Inc.)

Nelson Mandela Commemorative Fabric. From Malawi Veritable. English Wax 786.
Design #845. Text: "1994 Year of Liberation for All South Africans" and "Congratula-
tions from Warm Heart of Africa, Malawi."

West and Central African countries have a tradition of offering limited edition com-
memorative fabrics. African American themes can also be celebrated in commemora-
tive prints. One can imagine a profitable market for a historical black heroes fabric series,
for example.

Arkansas Centennial (1882–1982) of the African Methodist Episcopal Zion Church. Commemorative Fabric. Privately manufactured, about 1982. Clockwise from top right: Bishop Joseph Pascal Thompson 1818–1894, Mrs. Bessie D. Corrothers, Bishop J. J. Clinton, Bishop Singleton Tomas W. Jones 1825–1891, and Bishop R. L. Speaks (center). Collection of Cuesta Benberry.

CHAPTER 6

African American Quilting and Needlearts Timeline, 1800 to 2000

This timeline includes a range of events such as completion of important historical quilts, sewing inventions, publications related to American quilting, awards to Black quilters, important museum exhibits, and newsworthy popular culture, fine arts, and needlework events that may have influenced African American quilters.

1800s–1840s

1829 The Oblate Sisters of Providence, a congregation of Black Catholic nuns, is founded in Baltimore, MD. The order opened a school for African American girls. As early as 1834, the order taught fine sewing and embroidery. Church vestments were sewn to raise funds. The order continues to operate the school in Baltimore today.

1832 The Female Anti-Slavery Society is formed by free Black women in Salem, MA. At times during the abolitionist movement, women sold their needlework, including quilts, at annual fairs to raise funds.

1836 A star patchwork cradle quilt with an inscription to a "negro-mother" is exhibited at a Boston Anti-Slavery Society Ladies Fair. This quilt is currently in the Harrison-Grey-Otis House, Society for the Preservation of New England Antiquities, Boston, MA.

1837 Harriet Powers, the honored "Mother" of African American quilting, is born a slave in Georgia on October 29.

1839 The Salem Juvenile Colored Sewing Society pays a $15 lifetime membership to the Massachusetts Anti-Slavery Society for "an admired adult."

1840 J&P Coats starts to sell thread in America.

1843 Harriet Ross, who would later guide hundreds of slaves to freedom through the Underground Railroad, sews a patchwork quilt in anticipation of her marriage to John Tubman. The U.S. Postal Service twice honored Harriet Tubman by issuing commemorative stamps in 1978 and 1995.

1846 "The Patch-Work Quilt" by Miss. C. M. Sedwick is published in *The Columbian Lady's and Gentleman's Magazine*, March issue. The short story revolves around a wealthy White woman who visits Lilly, a Black former servant, who shares a patchwork quilt with the woman.

Mountain Mist–branded quilt batting introduced.

1850s–1890s

1850 Elizabeth Salter Smith, who would spend most of her life in Davisborough, GA, is born a slave. Gladys-Marie Fry will curate an exhibit, *Ev'ry Day'll Be Sunday*, at Radcliffe College in 1989 featuring eight of Smith's quilts made between 1875 and 1920.

Mary Jane Batson, a Virginia slave, stitches the *Couples Quilt*, which will later be exhibited at the 1982 World's Fair in Knoxville, TN.

1851 Singer Sewing machines introduced. To gain consumer market share, the Singer sewing machine would be sold on credit using installment payments.

1854 Sarah Ann Wilson, probably when in New York or New Jersey, creates the *Black-Family Album* quilt. This pictorial quilt is composed of 30 appliquéd blocks. Three of the blocks include human figures, which are each sewn with black cloth. It is unclear if Wilson is African American. In 1984, Skinner's of Massachusetts auctioned this quilt for a record $30,800. In the late 1990s, a miniature quilt influenced by this design would appear as an accessory for the American Girl Addy doll collection.

1859 Harriet Beecher Stowe, author of the best-selling, anti-slavery novel *Uncle Tom's Cabin*, publishes *The Minister's Wooing*. The book includes references to Candice, a Black servant who attends to those at a quilting party.

1861 The Civil War begins.

An advertisement for "fashionable dress making, shirt making, embroidering, and quilting" placed by three Black women appears in the October 19 issue of the weekly *Anglo-African* magazine.

1863 President Abraham Lincoln signs the Emancipation Proclamation, which free slaves in states rebelling against the Union.

1868 Elizabeth Hobbs Keckley publishes her memoir, *Behind the Scenes... Or Thirty Years a Slave and Four Years in the White House.* Keckley also created the *Mary Todd Lincoln Quilt* (circa 1850–1875) out of the President's wife's dress scraps. The quilt is now in the Kent State University Museum collection.

1869 Fanny Jackson Coppin is appointed principal of the Institute for Colored Youth, the first classical coeducational high school for African Americans in Philadelphia. The curriculum of the school included tailoring, dressmaking, sewing, and millinery. The insitution is now Cheyney University of Pennsylvania.

1870 Thomas Elkins, an African American inventor from Albany, NY, receives U.S. patent no. 100,020 for a combination dining, ironing table and quilting frame.

1872 Phebe Cook, a White woman, creates the *Boys and Girls Quilt*, which includes figures representing both her African American and Caucasian neighbors. The quilt is now in the Ohio Historical Society collection.

1875 *Hearth and Home Magazine*, in its April issue, features an article about "Aunt Pattie Earthman" of Nashville, TN, a 103-year-old quiltmaker who still sewed without eyeglasses.

1879 Betty West, an African American housekeeper, completes a star quilt for two White children in her care. The *Nurse's Quilt* in now in the collection of the Smithsonian Institution.

1883 "Brothers Assisted in the Quilting," an illustration showing an all-Black quilting party, appears in the April 21 issue of *Harper's Weekly*.

"Viney's Conversion and Courtship," a short story about a cherished silk pieced quilt made by a former slave, is published in *Harper's Weekly* April issue.

1884 "The Quiltin' at Old Mrs. Robertson's" by Betsy Hamilton is published in February *Harper's Weekly* issue. One character in this short story is Mammy Hester.

1885 Washington, DC school teacher Sarah H. Shimm exhibits a silk embroidered divan featuring the story of Toussaint L'Ouverture at the New Orleans World's Industrial and Cotton Exposition.

1886 Harriet Powers's *Bible Quilt* is exhibited at the Cotton Fair, Athens, GA, where Jeannie Smith, who would purchase the quilt for $5 in 1891, first sees it. This quilt is now in the permanent collection of the Smithsonian Institution.

1887 The Willing Workers of Detroit, Michigan, is founded on November 30. Mrs. Delia Barrier would serve at least 40 years as Club President. The group, which regularly raised money by making and selling quilts, was a member of the Needle Work Guild of America.

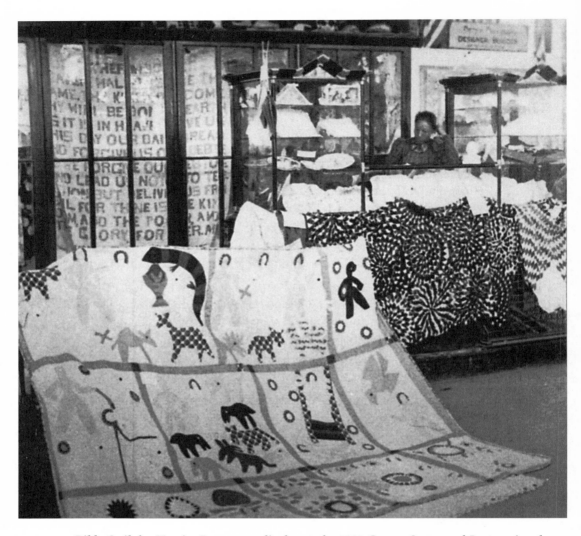

Bible Quilt by Harriet Powers on display at the 1895 Cotton States and International Exposition, Atlanta, GA. The appliquéd quilt was featured among several other quilts in the Negro Building. There appears to be another religious-themed quilt in the background by an unknown quilter. Behind the glass case is a quilt with the entire Lord's Prayer in appliqué. (Photograph courtesy of the Littleton Public Library, B.W. Kilburn Stereoview Collection, Littleton, NH.)

1889 "Mammy Hester's Quilts," a short story by Adelaide R. Rollston, is published in the August issue of *Harper's Bazaar*.

1890 The Harper Woman's Club of Jefferson City, MO is founded. The club established a training school for sewing instruction.

189(?) Lucy A. Delaney, a former slave, publishes *From the Darkness Cometh the Light or Struggles for Freedom*. Delaney, an expert seamstress, recalls "the days in which sewing machines were unknown, and no stitching or sewing of any descrip-

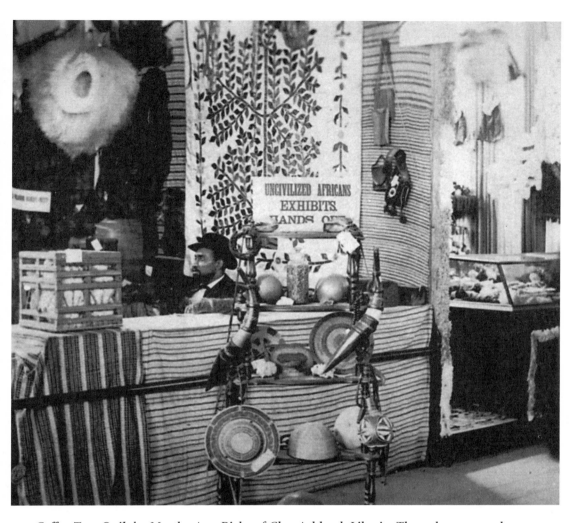

Coffee Tree Quilt by Martha Ann Ricks of Clay-Ashland, Liberia. The red, green, and white silk quilt hanging from the wall is a duplicate of one Ricks stitched for Queen Victoria and presented to Her Majesty in 1892. The quilt for Queen Victoria was also displayed at the 1893 Columbian World's Exposition in Chicago. The "Uncivilized African Exhibits" featured items from the collection of prominent A.M.E. Bishop Henry Turner. Ricks made this duplicate for Bishop Turner, who visited Liberia on missionary work. Coffee was an important cash crop for Liberia. (Photograph courtesy of the Littleton Public Library, B.W. Kilburn Stereoview Collection, Littleton, NH.)

tion was allowed to pass muster, unless each stitch looked as if it were a part of the cloth. The art of fine sewing was lost when sewing machines were invented…"

1892 Sarah Boone, a Black woman from New Haven, CT, receives U.S. patent no. 473,653 for an ironing board especially useful for ironing "ladies garments."

Martha Ann Ricks, a former Virginia slave, presents Queen Victoria of England with a quilt featuring a coffee tree on July 16. Mrs. Jane Roberts, the wife

of the first African president of Liberia, accompanies Ricks. It was recorded in the Booker T. Washington papers that Ricks stitched a second coffee tree quilt as a gift for AME Bishop Henry McNeal Turner.

1893 Queen Victoria sends the Martha Ann Ricks *Coffee Tree* quilt to the Columbia Exposition, Chicago World's Fair, as part of the British needlework exhibit.

A June 10th New York Times article "Work of Colored Women" reports on exhibit of needlework, including quilts, by Black women at the World's Fair. Nearly one hundred years later, an article entitled "What Quilting Means to Black Women" by Barbara Delatiner appears in the January 26, 1992 edition of the *New York Times*.

The R. T. Davis Mills Company promotes its "Aunt Jemima" pancake mix at the World's Fair. Nancy Green, a former Kentucky slave, is hired to impersonate Aunt Jemima. Green serves thousands of pancakes, sings, and tells stories about "the old South" during the Fair. The promotion is a huge success. Green becomes the first "living" trademark in advertising history. In time, the Aunt Jemima image would be used as give-aways and premiums to promote dozens of items, including sewing accessories such as sewing needle kits, pin cushions and cloth dolls.

1896 The National Association of Colored Women (NACW) is founded in Washington, DC. The NACW, a federation of Black women clubs, had as its motto, "Lifting As We Climb." Five thousand women were members the first year. Throughout the years, several clubs engaged in needlework activities. The NACW still exists today.

George Washington Carver joins the faculty of Tuskegee Institute as director of agricultural research. Carver painted, crocheted, knitted, quilted and sewed. He dyed his own threads. The Carver Museum in Tuskegee, AL, has many of his crafts and artwork in its collection, including a handsewn bedcover.

Julie Hammonds, a Black woman from Lebanon, IL, receives U.S. patent no. 572,985 for an apparatus for holding yarn skeins. This invention helped to keep yarn from tangling while knitting.

1898 Susie King Taylor, a former camp nurse with the 33rd U.S. Colored Troops, Late 1st South Carolina Volunteers, makes a large red, white and blue ribbon quilt for a Massachusetts Women's Relief Corps Ladies Fair. The quilt "made quite a sensation" and was awarded to the president of the Women's Relief Corps.

1900s–1940s

1900 The *Bible Scenes Quilt*, made by a member of the Drake family of Thomaston, GA, is presumed to have been created. The quilt is in the collection of the High Museum, Atlanta, GA.

Hampton Institute of Virginia introduces basketry and handweaving of cloth into its curriculum.

1901 The South Carolina and Interstate and West Indian Exposition is held in Charleston, SC. The Negro Building housed needlework, dressmaking, and sewing exhibits from the Avery Institute, Hampton Institute, Penn Normal and Industrial School and Scotia Seminary.

1904 Mary McLeod Bethune founds the Daytona Literary and Industrial School for Training Negro Girls in Daytona Beach, FL. The school started with five girls in a rented cabin. The curriculum would eventually include sewing, dressmaking, domestic science, and rug weaving. Thomas H. White, founder of the White Sewing Machine Company, was an early financial benefactor for the school.

1905 Mary Lyde Hicks Williams of Faison, NC creates a series of paintings, "Scenes From Negro Life," which includes two with quilting themes: *The Quilting Party* and *The Nursemaid*. Both paintings are now in the North Carolina Museum of History–Raleigh collection.

1907 Garrett Morgan, an African American inventor, opens his own successful sewing machine and sales shop in Cleveland, OH. Morgan would receive a patent for the automatic traffic signal in 1923.

1909 Effie Waller Smith's poem "The Patchwork Quilt" is published.

Nannie Helen Burroughs opens the National Training School for Women and Girls in Washington, DC. The school philosophy centers on three Bs—The Holy Bible (clean living), the Bathtub (clean bodies), and the Broom (clean homes). The curriculum includes mission work, academics, sewing and music. As late as 1958, the curriculum included plain sewing, dressmaking, tailoring, and needlecrafts.

1912 Mrs. Anna Lewis, representing the Willing Workers of Detroit, presents a "beautiful silk quilt to be used in some way as a source of revenue" for the National Association of Colored Women at its Seventh Biennial meeting in Hampton, VA.

1913 Paul Laurence Dunbar's poem "The Quilting" is published.

1915 Marie D. Webster publishes *Quilts, Their Story and How to Make Them*, the first American book devoted to quiltmaking and quilt history. Her quilt designs appeared in magazines such as *Ladies Home Journal*. She later sold quilt patterns through her own home-based business, the Practical Patchwork Company.

The Negro Historical and Industrial Exposition is held at the State Fair Grounds in Richmond, VA. Exhibits include "all kinds of sewing."

1917 Jamaican born Marcus Garvey, Jr. starts the American chapters of the Universal Negro Improvement Association (UNIA). Garvey's message of African American political self-determination, economic self-reliance, and a creation of a Black nation on the continent of African resonated in New York. The UNIA would later launch the *Black Star Line* shipping line. In 1991, New York quilter Hazel Blackman would design *Star Line* quilt to commemorate Garvey.

1920 The Negro Factories Corporations, an essential component to Garvey's vision of African American economic independence, is incorporated. Businesses begun in Harlem included the Universal Steam Laundry, the Universal Tailoring and Dress Making Department, and a Black doll factory.

1922 "The Bible Quilt: Plantation Chronicles" by Eleanor Gibbs is published in *The Atlantic Monthly*, July issue.

1926 Carter G. Woodson begins the celebration of Negro History Week.

The Harmon Foundation hosts its first annual exhibition for African American artists. The exhibitions would conclude in 1935.

The Jolly Sixteen Art Club is formed on October 6th in Kansas City, Kansas, by a group of Black women. The Club's goals were to serve the community and participate in various art and needleworks. Many Club members are now senior citizens. Club president Violet C. Jones reports that the club members had a meeting on Valentine's Day 2001.

Fritz Hooker, a Mountain Mist sales manager, starts to place quilt patterns on Mountain Mist batting wrappers to increase product sales. The collection of patterns would reach 130.

1927 *Black April*, a novel about South Carolina plantation life, is published by Julia Peterkin. One of the chapters is entitled "The Quilting."

Mary Effie Newsome's poem "The Quilt" is published in a poetry anthology edited by Countee Cullen.

1933 The Sears National Quilt Contest motivates nearly 25,000 quilt submissions for $7,500 in prize money.

1934 Ruth Clement Bond designs a set of pictorial quilts collectively referred to as the Tennessee Valley Authority (TVA) quilts. Bonds designed the quilts in appreciation to the TVA, one of the first federal agencies to hire African Americans in management positions at the same pay as white managers. Three of these quilts are in the collection of the American Craft Museum, New York.

1935 *The Household Magazine* starts publishing a monthly children's short story feature, *Little Brown Koko*, by Blanche Seale Hunt. The stories are in dialect and characters include Mammy, a little girl Snooky and a pet dog Shoog. Readers would use the story illustrations as inspiration for quilt blocks.

Anna Short Harrington of Syracuse, NY begins to make appearances as *Aunt Jemima* at local store openings and fairs. She demonstrated pancake making at the Dey Brothers Department Store and New York State Fair in Syracuse. Family members recall that Harrington was also a seamstress and ribbon-winning quilter. She died in 1955 at age 58.

1936 Writers and journalist employed by the Federal Writers Project, part of the Works Progress Administration (WPA), start to gather American slave narratives.

From 1936 to 1938, over 2,000 interviews with ex-slaves were collected. At times, sewing and quilting activities were recalled.

Nancy Cobot's quilt pattern column in the June 4th issue of the *Chicago Tribune* features a *Parasol Vine* quilt made by a "Kentucky Negro" in 1875.

1939 Florence Peto publishes *Historic Quilts*, a collection of stories about various quilts. Included is an account of Virginia slave quiltmaker Sarah Harris, who was permitted to sign and date her quilt during the time when it was illegal for slaves to be taught to read and write. The signed 1848 quilt *Rob Peter to Pay Paul* was featured on the book's dust jacket.

1943 Artist Horace Pippin completes *Domino Players*, an oil painting, illustrating a Black woman quilting while three others are playing dominos.

1946 Artist Jacob Lawrence completes the painting *The Seamstress*, featuring a Black woman guiding red fabric through a sewing machine.

1948 *History of the Helping Hand Club of the Nineteenth Street Baptist Church* booklet includes a section about the Washington, DC service group's quilting efforts.

1949 Marguerite Ickis publishes *The Standard Book of Quilt Making and Collecting*. This popular how-to book did not include any references to Black women and quilting.

1950s

1951 The Negro History Club of Marin City and Sausalito, CA stitches the *Harriet Tubman Quilt*, designed by Ben Irvin. The quilt won second place at the California State Fair. Theologian Howard Thurman and his wife Sue Bailey Thurman purchased the quilt, which was later donated to the Atlanta University Center. The quilt is now on permanent display at the Robert W. Woodruff Library.

1953 African American fashion designer Ann Lowe creates the ivory silk wedding gown which Jacqueline Bouvier wears to marry John F. Kennedy.

1954 John T. Biggers completes his dissertation, *The Negro Woman in American Life and Education: A Mural Presentation*, at Pennsylvania State University. The mural is located at the YMCA Blue Triangle Branch in Houston, Texas. A Black woman quilting is one of the subjects.

1955 Seamstress Rosa Parks refuses to give up her seat on an Alabama bus to a white passenger. She is arrested. This action sparked the Montgomery Bus Boycott, led by Rev. Martin Luther King. The boycott would last 381 days, when the U.S. Supreme Court declared segregation on public buses was unconstitutional.

1956 Folk artist and quilter Clementine Hunter publishes *Melrose Plantation Cookbook* with Francois Mignon.

1960s

1965 Jackie Peters, an African American woman, is named Chief Designer for H.M. Kolbe, a New York fabric studio. Peters later opens the first African American-owned textile design studio in 1979.

1966 Freedom Quilting Bee of Wilcox County, Alabama, one of the few all-Black women's cooperatives, is started with fifty-five members.

Margaret Walker publishes *Jubilee*, a slave narrative novel, inspired by her own family history. The novel would sell more than one million copies. There is a quilting party scene in the book.

Dr. Ron Karenga creates the affirming and reflective African American holiday, Kwanzaa.

1967 The first Smithsonian Folklife Festival in Washington, DC is attended by 431,000 visitors. The Freedom Quilting Bee is one of the featured folk artists invited to host a quilting demonstration.

1969 Jeri Pamela Richardson of Indiana University completes her Ph.D. dissertation on the Freedom Quilting Bee. This work is one of the first dissertations to explore Black women and quilting.

Du Pont commissions the Freedom Quilting Bee to make a promotional quilt for a Houston, Texas department store. The quilt was so large it was draped *outside* of the department store building. The quilt hung outside for two weeks. The 20 feet wide by 44 feet long quilt—about half the size of a basketball court— held the title of the "World's Largest Quilt" until 1982. The quilt toured the country and was returned to the Freedom Quilting Bee, which cut the quilt into eighteen different pieces and sold each for $10.

Nimble Needle Treasures, a quarterly magazine featuring reprinted quilt patterns and articles on quilt history, is launched. Quilt historian Cuesta Benberry is a regular contributor. The magazine ceased publication in 1976.

Quilter's Newsletter Magazine, one of the first professional magazines devoted to quilting, publishes its first issue in September.

The Hallmark Gallery in New York opens *Stitched in Time: American Needlework Past & Present*, a comprehensive exhibit containing over 500 items, including a quilt made by members of the Freedom Quilting Bee. In addition, a segment of the exhibit features needlework by twenty-eight celebrities such as Amy Vanderbilt, Gypsy Rose Lee, and Joanne Woodward. Entertainer Pearl Bailey contributes a framed needlepoint version of the Ten Commandments.

1970s

1970 Romare Bearden creates the collage *Patchwork Quilt*, now in the Museum of Modern Art (NY) collection.

Erroll Hay Colcock completes *De Patch-Wu'k Quilt*, a short story about South Carolina plantation life as told by a Black woman. The entire story is written in the Gullah dialect.

The National Quilting Association (NQA) is founded in Greenbelt, MD. In the 1990s, NQA would fund seven projects promoting African American quilting through its grants program.

1971 The groundbreaking exhibit *Abstract Design in American Quilts*, curated by Jonathan Holstein and Gail van der Hoof, opens at the Whitney Museum of American Art. This exhibit generated unprecented attention from the general art world to quilting. No African American quilts included.

Judith Wragg Chase publishes *Afro-American Art and Craft*, which includes segment on African American-made quilts. The quilts were from the collection of the Old Slave Mart Museum, Charleston, SC. Chase was the museum curator.

1973 Alice Walker publishes "Everyday Use," a short story about the opposing values two sisters have for a family quilt.

The Boston Museum of Fine Arts publishes a pattern book based on Harriet Powers' quilts.

Football hero Rosey Grier publishes *Needlepoint for Men*.

Lady's Circle Patchwork Quilts starts publication. The magazine would cease operating in 2000.

1975 Jessie Telfair, a school cafeteria worker from Parrott, GA, creates *Freedom Quilt*, a moving red and white quilt with bold, blue-colored block letters repetitiously spelling FREEDOM. This quilt was inspired by a life event. Telfair lost her job because she registered to vote.

1976 Mrs. J.M. Gates organizes fifteen women in Portland to create the *Afro-American Heritage Bicentennial Quilt*, now in the Oregon Historical Society collection.

Dr. Gladys-Marie Fry publishes her landmark research about Harriet Powers life in *Missing Pieces: Georgia Folk Art 1770–1976* exhibit catalog. Fry conducted the first full-scale investigation into Powers' life story.

1977 Mary Twining completes her Ph.D. dissertation at Indiana University where she writes about folk culture of the South Carolina and Georgia Sea Islands. Quilting is discussed in the context of folk culture.

Beatrice L. Cowans and Virginia E. Hall, both of Washington, DC, receive U.S. patent no. 4,016,314 for an embroidered fruit bowl wallhanging and kit.

The television mini-series *Roots*, based on Alex Haley's landmark look at his family history, is the highest rated program ever with 130 million viewers. The program and book prompted many African American families to rediscover their family history and artifacts, such as quilts.

1978 Roland Freeman's exhibit *Something to Keep You Warm* opens at the Old Capital Museum of Mississippi History.

John Michael Vlach curates *The Afro-American Tradition in Decorative Arts* at the Cleveland Museum of Art. Several patchwork quilts are included in the exhibit and catalog.

1979 Philadelphia quilter Lorraine A. Mahan donates an appliquéd story quilt commemorating the Carter Family to the White House. The quilt is now in the Jimmy Carter Library and Museum collection.

The exhibit *Black Quilters*, featuring ten African American quilters, opens at the Yale University School of Art in New Haven, CT.

Quilt National, a biennial juried art quilt competition, is started by Nancy Crow. The 12th exhibition will be in 2001. No African American-made quilts have been juried into a Quilt National show. *Never Done*, a collaborative quilt by New Image, was selected for Quilt National 1995. African American quilter Dorothy Holden participated in the creation of *Never Done*.

1980s

1980 American Quilt Study Group is founded to preserve the "accurate history of quilts, textiles, and the people who made them."

Cuesta Benberry writes "Afro-American Women and Quilts: An Intro-ductory Essay," one of the first published articles to place Black women's needle-work in the context of American quilt history. Benberry insisted a complete picture include quilts made by slaves, quilts made in a Euro-tradition, quilts made in African traditions, and quilts with black images made by white quilters.

Maude Whalman's Yale University dissertation, *The Art of Afro-American Quiltmaking: Origins, Development and Significance*, is published. This work nar-rowly defines African American quilts using specific characteristics. The seven traits Whalman outlines to distinguish African American quilts from the Anglo-American tradition: 1) an emphasis on vertical strips; 2) bright colors; 3) large designs; 4) asymmetry; 5) improvisation; 6) multiple-patterning; and 7) symbolic forms. For many years there would be debate about the authenticity of African American quilts that may or may not conform to such a narrow definition.

Pat Ferrero's film *Quilts In Women's Lives* premieres at the International Film Festival in San Francisco. The film wins a first-place award in the Fine Arts category. Mississippi quilter Nora Lee Condra is one of seven quilters profiled.

Viola Canady and Etta Portlock found the *Daughters of Dorcas and Sons* African American quilting guild in Washington, DC. The guild continues to meet weekly.

1981 The St. Martin DePorres Quilting Club of Providence is featured in the booklet *Quilting: Folk Tradition of the Rhode Island Afro-American community* sponsored by the Rhode Island Black Heritage Society.

The Kentucky Quilt Project, Inc. is formed to survey the state's quilts. "Quilt Days" are created so quilt owners can bring their covers in to be photographed and documented. One thousand Kentucky quilts are recorded. This project would inspire at least fifty other state, regional and international documentation projects to record more than 150,000 quilts.

1982 *Forever Free: Art by African American Women, 1862–1980*, the largest exhibit of Black women artists, opens. Includes references to folk artist and quilter Clementine Hunter.

Black Folk Art in America 1930–80 opens at the Corcoran Gallery of Art, Washington, DC. Regenia Perry contributes essay on quiltmaking to the exhibit catalog.

The Underground Railroad Quilt is created by twenty-five seniors to commemorate the sesquicentennial of the Underground Railroad and the role Oberlin (Ohio) citizens played.

Classified listings in popular magazines, such as *Quilt World* and *Stitch 'N Sew Quilts*, regularly feature needlework patterns for *Little Black Sambo, Mammy, Black Pickaninnies*, and other racially derogatory characters. These listings seem to continue until 1986.

1983 Cuesta Benberry is inducted into the Quilter's Hall of Fame for her contributions to quilt history research and pattern collecting. Hazel Carter of Northern Virginia designs a commemorative block entitled *Cuesta's Choice*.

Georgia quilter Lucinda Toomer is awarded a National Heritage Fellowship, the highest honor the U.S. government bestows on a traditional artist.

Betty C. Whitten opens a quilt and fabric shop, "Hearthside Quilts and Needleworks," in Milwaukee, WI. The shop is no longer open. Whitten now teaches quilting, crochet, dollmaking, and knitting in Illinois.

Senator Paul Tsongas (D-Mass) sends Winnie Mandela a "Lone Star" quilt signed by forty-six members of Congress. This quilt replaces a red, black, and green crochet bedspread confiscated by the South African police during a raid on Mandela's home.

1984 Thelma Pickett curates *Quilts a Bit of Afro American History*. The show featured 70 quilts and included an eight-page exhibit brochure compliments of the Ebony Museum of Art in Oakland, CA.

1985 *The Patchwork Quilt*, a beautifully illustrated children's book, by Valerie Flournoy and Jerry Pickney (ill.), is published.

1986 Carolyn Mazloomi requests correspondence with other "Black quilters worldwide" in a February *Quilter's Newsletter Magazine* classified listing. Responses to this ad lead to the formation of the Women of Color Quilters Network.

The exhibit *Soweto: The Patchwork of Our Lives*, featuring quilts by the Zamani Soweto Sisters Council of South Africa, opens at the Brixton Gallery of Art in London, England.

1987 Toni Morrison publishes the award-winning novel *Beloved*. Main characters Seth, Beloved, and Baby Suggs work together on a quilt.

Eli Leon publishes *Who'd a Thought It: Improvisation in African American Quiltmaking*. A national traveling exhibition opened at the San Francisco Craft & Folk Art Museum.

Hallmark Cards, Inc. introduces Mahogany, a sixteen-card promotional greeting card line for African American consumers. In the 1990s, Hallmark would license quilts by Michael Cummings and Yvonne Wells for Mahogany greeting cards.

1988 Faith Ringgold completes the story quilt *Tar Beach*, now in the Solomon R. Guggenheim Museum collection. The adapted children's story book *Tar Beach* receives a Caldecott Honor Award in 1992.

Jesse Jackson's keynote speech at the Democratic Convention encourages Americans to join together and build a quilt like the one his "grandmama" made.

Weavers of Dreams, a quilt designed by Marie Wilson of New York, is donated to the Martin Luther King, Jr. Center for Nonviolent Social Change in Atlanta, GA.

Bets Ramsey curates *Country to City: Changing Styles in Afro-American Quilts* at the Hunter Museum of Art in Chattanooga, TN.

1989 *Stitching Memories: African American Story Quilts*, curated by Eva Ungar Grudin, opens at Williams College Museum of Art, in Williamstown, MA.

Malverna Richardson, a St. Louis quilter, is designated a Master Teacher in the Missouri State Arts Council program.

1990s

1990 Gladys-Marie Fry publishes *Stitched From the Soul: Slave Quilts from the Ante-Bellum South.* The national traveling exhibition opened at the Museum of American Folk Art in New York.

Rose Shipp of Denver is appointed Master Quilter by the Colorado State Arts Council.

Belinda Crews is appointed director of the Maryland State Quilt Search Project.

Nora Ezell receives the Alabama Folk Heritage Award, the state's highest honor for traditional arts, for her quilting.

Nelson Mandela receives a quilt with blocks representing thirty-eight historically Black colleges and universities during his U. S. Freedom tour. Quilt made by Mable Benning and her daughter Shilla Benning.

The television news program *60 Minutes* focuses one segment on the Tutwiler Mississippi Quilters accomplishments.

Author Maya Angelou receives a $50,000 gift quilt from Oprah Winfrey, who commissioned Faith Ringgold to create the quilt.

Cultural historian bell hooks examines the role quiltmaking plays in the lives of black women in the book *Yearning: Race, Gender, and Cultural Politics.*

1991 Interest in "Afrocentric" fashions fuel sales of African fabrics such as kente cloth. Quilters incorporate African theme fabrics into their work. According to a *New York Times* article, one of America's largest importers of African fabrics is the Intercontinental Business Network (I.B.N.) in Manhattan. Retailer J.C. Penney, an I.B.N. customer, test-markets Afrocentric clothing in twenty stores nationally.

Marsha MacDowell curates *African American Quiltmaking Traditions in Michigan* at Michigan State University Museum. This is one of the first statewide efforts to concentrate on Black quilters. The exhibit includes a quilt made by Civil Rights heroine Rosa Parks.

Californians Arbie Williams and Gussie Wells are awarded National Heritage Fellowships for quilting.

Shirley Grear of Santa Rose, CA wins a $1,000 first place prize for her *Bits and Pieces of America* quilt in a national competition sponsored by a quilt template manufacturer.

Thelma Buchner and her brother open "The Piece by Piece Quilt Shop," a St. Paul, MN community center devoted to teaching quilting to neighborhood children, predominately African American.

An 1867 *American Pictorial Civil War* quilt, with forty squares illustrating scenes from freed slaves to Uncle Sam, sells at a Sotheby's auction to a New York dealer for $264,000, a then record for an American quilt.

1992 Cuesta Benberry curates *Always There: The African-American Presence in American Quilts*. The exhibition opens at the Museum of History and Science in Louisville, KY.

Narrations: The Quilts of Yvonne Wells and Carolyn Mazloom opens at the Louisville Visual Art Association (KY). This is one of the first exhibitions to couple the works of an African American folk art quilter (Wells) and an art studio quilter (Mazloomi) to demonstrate the diversity in quiltmaking styles.

"Thoughts on Being a Black Quiltmaker" by Joann Thompson published in *American Quilter*.

Nora Ezell, an Alabama quilter, is honored as a National Heritage Fellow.

Raymond Dobard is the first African American to serve on the Virginia Quilt Museum Board of Directors (1992–1996).

Michael Cummings's *Kitty and the Fireflies in the Bush* quilt is juried into "Visions," a critically acclaimed art quilt competition at the Museum of San Diego History.

The Smithsonian Institution's decision to reproduce selected 19th century quilts in their collection in overseas factories sparks a national controversy. One of the quilts is Harriet Powers' 1886 *Bible Quilt*.

Actress Daphne Maxwell Reid, in partnership with the McCall Pattern Company, produces and stars in a four-video project, *Suddenly You're Sewing*. Twenty-five thousand videos sold nationally. Reid also designs a biannual McCall pattern line.

1993 The Cincinnati African American Museum raises first-year operating funds through a quilt campaign in which patches are bought for $30–$3,000. The campaign's goal was to raise $56,000.

Willis "Bing" Davis curates *Uncommon Beauty in Common Objects: The Legacy of African American Craft Art*. This exhibit opens at the National Afro-American Museum and Cultural Center in Wilberforce, OH and includes many quilts.

Maude Southwell Whalman curates *Signs and Symbols: African Images in African American Quilts*. This national traveling exhibit opens at the Museum of American Folk Art in New York.

Hear My Quilt: 150 Years of African American Quilt Making exhibition curated by Cuesta Benberry opens at the St. Louis Art Museum.

Actress S. Epatha Merkerson initiates the role of Lt. Anita Van Buren on the award-winning drama *Law & Order*. Merkerson, a Detroit native, is also a passionate quilter.

1994 Results of the first national survey of the quilting industry, *Quilting in America 1994*, are released. More than 15.5 million American quilters are estimated to spend $1.5 billion on quilting related expenditures. No information is released on quilter ethnicity.

LaQuita Tummings of Vallejo, California, wins the Judges' Choice Award in the Lands' End "All-American Quilt Contest." Her quilt was called *My Heritage*.

Eighty-three year old quilter Mary Albertha Green of Suttons receives a South Carolina Folk Heritage Award for quilting. Green has won numerous first place ribbons at local county fairs.

1995 The movie *How to Make an American Quilt*, starring Maya Angelou, Anne Bancroft, and Alfre Woodard, premieres. African American quilters Barbara Brown, of Maryland, and Dora Simmons, of Los Angeles, contributed their quilting skills to the movie.

Deonna Green of Romulus, Michigan, receives the Michigan Heritage Award for her quilting.

1996 "Your Computer Quilting Neighborhood" article, in the April issue of *Quilter's Newsletter Magazine*, is one of the first to document African American quilting contributions on the Internet.

The Mississippi Cultural Crossroad Quilters participate in the Smithsonian Folklife Festival in Washington, DC.

Huisha Kiongozi designs and publishes the quilt pattern, "Simply… Congratulations," to commemorate the Olympic Games in Atlanta, GA.

Actress Phylicia Rashad is featured on the cover of *Women's World* magazine. The headline reads "Relax and Beat Stress the Way Phylicia Rashad Does!—And Make Her Christmas Quilt in a Weekend." This is possibly the first major women's magazine to feature a Black woman on its cover *because* of her quilting activities. Ed Johnetta Miller of Hartford, CT designed the Christmas Quilt.

1997 Roland Freeman publishes *A Communion of the Spirits: African-American Quilters, Preservers, and Their Stories*, the first national survey of Black quilters in America. The exhibit opens at the Mississippi Museum of Art in Jackson, MS.

Lula Willimas of Detroit, Michigan, receives the Michigan Heritage Award for her quilting.

Hystercine Rankin of Mississippi is awarded a National Heritage Fellowship for quilting.

The State of Alabama legislature designates the Pine Burr Quilt as the official state quilt. The March 11 resolution acknowledges Freedom Quilting Bee member China Grove Myles for her ability to stitch this complex quilt design.

Thieves break into and steal handmade quilts and other artifacts from the Tacoma, Washington, African American Museum.

1998 Carolyn Mazloomi publishes *Spirits of the Cloth: Contemporary African American Quilts*. The national traveling exhibition opens at the American Craft Museum in New York.

Gladys-Marie Fry curates *Man Made: African American Men and Quilting Traditions* at the Anacostia Museum in Washington, DC.

Phyllis Alesia Perry publishes *Stigmata*, a novel about a young Black woman haunted by a family quilt.

Carole Y. Lyles of Columbia, MD launches one of the first Internet discussion groups dedicated to African American quilting.

1999 Gwendolyn Magee launches QuiltEthnic.com, one of the most comprehensive Web site resources for African American quilting.

The Amistad Friendship Quilt Project, organized by Mary Staley, encourages quilters to submit quilt blocks for the bunks of a newly constructed schooner, *Amistad*. Hundreds of quilters participate, including several African American quilting guilds.

Rare stuffed, pieced cotton *Turtle Quilt*, from the late 19th or early 20th century and attributed to an African American quiltmaker, sells for $12,650 at a Sotheby's auction.

One hundred and twelve quilters in Hartford create four community *Connecticut African American Freedom Trail* quilts. The quilts are now in the permanent collection of the Museum of Connecticut History.

Raymond Dobard, quilter and co-author of *Hidden in Plain View: A Secret Story of Quilts and the Underground Railroad*, appears on an *In the Spirit* segment of the popular daytime talkshow *Oprah*.

Nora Ezell publishes *My Quilts and Me: The Diary of an American Quilter*, a autobiography from an award-winning quilter.

The AIDS Memorial Quilt tours historically Black colleges and universities to promote AIDS and HIV infection awareness.

2000

2000 The International Quilt Study Center acquires the Robert and Helen Cargo Collection of 156 African American quilts worth $500,000.

Quilter and photography historian Deborah Willis receives a $500,000 MacArthur Fellows Program award.

A Piece of My Soul: Quilts by Black Arkansans by Cuesta Benberry is published. Features the extensive collection of African American quilts collected by the Old State House Museum in Little Rock.

An African American Baltimore memorial quilt, circa 1900–1910, sells at Sotheby auction for $31,800.

Results of the third national survey of the quilting industry, *Quilting in America 2000*, are released. More than 19.7 million American quilters are estimated to spend $1.8 billion on quilting related expenditures. No information is released on quilter ethnicity.

The Daughters of Dorcas and Sons demonstrate quiltmaking at the Smithsonian Folklife Festival in Washington, DC.

Mississippi Cultural Crossroad Quilters sell over $30,000 worth of quilts during the year.

Kings Road Imports of Los Angeles unveils the *Unity Collection*, a line of fabrics designed by African American quilter Sandy Benjamin Hannibal of New York. The collection includes four prints and twelve textured solids.

CHAPTER 7

Future Developments in African American Quilting

Researching historical references to African American quilting has been an immense pleasure. It has also given me a unique perspective on missing pieces or under-explored aspects of the African American quilting story. The following list outlines my personal wishes for future developments in this field.

1. CRITICAL ANALYSIS OF WORKS BY AFRICAN AMERICAN QUILTERS

Bell hooks writes, "The progress of African-American artists in contemporary society cannot be measured solely by the success of individuals. It is also determined by the extent to which this work is critically considered." (*Art On My Mind: Visual Politics*, The New Press, 1995, p. 111)

Who critically considers the work of African American quilters? Many of the references to Black quilters or their quilts refer primarily to the artistic elements of the quilts—fabrics selected, color choices, obvious themes. There should be in-depth evaluation of the Black quilter's *body of work*, not simply individual quilts. We should learn about the influences on the quilter's work, the motivations for each quilt, and the value ascribed both intrinsically and monetarily for the quilts.

Faith Ringgold and Nora Ezell have written outstanding autobiographies that provide insights into the body of their quilting accomplishments. The 1998 retrospective exhibit and catalog *Eyewinkers, Tumbleturds and Candlebugs: The Art of Elizabeth Talford Scott* was a moving overview of Scott's quilting life.

227

I wish for books and articles that critically review and illustrate the body of work by African American quilters such as Denise Allen, Adriene Cruz, Michael Cummings, Francine Haskins, Gwendolyn Magee, Carolyn Mazloomi, Wini Akissi McQueen, Jim Smoote, Yvonne Wells and the late Marie Wilson, to name a few. The body of work by Black quilting groups should also be analyzed. I wish for a major 40th anniversary retrospective in 2006 to explore the impact of the Freedom Quilting Bee cooperative on quilt history and on the late 1960s patchwork-fashion craze. I wish the exhibit would include rooms filled with their quilts through the decades and a patch from their 1969 "World's Largest Quilt."

2. U.S. POSTAL SERVICE ISSUES HARRIET POWERS COMMEMORATIVE STAMP

Harriet Powers is known as the "mother" of African American quilting. She was born a slave in 1837. Powers exhibited an appliquéd quilt featuring different Bible stories at the 1886 Cotton Fair in Athens, GA. Jennie Smith, a white woman who saw the quilt, eventually met Powers and offered to purchase the quilt. Powers refused until 1891, when she desperately needed funds. Smith purchased the quilt for $5 and took time to record Powers' interpretation of the quilt. Years after Smith's death, the quilt was donated to the Smithsonian Institution, where the quilt remains on public display at the National Museum of American History. Powers made a second Bible story quilt in 1898. This quilt is in the permanent collection of the Boston Museum of Fine Arts.

I wish this nation would honor the "mother" of African American quilting on the 175th anniversary of her birth in 2012. Quilters all over this nation can petition the U.S. Postal Service to issue a Harriet Powers Commemorative Stamp by writing to: The Citizens' Stamp Advisory Committee, U.S. Postal Service, 475 L'Enfant Plaza, SW, Room 4474EB, Washington, DC, 20260-2437.

3. QUILTING IN AMERICA INDUSTRY STUDY TRACKS ETHNICITY

The 21st Century will see a shift in America's population composition. This population shift is sure to affect the quilting industry in terms of fabrics purchased, quilting patterns used, quilting traditions passed along, and quilts preserved.

I wish future *Quilting in America* studies would begin a meaningful dialog on how African Americans, Hispanics, Asians, and American Indians participate in this craft.

4. EXHIBITION AND CRITICAL REVIEW OF
AFRICAN AMERICAN NEEDLEWORK IN AMERICA

My mother taught several of us kids at Westminster Presbyterian Church in Los Angeles to crochet. We would spend an hour each week with a size J hook and a skein of colorful yarn. Our Youth Fellowship group made shawls and bed jackets for sick and shut-in church members. I had forgotten about our crochet lessons until I started working on this book. There is a rich history of African American needlework similarly forgotten.

I wish a major exhibition would be mounted featuring the history of African American needlework. Included would be fabrics once woven by slaves. We would see a range of plain and fancy sewing. We would see handsewn samplers. We would glimpse photographs of millinery, tailoring, and dressmaking classes from the early days at various historically Black colleges such as Bethune-Cookman, Hampton University, and Tuskegee. We would learn how being a seamstress was once one of the limited professions available to African American women. We would learn how African American organizations and churches raised money through the sales of needlework. We would see photos of the African American quilting and needlearts displays at various world, state, and county fairs. We would see examples of Black men, women, and children sewing, knitting, dollmaking, embroidering, weaving, and, of course, quilting.

5. MUSEUMS ACTIVELY INCLUDE AFRICAN AMERICAN–MADE
QUILTS IN THEIR PERMANENT COLLECTIONS

I wish that more American museums, quilting institutions, and historical societies would preserve and collect quilts made by African Americans than are doing so now.

6. QUILTING BY AFRICAN AMERICAN
WOMEN IN PRISONS IS STUDIED

The Bureau of Justice Statistics reports that 1.3 million men and women were held in state and federal prisons in 2000. African Americans represented 46 percent of the prison population. There have been sporadic news stories about quilting activities behind bars. Volunteers teach quilting at the maximum-security Patuxent Institution for Women in Jessup, MD, the Chillicothe Correctional Center in Chillicothe, MO, and the Brushy Mountain Correctional Complex in Morgan County, TN, to name a few places. For most men and women inmates, this is their first time quilting. Generally, the inmates are not allowed to keep the quilts. The work is donated to area hospitals and charity organizations.

I wish we would learn more about African American quilting in our nation's prisons, jails, and juvenile detention centers. What motivations do Black prisoners have for quilting that may or may not be different from non-incarcerated Black quilters? Is there flexibility to select both traditional and contemporary quilt patterns? We have seen in Chapter 5 that Black quilters regularly prefer African prints, abstracts, and solid fabrics for their quiltmaking. Are there similar preferences and access to these fabrics for Black quilting inmates? What do the quilts by Black quilters in prison look like? How, if at all, do these quilts differ from other African American-made quilts?

7. AMISTAD FRIENDSHIP QUILT PROJECT BOOK IS PUBLISHED

In 1998, the Connecticut-based AMISTAD America and Mystic Seaport organizations started building the schooner *Amistad*, a replica of the 1839 ship which carried fifty-three Africans sold into slavery. The Africans led a sea-board rebellion in which several crewmen were killed. The Africans were charged with murder. John Quincy Adams eventually helped win the Africans' freedom.

Mary Staley, an art professor at Montgomery College of Takoma Park, MD, coordinated the Amistad Friendship Quilt Project. The project's goal was to equip the *Amistad* bunks with quilts made by people of diverse cultures. Staley requested appliquéd, patchwork, or embroidered 14" square blocks based on the themes of ethnic heritage, human rights, or the 1839 Amistad incident.

I wish a book documenting the Amistad Friendship Quilt Project would be published. Close to fifty quilts will be stitched from the Amistad blocks. American quilt history needs a record in text and photos of the 1,000+ quilt blocks contributed by quilters worldwide, including many by African American quilters.

8. AFRICAN AMERICAN QUILTERS CONTINUE TO PRESERVE THEIR QUILT HISTORY

As I pack away my crates filled with research for this book, I marvel at the quilting history preserved by Black quilters themselves. African American quilters continue to record their quilts through photography, written self-documentation (see Appendix for sample form), and state quilt projects. I have been fortunate to read old newsletters from several African American quilting groups nationally. In these records, Black quilters, usually women, speak for themselves about how quilting is affecting their lives and how they are using quilting to make an impact on their communities. I have read about the needs to express creativity through cloth, the group challenges, the quilt raffles, annual exhibits, and quilting trips.

I wish these newsletters, exhibit brochures, online discussions and other ephemeral items produced by African American quilting groups could be preserved

as part of the broader American quilting story. I hope a set of the groups' newsletters, and maybe even a group photo, would be sent to institutions such as the American Folklife Center of the Library of Congress, the National Quilting Association Library, the Schomburg Center for Research in Black Culture, the International Quilt Study Group Library or other interested facilities so that future historians would have access to our quilting stories ... firsthand.

APPENDIX

Quilt Documentation Form

Today's Date _____

QUILT OWNER

Name _____
Address _____
City _____ State _____ Zip _____
Phone _____ Email _____
Relationship to Quiltmaker _____
How was quilt acquired? _____ Self-made _____ Gift _____ Inheritance
 _____ Commissioned _____ Purchased
 _____ Other _____
Purchase Price $ _____ Insurance Value $ _____
Quilt Condition _____ Excellent _____ Good _____ Fair _____ Poor
Previous Quilt Owner _____

QUILTMAKER OR QUILT DESIGNER

Name _____
Address _____
City _____ State _____ Zip _____
Phone _____ Email _____
Date of Birth _____ Location _____
Date of Death _____ Location _____
ETHNICITY: _____ African American _____ Asian American
 _____ Caucasian _____ Hispanic
 _____ American Indian _____ Other _____

Quiltmaker Notes _____

QUILT DESCRIPTION

Title of Quilt _____

Quilt Dimensions (Inches) _____ Height _____ Width

Year Quilt Completed _____

How long did it take to make the quilt? _____

Quilt Signed? _____ Where? _____

Quilt Dated? _____ Where? _____

Name of Quilt Pattern Used _____

QUILT TYPE:	___ Appliquéd	___ Crazy	___ Embroidered
	___ Pieced	___ Whole cloth	
	___ other _____		

FABRICS USED:	___ African prints	___ Batik	___ Brocade
	___ Cotton	___ Kente Cloth	___ Mud Cloth
	___ Polyester	___ Silk	
	___ other _____		

EMBELLISHMENTS:	___ Beads	___ Buttons	___ Cowry shells
	___ Doll(s)	___ Metallic Threads	___ Paint
	___ Photo transfer	___ Other _____	

TOP CONSTRUCTION: ___ Hand ___ Machine ___ Both

QUILTING CONSTRUCTION: ___ Hand ___ Machine ___ Both ___ Tied

Who Quilted Piece? _____

Quilt Awards _____

Quilt Exhibitions _____

Story Behind the Quilt _____

Form Completed by _____ Date _____

Index

Numbers in italic represent photographs.
Letters represent plates in the color insert.